Hubert Robert
Painted Spaces of the Enlightenment

Hubert Robert: Painted Spaces of the Enlightenment provides an analysis and interpretation of selected works by one of the most important French artists of the eighteenth century. Examining four sets of pictures that involve multiple canvases, Paula Rea Radisich discusses these works in the light of the architectural settings for which they were designed and the demands imposed by the patrons who commissioned them. Through this inquiry, she establishes the broader function and significance of art in pre-Revolutionary France, moving from the creation of the work of art to questions about its architectural and cultural setting. In considering issues of production and reception of artworks, this study also examines how the Revolution affected the iconography of Robert's late paintings.

Paula Rea Radisich is professor of art history at Whittier College. She has published articles on aspects of eighteenth-century art in *Eighteenth-Century Studies* and *The Art Bulletin*.

Hubert Robert

Painted Spaces of the Enlightenment

Paula Rea Radisich

CAMBRIDGE
UNIVERSITY PRESS

PUBLISHED BY THE PRESS SYNDICATE OF THE UNIVERSITY OF CAMBRIDGE
The Pitt Building, Trumpington Street, Cambridge CB2 1RP, United Kingdom

CAMBRIDGE UNIVERSITY PRESS
The Edinburgh Building, Cambridge CB2 2RU, UK http://www.cup.cam.ac.uk
40 West 20th Street, New York, NY 10011–4211, USA http://www.cup.org
10 Stamford Road, Oakleigh, Melbourne 3166, Australia

First published 1998

Printed in the United States of America

Typeset in Sabon and Cochin 10.25/14 pt. in Penta [RF]

*A catalog record for this book is available from
the British Library*

Library of Congress Cataloging-in-Publication Data
Radisich, Paula Rea.
Hubert Robert : painted spaces of the Enlightenment / Paula Rea
Radisich.
p. cm.
Includes bibliographical references.
ISBN 0–521–59351–4 (hardcover)
1. Robert, Hubert, 1733–1808 – Criticism and interpretation.
2. Artists and patrons – France – History – 18th century. 3. Art and
society – France – History – 18th century. I. Robert, Hubert,
1733–1808. II. Title.
ND553.R6R24 1998
759.4 – dc21 97–30194

ISBN 0 521 59351 4 hardback

T

100 259 1660

Contents

Illustrations

Acknowledgments

This book owes its existence to a mix of public support and private encouragement. On the public side, my evolution as a scholar is due in large part to the magnificent programs developed by the National Endowment for the Humanities to facilitate the scholarship of college teachers, such as myself, who are tenured at institutions in which the primary mission is teaching rather than research. Over the years, my research on various aspects of Hubert Robert's oeuvre has been funded by an NEH Summer Stipend (1982) and an NEH Fellowship for College Teachers (1990). The benefits I received from participating in an NEH Summer Institute at Stanford (1995) on *The Public Sphere*, although not directly related to my scholarly pursuits, were incalculable. That Institute was an idea shaper. Traces of the questions it raised and the controversies it provoked, not to mention the voluminous readings we analyzed and discussed, are evident throughout this book. I am deeply grateful to the National Endowment for the Humanities for having sponsored these programs and for the support that I have received from it.

Two art historians have been very important in the development and fruition of this project. Especially during the last two years, my many conversations with Jeri Mitchell about this book have immeasurably helped me to focus and refine its themes. Her questions and observations have contributed much, and I wish to thank her for the intellectual and moral support she has given me. Likewise, the debt I owe Mary Sheriff is beyond measure. Only she knows the scale of her contributions to this project. For several years, she has given me generously of her time, advice, and resources. For that, and for her steadfast encouragement, I thank her.

In France, a number of persons deserve special acknowledgment. I wish to thank the archbishop of Rouen, for permitting me to examine and photograph the pictures in the *archevêché* and for spending time with me there. Jean de Cayeux, rather like our shared enthusiasm, Hubert Robert, has always seemed to me to be a model of French *politesse*; for his kindnesses over the years to an American

professor making an incursion into his scholarly territory, I thank him. I am also indebted to the present owner of Hubert Robert's Abbey Saint-Antoine cycle, who graciously allowed me to examine and photograph the paintings displayed in the residence. Without the cooperation of these individuals, this project would never have materialized.

I wish to thank Ann Topjohn, Research Librarian at Whittier College, for the ardor with which she tracked down hundreds of interlibrary loan requests, and Whittier College, which provided me with travel funds for a research trip to Paris in 1986. For her abiding interest in Hubert Robert, I am grateful to Beatrice Rehl of Cambridge University Press. I also wish to thank my son, Jeremy Radisich, for his editorial contributions to the manuscript.

Finally, I wish to acknowledge all that my husband, Michael Praetorius, professor of philosophy at Whittier College, taught me. His unexpected death in April 1995 lies at the emotional center of this book. I would dedicate the book to him, but I know he would not consider such a gesture to be very meaningful.

Paris, France
March 29, 1997

Chapter 1

Introduction

Hubert Robert *and* La Vie Privée

> Excessively arduous, tireless in his work, his presence still created the
> pleasure of society because of the charms of his wit, which was refined
> in the company of the illustrious personages of his time, all of whom
> became his friends.
>
> Fournier-Desormes, *Epître à Hubert Robert*, 1822

HOW IRONIC that Hubert Robert, an artist in his own time
reputed to be the most urbane and polished of men, should
today be regarded as an artistic misfit. Like a square peg in a round hole, Robert's
art is at odds with the organizing structures that prevail in eighteenth-century
French art. Neither the rococo nor the neoclassic stylistic category describes his
art well. Nor can he be reduced satisfactorily to the subject matter he painted
because his subjects – architecture and gardens, most typically – fell outside the
primary classifications devised by the theorists of the Royal Academy of Painting
and Sculpture. Even when Hubert Robert sallied forth into subject matter broadly
construed as either portrait, landscape, or history, the result did not resemble
portrait, landscape, or history as a categorical type practiced in the 1770s and
1780s. For example, it is a simple matter to identify Elisabeth Vigée-Lebrun as a
portrait painter, Joseph Vernet as a landscape painter, and Jacques-Louis David
as a history painter, because they all worked within the well-defined and well-
established conventions associated with their respective subject type. It is a far
more problematic task to map the subjects of Hubert Robert on this matrix.

When contemporaries of Robert strove to distinguish him from other artists,
they, like his friend Fournier-Desormes,[1] used terms whose meanings are in
doubt.[2] At first glance, the set phrases in Fournier-Desormes's rambling charac-
terization hold little more than anecdotal interest for the art historian; however,
as incongruous as these formulations may seem, they merit a closer look. In most
descriptions of Hubert Robert penned by those who knew him, his work habits

and sociability, like two thematic braids, twist together to articulate his artistic identity. Fournier-Desormes begins with references to Robert as a producer: the artist is said to be industrious to a fault "dans ses travaux." Yet his being absorbed in his work did not result in Robert's separation from society. On the contrary, Fournier-Desormes implies that the key to Robert's distinction lies in the equation he maintained between laboring in the studio and mingling conviviably in the gatherings of notables.

To the twentieth-century historian, this implied relation between the artist's work and his sociability appears obscure, even suspect, because it inflects the life of the artist rather than the artwork. So Hubert Robert was gregarious; what can his gregariousness have to do with an analysis of the representations he crafted? This became one of the generating questions of my inquiry. To answer it, I began, tentatively, to form an account of those artworks by Hubert Robert displayed in venues other than in public exhibition, concentrating on places that served as sites for sociable exchange.

Not that Hubert Robert was shunned by the organizers of the Salon, the exhibition sponsored by the Royal Academy of Painting and Sculpture – far from it. He received most of the honors that the Academy could bestow and enjoyed considerable prominence within the Academy's hierarchy. Nonetheless, I had been launched on a different path of historical investigation and sought to develop ideas that situated Robert's work within the domains of fashion, luxury, and the free market. As my research progressed, however, the project took a surprising turn: I discovered that these very subjects emerge also as repeated themes in the Salon criticism of Denis Diderot, the eighteenth century's preeminent art reviewer.[3] Paradoxically, Diderot provided me with a new perspective on this subject.

It struck me that for Diderot Hubert Robert signified a series of largely negative associations linked to "la vie privée," in which assumptions about an artist's work and sociability take on great importance. I do not use the English phrase "private life," because its nuances are too modern to describe what I believe Diderot had in mind. The phrase "la vie privée" comes from the title of the final volume of the baron d'Holbach's three-volume *La Morale universelle ou les Devoirs de l'Homme fondés sur sa Nature* (1776).[4] D'Holbach distinguishes the contents of Volume II, "The morality of peoples, of rulers, of notables, of the wealthy, etc., or duties of public life and different estates," from the concerns he addresses in Volume III, which he terms "les devoirs de la vie privée."

When Diderot writes about the purpose and nature of art in the *Salons*, he has the morality of the French people much in mind. He expresses his opinions about it constantly, and usually in the imperative mood. "Do you believe there is no difference between a man who works for a vast populace (*un peuple immense*)," he writes in his review of the Salon of 1769, "and the man who works for a tiny individual (*un petit particulier*) [one who] closets the artwork, confining it to two stupid eyes?" In the piece from which this quotation is drawn, Diderot

takes aim at one of his favorite targets, "les amateurs" – art lovers or patrons. He castigates one, Jean-Joseph de Laborde, as "unfair, antipatriotic, and dishonest" for refusing to lend to the Salon exhibition eight large landscapes that Laborde had commissioned from Joseph Vernet. Diderot complains that Laborde's selfish act could lead to a situation in which the Salon exhibition would simply die out. Without the Salon, exemplars for the student of art would cease to exist, as would fruitful comparisons between masters; posterity would be deprived of the judgments of artists, the criticism of amateurs and men of letters, and the voice of the public goading artists to produce masterpieces.[5] Diderot's reference to the "voice of the public" is consistent with studies, notably that of Thomas E. Crow, showing how the Salon became the headquarters for various claims made to and about "the public" concerning art during the second half of the eighteenth century.[6]

My interest, however, became more and more focused on the obverse of this construction. Whatever "the public" was, it achieved lucidity only when it could be defined against its opposite, a shadowy clump of elements that had no name (though we sometimes refer to it as "the private"). If we depend upon the eighteenth-century texts of writers like Diderot, we will find only "the antipublic" represented negatively.[7] For example, private patrons, as Diderot indicates in his quote, become those individuals who pursue their private interest at the expense of the greater good: thus Laborde is deemed to be antipatriotic.

To describe the activities and values circumscribed within the domain of the "antipublic," the encyclopedists, for Diderot is not alone in this, resorted to a special discourse. They used the old language of *luxe* – luxury, opulence, sumptuousness – but in an elaborated form that inevitably signified dissipated excess.[8] Much of Diderot's art "theory" is shaped by this disposition. A fault line separates the public from its antithesis. On the positive, "public" side, visual art is construed as a liberal art imbued with edifying intellectual appeal apprehended by the good taste of a male beholder. Opposing this viewpoint is a construction of art as a luxury object providing a species of pleasure akin to the delight experienced by a woman for a new dress. One unusual aspect of what is written on art after mid-century is how women intrude so significantly into the discourse, being perceived, ultimately, as the capricious rulers of the other nameless (private) domain.[9]

Luxe comes to represent the manifest evil against which a nascent "public," led by the male battalions of the Republic of Letters, must battle. Without *luxe*, the utopian "public" sphere of the future could be neither envisaged nor proselytized.

Panning the Private: Diderot on Luxe

The rhetoric of *luxe* in the eighteenth century was shaped by considerations of class as well as of gender, for it tacitly hinged on the supposed intemperance of

a special class, wealthy financiers. Diderot lambastes this group in a lengthy digression about *luxe* and the fine arts, which he inserts in his review of the Salon of 1767 in the form of a conversation between the critic and his editor, Frédéric-Melchoir Grimm. *Luxe*, claims Diderot, produces a cultural warrant imposed by the fantasies and caprices of a fistful of "rich, bored, fastidious men, their taste as corrupt as their morals."[10] Grimm puts Diderot's remarks in context by exclaiming with false innocence at one point: "Ah! You want to talk politics." "And why not?" retorts Diderot.

Diderot decries the present order of things in France. He would prefer an economic system reformed along Physiocratic lines. In such a system, all riches would originate from and recirculate through the land, and the inflection would fall on the genuine unit of wealth derived from nature – agriculture – rather than on money. Money, writes Diderot wrathfully, has become the measure of all things. "It became necessary to have money, and then what? More money."

Like most progressive thinkers in eighteenth-century France, Diderot reviled financial operations. He believed such activities siphoned off riches that should remain coursing through the circuits of the economy. Specifically, surplus wealth should percolate through agriculture. Sébastien Mercier expresses the same idea in an unforgettable metaphor in which he complains about "that cruel finance that causes the pure blood of the State to seep out in large, stagnant pools of opulence (*luxe*)."[11] As Mercier's statement suggests, the Physiocrats and their partisans conflated money made by financial means with money spent on luxury goods. They believed both activities caused abcesslike pockets of sterile wealth to form in the body politic.

The decorative arts were seen to play a particularly culpable role in this process – and rightly so, since one traditional object of decoration had been conspicuous display. *Bienséance* mandated that decoration point to a patron's social rank and status. The equation of magnificence to display, however, was decidedly out of fashion after the mid-eighteenth century. As defined in the *Encyclopédie*, magnificence belonged to the domain of morals (XX, 741). The chevalier de Jaucourt, who wrote the article, associates magnificence with appropriate expenditures for the public good (i.e., wealth spent on objects "qui font de grande utilité au public"). When used for personal pleasure, magnificence reified into *faste*, or ostentation – an unseemly "affectation" of announcing merit, power, or grandeur through external signs (XIII, 863). The article "faste" includes an admonition from Voltaire: "You can live in comfort without parading a revolting opulence in public."

It is easy to see how artists might be implicated in this discourse, and indeed, sometimes they were.[12] In Sébastien Mercier's *Tableau de Paris* (1781–88), for example, a decidedly unsavory image of the modern artist rests on precisely this foundation. Mercier links the untroubled consciences of artisans to their occu-

pations, for their labors are useful to society. Artists, on the other hand, produce nonutilitarian objects "du luxe" and demonstrate in consequence bad morals and licentious behavior.[13] For critics of *luxe*, the makers and the users of luxury objects are equally contaminated by them. As the Physiocrat Mirabeau writes in 1759: "The man whose furniture and jewels are *guillochés* (a checkered ornamental pattern) will be similarly marked in body and mind."[14]

Deconstructing Diderot

In the rhetoric of *luxe*, money and morality are mediated by taste, for it is "taste" that separates the object of luxury from its more exalted counterpart, the work of art.[15] And after 1750 the agent who claimed to enforce standards of taste was the critic, or more broadly, the man of letters.

To illustrate how a critic such as Diderot wielded this discourse, I want to scrutinize one particular text that he wrote about Hubert Robert, a piece ostensibly pertaining to an esthetic issue. A close reading of these passages, however, reveals Diderot baldly manipulating an esthetic question to make "de la politique," to use Grimm's phrase. The porousness of the rhetoric of *luxe* enables the critic to apply it to a vastly different context in which connotation becomes the means to communicate a wide range of meanings.

In the Salon of 1771, Diderot writes a lengthy parenthetical harangue about Hubert Robert that builds to a thundering denunciation of the artist's lack of finish.

> (One more word on Robert. If this artist continues to sketch, he will lose the practice of finishing, his head and his hand will become libertine. He sketches while young, what will he make then when he is old? He wishes to earn his ten louis in the morning; he is ostentatious, his wife is a woman of fashion, he must work fast, but he will lose his talent, and born to be great, he will remain mediocre. Finish your works, Mr. Robert; get in the habit of finishing, Mr. Robert, and when you have gotten it, Mr. Robert, it will not cost you much more to make a painting than a sketch.)[16]

Diderot equates artistic sketchiness with license – implicitly with sexual license, "his head and his hand will become libertine." Then, moving to an entirely different register of meaning, he connects Robert's sketchiness to an extreme haste necessitated by the artist's need to overproduce.[17] The artist must maximize his output, Diderot explains, because of his appetite for cash. Why does he need money? The artist has adopted a conspicuously lavish style of living, and his wife is a woman of fashion; therefore, he must produce and sell his work quickly: "il veut gagner ses dix louis dans la matinée." Like a journeyman who insults the master through the surrogate of the master's wife, Diderot unexpectedly focuses

upon Madame Robert. He imputes a substantial role to her as the driving force behind her husband's need for money. Madame Robert, he tells us, is an *élégante*, or a woman of fashion, so (the "so" is implied) Robert must work quickly. In this text Diderot constructs the excessive desire to consume as a feminine quality.

Recent scholarship has drawn our attention to this representation in French letters as a manifestation of a broader concern over the place of women as buyers and sellers within a burgeoning commercial culture.[18] This same fear, I propose, lies behind Diderot's critique of sketchiness. Anxiety about the commercial prominence of the *marchande de modes*, the retailer of high fashion garments for the woman of fashion, and the newly prosperous artist provoked strangely similar rhetoric from men like Diderot, peppered with such words as "fantasy," "caprice," "ostentation," "moral corruption," and "dissipation." Liberty of the marketplace – at least in matters pertaining to fashion and art – aroused suspicion in these reformers and a deep-seated need to control.

So, goaded by the whimsical appetites of his wife, Hubert Robert, according to Diderot, has become an equally avid consumer of luxury goods. The critic upbraids Robert for his ostentation (*fastueux*), a reprimand that Diderot usually reserves for that handful of "rich, bored, fastitious men" whose taste is as corrupt as their morals. ("Dialogue on *Luxe*," 1767.) As if that were not enough, in a surprising change of emphasis, Diderot criticizes Robert as a producer too. Compressing a day's labor into a morning, Diderot implies, will necessarily result in a poorly made product.[19]

Diderot's text is rife with contradictions. Its purpose is evident though – to impose the criteria of "public art" on Robert's work. Thus Diderot's comments about a picture, labeled no. 87, *Une partie des portiques de l'ancien palais du Pape Jules à Rome*, which was exhibited at the same Salon:

> Here is a very pretty sketch that M. Robert can make into something of real merit if less expedient, less slapped-out, [if] he had wished to treat this piece seriously and in larger dimensions. Panini would have made an admirable painting out of it. But today one must have "des petits tableaux,"[20] one hardly looks at them, but one counts them, and the artist finds his own among them.[21]

As he evaluates no. 88, *Deux dessins faits d'après nature au château d'Amboise*, and no. 89, *Plusieurs autres dessins coloriés de différentes Vues et Monumens d'Italie*, the critic continues to expostulate with the artist:

> Again a plethora of ideas but no paintings. Eh! My friends, I should say to these Mister sketchers, keep your drawings and sketches, [washed with] brown, [or] colored, and whatever pleases you, in your portfolios, and let them only appear before our eyes as paintings well rendered and well finished. One chases after drawings of Raphael, of Rubens, etc. because their paintings are scarce, and all their known work bears the mark of the knowledgeable man (*l'homme savant*),

the grandee. But your offspring so promptly placed in the light of day discloses the quantity of your ideas, true enough, but are they great and sublime?[22]

Diderot presents his norms as unqualified truths. "Your sketches should appear before our eyes," that is, should appear to the male critic evaluating art exhibited at the Salon, "as highly rendered paintings imbued with grand and sublime ideas."

For a fresh look at Robert's art, however, we must set Diderot aside. We must recognize that Diderot's "public" art is an ideological construction against which Robert's compositions will inevitably be found wanting, for Robert's art is informed by very different criteria.

Art, Commerce, and Hubert Robert

One interesting aspect of Diderot's denunciation of luxury is the ambivalence that it reveals about the values of commercial society. Although artists had for centuries thought of themselves as professionals, a number of new factors shaped Robert's professionalism. In his important article on the development of commercial capitalism in eighteenth-century France, Colin Jones calls these new factors "a developing market-consciousness."[23]

Pierre-Jean Mariette reports that Robert decided to become an artist against the wishes of his parents. But more striking is that having decided on an artistic career, Robert did not choose to study with an established painter of the Royal Academy.[24] Instead, Robert turned to the studio of a sculptor, one whose family was deeply engaged in the Paris market for luxury goods, Michel Ange Slodtz. Although Slodtz is best known in art history as a sculptor, his brothers figured among Paris's leading suppliers of "les ornements intérieurs et extérieurs d'une maison."[25] During the period in which Robert studied with him (1751–53), the sculptor was only beginning to establish himself in Paris following a decade in Rome. With no clientele yet to call his own, he is known to have collaborated with his brothers on various decorative projects, and one may suppose he delegated to his students some of this work, which involved conceptualizing sets for royal ceremonies and theater, as well as producing designs for fixed and movable decorative objects for residences and gardens.[26]

Following his apprenticeship with Slodtz, Robert traveled to Rome in 1753 as part of the entourage of the comte de Stainville (later the duc de Choiseul), who was the French ambassador to Rome. In Rome, as Mariette tells us, "for twelve years [Robert] worked in the same genre as (Gian Paolo) Pannini, that is to say he painted ruins and Italian fabriques enriched with small figures and landscape." Views of antiquities, like the antiquities themselves, supplied part of a market geared to the foreigner visiting Rome on the Grand Tour or to the reader in Paris resigned to wistfully imagining the city. Robert catered to this market. "Study for

the sake of studying; it is better to be paid for it," remarked the comte de Caylus, who hired Robert briefly in 1760 to produce certain "morceaux curieux à Rome" that Caylus intended to engrave, publish, and offer for sale.[27] Although the project never materialized, it was through such venues that classical culture was commodified for a broadening market of consumers – a market mediated by antiquarians such as Caylus and serviced by expatriate artists such as Hubert Robert.[28]

As the Caylus project suggests, Hubert Robert was not averse to exploiting his talents as an artist in the marketplace. He met the demand for images of Italianate monuments by producing for sale a large number of paintings and, especially, drawings on these subjects.[29] Indeed, Mariette notes that Robert's drawings were finer than his paintings and that they were highly sought after: "Everyone wants one of them."[30] Diderot's outburst in the 1771 Salon, which ordered Robert to keep his drawings shut away in his portfolio, speaks volumes in this regard.

A Versatile Brush

The shadowy contours of the Hubert Robert that emerges from those historical sources is a figure of versatility. Yet his versatility is one of these factors that make Robert difficult to classify as an artist. Once he had devised a striking composition, he was likely to recycle it in chalk drawings, in watercolors of comparatively more finish, in oil paintings formatted as *petits tableaux*, in oil paintings configured to cover a breadth of wall, and, finally, in three-dimensional installations placed in gardens of his design. Moreover, the units of esthetic experience staged for the stroller's delectation in gardens often became the subject of easel paintings. For instance, Robert painted many versions of the Bains d'Apollon (Fig. 1), the famous garden installation he had designed for the grounds at the Palace of Versailles in the 1770s.[31] The example in Figure 1, from the Musée Carnavalet, is signed and dated "H. Roberti 1803." By 1803 over twenty-five years had elapsed since the completion of the Bains d'Apollon, yet the artist indicates in this picture that a post-Revolutionary generation will find his confection as enticing as had Louis XVI and Marie-Antoinette. In the picture, he represents another generation of spectators admiring the versatility of Hubert Robert!

Versatility is a timid claim for the art historian to offer on behalf of an artist's worth. In common parlance, to be deemed an artist of versatility instead of an artist of genius may even be interpreted as a slur. But why do we conceptualize value in this manner? Isn't our aversion to versatility in the artist a legacy of modernism's deeply rooted cultural need to sever the production of art from the market? In the marketplace, versatility is an asset (or so we tell the students who attend our liberal arts colleges). However, when we shift our focus to fine art, we

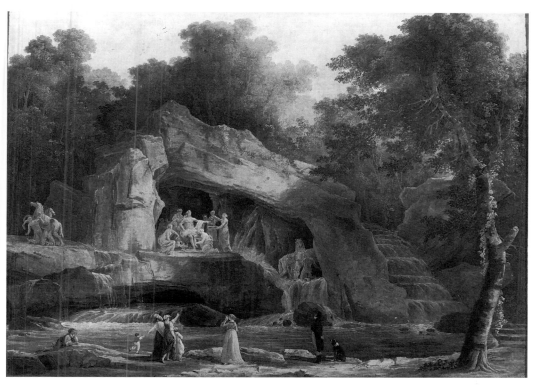

Figure 1. Hubert Robert, *Les Bains d'Apollon*, 1803 (oil on canvas, 99 × 103 cm). Signed and dated "H. Roberti 1803." Paris, Musée Carnavalet. Photo: Art Resource.

prefer to abide by the myth that the creation of art transcends market interests. This tension between art and commerce first developed in the eighteenth century. Hubert Robert is an artist whose work was shaped by the force of these powerful constructions.

Because the commercial aspects of art production have concerned artists since the beginning of time, I do not argue that Hubert Robert was the first artist to set a price on his work. Rather, I wish to suggest that one factor inflecting Robert's artwork in the 1770s and 1780s was a developing market consciousness in which he, like many writers of his day, became aware of the significance of mediating his work directly to consumers.[32] Antoine Watteau, for example, provides an instructive comparison to Hubert Robert. A solitary figure of ambiguous status within the culture of the Regency, Watteau was always lodged in the household of another and, consequently, was always a retainer in some sense.[33] Robert's professional independence was far more fixed: he married and he acquired a family, servants, an art collection, and a country house in Auteuil with a gallery to hold his own pictures.[34] In some sense, he resembles Watteau's patron Pierre

Crozat or Watteau's "entrepreneurial promoter" Jean de Jullienne,[35] more than he does Watteau. As I discuss in Chapter 2, control of cultural production and of self-representation appear to be far more central to the nature of Robert's work than it had been for an artist such as Watteau. "Sociability" as a signifier in the second half of the eighteenth century is connected to these issues.

Thus let me try to inflect the word "versatile" positively, from a point of view that Hubert Robert would have appreciated (he would not have been pleased to be described solely as a producer for the market or as a cipher at the mercy of modern sociological constructions such as "commerce" or "the public sphere"). Formulating the value of my subject into a thesis, I argue that Hubert Robert is an artist of significance because he composes works of art that display the quality of invention. This same quality marked his conversation, one reason "his presence . . . created the pleasure of society," as Fournier-Desormes expresses it. The paintings I analyze in this study are all characterized by this common feature: they are "bien-inventée."[36] Admittedly, this is a most traditional frame of reference to impose on my subject, but it is within this frame that I wish to locate Robert's "versatility." A look at the entry "invention" in the *Encyclopédie* indicates that it is a rhetorical term. "Invention," we are told, is a matter of choosing just the right thought to suit a given situation.

> Properly speaking, invention consists of choosing from among the thoughts that present themselves, those that are the most appropriate to the subject that one treats, the most noble, and the most solid, to dispense with those that are false or frivolous, or trivial; to consider the time, the place where one performs; what one owes to oneself, and what one owes to one's audience. (VIII, 849)[37]

In the domain of the visual arts, the adjective that comes closest to conveying this meaning is *habile*, a word for which we have no exact translation in English. *Habile*, in the French dictionary, refers to one "who demonstrates a particular *adresse* (another word that lacks an English equivalent)" or to one "who demonstrates a particular ingenuousness." This definition strikes me as one that can be brought profitably to the problem of articulating Hubert Robert's special brand of artistry.

To prove this loop of claims signified by the term "inventive," taken in its eighteenth-century sense, I survey Robert's pictorial *adresse* or response to different situations, for only then can we assess the degree to which his works are *bien-inventée*. We must grasp what various situations require as well. For example, how should an artist fabricate representations for the salon of Madame Geoffrin, one of the most celebrated hostesses in Paris? For the formal hall of the archiepiscopal palace, the seat of the archbishop of Rouen, Dominique de la Rochefoucauld? For the bathing room in the garden villa of the count d'Artois,

rumored to be one of the court's notorious libertines? For the new dining room at Fontainebleau of Louis XVI, the king of France?

My understanding of how Hubert Robert managed to turn with ease from one to the other of these disparate tasks, while remaining true to himself, forms the substance of this book.

Hubert Robert in the Salon of Madame Geoffrin

Hubert Robert painted five representations of Marie-Thérèse Geoffrin, which are the subject of Chapter 2. Her gender is not insignificant to the line of thought that I have adumbrated thus far, for, as we have seen, women occupied a central position in *la vie privée*. Robert's paintings are representations that relate to and picture the social life they frame. Although Madame Geoffrin is best known as a leading salonniere in Paris from 1740 until her death in 1777,[38] an inquiry into her involvement with the buying and selling of art highlights the pivotal role of commerce in the paradigm of sociability. Men and women circulating in *société* construed commerce as an eminently civilized activity connected to the rational quest for happiness and progress.[39] When Charles-Nicolas Cochin characterizes the *lundis* (Madame Geoffrin's weekly Monday salons) as a "bureau des amateurs" or a "petite république des arts" he acknowledges the overlap between sociability and the marketplace, for this salon was no alternate Academy, as Pierre Crozat's weekly gatherings earlier in the century appear to have been.[40] It was a peculiar eighteenth-century variant of commerce, though, caught halfway between the feudal court and the world of capital.

We are reminded that sociability is a category of experience that Hubert Robert's contemporaries, writers like d'Holbach, for example, subsume under the heading of the nonpublic side of life. *Politesse*, for d'Holbach, was one of the "devoirs de la vie privée."[41] Furthermore, when we shift from the realm of the sociological to that of the architectural, we find that the layout of the rococo hôtel early in the eighteenth century offered distinct spaces in which sociability could be either discouraged or accentuated. Sites for sociability were actually termed "appartements de société."[42] Katie Scott has shown how decoration in these spaces – which might include an antechamber, a dining room, a *salle de compagnie*, a salon, and various cabinets – omitted symbols pointing to status, because sociability was grounded in the pretense of equality and mutual pleasure. Status claims were expressed in a different set of spaces, the "appartements de parade," decorated with signs of hierarchy against which nobles could perform the rituals of rank.

One conclusion arrived at in Chapter 2 is that the relation between the ceremonial and the sociable had begun to change dramatically by midcentury, at least

if Madame Geoffrin's townhouse is taken as an example. If this conclusion is correct, then the place of art within the confines of *la vie privée* may have changed along with it. In hôtels of the seventeenth and early eighteenth centuries, art collections were housed in the *cabinet de tableaux* or *gallerie*, chambers relegated to ceremonial rather than sociable functions.[43] For a person such as Madame Geoffrin, however, the conventions of the *appartements de parade* become nearly meaningless. Madame Geoffrin epitomizes the Enlightenment sensibility for which the values of *société* coalesced into a new life style. One result was that she dispersed her remarkable painting collection, comprising only living French artists, throughout her residence, rather than containing it within a gallery or separate room.[44] "Her *appartements*, filled with precious paintings," recollected one visitor, "were marked by noble simplicity."[45] This stress upon noble simplicity instead of magnificence is precisely what we would expect to find in chambers devoted to the theoretically egalitarian pursuit of sociability.[46] Of course, that Madame Geoffrin was bourgeoise is not without relevance here. Her townhouse, at 372 rue Saint Honoré, lacked the most recognizable feature of the early eighteenth-century noble hôtel, the *porte cochère*, a monumental gateway separating the building from the street. On the contrary, portions of the Geoffrin structure extended to the street and were subdivided into shops.[47]

The salonniere seems to have held both the Monday and the Wednesday gatherings that brought her such international fame in the same rooms.[48] The site of sociable activity remained constant, then; only the participants and the primary topics of conversation shifted: *lundis* devoted to the visual arts, *mercredis* to matters of general cultural interest. Consequently, paintings in this setting became more assertive units of ornamentation than they had been in the past.

Art, Mode, and Hubert Robert

Diderot, in the passage discussed earlier, paints Madame Robert as a woman of fashion and suggests that her frivolous desire to be *à la mode* drives her husband's production. Like *luxe*, *mode* was construed by Diderot and like-minded critics as being what worthy public art was not. *Mode* was the timely, rather than the timeless, and was provoked by enthusiasm, rather than by reason. Fashion was based on a compulsion to imitate others and a "vivacity of imagination that attached itself unreflectively to an object," with no thought to consequence.[49]

Hubert Robert did create an unusual and distinctive artistic product that responded to what more censorious commentators saw as the mania for *mode* prevailing in France during the last two decades of the Old Regime. He became the leading exponent of decorative ensembles. In Chapter 3, 4, and 5, I analyze three sets of ensembles that Robert produced on commission to decorate specific architectural spaces. I selected these ensembles because either they remain in situ

(the Rouen cycle) or the pictures forming the ensemble survive together (the Bag-atelle pictures in the Metropolitan Museum, New York and the antiquities of Languedoc now in the Louvre).[50] An ensemble is a set of canvases consisting of four to six pieces custom designed to decorate specific chambers. "It was the height of fashion, and very magnificent, to have your salon painted by Robert," recalls his friend Elisabeth Vigée-Lebrun.[51] Vigée-Lebrun's syntax is interesting. Although admittedly she is using the term loosely, one could infer from her statement that "magnificence," freighted with its old associations of rank and status, had become absorbed into a new category of decoration, the painted salon.

Hubert Robert's name is associated with this phenomenon. By the 1770s, a commodity that could be summarily described as "a Robert room" had been devised and successfully marketed by the artist. Baron de Frénilly's description of his penniless friend Mathieu Molé in 1799 redecorating the family chateau conveys a sense of how the Roberts formed part of a distinctive decorative idiom. Molé transformed an immense rococo salon, "a triumph of volutes and gilded moldings" adorned by eight or twelve Boucher paintings embedded in massive gold frames, by replacing the Bouchers with squared canvases by Hubert Robert in thin cylindrical frames, "petites baguettes." Tacked over the windows and on the chairs were yards of lightweight printed cloth (*la toile de Jouy à petites mouches*). When Molé was finished, Frénilly observes, "ce salon royal" gave the impression of an empress *en chemise*.[52]

I like this anecdote for several reasons. First, I am struck by the way Frénilly correlates the Roberts with a style of picture frame and a particular factory-produced textile. Second, I deem it noteworthy that Molé is said to believe that these materials can form a decorative package unified enough to neutralize the appearance of the rococo in which the chamber had originally been designed. Third, I mark that Frénilly uses the figure of woman as a simile to describe the result. The effect is said to resemble a queen in her slip.

Frénilly's evocative simile regarding the appearance of Molé's grand salon, decked out in the latest styles, accentuates how, under Louis XVI, a taste had evolved that favored the "natural" and unencumbered over the "formal" and inhibited – a taste in which the Roberts are complicit. The undergarment quip underlines this new inflection upon informality. And, as the dry, amused tone of Frénilly suggests, no constituency of the French elite at the time was immune to this new taste.

Mathieu Molé, who hailed from an ancient parlementaire family, was distinguished by birth, but other Robert patrons, such as Jean-Joseph de Laborde, banker to the court, owed their preeminence to wealth and merit. In short, Hubert Robert's patrons were a cross-section of the French elite in the last third of the century – a composite of wealth, birth, and talent.

The point is that nobles, parvenus, and, ultimately, the king himself were eager

to solicit Robert's assistance in the ornamentation of their residences. Beaumarchais actually writes Robert in 1790 that he desires representations for the decoration of his salon that will harmonize with an impression of simplicity and antiquity. Why? Because what he fears above all is to be reproached with *luxe*.[53] This suggests that as the eighteenth century drew to a close, "simplicity" and "antiquity" became the cultural codes of an elite wishing to see themselves as creatures of a new age, distinct from the past.[54] Robert's decorative ensembles responded in different ways to the demand to counter *luxe* with other signs.

The middle chapters of the book aim to interpret the decorative ensembles within their settings, calibrating the images with the desires of the patron, the will of the artist, and the use of the space. No causal chain connects them. All they share is their taxonomy as decoration of different spaces devoted to sociable activities. In other words, these chapters are parallel accounts, not causally linked units of a linear argument.

The epilogue takes a diametrically different turn, returning to an examination of easel paintings and drawings produced in the 1790s. These works, like those discussed in Chapter 2, include pictures of interiors. *Painted Spaces of the Enlightenment* thus moves chronologically from representations by the artist in the townhouse of Madame Geoffrin to those by the artist in the Grand Gallery of the Louvre. The epilogue is specifically concerned with the impact of the Revolution on the imagery of Hubert Robert. It is more speculative than the preceding chapters, although the readings of the art are based on understandings gained from the line of inquiry developed in earlier chapters.

This book is not a monograph on Hubert Robert.[55] Nor is it a description of the decorative interior in France during the last decades of the Old Regime. Rather, it is best described by its internal organization, which fluctuates, shifting the reader's attention between the artwork and its cultural and architectural settings, between the producer and the consumer. I have tried to write a book that would interest my colleagues in other disciplines of the academic community as much as my own.

Chapter 2

Making Conversation

Hubert Robert in the Salon of Madame Geoffrin

Her [Madame Geoffrin's] good taste, her fine and delicate tone contributed to the development of the talent of artists and writers. Her wealth and her generosity were like a mine always open to their needs.

L'Abbé Georgel

Iᴎ 1773 Hubert Robert was commissioned by Madame Marie-Thérèse Geoffrin to paint three pictures representing the gardens of the Abbey of Saint-Antoine. He evidently performed this task to her satisfaction, because shortly thereafter her notes record "Plus deux" – two more paintings representing the interior of her bedroom.[1] The Saint-Antoine cycle consists of two narrow rectangular canvases and one oval format. In one (Fig. 2), Madame Geoffrin is depicted dining in the Abbey gardens; in another, she is absent (Fig. 3), but members of the religious order are shown at leisure on the grounds, grouped casually around the figure of a nun feeding a pair of swans in a small pond. In the oval canvas (Fig. 4), Madame Geoffrin is seen standing at the edge of one of the paths in the Abbey garden.

Hubert Robert produced a type of picture for Madame Geoffrin on these occasions not generally associated with eighteenth-century French art, although it plays a central role in English painting of the same period. The paintings, five in all (see Figs. 9 and 10), are conversation pieces, that is, they are pictures representing "real people 'at home' or in intimate or private surroundings."[2] In 1737 the Englishman George Vertue jotted down characteristics of the new portrait form – one that he called "pieces of conversations" – in his notebook. His words aptly describe Robert's images: "[a portrait of] small figures from the life in their habits and dress of the Times. well disposed graceful and natural easy actions suitable to the characters of the persons and their portraitures. well touched to the likeness and Air."[3]

For their thrust, conversation pictures draw upon a subtle interplay between

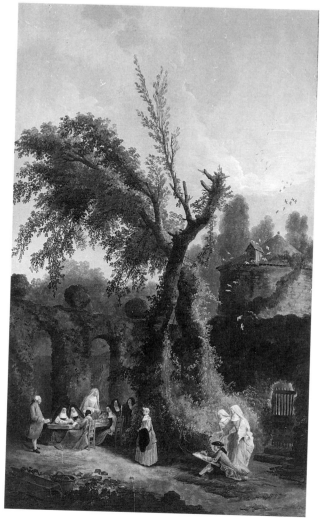

Figure 2. Hubert Robert, *Madame Geoffrin déjeunant avec les dames de l'Abbaye Saint-Antoine*, 1773 (oil on canvas, 155 × 86 cm). Signed "peint par H. Robert." Paris, Private Collection. Photo: Courtesy of owner.

the typicality of genre painting and the particularity of the portrait likeness. At this time in Paris, a fashion existed for renderings that caught notable personalities in unaffected postures as they watched, directed, or attended public events – a type of reportorial image related to the conversation piece. Several examples were included in the Salons of 1773 and 1775, notably, De Machy's *Mgr le Dauphin et Mme la Dauphine aux Tuileries, allant vers le Pont Tournant, le 23 juin 1773*

Figure 3. Hubert Robert, *Les Cygnes de l'Abbaye Saint-Antoine*, 1773 (oil on canvas, 155 × 86 cm). Signed "peint par H. Robert." Paris, Private Collection. Photo: Courtesy of owner.

(Salon 1773); Joseph Vernet's *La Construction d'un grand chemin*, showing the engineer Perronet supervising a road crew (Fig. 5; Salon 1775); and Hubert Robert's *Décintrement du pont de Neuilly* (Salon 1775), a representation of the opening of Perronet's new bridge on 22 September 1772, an event attended by Louis

Figure 4. Hubert Robert, *La Promenade de Mme Geoffrin à l'Abbaye Saint-Antoine*, 1773 (oil on canvas, 120 × 85 cm). Signed and dated "H. Robert 1773." Paris, Private Collection. Photo: Courtesy of owner.

XV, the comte de la Marche, Madame DuBarry, the abbé Terray, the duc de Vrillière, and many other notables, all of whom were recognized in the crowd Robert painted.[4]

Like the paintings just enumerated, Robert's Saint-Antoine series does not present a notable (Madame Geoffrin) "at home," following the norms of the English conversation piece. The convent of the twelfth-century Abbaye royale de Saint-Antoine-des-Champs was located outside the walls of Paris in the faubourg Saint-Antoine, at the opposite end of the city from the salonniere's hôtel on the rue Saint-Honoré near the Place Louis Le Grand (see Fig. 34).[5] Nonetheless, the

Figure 5. Joseph Vernet, *La Construction d'un grand chemin*, 1774 (oil on canvas, 97 × 162 cm). Paris, Musée du Louvre. Photo: Art Resource.

convent was not exactly a public place either. Indeed, it could be described as an "intimate or private surrounding" for Madame Geoffrin, for she regularly rented a room there to make retreats. In Figure 2 Madame Geoffrin is shown dining in the convent gardens with specific individuals, the princesse de Beauvau, who was the abbess, Madame de Mainville, Madame de Massabeky, and Madame de Blaiset – all portraits, as our definition of the conversation piece would have it, and all engaged in what one supposes is an intimate and typical occupation.

We shall return later to the question of what the convent gardens signify, because in a conversation piece the surroundings and how the portrait subject relates to them are of central significance. The objects in a conversation painting also have meaning, for the aim in a conversation picture is to define identity through relationships – between people, between people and their possessions, and between people and their environments.[6] In Figure 2, Robert paints Madame Geoffrin at the dining table with her friends, but he also includes her female servant, holding her cloak, and her male domestic, handing her a letter, both symbolic references to the outside world. Compositionally, the two servants, located at the center and the far left, respectively, form a triangulated figure with their seated mistress in the center. Of more than passing significance is the image of the artist, who has inserted himself into the scene (to the right) in the act of representing it.

Conversation pictures express meaning through the placement and spacing of forms, a strategy Hubert Robert expands upon and refines in his Saint-Antoine series by spinning the theme into three different canvases.[7] In Figure 4 Madame Geoffrin, accompanied by the abbess and two other nuns, stands at the head of a garden path leading through a tunnel of leafy trees. She is nowhere to be seen in Figure 3. Although nuns are shown sitting within the shadows of an arbor and several look down from a parapet surmounting a large open door, Madame Geoffrin is conspicuously absent from this representation.

What is the nature of the identity that Robert constructs for Madame Geoffrin in these paintings, and how does he create it? These questions are complicated, because Madame Geoffrin was no ordinary patron. She was, as commentators often observed, "unique."[8]

The Czarine of Paris: Madame Geoffrin (1699–1777)

The salient biographical details of Marie-Thérèse Rodet Geoffrin's life are well known.[9] Madame Geoffrin was the daughter of Pierre Rodet, a man who rose from the higher ranks of domestic service (*valet de garde-robe* of the dauphine) to retire to a modestly lucrative post purchased from the city of Paris (*commissaire contrôleur juré mouleur de bois*). Rodet's marriage was equally upwardly mobile, for he wedded the daughter of Louis Chemineau, a Paris banker.[10] Two children were born – Marie-Thérèse Rodet in 1699 and her brother. Orphaned in 1706, they were raised in comfortable circumstances by their maternal grandmother. In 1713, when Marie-Thérèse Rodet was fourteen, her grandmother married her to the forty-eight-year-old François Geoffrin, a wealthy neighbor who had made a fortune manufacturing mirrors at the Saint-Gobain works. The only child of this couple to survive to adulthood was the marquise de la Ferté-Imbault, Madame Geoffrin's contentious daughter, born in 1715.

Around 1730, Madame Geoffrin began to interact socially with the notorious Claudine Alexandrine Guérin de Tencin (1681–1749), and by the early 1740s, she had succeeded in attracting several of the older woman's more notable habit-ués, like Fontenelle, to her own gatherings on the rue Saint-Honoré. After François Geoffrin's death in December 1749, Madame Geoffrin hosted one of the capital's most fashionable salons, famed for its thinkers, writers, and artists. It was the great age of salon culture: "Every woman has one [a writer] planted in her house, and god knows how they water them," wrote Horace Walpole in 1765.[11] Madame Geoffrin's name was particularly associated with the encyclopedists, whom she supported both figuratively and literally. (The epigraph from the abbé Georgel likens her fortune to an open mine at the disposal of arts and letters.) When Grimm recounts for readers of his *Correspondance Littéraire* the cruel losses that philosophy had suffered in the year 1776, he includes in the same breath the stroke

of Madame Geoffrin, the disgrace of Turgot, the death of Julie Lespinasse, and the death of Madame Trudaine: "Here are then the cruel losses experienced by philosophy in the space of a few months: the death of Madmoiselle de Lespinasse, that of Madame de Trudaine, the disgrace of Monsieur Turgot, and the stroke of Madame Geoffrin. It is only the appointment of Monsieur Necker that can console us through these misfortunes."[12] Madame Geoffrin died the following year.

The Domain of an Amateur

One dimension of Madame Geoffrin's uniqueness – a component of the self she fashioned – was her inventing of a weekly *salon* "de fondation," as Saint-Beuve described it,[13] for artists. The fame of this salon indicates the brilliance of Madame Geoffrin's stratagem; other salonnieres might have men of letters or philosophers in their coterie, but only she had artists. The success of the *lundis*, moreover, reflects the rising stature of artists in the eighteenth century and the avidity with which their works were sought by collectors.

This last consideration deserves emphasizing, for one characteristic of the mid-eighteenth-century art world was the emergence of the private collector of the modern French school. Whereas collections formed early in the century contained mainly Italian and Flemish paintings of the seventeenth century – as did the collection of sixty-odd paintings owned by Jean-Baptiste Colbert, the marquis de Torcy (1665–1746),[14] for example – those formed after midcentury, like the collections of the comte d'Orsay (1749–1809) and the comte de Vaudreuil (1741–1817), contained a large number of works by living French artists.[15] One consequence of this new enthusiasm for modern French painting was that artists such as François Boucher and Joseph Vernet were deluged with offers and commissions. The published correspondence between Carl Fredrik Scheffer (1715–86) and his employer, the Swedish statesman and art collector C. G. Tessin (1695–1770), regarding the difficulties of procuring commissioned works by Boucher and Chardin is instructive: "Monseigneur," writes Scheffer from Paris, "with respect to Chardin, and Boucher, who I badger every day to give me one of his paintings, [he] says he is busy with orders from M. de Tournehem, to whom he must often surrender his paintings, . . ."[16] Madame Geoffrin became the person called upon in such cases to exert influence on behalf of frustrated collectors.

Having fixed upon the concept of gathering artists into her salon, Madame Geoffrin set out to cultivate them with ardor. For this, her social origins proved to be an advantage because her house, like the homes from which all eighteenth-century painters, sculptors, and architects hailed, was "assez bourgeois."[17] Marmontel's oft-quoted but mean-spirited comment about Madame Geoffrin's artists as men uniformly lacking in instruction and culture ought to be read with some skepticism.[18] To be sure, the artists of this generation were not as charming or as

vivacious as were those of the generation of Hubert Robert and Elisabeth Vigée-Lebrun that was shortly to follow, but neither were they social misfits. Herself described invariably as "bourgeoise and very bourgeoise by birth,"[19] Madame Geoffrin was optimally positioned to befriend someone like Vernet, who Marmontel described as gay enough, but nevertheless "a common man." Even so, she labored diligently to establish her relations with artists.[20] Morellet wrote it required "very assiduous care" to gain these men for her coterie. She succeeded, in his account, because she took their successes to heart, visited them in their studios, and commissioned works of art for her own collection from them.[21] As she put it, "artists do not govern themselves to suit others. I have become their friend because I see them often, provide them with commissions, caress them, praise them and pay them very well."[22]

Madame Geoffrin owned at least sixty-nine paintings. She commissioned them to keep, not to sell. In her meticulous accounts, she records selling only four paintings. The works of art that she owned were all of the modern French school, all by artists she knew well; indeed, all were by artists she called her friends. Moreover, each work was executed on commission: "I began my collection of art in 1750," she wrote in her *carnet*, "They were all made under my eyes."[23] The Roberts representing the Abbey Saint-Antoine, followed by the pendants representing "l'intérieur de ma chambre," were the last canvases that she commissioned for her collection.[24] Works that she is known to have owned, but not personally commissioned – a Nattier portrait of herself and another of her daughter – are not included as part of her "collection."[25]

The Lundis

The Monday salons at Madame Geoffrin's owed their importance to a new phenomenon in French cultural life, the rise of the art dealer or arts professional.[26] Around the middle of the century, the belief that profits could be reaped from speculation in works of art gave rise to an unprecedented (and little recognized) commerce in art.[27] As the number of collectors increased, so did the prestige of the dealer who serviced these amateurs.

Abstract esthetic principles mattered little to the new breed of art enthusiast; for them, the inflection fell on the name of the artist and the value of that name once it could be securely attached to a canvas. The anonymous "old amateur of arts," who wrote to the *Journal de Paris* in 1780, put it well: "I did not buy, as the merchants advised, because the work was expensive, even less because it was beautiful, but because it was rare."[28] In this atmosphere, the auction house began to rival the Royal Academy's biannual exhibition as the site of conversation about the value of artworks. But at the auctioneers, worth was indexed rather differently than it was at the Salon. For example, when Madame de Genlis brought her young

charges to a public auction at Lebrun's in 1789, she sought to teach them the mechanisms governing "the pricing of objects, even a mediocre drawing, selling high because of its rarity."[29] Unfortunately for collectors, rarity was often accompanied by questions of attribution and authenticity. It was in these circumstances that the dealer, or a connoisseur whose eye had been formed by dealers, played a new and privileged role, for he became the agent with the necessary expertise to identify the "hand" of an artist and verify the work of art as genuine.

At Madame Geoffrin's *lundis*, artists, dealers, and amateurs came together each week to scrutinize art from this special perspective. This activity followed a particular format, a format with a surprisingly pedagogical slant. Rather like graduate students enrolled in a connoisseurship course, members of the circle each brought an art object to be analyzed and discussed. At one gathering, which included Marigny and Marmontel, Joseph Vernet brought fresh from Italy a picture thought to be by Correggio; the duc de la Rochefoucauld, a small painting on marble overlaid with a mysterious incrustation process; Mariette, a portfolio of Old Master prints; and Cochin, some ink drawings.[30] Each artwork presented a particular problem for the group's collective consideration. One goal of the *lundis*, then, was to refine the participants' connoisseurship skills and generally exercise their faculties of evaluation. Costa de Beauregard, a fourteen-year-old witness to this process, brought his own paintings to the salon to be assessed! More typically, a collector considering the purchase of a particular painting would take it to Madame Geoffrin's salon for "les maîtres de l'art" to appraise and evaluate.[31]

Madame Geoffrin's salon physically resembled the space of an auction house. Many visitors to the hôtel on the rue Saint-Honoré remarked upon the impression of walls laden with works of art. Morellet referred to these works by the names of their authors, citing Van Loo, Greuze, Vernet, Vien, Lagrenée, and Robert and busts by the sculptor Lemoine. According to Madame Geoffrin's record book, in 1774 the collection consisted of nine Bouchers, six Drouais, one Greuze, one Guérin, five Lagrenées, one Lefèvre, two Leprinces, one Oudry, sixteen Roberts, ten Carle Van Loos, eight Vernets, eight Joseph Viens, two Madame Viens, one Servandoni, and one work begun by Deshays and completed by Joseph Vien. The most expensive commissions were *La Conversation Espagnole* and *La Lecture Espagnole* by Carle Van Loo (Fig. 6)[32] and a set of the Four Seasons by Joseph-Marie Vien, which cost Madame Geoffrin 6,000 livres each; next in value were a Vernet seascape, 2,400 livres, and Vernet's *La Bergère des Alpes,* 1,800 livres.[33] All these works, moreover, displayed the cachet of undisputed authenticity, for they were all created, as Madame Geoffrin proudly asserted, "under" her eyes.

Who attended the Mondays in 1773, the year in which Hubert Robert painted Madame Geoffrin at the convent of the Abbey Saint-Antoine? Both Carle Van Loo and the comte de Caylus had died in 1765, followed by Boucher in 1770.[34] Most of the original *convives* were still active, however, and they included some

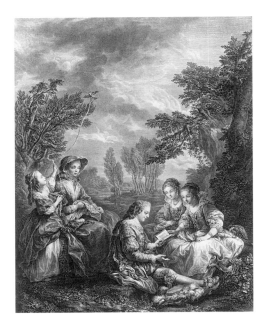

Figure 6. Print by Jacques-Firmin Beauvarlet (1731–97) after Carle Van Loo, *La Lecture Espagnole*, 1761. Photo: Bibliothèque Nationale de France.

of the most famous artists and amateurs in France: Joseph Vernet, Joseph-Marie Vien, Jacques-Germain Soufflot, Charles-Nicolas Cochin, Pierre-Joseph Mariette (he would die in 1774), Claude-Henri Watelet, the abbé Jean-Claude Richard de Saint-Non, Louis-Alexandre the duc de La Rochefoucauld, Abel-François Poisson (the marquis de Marigny; though Marigny would resign from the Ministry of Fine Arts in 1773), François-Hubert Drouais, Jean-Baptiste II Lemoine (or Lemoyne), and Maurice Quentin de La Tour.[35]

Hubert Robert, after returning to the capital in 1765, had been immediately absorbed into the ranks of the powerful individuals who attended Madame Geoffrin's *lundis*. Mariette informed one of his Roman correspondents in 1766 that Robert had been admitted to the Royal Academy under special circumstances. The Academy "treats him with a sort of distinction that is extraordinary," he writes, a reference to Robert's acceptance as *agréé* and as an academician at the same session.[36] Supported by the coterie of the *lundis* – Soufflot, Mariette, Watelet, Marigny, and Vernet, his sponsor to the Academy – Hubert Robert's success was assured.

Mariette was a significant presence at the Geoffrin salon. Both he and Caylus, his friend for over forty years, had belonged to the intimate coterie of artists and amateurs who, earlier in the century, had congregated at the Hôtel Crozat to study

the superb collection of art possessed by the financier Pierre Crozat. In fact, Crozat's "réunions" may have served as a model for Madame Geoffrin's Monday dinners. Crozat's death in 1740 roughly coincides with the founding of the *lundis*, instigated, according to one source, by Madame Geoffrin at Caylus's urging.[37] Several members of the Crozat entourage, notably, Mariette, Caylus, Bouchardon, and Boucher, turn up at Madame Geoffrin's as *lundi* regulars.[38]

Although the Crozat *réunions* and those of Madame Geoffrin superficially resembled one another, there are marked differences between them. Katie Scott explains how the *réunions* "strongly and self-consciously" evoked the organization and substance of the *conférences* of the seventeenth-century Academy, and she concludes that Crozat's weekly gatherings should be perceived as a kind of alternate Academy.[39] Like a gathering of artists and amateurs at the Academy, Crozat's group analyzed Old Master paintings, only they used examples from Crozat's private collection instead of art belonging to the king. Madame Geoffrin, on the other hand, was no collector of Old Master art, but was an enthusiast of contemporary French art. Furthermore, discourse at the *lundis* was not limited to works in the Geoffrin collection. Rather, each discussant brought an item to be analyzed, so the range of topics considered was far broader and the discussion more freewheeling. Although the conversation may have included disinterested esthetic speculation regarding the finer points of the beauty of the items under examination, it more likely turned to questions regarding market value. According to Morellet: "An amateur debating over the purchase of a painting would take it to Madame Geoffrin's Monday salon, and the 'maîtres de l'art' would evaluate it." Amateurs who already knew what they sought for their collections similarly depended on the aid of the group to provide it. Even Poniatowski, the king of Poland, reminds Madame Geoffrin in 1767 about the "one or two good Vernets, really good" that she had promised to acquire for him.[40]

Evidently, then, Madame Geoffrin's salon was no private "Academy." Furthermore, it offered a particular advantage that the Academy did not. Artists could converse about esthetics and even about technique at the Academy, but they could not measure the value of art in francs there. They were prevented by the same barriers that prohibited them from displaying their art in a shoplike setting.[41] The commercialization of fine art robbed it of its exalted fine arts status, and members of the Academy were prohibited from engaging in such activities.

Dealers also felt the force of these strictures and began to distance themselves from overt signs of commerce as the century progressed. The shop sign whereby Gersaint had announced his business to the world early in the century no longer suited Pierre-Jean Mariette. Mariette sold les Colonnes d'Hercule, his family's print shop, in 1750, so that he could dedicate his energies to editing catalogues of artworks, translating texts about art and artists, and documenting biographies of past and current masters. The issue of a humble dynasty of bookbinders and

engravers, Mariette belonged to the new class of art expert charged with verifying
the authenticity of works of art.[42] As his example illustrates, the social origins of
the new professionals might range from artisan to aristocratic. The count of Cay-
lus, for instance, was a descendant of one of the oldest noble families in Langue-
doc. What was crucial was that these men pursue their activities without the taint
of commerce in a suitably neutral venue. The charms (*agréments*), as Morellet put
it, and advantages of Madame Geoffrin's salon as a gathering place for these
individuals are obvious.[43]

Artists were as important as dealers at the *lundis*, though. Morellet makes
clear that notables "admitted to this society" became personally acquainted with
artists and thus determined more easily *how to put their talents to work* (*se dé-
terminoient plus aisément à mettre leurs talens en oeuvre*; emphasis mine). He
adds that through the *lundi* salons, Madame Geoffrin contributed greatly to the
formation of collections "of the modern French school, that grace today all . . .
of Europe." In sum, the role of Madame Geoffrin as an amateur and the place of
her salon as a kind of arts institution differ quite distinctly from that played by
Pierre Crozat and his *réunions*.

Although I have emphasized the salon's commercial aspects, the activities of
its habitués obviously affected the esthetics of the day. Through the Monday sa-
lons, Madame Geoffrin and her coterie set standards and formed taste. All stu-
dents of eighteenth-century art have read the account of Marigny's Grand Tour
of Italy, undertaken in the company of Cochin and Soufflot, to develop his knowl-
edge about art. If we are to believe Dufort de Cheverny, though, Marigny, a
member of the Monday circle, required the additional ministrations of Madame
Geoffrin to "purify" his taste. It was in her salon, "in her society," that the
minister of fine arts was inculcated with "le goût du vrai beau,"[44] a taste he
propagated during his tenure at the ministry. In her own domain, the salon on
the rue Saint-Honoré, "la dame du lundi"[45] wielded tremendous influence over
the arts.

Friendship and Gift Giving in the Salon

In the *Correspondance littéraire* Grimm relates how Madame Geoffrin had re-
cently made a huge profit from the sale of two pictures in her collection. Buying
paintings for resale, he concludes, is an excellent means of making money, though
Madame Geoffrin had not had this end in mind when she commissioned the
pictures a dozen years before. Grimm speculates that Madame Geoffrin would
find a worthy use for this unexpected windfall: "the good that Madame Geoffrin
does with her fortune does not permit us to doubt that she will employ the profit
that she is going to make with this sale in a suitable manner."[46] The deserving

cause would turn out to be a stipend given to her friend, Julie de Lespinasse, establishing the young woman's independence as a salonniere.[47]

Anthropologists like Marcel Mauss note that gift giving, despite its appearance of disinterest, always hides an obligation to reciprocate. It is difficult to know whether Madame Geoffrin bestowed presents to maintain a personal bond or to create a master-servant relation with her covey of artists and writers. In an important study, Sharon Kettering explains that during the early modern period patrons and clients used the terms "friend" and "friendship" (*ami* and *amitié*) to express their trust and loyalty. The service obligations of clientage, on the other hand, were expressed in the language of master and servant, but this language can be very imprecise. Clients referred to themselves as *serviteurs*, those who served, but the meaning of service and *serviteur* changed during the eighteenth century to become associated with paid domestic service and subservience.[48]

Friendship and generosity are threads that appear again and again in the weave of the fabric that constituted Madame Geoffrin's eighteenth-century identity. They are central to the way in which her persona was constructed and represented to others. Madame Geoffrin refers to artists as her "friends" in the letter to Poniatowski.[49] She proposed that "the artists who are her friends" choose a particular subject, declares one reviewer of the Salon of 1755.[50] A painter among her "friends" had the idea of representing her in a certain fashion, writes a memorialist.[51] Within this context, for Madame Geoffrin to commission a work of art was an act of friendship. Thus works by the inner circle of artist-friends attending the *lundis*, such as Vernet, Vien, and Boucher, were well-represented on Madame Geoffrin's walls. But it follows that to reap a profit from the sale of one of these works would be to exploit the sacred ties of friendship. The solution was to give the money away as a gift to yet *another* friend, such as Mille de Lespinasse.

Madame Geoffrin's gift giving was notorious.[52] The "Regrets sur ma vieille robe de chambre" by Denis Diderot was written after Madame Geoffrin swept into Diderot's flat and replaced some of his furniture with finer pieces as a "surprise" gift.[53] Artists who were particular friends were the object of special "galanteries" or gifts of cash, which the salonniere indicated in her account books. For example, she gave 2,400 livres to Carle Van Loo's wife and daughter "during the time he worked for me." Madame Vien is listed as receiving 240 livres, the Vernets (monsieur et madame) 600 livres, and Boucher 300 livres – all "galanteries." The gift giving intersected with the art collecting because Madame Geoffrin often tendered artworks as presents. Indeed, the potlatch element is an important aspect of Madame Geoffrin's largesse. Like a monarch or a head of state, she presented paintings and sculptures as gifts to reciprocate an act of hospitality or to commemorate a friendship. Bachaumont's newsletter relates in 1770 that Madame Geoffrin was sending a "very beautiful" Carlo Maratta to fill an

"empty spot" she had noticed on the palace walls of the empress of Austria, who had graciously received her in 1766 en route to Poland.[54] Her friend Stanislas-Auguste Poniatowski, the Polish monarch, received several such presents, and at one point writes back: "In truth, only a queen or yourself is able to give presents like this."[55]

Several years earlier, Watteau created his *Sign of Gersaint* to give to his dealer-friend in return for the latter's hospitality, a factor that did not prevent Gersaint from selling the painting after it was hammered over the portal of his shop. This example illustrates the complexities of the new world of art commerce to emerge during this period. In this new world the old terms of courtesy and service took on vastly different connotations. As in earlier centuries, there were still patrons and clients, but their relations were unstable and their connections problematic in a rapidly developing commercial society into which considerations of profit had suddenly intruded.

The Saint-Antoine Cycle as a Conversation Piece

Like all the artwork commissioned by Madame Geoffrin for her collection, Robert's conversation pieces of around 1773 were conceived and completed "under her eyes" and under the presumption of friendship. They are singular, though, on several counts. First, because Robert's paintings are the last works she ever commissioned, there is a capstone quality to both the commission and the imagery. She expected to die in 1769, when she was seventy. When she was young, this remarkable woman had composed a plan for the progress of her life, a plan to which she made surprisingly few exceptions over the years. The last stage was to draw quietly to a close when she reached seventy. Each year after the age of seventy was another that drew her "à la fin," as she put it, in January 1774.[56] Since the Robert conversation pieces date from around 1773, they represent a time she conceived of as her last "stage." Second, the Robert conversation pieces are the only portraits of Madame Geoffrin to be included in her collection of commissioned works.

These caveats aside, the pictures Robert produced strongly conform to the general contours of Madame Geoffrin's collection. For example, an examination of the subject matter of her paintings indicates her love of landscape.[57] Her collection contained eight landscapes and marines by Vernet, one by Servandoni, two by Boucher, eleven by Robert (excluding the conversation pieces), and six more "pastorals" by Boucher. On one level, then, the gardens of the Abbey of Saint-Antoine presented Madame Geoffrin with one of her favorite subjects. Indeed, it is possible to enjoy Robert's paintings as generic scenes of aged, vaguely Italianate gardens bounded by thick eroding walls and adorned by a classical urn or two.

What sets Robert's garden pictures apart are their portraits. Madame Geoffrin liked landscapes, but she also enjoyed viewing the likenesses of her friends and relatives in her pictures. In *La Lecture Espagnole* (Fig. 6), the governess shown seated next to the little girl is a portrait of Christine Van Loo, the artist's wife. According to Grimm, it was at the patron's behest that Carle Van Loo wove this likeness into the imagery.[58] Robert, then, was sure to please his patron by including a portrait of the princess Beauvau-Craon in the Saint-Antoine cycle.[59] The abbess of the Abbaye Royale de Saint-Antoine-des-Champs, Madame de Beauvau, was an old friend of Madame Geoffrin's, and when she stayed at the abbey, Madame Geoffrin rented the abbess's apartment. In Figure 2 portraits include that of Madame de Mainville, a trustee; Madame de Massabeky, a vestry nun; and Madame de Blaiset.[60] In Figure 4, Madame Geoffrin is accompanied by Madame de Beauvau and surrounded by individuals identified in the family archive.[61] As noted earlier, portraits of Pichard, Madame Geoffrin's valet, and Nanette, her chambermaid, are also included in Figure 2, as is a likeness of Hubert Robert.

Although most of the works in her collection do not seem to have been narrative paintings, Madame Geoffrin was evidently amenable to the idea of literary pictures. When she commissioned a work from Joseph Vernet around 1763, she requested that he include staffage from a short story by Marmontel, one of the regulars at her Wednesday salon. The result was *La Bergère des Alpes*, which depicts an episode taken from Marmontel's *Contes moraux*, published between 1761 and 1763. Diderot later blamed the picture's shortcomings on Madame Geoffrin's having "meddled" with the artist's intention by dictating the subject. Whether this is true or false is a matter of debate: Diderot's position is clear, though. He believed that a patron should never tell the artist to do anything (*ne faut rien commander à un artiste*). When a patron wishes to own a beautiful canvas, he or she ought to say to the artist, "Make me a painting; you choose the subject," or better yet, ought to buy a picture that has already been painted (*encore serait-il plus sûr et plus court d'en prendre un tout fait*).[62] This approach, which, paradoxically, can be described as capitalist (paradoxical in view of Diderot's comments about the market and about Robert, which were examined in Chapter 1), becomes the norm in the nineteenth century, but it was not the way in which Madame Geoffrin acquired works of art. This is precisely the point that bears emphasizing.

In the Saint-Antoine canvases, Robert caters to his patron's taste for landscape, for pictures of her friends, and perhaps even for a bit of narrative. The letter that Pichard, the valet, hands to his mistress in Figure 2 is hardly on the scale of an episode from a Marmontel *conte*. Nonetheless, because of the letter, the pictures in the cycle may be construed as a compressed narrative: Madame Geoffrin is

dining and receives an urgent message (Fig. 2), she prepares to leave the convent (Fig. 4), and in Figure 3, she is absent, having passed through the open doorway.[63] A subtle means of linking the three canvases into a whole, the letter is a small detail with considerable resonance.

A document such as a letter is one of those "objects" often included in a conversation piece to characterize the identity of the patron in the image.[64] Hubert Robert renders Madame Geoffrin at the dining table with her friends, but her female servant stands to the right holding her cloak, a sign of arrival or departure, and her male domestic hands her a letter. In conventional eighteenth-century iconography, any letter that a woman receives from a servant is a love letter. What delicious irony for Madame Geoffrin's *convives* – for this was a woman who chose to take on the costume of old age when she was thirty so that when she did become old, the change would not decompose her![65] No, this letter is no love letter, but is one concerned with important salon business, for the letter, above all, is the attribute the salonniere. Like other Parisian hostesses of the day, Madame Geoffrin was a celebrated correspondent. She wrote at least seven letters each day to "friends" all over Europe – eighteenth-century notables such as Voltaire, David Hume, and Catherine the Great.[66]

The dining motif, which often appears in the imagery of the conversation piece, is an equally inspired conceit for Madame Geoffrin, a woman who maintained one of the most celebrated open tables in the eighteenth century. One way to describe a salon is a meal taken among friends.[67] Moreover, the pictured banquet, in its dignified restraint, resembles descriptions of Madame Geoffrin's dinners, where the courtesy and propriety of guests ensured an enlightened flow of conversation. As Nicolas Lancret showed in *La Partie de Plaisirs* (Fig. 7), feasts (for men) taking place out of doors could be raucous and rowdy.[68] In Figure 7, a man stands with one foot on a chair and the other on the table; he appears to pour a drink, presumably to toast his companion, who is being given the two-finger "horns" or cuckold sign by a woman who simultaneously chucks him under the chin with her other hand. Perhaps in Figure 2 Robert is playing off of *La Partie de Plaisirs* by way of contrast. Both representations frame the diners with a garden wall surmounted by large ornamental urns, and both include the motif of the servant, a sign of the power and prestige of their superiors. The idle servants in Lancret's image, however, cast reproving looks at the antics of the wigless aristocratic males who are their masters, whereas the servants attending Madame Geoffrin and her female companions are all attention and respect.

Madame Geoffrin's civility is stressed in Robert's rendering. She is pictured as someone who, though bourgeoise, adapts easily to aristocratic manners. The women portrayed at the convent dinner are *all* noble, except for Madame Geoffrin and her maidservant. The Abbaye Royale de Saint-Antoine-des-Champs, it should be noted, was one of the richest convents in the Paris area because of the extraor-

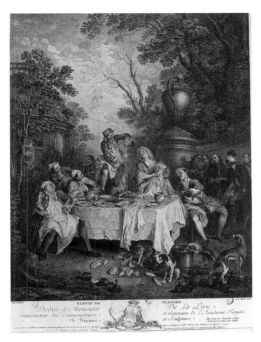

Figure 7. Print by Pierre-Etienne Moitte from 1756 after Nicolas Lancret, *La Partie de Plaisirs*, 1735. Photo: Bibliothèque Nationale de France.

dinary number of privileges it enjoyed from the crown. Consequently, the post of abbess there was an extremely lucrative one reserved for women of the highest nobility.[69] Robert shows in the image that birth matters little among "friends"; just as they were at the dinners at Madame Geoffrin's hôtel, distinctions based on privilege are irrelevant among a circle joined by salon conversation. Robert depicts Madame Geoffrin as moving gracefully and comfortably in this world. She dines with perfect ease and composure, her assurance accentuated by the respectful attention of Nanette and Pichard, who by standing to the front and the rear of their mistress set her apart from the company like a parenthesis.

Why choose the convent as the place in which to carve out these dimensions of Madame Geoffrin's identity? As noted already, the setting is always of paramount significance in a conversation piece. First, convents represent an all-female society in which women have power.[70] Thus, by focusing on the convent setting Robert draws attention to the gender of his patron.[71] Second, Catholicism – or at least, religion – is an association that is clearly evoked by this locale. Robert's pictures advertise Madame Geoffrin's retreats at the abbey, an activity that might have surprised the general public but would not have surprised Madame Geoffrin's friends.

Because of her relations with the encyclopedists, Madame Geoffrin was often characterized as a Freethinker, an image she seemed reluctant to refute in her younger days. The Reverend William Cole, visiting Paris in 1765, described her as "a widow Lady, very rich, a great Protectress of the Party of Philosophers, & . . . herself a *Bel Esprit*, or Free-Thinker."[72] But Marmontel, among others, claimed she only appeared to be indifferent to religion to placate her philosophical friends. In fact, she followed "a kind of clandestine devotion," maintaining an apartment in a convent of nuns and a pew in the Church of the Capucins; she shrouded these activities in as much secrecy as libertine women of the day did their hideaways in the country (*des petites maisons*).[73]

The convent to which Marmontel alluded is, of course, the Abbey of Saint-Antoine. Toward the end of her life, Madame Geoffrin was becoming less "clandestine" about her religious activities, so much less so that she commissioned Robert to paint the convent gardens for her to display on the walls of her townhouse. Remembering that these are "final paintings" for her collection, and her advanced age at the time, the religious setting takes on added significance. "As the soul grows older, some religiosity reappears," mused Grimm, as he ruminated over the stroke that felled Madame Geoffrin (right after mass) in 1776.

An overly positivistic reading of the images, however, fails to do justice to their elegiac quality. The paintings can be construed as a set of devotional images Hubert Robert has tailored to the habits of an elderly woman nearing death. The iconography of dining, especially the interrupted meal, is a tradition in western art associated with *vanitas*, the transience of life. What summons the diner away from the table suddenly, to put it prosaically, is death. Other motifs in the three panels reference the same theme: the open door in Figure 2 and the receding path through the woods and towards the light in Figure 3. Homing pigeons circle above a dovecote in Figure 2. Just so the soul metaphorically passes through the roads and gates of the physical world to return to union with God. "I assure you," Madame Geoffrin writes to Poniatowski in 1767, "that I look upon the epoch of my death very gaily."[74] And again, in 1768 she writes, "I think I am more philosophical about death than Socrates, to whom death was an occasion to make a very pretty speech; for me, death is merely the cessation of being, and I view it without anxiety. I make my preparations as I packed my bags for my trip to Poland, gaily. I desire that my friends love me while I am alive, but I do not want to leave them with regrets."[75]

In this section, I have examined Robert's three Saint-Antoine pictures as conversation pieces, speculating upon the significance of the setting, of the figures included there, and of the objects they contemplate in defining identity. The pictures visually celebrate friendship, the "profession" of salonniere (to facilitate edifying conversation around a table), and the position of the Church in the life of the aging salon hostess.

The Act that Grasps

A third singular feature of Robert's Saint-Antoine cycle not discussed in the pre-
ceding section is the conspicuous figure of the artist present in two of the five
canvases. Self-display runs through this series like the subordinate theme runs
through a Mozart sonata.

Self-display, of course, was one of the advantages offered to the artists who
attended Madame Geoffrin's *lundis*. There was both material and cultural capital
to be accrued by being seen at Madame Geoffrin's salon, but it was better yet for
an artist to have his or her works seen hanging on her salon walls. A commission
from Madame Geoffrin signified that the artist was her "friend," and at the same
time it allowed the artist to display his or her talent before a highly influential
group of artists, writers, and collectors. Robert's inclusion of his own likeness into
compositions that the French could only call "piquant" (pleasantly striking) ad-
vertised his invention, his skill, and most importantly in this context, his wit before
the erudite constituencies who still gathered on Mondays and Wednesdays at the
Geoffrin hôtel.

One difficulty we have in assessing works of art in private or quasi-private
spaces – spaces that are not "public" like the Academy's exhibition – is a lack of
textual "evidence" describing them there. Venues such as the Salon exhibition or
the Royal Academy of Art generated a textual discourse about art, whereas private
spaces did not. In salon practice, the written word was supplanted by the voice
as the chief means of communication. Moreover, it was the voice in dialogue, in
conversation. Vestiges of these conversations sometimes found their way into print
– the fragmentary *bon mot* or anecdote – but these are flimsy pilings upon which
to construct a sturdy persuasive argument about the dynamics of art in the salon.
As luck would have it, a capital bit of textual evidence about the Roberts in the
Geoffrin salon has survived, and I rely on it as a foundation for the argument in
this section.

In his reminiscences, the baron de Gleichen shares some fascinating informa-
tion with his readers. Madame Geoffrin, he writes, employed a unique "science
of physiognomy" to read human character: she deduced character from the backs
of people. Her devotion to this physiognomic system gave one of her painter
friends the idea to make her portrait in "une manière fort ingénieuse." In his
picture, he represents her from the back, ready to enter the cloister. She wears her
gray "robe de chambre" and her black bonnet. The resemblance, Gleichen con-
cludes, is striking, although the figure turns her back to the viewer.[76]

The picture that Gleichen describes is the tondo of the Saint-Antoine series
(Fig. 4) and the "artist friend" who came up with this clever idea is Hubert Robert.
Even in Figure 2, the painter is seated to the rear of his patron, so that the drawing
he makes of her at the dining table will represent her back.

From my point of view, the significance of this anecdote is not in what it reveals about the physiognomic interests of Madame Geoffrin, but in what it suggests about reading a painting in Madame Geoffrin's salon. Gleichen had looked carefully at Robert's picture, and he had understood the gentle visual parody of their hostess it displayed. Robert's ingenuity had been duly appreciated. An exchange such as this one would not have been unusual in a salon conversation. Here, however, the sally was visual. The sight of the artist in Figure 2 – on the spot, with his open sketchbook – is a rather distinctive iconographic "signature." The motif, besides acting as a splendid signboard for Hubert Robert (each time visitors would glance at the wall they would see Robert working for Madame Geoffrin), reminds us that the eye studying the salonniere in these pictures is Robert's.

Madame Geoffrin had been "represented" before, and not always favorably. Palissot ridiculed her in his comedy *Les Philosophes*, performed by the Comédie Française in 1760.[77] For favorable representations, though, none matches the density and complexity of the "portrait à la plume" devised by Julie de Lespinasse. As a tribute to Madame Geoffrin, Mlle. de Lespinasse concocted two additional chapters to Laurence Sterne's *A Sentimental Journey*, which she read aloud to the assembly gathered at Madame Geoffrin's salon in the presence of her unsuspecting hostess. She had Sterne telling his fellow Englishmen to visit France, where they would find "Bienfaisance" and "Bonté" (beneficence and kindness) personified in a single woman – Madame Thérèse Geoffrin. The young woman read the pretended chapters describing the beneficence of Madame Geoffrin as if they were in a French translation, imitating Sterne's style perfectly.[78]

The wit, intelligence, and art informing such an enterprise lies very much at the heart of salon social exchanges. Hubert Robert's representation, I believe, aims at the same sort of tribute. A blatant reference to Madame Geoffrin's virtues would be crude flattery, a vulgar breach of taste. In this society, the form of expression mattered a good deal, and a *bon mot* or inventive performance like Lespinasse's brought glory to the author as well as pleasure to the hostess.[79]

Anecdotes and *bons mots* about Madame Geoffrin's own peculiar form of expression proliferate. Antoine-Léonard Thomas struggled to define her manner of speech and expression in an *éloge*, resorting to metaphors drawn from the world of art. She knew, he wrote, how to paint character and humanity in an original and striking fashion, but she always employed familiar imagery to communicate "refined ideas." In this respect, Thomas added, she was like a Flemish painter: "One could say that her descriptions had the character of the Flemish school [of art], but with a familiarity more noble in the figures."[80] She was also fond of citing maxims. Her two most celebrated epigrammatic expressions were "Thrift is the mother of independence and generosity" and "Grass must not be allowed to grow on the path of friendship."[81] Both were engraved on her calling

cards.[82] Gleichen speaks of her fondness for similes: "The genre of wit favored by Madame Geoffrin was that of the comparison, and she had discovered some [witticisms] that were infinitely appropriate and ingenious."[83] Note that the "ingenuity" admired by Gleichen in Robert's paintings is equally invoked to describe Madame Geoffrin's pointed similes.

What Hubert Robert accomplished was to transform Madame Geoffrin's pointed similes into painted ones – ones, moreover, that superficially appear ordinary to an extreme, just like Madame Geoffrin's. In Figure 4, a nun bends down to prune the roses as Madame Geoffrin and her friends contemplate a remarkably clean dirt path unfurling before them through the trees. A gardener to their right rakes the dirt around them. Now we realize that Robert has represented the saying on Madame Geoffrin's calling card: "Il ne faut pas laisser croître l'herbe sur le chemin de l'amitié" (Grass must not be allowed to grow on the path of friendship).

An enigmatic feature of the Saint-Antoine pictures is the absence of Madame Geoffrin in Figure 3. The open door, a motif obviously connected to the missing patron, may be interpreted in different ways.[84] In the painting, a group of nuns sits under an arbor of bright pink and white roses.[85] Two large and eager swans, floating in a remarkably diminutive pond, are being fed by an elderly nun.[86]

The swans are a figure, not a fact. They accompany the allegorical figure in Cesar Ripa's emblem of Benevolence (*Bienveillance*), just as his Goodness (*Bonté*) is emblematically represented by a bird feeding its young (Fig. 8).[87] Figuratively, the aged woman in Figure 3 who feeds the swans is Madame Geoffrin, although the "real" Madame Geoffrin does not appear in the picture. It is a charming and subtle reference to the legendary kindness and charity of the salonniere who deluged her "friends" with gifts and financial assistance. Contemporary accounts relating to Madame Geoffrin's character reveal nothing was perceived as more central to it than these particular virtues. "Elle étoit bienfaisante"[88] and "Sa bonté se répandoit."[89] She had "une bienveillance active."[90] "Elle est bonne et bienfaisante."[91] Her success was because "elle était bonne."[92] Recall that Julie de Lespinasse had also specifically represented Madame Geoffrin's beneficence and kindness in her imitation of *A Sentimental Journey*. "Allez en France," she wrote, "allez voir madame Geoffrin, vous verrez la Bienfaisance, la Bonté; vous verrez ces Vertus dans leur perfection."[93]

There was one peculiarity of Madame Geoffrin's giving, however, that all her friends remarked upon. It was furtive. Thomas described her mania for secrecy with the trenchant reflexive verb "to obliterate oneself."[94] She insisted upon concealing her charitable acts. Naturally, there was a Geoffrin maxim, framed and mounted, on this subject: "If you do a good deed, throw it into the ocean; if the fishes devour it, God will remember it."[95]

Not the least of Mlle. de Lespinasse's accomplishment in fabricating the Sterne narrative was that she managed to discover a means by which to celebrate her

Figure 8. Emblems from E. Baudoin, *Iconologie, ou, explication nouvelle de plusieurs images, emblèmes, et autres figures; Tirée des Recherches et des Figures de Cesar Ripa* (Paris, 1644), 28. Photo: author.

benefactor publicly. Morellet described how moving it was to see the modest Madame Geoffrin forced to hear her praises sung in front of others, but sung in a manner worthy of her. As Morellet recalled that day, he concluded: "and friendship tasted, in the eyes of friendship, the pleasures that it had wished to reserve for itself alone, and that are all the more sweet when shared."[96] Thus part of the difficulty of formulating a representation of the beneficent Madame Geoffrin was finding the appropriate form to make her virtue public. By replacing her likeness in Figure 3 with an emblem, Robert could reference the celebrated virtues of his patron without picturing her.

I do not suggest that this reading of Robert's Saint-Antoine series is unitary and absolute. That would be far from the "genre d'esprit" valued in this culture.[97] But I do insist that the space in which the paintings were destined to hang – the walls of the salon on the rue Saint-Honoré – affected their meaning. For meaning is a result of a particular knot of convoluted relations between the image, its display, and its reception.

The order of Robert's three-part series as it was displayed in Madame Geoffrin's townhouse is provocatively indeterminate, although it is fairly certain on the basis of formal considerations that the oval canvas was centered between the other two.[98] Eighteenth-century pendants and panels were constructed according to principles of balance, contrast, and reciprocity.[99] The three panels are visually connected by a repetition of the arch shape – attenuated and parallel arches in the dining scene, a centered and rounded arch of trees in the tondo, and then the broad arch of the arbor sweeping in from the left in the image with the open door. Figures 2 and 3 could be reversed, though, and the series would remain unified by the semicircular accents, the single tree, and the similar relations of weight, scale, and shape established between the groups of figures and the individuals (Robert and the elderly nun) set at a diagonal beneath them. Placing the panel with the open door first would change the reading of the whole by emphasizing Madame Geoffrin's passage *into* the cloister: she is not there, she prepares to enter, then she finally finds refuge behind its walls. (Note that Gleichen read the tondo as a rendering of the salonniere advancing into the convent.) Moreover, each panel can play the role of part to whole or stand on its own.[100]

In the "space" of the salon, a conversationalist received pleasure from considering the parts of a subject under discussion arranged in a different order – indeed, to do so was a highly valued aspect of the edifying salon conversation. Hubert Robert constructed his compositions to present the same edifying pleasures to a knowledgeable viewer, equipped, like the baron de Gleichen, to appreciate the artist's ingenuity. Robert had every reason to expect this mode of reception from Madame Geoffrin's select group of guests in 1773 and certainly little reason to doubt it from the assembled artists and collectors who attended the *lundis*.

Coda: The Bedroom Pendants

Robert finished the three Saint-Antoine canvases in 1773, inscribing his name and the date under one of the urns framing the path in Figure 4. His patron carefully recorded the cost of the commission – 1,800 livres – in her account book. She added that she had commissioned two more pictures, "representing the interior of my bedroom." Slightly later in date, then, and considerably smaller in scale (about two feet square), these pictures share a degree of thematic unity with the Saint-Antoine triad, for they are also conversation pictures representing Madame

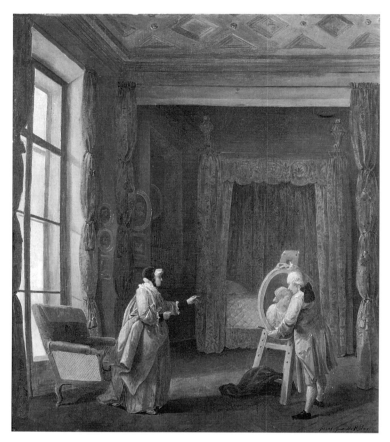

Figure 9. Hubert Robert, *Un Artiste Présente un portrait à Madame Geoffrin*, 1773–74 (oil on canvas, 66 × 58 cm). Signed "Peint par H. Robert." Paris, Private Collection. Photo: Art Resource.

Geoffrin. They depict Madame Geoffrin in an interior that she identifies as her bedroom.[101] In Figure 9, Hubert Robert stands with the hostess in the bedroom of her townhouse on the rue Saint-Honoré. They contemplate a work of art; the cloth covering the oval frame has dropped to the floor, and Madame Geoffrin appears to comment upon a detail in the canvas. The pendant (Fig. 10) depicts Madame Geoffrin at her desk having a cup of hot chocolate while her servant Nanteuil, his feather duster wedged under his arm, reads to her from the *Gazette*.[102]

I have called this section a *coda* because these two paintings never hung in Madame Geoffrin's townhouse. She gave them to a friend, Jean Philippe de Trudaine, the minister of finances and director of bridges and roads.[103] Nonetheless, these pictures offer tantalizing insights into the domain of the amateur, and I

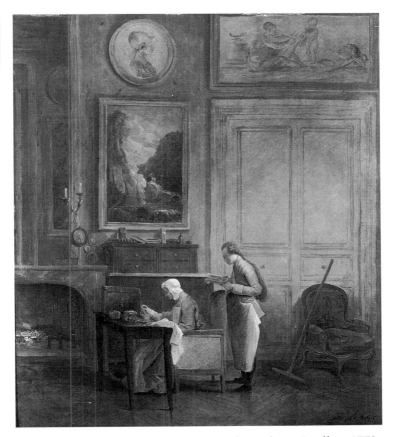

Figure 10. Hubert Robert, *Le Déjeuner de Madame Geoffrin*, 1773–74 (oil on canvas, 66 × 58 cm). Signed "Peint par H. Robert." Paris, Private Collection. Photo: Art Resource.

believe they take up this theme from a perspective worthy of attention. In the pendants, Robert probes and problematizes the intrusion of the artist into the new sociological field, exemplified by the *lundis*, that I have mapped out.

Hubert Robert and Rococo Art

A close study of the five Geoffrin pictures reveals the fundamental importance of seventeenth-century Dutch cabinet pictures to eighteenth-century French art. Although I am hardly the first to acknowledge this filiation, it has been oddly obscured in normative art history. The taste for the Dutch cabinet piece and the vigor of the so-called minor genres in French art after 1700 are related phenomena, resting on a common base. The conversation piece, for example, is an eighteenth-century adaptation of "conversations" depicted by such

seventeenth-century Dutch painters as Gerard Terborch and Gerard Dou in their small, highly finished pictures. This imagery lies at the core of the conversation picture in England as it was developed and refined by such artists as William Hogarth and Arthur Devis.[104] Robert's Geoffrin bedroom pendants (Figs. 9 and 10) closely approximate the scale and appearance of pictures by seventeenth- and eighteenth-century artists working within this tradition.

In the 1770s, the popularity of Dutch cabinet pictures in France was still rising. Dutch paintings were enormously popular, fetching astronomically high prices at auction.[105] Though he was a prosperous artist, Hubert Robert lacked the means to purchase paintings by Dou or Terborch, but he was able to acquire works by French specialists in the "minor genres" influenced by the Dutch and Flemish schools.[106] The catalogue of Robert's studio sale in 1809 indicates he owned a painting by Watteau, one by Chardin, and eight by Boucher, as well as hundreds of drawings by Boucher and Fragonard. The imprint of these French sources runs through the Geoffrin series like so many vectors; these were masters who themselves had drawn on the example of the Dutch cabinet piece.

Robert's oval canvas showing the promenade of Madame Geoffrin and her friends (Fig. 4), for example, is a loose adaptation of compositions like Watteau's *The Perspective* or the *Assemblée dans un parc* (Fig. 46). The general theme of figures at leisure in a parklike setting is vintage Watteau, as are the Watteauian motifs of figures seen from the rear and the soft foliate arch of tall trees.[107] The scale of the figures relative to the spacious landscape and the wide expanse of sky replicates the formal organization of a Watteau "fête galant," as does the hovering vantage point of the beholder. Moreover, the mixture of portrait likenesses with generic types displayed in Figure 2 was popularized by such pictures as Watteau's *The Conversation*,[108] an image that stimulated the development of the conversation picture in England.

The pictures of the Geoffrin bedroom are smaller and squarer than the canvases of the Saint-Antoine cycle, owing less to the conventions of the *fête galant* than to the influence of the Dutch cabinet piece. Like Dou, Terborch, or de Hooch, Robert centered his full-length figures in a miniature boxlike interior or against an articulated wall surface. He shifted the focus to the setting, which becomes, as it is in the Dutch cabinet piece, richly endowed with meaning.[109]

To some extent, this format owed its currency in France to Chardin's genre paintings of the 1730s and 1740s, in which one or two tranquil figures are pictured engaged in ordinary, mundane activities. Echoes of Chardin's *Dame Prenant son thé* (Fig. 11), for example, resonate in the profile view of Madame Geoffrin in Figure 10, who is caught in the distracted act of stirring the liquid in her cup with a spoon as she listens to her servant read to her.[110] What differentiates the Geoffrin pendants from a work such as Chardin's *Dame Prenant son thé* is its setting, which represents a richly adorned environment. Indeed, modern writers

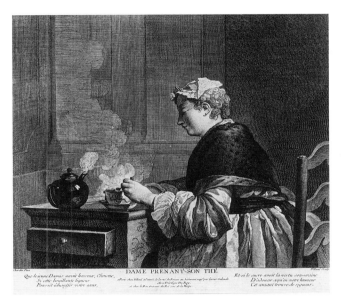

Figure 11. Print by Pierre Filloeul (b. 1696) after Jean-Baptiste Chardin, *Dame Prenant son thé*, 1739. Paris, Bibliothèque Nationale. Photo: Bibliothèque Nationale de France.

such as Lastic Saint-Jal have enjoyed matching the objects rendered in the pendants with expensive items in the Geoffrin inventory, such as the armchairs by Pierre Garnier and Jean-Baptiste Le Rouge and the clock by Boule. The depiction of fashionable interiors in the eighteenth century derives from a different pictorial tradition – the *tableaux de modes* popularized by works like Jean-François de Troy's *A Reading from Moliere*, c. 1728, or Boucher's *La Marchande de Modes*, 1746 (Fig. 12).

In situating Hubert Robert within this indigenous rococo tradition I aim not just to emphasize its coherence and vigor for artists maturing after 1750, although I do believe that this point is overdue for serious consideration. I am more interested in establishing a frame by which to examine the self-referentiality (and the resultant irony) of Robert's imagery.

The motif of the sketching artist in the convent gardens (Fig. 2), hunched over and seated on the ground, harks back to Chardin's *Young Student Drawing* (1738 Salon).[111] As a motif, it appears frequently in Robert and occasionally in Fragonard (notably in his *The Lover Crowned* of the Louveciennes cycle, painted around 1772, approximately the same years that Robert is working on the Geoffrin commission).[112] Chardin reprised the motif more ironically in his *Le Peintre* (Fig. 13) and its pendant, *The Monkey as Antiquarian*, pictures that address the imitative nature of the painter's enterprise and the norms by which connoisseurs

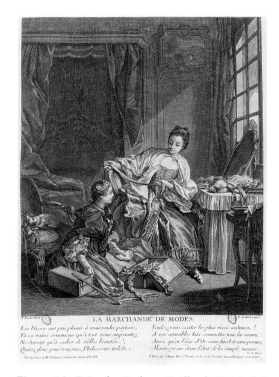

Figure 12. Print by Robert Gaillard (1722–85) after François Boucher, *La Marchande de Modes*, 1746. Paris, Bibliothèque Nationale. Photo: Bibliothèque Nationale de France.

may choose to evaluate it. When Hubert Robert depicted a painter before his easel dressed as a clown in *Polichinelles peintres* (Fig. 14),[113] he was making the same sort of joke, although his use of the character from the *commedia dell'arte* connotes the theater and performance, in particular the ridiculous performances required of both mimes and painters to please an audience.

As Watteau proved in his fêtes, to catch figures, who appear to be unobserved, in action at a particular moment was a potent expressive device. With Hogarth, the Watteauian edge became sharper and more pronounced, developing into a means by which to make ironical observations about individuals and about English society.[114] And that edge became sharper still when the artist included himself in the scene as Watteau did in the *Fêtes Vénitiennes* (Fig. 15), where he is a wan, awkward figure, on the far left of the print, playing the humble bagpipes for a sophisticated group of young elegants.[115] The vein of self-parody that Watteau gently inserted into this image runs through the imagery of artistic self-representation in rococo art. Both the Chardins and the Roberts described earlier

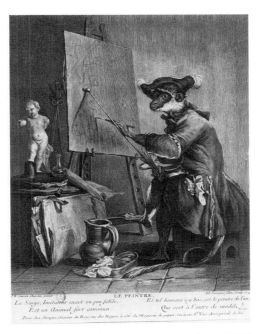

Figure 13. Print by P. L. Surugue from 1743
after Jean-Baptiste Chardin, *Le Peintre*, 1740.
Paris, Bibliothèque Nationale. Photo: Biblio-
thèque Nationale de France.

were originally owned by other artists, underlining the self-parodying quality of
the referent. The humorous surrogates with which these eighteenth-century artists
"signed" their works – Watteau's bagpipes or Hogarth's pug dog, for instance –
make the same point.

I turn to this theme because the surrogate that Robert chose in the Geoffrin
series is the servant.[116] If Hogarth's pug is a sign of self connoting a cocky, hu-
morously disruptive relation to the world,[117] what does it mean to sign oneself as
servant? And although both domestic pets and servants implicate a master, the
servant is a more volatile sign because a parody aimed at the servant risks over-
shooting its mark and hitting the patron as well.

Satire and Parody

How do we assess comical references? How far can we take Robert's adaptation
of fête imagery, for example? We might infer that in the hands of a Hogarth the
recycling of the Watteau format points satirically to the vast difference between
Watteau's graceful young lovers strolling through the garden and a woman in her
seventies promenading in the abbey – the latter representing a not-so-gallant fête

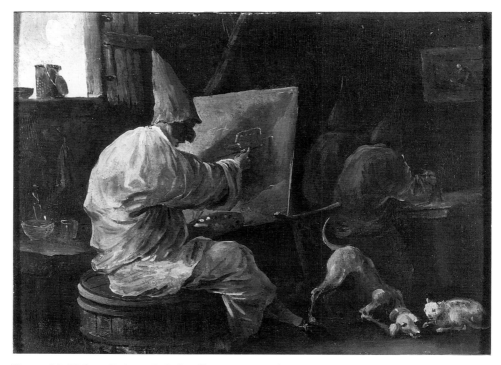

Figure 14. Hubert Robert, *Polichinelles peintres* (oil on canvas, 17 × 22 cm). Amiens, Musée de Picardie. Photo: Art Resource.

taking place behind convent walls.[118] Before examining the imagery of Robert's townhouse pendants, however, we must ground our definitions of satire and parody as much as we can in eighteenth-century understandings. Only then can we begin to calibrate Robert's comical references to normative parameters of satire, parody, or irony.

Fortunately, an excellent example of a visual satire by Hubert Robert exists, evidently annotated by a contemporary of the artist. It is a watercolor that is called by modern curators *Hôtel Dubarri* (Fig. 16). Apparently created for the pleasure of the Choiseul faction, perhaps even for the duke himself, the work refers to the departure of Madame Dubarry from the court after Louis XV died in May 1774. In a village near Monthlery Madame Dubarry had arranged to join her mother, who is depicted as an old procuress greeting a young woman and child on the steps of a dilapidated farmhouse identified as the Hôtel Dubarry. Three figures peer from a large window that is framed on one side by a cluster of dead mackerel, a pun on the word "maquereaux," or whores. Two asses gaze meaningfully out toward the viewer, a sign, the caption tells us, of the ignorance and baseness of the Dubarry family. Finally, Robert has depicted a rosebush growing out of a chamber pot on the window sill.[119] To create his satire, visually,

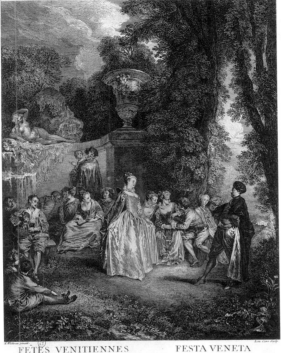

FÊTES VENITIENNES FESTA VENETA

Figure 15. Print by Laurent Cars (1699–1771) after Antoine Watteau, *Fêtes Vénitiennes*. Paris, Bibliothèque Nationale. Photo: Bibliothèque Nationale de France.

Robert relies on emblematic objects like the ass and the chamber pot, visual puns (mackerels), and iconographic traditions such as those found in Dutch painting like the old procuress.[120]

Parody, though, rather than satire, was the dominant form of comic expression in the world of Madame Geoffrin.[121] Parody – the burlesque or ridicule of something serious in a nonsensical fashion – structured many an interaction at the Geoffrin hôtel on the rue Saint-Honoré. The most notorious example of parody, well-known to the elites of Paris in the eighteenth century, was the Sublime Order of the Lanturelus, an "organization" with its own annals, statutes, and codes created by Madame Geoffrin's daughter, Madame de la Ferté-Imbault, in 1771. The Sublime Order of the Lanturelus was a "société badine," an association, with a queen and mock knights in which nonsensical songs and verse were ceremoniously recited in a burlesque of medieval court society. Such clubs were rife in the eighteenth century, but none was as famous as the Lanturelus. Madame de la

Figure 16. Hubert Robert, *Hôtel Dubarri* (ink, watercolor, chalk on paper, 348 × 300 mm). Signed "H. Robert invt fecit." Frankfurt am Main, Städelsches Kunstinstitut. Photo: Ursula Edelmann, Städelsches Kunstinstitut.

Ferté-Imbault, an avowed opponent of the *philosophes*, established the Order of Lanturelus and Lampons "pour se moquer des académies et de l'esprit de parti."[122] Her *souper*, in a parody of her mother's, met on Mondays, and her guests, instead of bringing a work of art to discuss, brought an original song, an epigram, or an allegory to share with the group.[123] In his memoirs, the baron de Gleichen described the Lanturelus as "pure craziness."[124]

Lanturelus aside, Madame de la Ferté-Imbault was also fond of pretending to be insane, an eccentricity that Gleichen attributes to her deafness; but why this disability should have caused her to act demented can be explained as a parody of her mother's respect for reason. Gleichen writes that she habitually took on the role of a fool, an act she called her domino. She played this part so perfectly that "the ignorant (*les sots*) were tricked" – a farce that amused the *gens d'esprit* of her coterie who knew better.[125]

As these anecdotes suggest, relations between Madame Geoffrin and her daughter were decidedly cool.[126] But in 1775, Madame de la Ferté-Imbault resolved to call a truce between them. To celebrate the reconcilation of the seventy-six-year-old mother and sixty-year-old daughter, a mock wedding was staged and celebrated with great pomp. Matou, as Madame Geoffrin called her daughter, and Minette, the name Madame de la Ferté-Imbault had used as a child for her mother, were brought together in a parodic marriage ceremony, complete with guests, bouquets, speeches, and epithalamia![127]

If all of this appears to be remote from Hubert Robert, consider the following. In 1779, two years after Madame Geoffrin had died, the queen of the Lanturelus contracted measles. When she recovered, her devoted court of knights and ladies surprised her with a Lanturelus fête. After all the "chevaliers" and "chevalières" had prostrated themselves at the foot of the queen's throne and kissed her hand, the assembly moved into the next room to view a charming theatrical skit involving Confucius, Montaigne, Momus, and Polichinelle. This performance delighted Madame de la Ferté-Imbault, because all the roles were played by "amis intimes" who had never appeared on stage together. Playing the part of Polichinelle was "le célèbre peintre Robert, qui est aussi aimable et aussi gai dans la société qu'il est grand peintre."[128] (One thinks back to the *Polichinelles peintres* by Robert; Fig. 14.)

Parody, especially self-parody, was the accepted form of wit in this milieu. Within the parameters of salon culture, a field in which wit and style were required for success, parody attained the level of an art form.

The Pendants

As our exegesis of the Saint-Antoine cycle indicates, Robert was likely to fabricate images in which the mimetic structure of the picture is in dialogue with a metaphorical one, for it is in the oscillating relationship between fact and figure that the artist reveals his imagination and ingenuity. Two black chalk drawings by Robert conserved at the Musée de Valence seem to be preliminary studies made by the artist for the commission. One shows Madame Geoffrin, seen from the rear, having her chocolate at her desk and writing (Fig. 17).[129] A lackey adjusts a candle into its fixture on the wall nearby. Framed above the desk is a large painting from a series on the Four Seasons that Madame Geoffrin had commissioned from Joseph-Marie Vien around 1763.[130] Another represents a view of her bedroom occupied only by a servant who ties back one of the bed curtains (Fig. 18).

A comparison of the drawings with the paintings indicates that Robert made significant changes. Into the scene with the bed he inserted large, individualized figures representing artist and patron, which do not appear in the drawing. In

Figure 17. Hubert Robert, *Madame Geoffrin dans son Cabinet* (black chalk on paper, 290 × 240 mm). Valence, Musée des Beaux-Arts. Photo: Bulloz.

Figure 10 he shifted Madame Geoffrin's desk to stand perpendicular to the plane, so the wall presents a wider expanse of surface parallel to the plane. He added a servant, wearing an apron and accompanied by his attributes – a feather duster and a broom – who seems to have been called away from his tasks to read to his employer. Finally, Robert replaced the Vien over Madame Geoffrin's desk with one of his own canvases. Madame Geoffrin as a patron of the arts is the dominant theme here: above the closed doors in Figure 10 is a grisaille featuring the muse of painting; next to it hangs another work, showing Minerva, the goddess of wisdom and protectress of the visual arts. Robert plays with the dual profiles of the seated woman and the helmeted goddess, punning on the helmet and the white bonnet of Madame Geoffrin and suggesting that Madame Geoffrin is a sagacious muse of painting herself.[131]

Bedroom imagery is conventionally associated with the feminine in eighteenth-century French art. Most typical in that iconography is the vanity table with its

Figure 18. Hubert Robert, *L'appartement de Madame Geoffrin* (sanguine, black chalk on paper, 340 × 285 mm). Valence, Musée des Beaux-Arts. Photo: Bulloz.

omnipresent mirror, a symbol of the vanity of women. As in such pictures – I have in mind Boucher's *La Marchande de Modes* (Fig. 12) – Madame Geoffrin regards an oval frame, but it is not a mirror. Instead, it is a painting,[132] a clever analogy between both the artwork and the mirror as surface reflections of the world, and a motif that may also suggest, most subtly, that Madame Geoffrin's vanity lies not in her person, but in her art expertise.[133]

Readings and conversation about art were, of course, the essential activities of Madame Geoffrin's salon, but, in addition, the listening and conversing thematized in Robert's representations replicate the subjects of the most celebrated pictures in Madame Geoffrin's collection – Carle Van Loo's pendants *La Lecture Espagnole* (Fig. 6) and *La Conversation Espagnole*, paintings that were sold to Catherine the Great around 1771. To replace these pictures, which had hung in the bedroom in Figures 9 and 10, Madame Geoffrin had commissioned three architectural paintings from Hubert Robert in 1771 and 1772. But it is in the

pendants, also devoted to the subjects of conversation and reading, that Robert seems to have quoted the substance and the composition of the Van Loo pendants. For example, Madame Geoffrin sits configured in angled profile in the center of *Le Déjeuner de Madame Geoffrin* (Fig. 10), just like the courtier who is shown reading aloud in Van Loo's *La Lecture Espagnole* (Fig. 6). If this parody is intentional, the Robert is dangerously close to satire, particularly in Figure 10, where a servant, not a courtier, has been obliged to lay aside his broom to read to his elderly mistress as she breakfasts.

Servants in Fact and Fancy

The representation of servants is a stock element in the conversation piece, and, accordingly, servants play significant roles in Robert's imagery in both the Saint-Antoine cycle and the bedroom pendants. In his dining scene in the convent gardens (Fig. 2), the focal point of the composition is the female servant set in the lower center of the ground, looking at Madame Geoffrin's back and holding her cloak. In the reading scene (Fig. 10), the pivotal position of the servant is more pronounced, and even somewhat disconcerting. There is a peculiar tension and ambivalence about this image of a servant, set squarely in the center of the composition where his presence must be registered by the spectator. Although Nanteuil displays all the signs of domestic servitude – livery, apron, feather duster, a position to the rear of his mistress – other aspects of the image neutralize these marks of submission. He stands, while she sits. He is vigorous and youthful, while she is old and frail. The relationship between these two persons, as pictured by Hubert Robert, is more difficult to define than we first supposed.

What is the significance of a servant who reads? Boucher and Lancret had represented male domestics, but their servants are occupied by the conventional business of serving coffee.[134] Madame Geoffrin's servant in Figure 10, on the other hand, has put aside his regular chores – sweeping and dusting – to read to his employer. How unusual was this in fact?

Literate servants were no rarity in the late eighteenth century. As Cissie Fairchilds argues in her study of eighteenth-century servitude, masters had an obligation to supervise the morals of their servants, and teaching them to read the Bible and other "improving literature" could be construed as a means to that end.[135] Parenthetically, the text that Nanteuil appears to be reading to Madame Geoffrin is a newspaper. Thus neither that Nanteuil can read nor that he does so for the edification of his mistress is particularly unusual for servants at this time. A valet de chambre was expected to perform this task. To see the servant pictured doing so, however, is rare. Why? Because by the third quarter of the eighteenth century, the image of servant and master was one of ambivalence, mirroring the real status of servants at the time, especially of male servants.[136] Robert's picture

simply presents the fact of the servant's ambivalent and awkward role: it does not explain the reasons for it, which must be inferred.

Some sense of Madame Geoffrin's attitudes about domestic service can be gleaned from her letters and account books. Although Ségur describes her staff as modest and "bourgeois," Madame Geoffrin lived quite comfortably. Her staff was composed of an intendant, a butler, a cook, a coachman, two lackeys, two chambermaids, a porter, and a "frotteur," or floor-waxer. Referring to Nanteuil and Marianne in a letter to Poniatowski, she wrote, "I . . . pay dearly for their attachment to me."[137] Marianne, the head chambermaid, according to the account book, received 400 livres annually. Although Nanteuil's wages are not recorded, Madame Geoffrin's male servants seem to have earned about 720 livres a year.[138] These were high wages for the time.

Yet more than wages were at the core of this relationship. Madame Geoffrin appears to have regarded Marianne and Nanteuil with genuine affection.[139] While on her celebrated voyage to Poland in 1765, Madame Geoffrin declined to ride with M. le Loyko, the Polish delegate selected by Poniatowski to accompany her. Instead, she preferred to ride in the coach with Marianne and Nanette, her two chambermaids. "I had for company," she wrote to a Parisian correspondent, "my two maidservants whom I urged to speak freely with one another – and they often spoke of subjects which diverted me."[140] Later, she remarks to Poniatowski that Marianne and Nanteuil, who had endured the hardships of travel to Poland with her, would be touched and flattered by a parting gift from him.[141]

A French household manual of 1726 advised its readers to view their servants as unfortunate friends. Because service had been established against the natural equality of all, the employer must sweeten it: "One must maintain authority over one's servant, but a gentle authority."[142] Such counsel seems to describe Madame Geoffrin's relations with her domestic staff. Hers was a relationship structured around wages, but infused with paternalistic values.

Robert understood such a relationship well. His father, his uncle, and at least one relative on his mother's side came from the upper ranks of domestic service. The artist's father served as an "officier," or head valet, to the marquis de Stainville of the Stainville-Choiseul house, just as Madame Geoffrin was the daughter of a head valet, who served Madame la Dauphine. The social origins of Hubert Robert and Madame Geoffrin, then, share a common root.

The Uneasy Artist

Robert's two canvases are clearly pendants, that is, they are constructed to interrelate as parts of a whole. Chardin was a master of this form. In the pendants *L'Écureuse* (Fig. 19) and *Le Garçon Cabartier* (Fig. 20), Chardin constructs the figures so that they relate both formally and psychologically to one another.[143] A

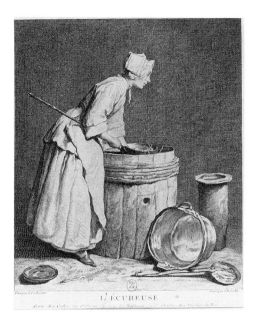 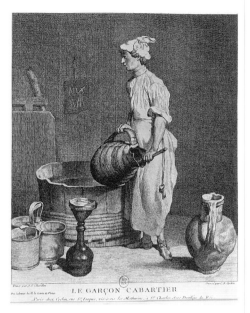

Figure 19. Print by C. N. Cochin from 1740 after Jean-Baptiste Chardin, *L'Écureuse*, 1738. Paris, Bibliothèque Nationale. Photo: Bibliothèque Nationale de France.

Figure 20. Print by C. N. Cochin from 1740 after Jean-Baptiste Chardin, *Le Garçon Cabartier*, 1738. Paris, Bibliothèque Nationale. Photo: Bibliothèque Nationale de France.

set of parallel verticals, horizontals, and opposing diagonals unifies the two separate pictures into a single balanced whole. An implied narrative structure links them, too; Chardin represents the kitchen maid as if her thoughts were occupied by an object outside the picture frame, and in the pendant, we discover just what that object might be, the cellar boy. His attention, in turn, seems to be directed toward the image of the kitchen maid in exactly the same fashion. Robert follows this format, setting up an analogy between the person of Nanteuil, the servant (Fig. 10), and Hubert Robert, the artist (Fig. 9). Through the organization of this two-part composition, he has devised a pointed parallel between the standing figure of the servant in Figure 10 and the deferential figure of the artist in Figure 9.

As the light falls diagonally from the left in the bedchamber scene, so it falls from the right in the reading picture. Formal patterns in the former – diagonal, vertical, horizontal – are repeated in the latter, and a zig-zag configuration of ovals visually stitches the two canvases together. Both images are set in a shallow space, curbed by a wall parallel to the picture plane, which is notable for its squared rectangular shapes. Set side by side, Robert and Nanteuil occupy similar positions in the picture space; both are looking leftward and are seen in profile.

Taking the picture space as a metaphorical social space, Robert's identification with the servant may be construed as wry reference to his roots, but I believe that the referent is more complicated. Robert uses the ambivalent social relation of the servant to his mistress to express the same ambiguous and tense relation of the artist to the patron. Like the servant-master relationship, the relationship between artist and patron was difficult to define. Madame Geoffrin's remark about paying dearly for the attachment of her servants is strikingly similar to her comment about her artists: "I have become their [artists'] friend because I see them often, provide them with commissions, caress them, praise them and pay them very well."[144]

What Robert's image so marvelously conveys is the ambivalence of a relationship in which the threads of cash and friendship are inextricably woven together to bind and to control artistic temperament. The artist seems to question Madame Geoffrin's rhetoric of friendship, and he throws into doubt the claims of equality and mutual satisfaction associated with the practices of sociability. Robert's peculiar presentation of self – calling attention to it while gesturing away from it – finds an analogy in the *sotto* voice of an author (Johnson, Diderot, or Mercier, for instance) who communicates with the reader by a marginal aside, such as a footnote or cross-reference. Something of a trope in Enlightenment texts, it is a pose of false humility meant as a contrast to the arrogance of *les grands* in a society structured on privilege and wealth.[145]

Chapter 3

Sanctifying Circulation
Hubert Robert in the Archiepiscopal Palace of Rouen

A FORMAL STAIRCASE located slightly off center on the long side of the rectangular Salle des États (Fig. 21) in Rouen's archiepiscopal palace deposits the visitor abruptly in front of four majestic topographical views of Normandy, each over twelve feet long (Fig. 22), painted by Hubert Robert for this room in 1773.[1] The effect is stunning, due to the narrowness of the chamber and the towering size of the pictures. Because this room has remained unaltered in its essentials since the eighteenth century, the site provides a rare opportunity for the art historian to study the relation of pictures to setting. Robert created these representations specifically for this chamber and for display on this very wall (Fig. 23).

The paintings represent four locations in the ecclesiastical domain of the archbishop of Rouen,[2] Dominique de la Rochefoucauld. The first canvas is a view of the chateau of Gaillon, the country estate of the archbishops of Rouen since the thirteenth century (Fig. 24).[3] Next in line is an expansive prospect of Rouen (Fig. 25), taken from the faubourg Saint-Sever on the opposite bank of the river Seine. Lodged against the banks of Saint-Sever, on the viewer's left, is the Petit Chateau, an abandoned medieval fortress; across the Seine, behind the city wall of Rouen, we recognize the Romaine (a customs house opened in 1726), the church of Saint-Vincent, the church of Saint-André, the Cordeliers, Saint-Pierre du Châtel, the belfry of the Grand Horloge, Saint-Martin du Pont, the tour Saint-Maclou, the pavilion of the Porte Dorée, and finally the markets of the cider merchants. Dieppe (Fig. 26), the third canvas, is easily distinguished by the church of Saint-Rémy to the left and Saint-Jacques to the right. Nearby rises the dome of the Jesuit church, the bell towers of the Carmelites, the roof of the Hotel Dieu, the city hall, and the convent of the Daughters of Saint Mary. In Le Havre (Fig. 27), the last painting on the viewer's right, Robert depicts the medieval structures of the old quarter of Notre Dame behind the fortification guarding the channel, keying them to the bell tower of the city. A ship with cannon is shown entering the channel.

Of this as their original sequence we can be reasonably sure, for after being

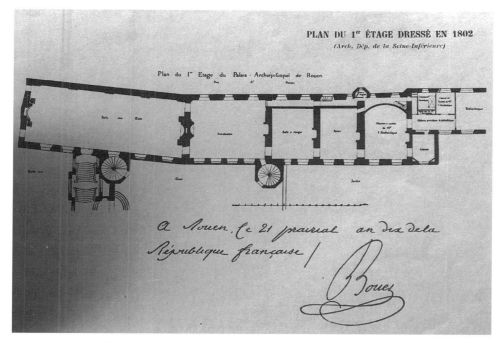

Figure 21. Ground plan of the Archiepiscopal Palace, Rouen, showing the Salle des États (far left) from Jouen, *Comptes, Devis et Inventaire du Manoir Archiépiscopal* (1909). Photo: author.

confiscated as national property during the Revolution, the four canvases were reinstalled at the request of "Sieur Robert" himself.[4] They have remained at this site ever since, except during World War II when they were removed for safe-keeping.

Name Claims

The pictures in the Salle des États evoke a naming response. Portraits of real places, the Norman views invite town dwellers and visitors alike to measure the representation on canvas against the actual site. I encountered this response personally in 1992 when the present archbishop of Rouen identified for me in great detail and with obvious pleasure all the parishes represented in the paintings. We read each canvas from left to right, moving from one to the next along a horizontal axis of spiky contour lines delineating church steeples and belfries aligned several feet above eye level (Fig. 22). We studied them in this way because Robert had employed representational conventions that derive from profile maps (see, e.g., Fig. 28 and Fig. 29).[5] Profile maps pull their beholders along in a line parallel to the plane, as if the viewers were at sea scanning landfalls from afar. Seen from

Figure 22. View of the Salle des États. Photo: author.

such a vantage point, a city's most visible marks are its church towers. Indeed, the key to the profile map of Rouen (Fig. 28) indicates that the mapmaker organized the site by its notable religious edifices and its gates. Thus, for example, the area labeled C is identified as Saint Eloi, D as Saint Michel, F as the Cordeliers, 9 as the Porte de la Poissonnerie, and 11 as the Porte de Paris. (The vantage point of the map's beholder is shifted at a right angle compared to the one adopted by Robert.)

We are not at sea, however; rather, we stand in the formal hall of the archiepiscopal palace of Rouen, an antiquated gothic structure abutting the city's thirteenth-century cathedral. The medieval character of the old quarter, which tourists find so charming today, was distasteful to eighteenth-century esthetes, with their enlightened sensibilities. One such individual, Mathieu Le Carpentier, the architect responsible for Rouen's new Hôtel de Ville, grumbled in 1758 about the area's narrow, badly lit streets and its wooden houses. Lecarpentier loathed the winding, convoluted arteries twined around the cathedral, a feature that, he averred, recalled "the barbarism of the Goths and the Vandals in the century of taste."[6] The century of taste was, of course, Lecarpentier's present day – that enlightened progressive age to which Hubert Robert also belonged.

A reforming spirit had even infected earlier occupants of the *archevêché*. Dur-

Figure 23. View of the Salle des États. Photo: author.

ing the first half of the eighteenth century, Dominique de la Rochefoucauld's predecessor had attempted to modernize the archiepiscopal palace. The Salle des États, so-called because the Estates of Normandy had met in this chamber until the mid-seventeenth century, had been one of the chambers targeted for remodeling. (Although the hall had played an important role in the past, it is not clear how often it was actually used by the archbishops at this time.) The remodeling effort languished, presumably because of a lack of funds, but before this occurred the chamber was altered by enclosing the windows on its street side with a brick wall and by laying new paving stones in the floor.[7] Rochefoucauld, appointed archbishop in 1759, inherited a comparatively vast, empty space in the middle of the palace, only partially complete. He aimed to remodel it according to the latest fashions. Under his patronage, the vertical surfaces of the chamber were encased in a unifying plaster shell of neoclassical pilasters, garlands, and medallions (Fig. 23). Presented with the empty wall of the chamber's bricked-in face, which is clearly

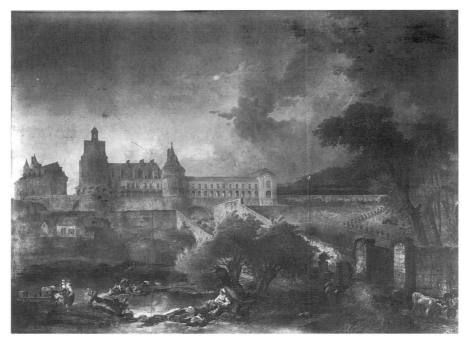

Figure 24. Hubert Robert, *Vue du château de Gaillon en Normandie* (oil on canvas, 4 m. 20 × 3 m. 20). Rouen, Archiepiscopal Palace. Photo: Caisse Nationale des Monuments Historiques et Des Sites.

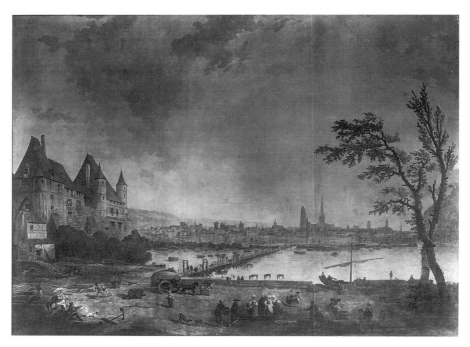

Figure 25. Hubert Robert, *Vue de Rouen* (oil on canvas, 4 m. 20 × 3 m. 20). Signed and dated "Robert 1773." Rouen, Archiepiscopal Palace. Photo: Caisse Nationale des Monuments Historiques et Des Sites.

59

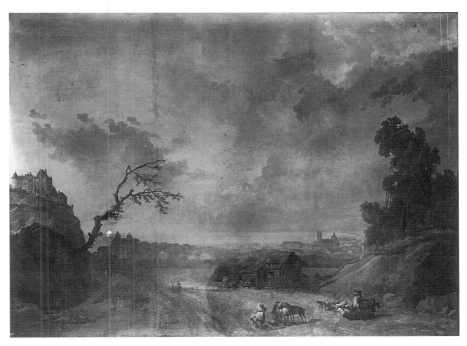

Figure 26. Hubert Robert, *Vue de Dieppe* (oil on canvas, 4 m. 20 × 3 m. 20). Rouen, Archiepiscopal Palace. Photo: Caisse Nationale des Monuments Historiques et Des Sites.

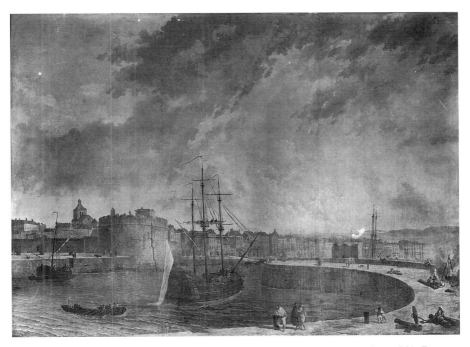

Figure 27. Hubert Robert, *Vue du Havre* (oil on canvas, 4 m. 20 × 3 m. 20). Rouen, Archiepiscopal Palace. Photo: Caisse Nationale des Monuments Historiques et Des Sites.

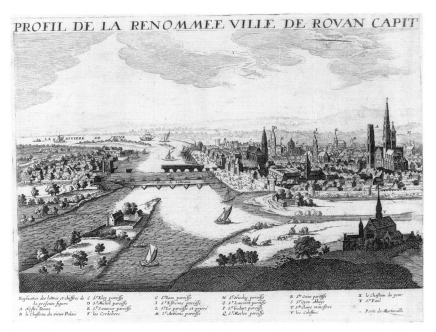

Figure 28. *Profil de la Renommee ville de Rouen capitale et metropolitaine du duché de Normandie* (Paris: I. Boisseau, 1645). Paris, Bibliothèque Nationale. Photo: Bibliothèque Nationale de France.

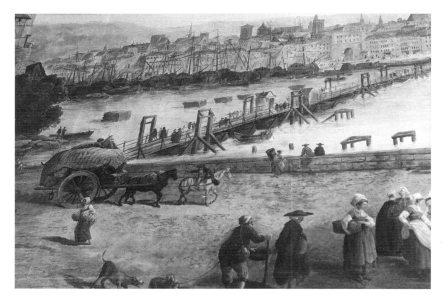

Figure 29. Hubert Robert, Detail *Vue de Rouen*. Photo: author.

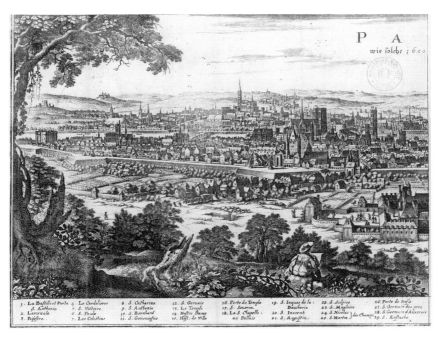

Figure 30. *Paris*, 1620, from Martinum Zeillerum, *Topographia Galliae* (Frankfurt am Mann: Caspar Merians, 1655), 21. Paris, Bibliothèque Nationale. Photo: Bibliothèque Nationale de France.

Figure 31. Hubert Robert, Detail *Vue de Rouen*. Photo: author.

indicated in the ground plan (Fig. 21), Rochefoucauld allotted that virgin surface to representations commissioned from Hubert Robert and tailored to the demands of the chamber.

The portly figure in clerical dress shown strolling toward the right past the beggar in the center of the picture representing Rouen is in all probability a portrait of Rochefoucauld, the archbishop of Rouen (Fig. 29).[8] But as with the scene showing Madame Geoffrin dining at the Abbey Saint-Antoine (also painted in 1773), the eye of the beholder is redirected away from the patron's figure to that of the artist. Robert included himself working in the foreground to the clergyman's left (Fig. 31). A figure we identify as the artist's is sitting on the bank opposite the city, his portfolio propped on his knees, sketching the site before him. In this painting, Robert transformed a stock motif out of the representational conventions of the profile map (see, e.g., Fig. 30) into a vignette of sociable exchange centered on spectating. From over the artist's shoulder, a group of local women and men watch his progress with interest; one man, holding a staff, gestures, making a sign for "naming" consistent with the viewing protocol we are cued to follow in this chamber. Nearby, an anchor, imprinted on the picture plane in an arrowlike configuration, points to the artist, Robert. On it, the artist has inscribed his name and the date, 1773.[9]

For the Geoffrin pendants, I claimed that Hubert Robert allowed himself the liberty of representing an artist-patron relationship fraught with tension. A similar tension appears in these paintings, though its object is different. Displayed in this chamber, in this manner, these pictures have an unmistakable connotation of proprietal interest. The tension we sense in these representations, then, concerns land claims. And it is clear from the subject matter of the four paintings that the terrain in question is specifically that of the city, of the dynamic port cities – of Rouen, Dieppe, and Le Havre – to be exact.[10]

Town and Temple in Eighteenth-Century France

Although the Church had its own considerable economic interests in the city, its moral position on port commerce was another matter altogether.[11] Commerce trafficked with the vice of *luxe*, thus exposing the populace to dangerous temptations of a moral order. According to this reasoning, commercial prosperity was a matter of religious concern, for "le commerce" brought to the port of Rouen the "products of two worlds, [and consequently, the] vices of all nations."[12] In the eyes of the Church (it was an abbot who was just quoted) the disorderly forces of commerce needed to be bridled or, at the very least, soothed by the strong hands of the First Estate, the Church.

So the pictorial program on the wall of the Salle des États signaled a certain posture adopted by the Church towards the city and, by extension, towards the forces of commercial capitalism. As we shall see, the paintings' iconography suggested that the reorientation under Rochefoucauld's direction would be more sympathetic than it had been in the past. Such a change was wholly consistent with the mood of the 1770s and the views expressed in the *Encyclopédie*, for example. In the article "Christianisme," one of the criticisms leveled against Christianity is that it proscribes *luxe*, and by this misplaced spirit of abnegation and renunciation, "It introduces instead sloth, poverty, neglect, in a word the destruction of industry."[13]

During the time Hubert Robert worked on the Rouen commission, the early 1770s, relations between city and country were more than a little strained. A dwindling grain supply resulted in periodic shortages of bread. New economic policies appeared to be urgently needed; what form they should take was the question. Whether the unregulated trade in grain espoused by the economists of the Physiocratic school encouraged surplus or impeded it was hotly debated among the interlocutors in salons like Madame Geoffrin's.[14] It is worth noting that the salon most associated with the sect of Physiocracy was not Madame Geoffrin's, but the duchess de La Rochefoucauld-Liancourt's. In the winter, the Physiocrats gathered at the duchess's Paris salon, and in the summer, they con-

gregated at the Rochefoucauld country seat of La Roche Guyon.[15] Since Hubert Robert was one of the "artistes-habitués" of the Hôtel de La Rochefoucauld,[16] his awareness of the political sentiments expressed there cannot be doubted.

The same is true for Dominique de La Rochefoucauld (1712–1800), who was a member of one of the more obscure and impoverished branches of the La Rochefoucauld dynastic line. Louis-Alexandre, duke de La Rochefoucauld, regularly attended Madame Geoffrin's *lundi* salons, and it was through the duke that the clergyman had become acquainted with Robert. This acquaintance evidently resulted in his choosing Robert to decorate the newly remodeled hall of the archiepiscopal palace.[17]

Hubert Robert brought with him to Rouen the perspective of a Parisian, so the extent to which the iconography of the pictures refers to local matters is doubtful. But certainly Parisians would have been well aware that the region had experienced what authorities called "émotions," or riots, over the scarcity of grain, simply because the port of Rouen serviced the capital. During the 1760s, especially in 1768, Archbishop Rochefoucauld officiated over a region beset by economic problems. The deregulation of commerce in cereals was followed by a series of poor harvests, and the cost of bread began to skyrocket. For the strapped artisans who fabricated textiles in Rouen (and who lived in the faubourg Saint-Sever), an increase in the price of bread meant less money with which to purchase the materials they needed to practice their trade.[18] With either their empty stomachs or their livelihoods prompting them, they rioted twice in 1768, believing that the king had betrayed them. Many years later, at Rochefoucauld's funeral, the abbé Jarry recollected how these circumstances had affected the archbishop: "when thousands of families in despair demanded bread they could no longer afford from their rulers, the sympathetic archbishop flew to their aid; he emptied his coffers;. . . ."[19] His coffers were indeed emptied, for during each of the riots in 1768, Rochefoucauld's monasteries were attacked by rioters and their granaries ransacked.[20] Shortages of grain implicated the Church as well as the crown.

The Space

As already noted, in earlier centuries the Salle des États was used as the meeting hall for the Estates of Normandy. By the 1770s, however, the chamber's character had become less political and more social, though the terms "public" and "private" do not really describe this space well. Some events that the archbishop hosted in the Salle des États were clearly ceremonial. For example, when Louis XVI visited Rouen in 1786, traveling for the first and only time during his reign, he received dignitaries from the Rouen Academy, the mint, the Finance Office, the law court, and the Chamber of Commerce in this space. Considerations of

rank and hierarchy structured the occasion.[21] At other times, though, Rochefoucauld would invite guests to the Salle des États to enjoy the pleasurable pursuits of *société*.[22]

Did Rochefoucauld use this chamber for activities that reinforced his status (ceremony), or did he use it for purposes predicated upon the fiction of effaced status (*société*)? Perhaps our confusion is precisely the point. A decorative scheme keyed to panels created by Robert was likely to encode power claims in a new guise, deflecting attention away from such old and potentially bothersome questions.

Wall maps, like heroic battle paintings, belong to the repertoire of status signs that often decorated the formal halls of noble residences. According to an inventory taken of the palace prior to Rochefoucauld's occupancy in 1759, a large view or map of Gaillon, the centuries-old feudal seat of the archbishops, was displayed in the palace dining room.[23] Gaillon reappears as a subject in Robert's decorative cycle in the Salle des États, but here the transplanted motif suggests more (and ultimately less) than its value as a feudal possession of the archbishop of Rouen. Gaillon is completely overshadowed by the vision of dynamic cities and ports against which it is juxtaposed. These sites are claimed by the archbishop in a wholly different way than is Gaillon and on different legal grounds.

To suggest this, Robert draws upon the decorative scheme of the eighteenth-century Venetian *portego*, or formal room of a noble's manor, which was often decorated with urban *vedute* and other representations of civic spectacles and festivities. Robert's *Vue de Rouen* (Fig. 25) resembles *vedute* by Antonio Canaletto (see, e.g., Fig. 32). Pictures such as this by Canaletto were fashioned to form a "fitting context" for the social activities of Venetian aristocrats wishing to advertise their political solidarity with the Republic.[24] According to recent scholarship, certain *vedute* by Canaletto had been created for a *portego* with this purpose in mind.[25] Like the relation implied between the Venetian nobleman and the sites of the city displayed in his *portego*, the ostensible identification of the archbishop of Rouen with the secular interests of the city and its suburbs is assertively declared by this choice of imagery.

The overdoors painted by Robert for the Salle des États, now in the Musée des Beaux-Arts in Rouen, depict Roman ruins and Italianate motifs, another iconographic element linking the concept of the chamber to the program of the *portego*.[26] It was not uncommon for a Venetian *portego* to include pendants linking Venice with ancient monuments – a conceit suggesting Venice was the "other" Rome.[27] As we shall see, the iconography of the overdoors in the Salle des États similarly points to a subtle relation between past and future civilizations, but with an inflection upon "future" that resonates with the ideals of the French Enlightenment.

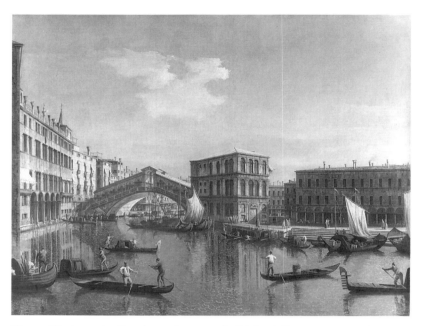

Figure 32. Antonio Canaletto, *Le pont du Rialto* (oil on canvas, 119 × 154 cm). Paris, Musée du Louvre. Photo: Réunion des Musées Nationaux.

Mapping Normandy

The canvases that Hubert Robert designed for the Salle des États draw on conventions of the eighteenth-century urban *vedute* as well as on those of profile maps. However, Robert was mapping these areas for the spectator in a peculiar Enlightenment fashion, situating the city in the distance and emphasizing the open spaces of the suburbs or the sea (Figs. 25, 26, and 27) in the foreground. He consistently contrasted relatively vast but vacant foregrounds with the distinctive markers of the church towers behind them, there to anchor a compasslike arc of movement forward into space as the city asserts its will on coast and country. In the three port paintings, the cities surge out toward the country (or the ocean) under immense expanses of sunny blue sky filled with billowing cumulus clouds, a detail that suggests, as in the Dutch cityscapes of the previous century, that the march of urbanization unfolds under the beneficent direction of Providence.

The imagery thus presents a vision of the city encroaching upon its surroundings as natural and good. Hubert Robert is not the first artist in the eighteenth century to depict towns this way. In fact, others had represented the city of Rouen from a similar perspective. For example, Jean-Pierre Bardet describes a 1768 print in which the ramparts girding Rouen have vanished and a fusion of the city and the suburb has taken place.[28] As Bardet notes, this rational spatial rupture of the

city walls is an Enlightenment conceit. We are reminded that the Enlightenment
viewed the extension of urbanism into the suburbs as a gain. Robert's represen-
tational strategies are grounded in this rhetoric. So despite a dependence upon the
conventions of old-fashioned profile maps, Hubert Robert is expressing very mod-
ern attitudes about the possession of the terrain.

Robert's formulation is consistent with the shift we can detect at this time in
the morphology of French maps, which changed from the illusionistic bird's-eye
view, such as the 1615 perspective map of Paris by Mathieu Mérian (Fig. 33), to
the map of geometric figuration, like that in de Fer's *Les Beautés de la France* of
1724 (Fig. 34). Evolving out of the idiom of the surveyor, the geometric map
ignored old feudal relations of privilege and power – relations represented around
the frame of Mérian's map (Fig. 33) by emblematic referents to a social and
political hierarchy dominated by the monarchy and sorted by class and gender –
focusing instead on measurable spaces of the terrain as empty units "waiting to
be filled."[29]

Mérian's map of Paris presents a striking contrast to Nicolas de Fer's. The
bird's-eye view of a city dominated by churches and belted comfortably by its
wall offers the beholder an intimate and manageable prospect that can be grasped
easily in a single sweeping glance (Fig. 33). Mérian's map differs in this respect
from profile maps. Also unlike profile maps (e.g., Figs. 28 and 31), Mérian's is
keyed to a different register. It pivots on an inscription contained within the car-
touche: "This city is another world within a flourishing world, powerful in pop-
ulation and in goods, which in all things abounds."[30] As proof of that prosperity,
Mérian borders the map with a composite picture of French society, which is led,
in the upper right, by a picture of the French king (*Tel est dans son haut appareil
le Roy, en vertu non pareil*) and followed (reading down) by his gentlemen of the
court. Third from the top is an image of France's "financiers and rich merchants,"
and on the bottom are "paysans," or peasants. A corresponding social ladder is
offered on the right, topped by the "admirable" queen of France, who is followed
by her "grandes dames et demoiselles," then by the "gentilfemmes et bourgeoises
. . . belle et cortegé," and lastly, by the faggot gatherer and the water carrier,
"vetue . . . d'une autre sorte." The many references to dress that annotate these
images are connected to the sumptuary edicts passed in 1601, 1606, and 1613
attempting to regulate the costume that could be worn by the subjects of Henri
IV and Louis XIII. Roughly a century later, in the map made by de Fer (Fig. 34),
the primacy of the Church and the dominance of the privileged have vanished
altogether. Indeed, this particular page is one in a small bound volume devoted
to illustrating just how the city of Paris had burst its original Roman walls in
successive expansions over time, a point that de Fer makes in a chronological
sequence of plans of the city. "The present" moment was 1724, the year of the
"last observations of the members of the Royal Academy of Sciences" on this

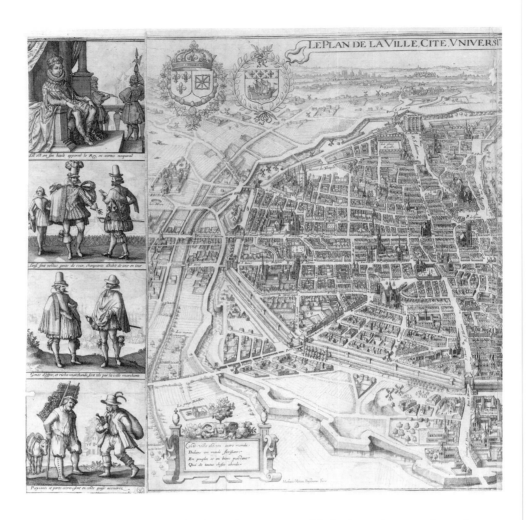

topic and the year in which the volume was published. In de Fer's formulation, change is the norm; therefore, distances cannot be computed by sociological or political standards. As the "Echelle" within the frame at the left indicates, distance is essentially a matter of measuring space by mathematical means.

The tension between the morphologies of a perspective rendering and a geometric one may explain the disconcerting play between depth and surface that distinguishes the representation of the city in Robert's paintings for the *archevêché*. Although the images are designed to be framed illusionistically by pilasters (see, e.g., Fig. 23), they refuse to recede behind them. Various features, such as the odd dislocations of scale that are evident in the minuscule figures on the road to Dieppe (Fig. 26), call attention to the plane, just as maps do.

If the edge between civilization and nature that Robert chose to accentuate in the Norman views is the empty terrain waiting to be filled, how it should be filled

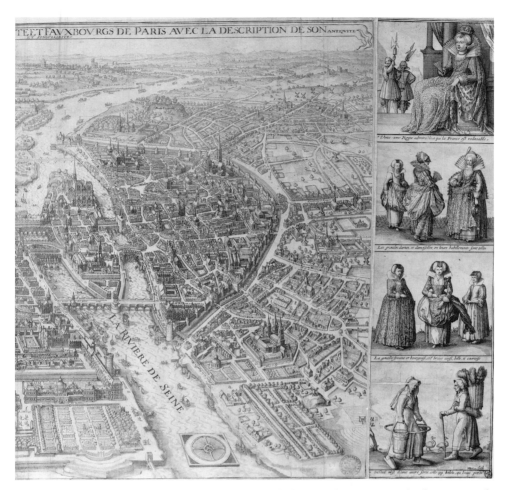

Figure 33. *Le Plan de la ville, cité, université et faubourgs de Paris avec la description de son antiquité*, by Mathieu Mérian, 1615. Paris, Bibliothèque de l'Histoire de la Ville de Paris. Photo: Bibliothèque Nationale de France.

and to what purpose are matters that Robert left to the patron and his visitors to resolve. In this respect, the Norman views are more like the modern geometric maps of the last half of the eighteenth century. But one thing is certain. This openness – of the river, of the road, and of the port – contrasts visibly with the signs of confinement that structure the composition of Gaillon (Fig. 24).

Configured to dramatize closed gates and angled, doubled walls, Gaillon's structure pulls the eye about in abrupt starts and stops, whereas Robert's vision of Rouen, Dieppe, and Le Havre insistently draws our attention to unimpeded roads, bridges, rivers, ports, and channels. For example, in the view of Rouen (Fig. 25), the pontoon bridge slicing across the river Seine is the composition's

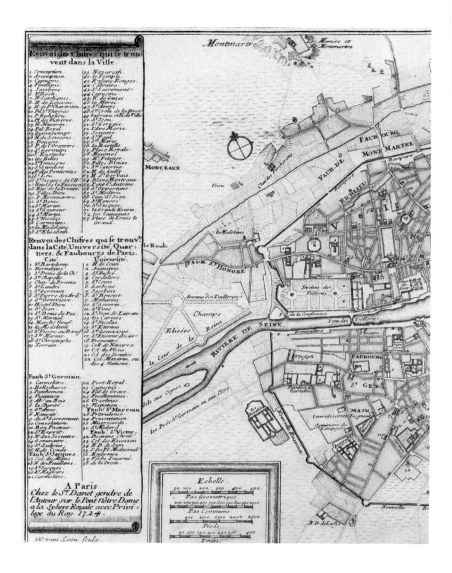

symbolic focus. In *Dieppe* (Fig. 26), the picture is dominated by a massive road spilling out of the distance into the foreground. It is not the wharf, but the curving arms of the aperture to the channel (Fig. 27) that Robert accentuates in his representation of the port of Le Havre. A leitmotif in all three images is passage. The theme of freedom of movement distinguishes Robert's representations of the port cities of Normandy. "The road, the canal and the river," writes Daniel Roche, "... are the instruments of a politic of communication."[31] In the eighteenth century, these signs became the basis of an *imagined* and longed-for flourishing nation-state that we associate with the French Enlightenment.

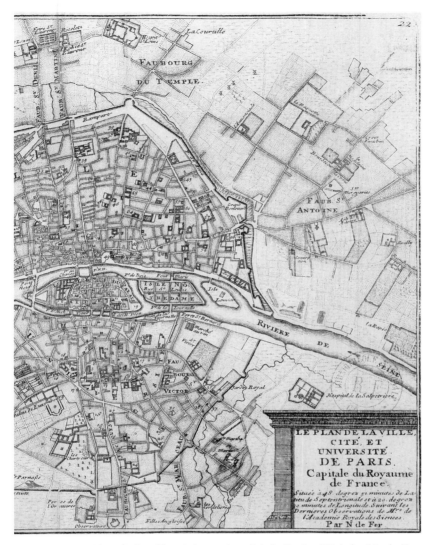

Figure 34. *Le Plan de la ville, cité et université de Paris*, 1724, by N. de Fer, *Les Beautés de la France* (Paris: Chez le Sr Danet, 1724), 13. Paris, Bibliothèque Nationale. Photo: Bibliothèque Nationale de France.

The Fictive Cosmos in the Archevêché

On the wall of the Salle des États, a prospering commercial society becomes the fictive cosmos in which the sacred takes on value. Even in Mathieu Mérian's representation of Paris in 1615, the environment before which the pictured financiers and rich merchants stand is the port. The emblem of the port, I suggest,

has come to stand for all of Normandy in 1773. How to integrate a Catholic Church harboring theologically based hostility to luxury into a society geared toward a developing concept of profit as the basis of the common good is the issue that lies at the heart of this pictorial program.

Unlike the other "fatal" philosophies proposed by Enlightenment thinkers that caused Dominique de la Rochfoucauld to fear for religion in France (the subject of one of his speeches to the clergy), the Physiocratic model, which is what Robert represents here, did not oppose the interests of the Church. Indeed, some have seen this model as the "last and highest manifestation of traditional Catholic thought."[32] First, and most importantly, in Physiocracy, Deity is the "quiet agent" behind nature's gifts. Nature gives humanity the materials it needs to prosper; the humans merely rework the materials for consumption. Consequently, the creative source of order, according to Physiocracy, is inscribed within the workings of nature rather than within the monarchical state. In this way, Physiocracy leaves the door ajar for the Church to step into its old role as the mediating force that will "coax God and the saints" to see that nature gives generously to the French people.[33]

The Physiocrats and their supporters believed that the task of men and women was to ensure that the bounty bestowed on them from nature circulated freely throughout the nation. Circulation is thus one of the primary metaphors of Physiocracy.[34] François Quesnay, the progenitor of the Physiocratic model, was a doctor by profession, and he had been much influenced by Harvey's description of the flow of blood. Like blood as it moves in a human body, grain and other foodstuffs, according to Quesnay and his adherents, ought to circle their way throughout the realm. It follows that all impediments to the free-flowing circuit of foodstuffs and other goods, such as taxes or tolls on imports or exports, should be eliminated.

Starting in 1763, various royal officials influenced by the reasoning of Quesnay lifted controls on cereals to permit grain to reach its "natural" market value. Although the focus of Physiocracy is a depersonalized, internal system binding the economy of France together, the "natural market value" of grain is arrived at as a result of external exchanges – that is, commerce between nations.[35] Hence, for Physiocrats, it was crucial that ports be free of all duties and ordinances that limited foreign trade, the exchanges that induced domestic prices to stabilize at their "natural" level.

The vessel spiked with cannon slipping easily into the welcoming arms of the channel in Robert's *Le Havre* (Fig. 27) is an image guaranteed to delight the Physiocrats. When Sébastien Mercier speculated upon various political themes for the new theatrical genre of the *drame*, the first example he offered was a scene in which a merchant successfully appeals to a minister to establish liberty of commerce in France.[36] In a footnote to that passage (written in 1773, the same year

Robert's pictures were painted), Mercier explained the virtues of free trade to his readers, illustrating his points by describing his rapture at the sight of a port thriving with commercial activity. "How I love the commerce in a sea port! how these active figures, these crowds of workers, this perpetual movement, these channels, these roads, these wagons, this vast and unencumbered circulation asserts the health of a State that is doing well!" But for the crowds of workers, Mercier could have been describing Robert's pictures, for this "circulation vaste et facile" – the supreme mark of a healthy state – is precisely the thematic visualized by Hubert Robert in the *archevêché* paintings.

Crowds of Workers

Mercier's description of a bustling port draws our attention to the fact that "crowds of workers" are notably absent in all four of Robert's Norman views. Robert drew on highly conventionalized sources in fashioning his views of Normandy, but, by omitting groups of workers in his representation, he diverged from the generic types that prescribed the images. For example, Robert's prospect of the city in the *Vue de Rouen* (Fig. 25) is nearly identical to a representation painted around 1715–20 (Fig. 35) by Pierre-Denis Martin (1663–1742). Martin extended his field of vision by another half beyond the pronged tree at the edge of Hubert Robert's version (the tree – a local landmark, actually struck by lightning – appears in both canvases). But Martin, unlike Robert, distributes masses of people in the faubourg Saint-Sever. The leisured as well as the laboring are shown pouring *into* the center of metropolitan Rouen. In contrast, Robert's *Rouen* contains only a small number of figures scattered throughout the deep foreground (see, e.g., Figs. 29 and 31).

Similarly, although a number of the details in the Normandy cycle seem to refer to the *Ports of France* painted by Robert's friend, Joseph Vernet, between 1754 and 1762, differences abound, especially in the matter of staffage.[37] The *Ports* present a microcosm of a healthy and prosperous modern society of merchant capitalists.[38] Vernet literally inventoried the occupations peculiar to each port with an attention to detail worthy of the "work" plates published in the *Encyclopédie* (see, e.g., Fig. 36). He reinforced this impression by generally including a mix of distinctly recognizable classes mingling on the quai, an expressive means to suggest that the existing social structures of French life were not incompatible with the depicted economic activity.

View of Dieppe

As I already observed, Hubert Robert constantly draws our attention to space that is conspicuously empty. To read space as empty, we must posit a lack. Com-

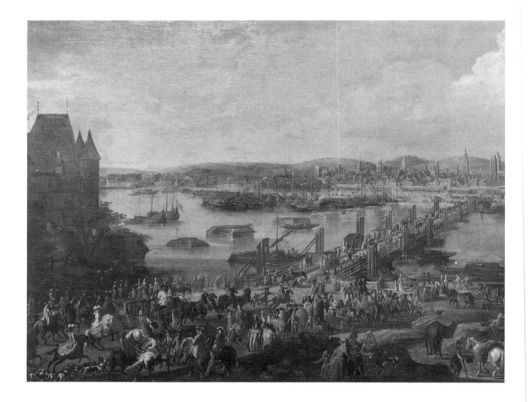

pared to landscapes by Martin and Vernet, Robert's Norman views lack ag-
gregates of self-absorbed figures industriously going about their business. The
vacuous quality of the foregrounds in these paintings is reminiscent of seventeenth-
century Dutch landscapes, such as those by Meindert Hobbema or Jan van Goyen,
but the peculiar quality of the scattered, isolated figures is not Dutch at all. This
is especially true of the group on the road to Dieppe (Fig. 26).

A road of enormous breadth springs out in this composition toward the spec-
tator. Discrepancies of scale throw the perspective of the picture off, for the road
and the figures occupying it in the foreground seem to belong to two different
paintings. This road, as I contended earlier, is the real Physiocratic hero of the
representation. Not only does it connote energy by its surging curve, uncoiling in
our direction, but on its surface are painted the movements and countermove-
ments of cattle, sheep, dogs, and distant figures circulating toward and away from
Dieppe.

Aligned in the foreground on this massive highway are six figures – a nobleman
accompanied by two of his huntsmen and his dogs, a single somberly dressed
figure traveling by horse (perhaps a tutor or a member of the lower clergy), and
a woman who has faggots on her back, on foot and accompanied by a child. Each

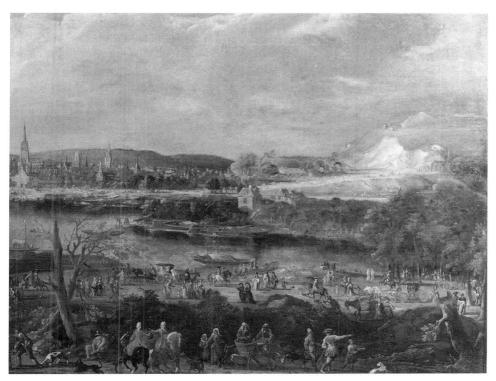

Figure 35. Pierre-Denis Martin, *Vue de Rouen prise de Saint-Sever*, c. 1715–20 (oil on canvas, 80 × 201 cm). Rouen, Musée des Beaux-Arts. Photo: Musée des Beaux-Arts.

group represents a class of eighteenth-century French society (Fig. 37). As he was wont to do, Hubert Robert has borrowed a graphic convention from the past – the standardized emblems of privilege and class bordering maps such as those by Mérian (Fig. 33) – and adapted it to his own ends.

In his reformulation, Robert dismantled the hierarchically ordered stacked boxes that signified the high and low ends of French society and were ornaments on maps of the seventeenth century. He replaced this social ladder with a much more ambiguous configuration, a line of figures, apparently on the same level, sharing the road that led to the city of Dieppe. Social and political hierarchies were not entirely effaced by this arrangement, because the alignment of the figures angles upward from the peasant woman to the nobleman, who occupies a spot higher in the visual field (and who takes up more of the road). Nonetheless, the spectacle of the shared road invites speculation. So does the figure of the woman, who arrests the beholder's eye by her pose of address, facing toward us, and looking out in our direction – a contrast to the self-absorbed depictions of the others. Because neither a unified perspective nor a narrative pretense binds these figures to their setting or to each other, they begin to alter the way we apprehend

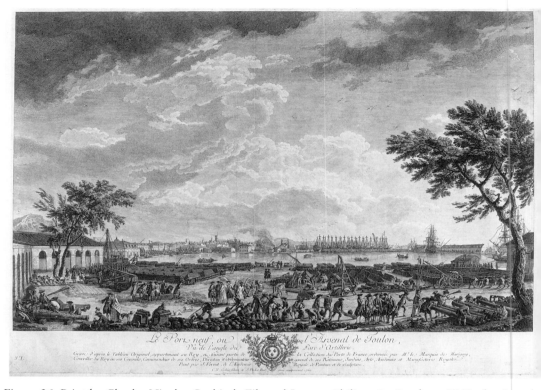

Figure 36. Print by Charles-Nicolas Cochin le Fils and Jacques-Philippe Le Bas from 1760 after Joseph Vernet, *Le Port neuf ou l'Arsenal de Toulon*. Paris, Bibliothèque Nationale. Photo: Bibliothèque Nationale de France.

the subject. In other words, these figures cause the representation to appear less topographical and more allegorical.[39] As an allegory, the Dieppe representation must have flattered the archbishop's imaginary picture of himself as a power whose reach (figuratively) extended to all classes of Norman society. We are reminded that the "bien inventée" takes account of what the performer-artist owes to his or her audience. This gallant little detail acts just like a rhetorical flourish in oratory, a sign of the artist's *adresse* and invention. Instead of to the archbishop, or, more likely, in addition to the archbishop, Robert's flourish may be directed equally to the space – a chamber called "The Room of the Estates" – as a presence with its own identity and history. A pictured gathering of representatives of the three estates, albeit on the road near Dieppe, points to the character of the Salle des États, which had provided the venue in the past for the segments of Norman society to work out their differences politically.[40]

What we note, however, is how these oddly dislocated figures call attention to the artifice of the construction, just as does the figure of the sketching artist in

Figure 37. Hubert Robert, Detail of *Vue de Dieppe*. Photo: author.

the view of Rouen (Fig. 31). The dream of a rational economic order in harmony with nature and the Church is celebrated in these images, but it is presented as an enticing fiction for the spectator, not as reality. Hubert Robert's own voice emerges at this juncture in the spectacle he has staged for the pleasure of the archbishop in the Salle des États, but his "comment" is possibly tinged with irony, and its meaning equivocal.

Chapter 4

Performing the Libertine
Hubert Robert in the Bagatelle

> The bathing room placed to the left of this salon is decorated with mirrors and six charming paintings by M. Robert, peintre du Roi, one of the Gardes of the Museum, and Designer of the King's Gardens.
>
> L.V. Thiéry, *Guide des Amateurs et des Étrangers*, 1786

A N ENTICING FICTION of a wholly different order is staged for the beholder by Hubert Robert at the Bagatelle, the suburban retreat of the comte d'Artois, the king's younger brother, designed by F.-J. Belanger in 1777. "Bagatelle" refers to a number of structures – a pavilion, a stable, service buildings – surrounded by a comparatively vast garden. Because outside and inside are woven together into a finely calibrated totality, the Bagatelle cannot be reduced to just the sum of its parts. It is more than a park or a pavilion. In addition, because one of the Bagatelle's functions was to serve as a site for outdoor *fêtes*, its design owed a conceptual debt to the spaces and sets of courtly feasts and parades.[1] Consequently, the Bagatelle was constructed as an experience of movement, which culminated, rather than commenced, in the elfin *faux* marble palace-pavilion (Fig. 38).

At the Bagatelle, the learned public of Hubert Robert's day was treated to an esthetic experience rather different from the courtly entertainments that had transpired at such sites in past centuries. The Bagatelle experience was more unregimented and playfully voyeuristic. For though the patron was virtually absent, the prince nonetheless remained a pivotal figure in the Bagatelle's optics. He was the *imagined* denizen of its attractions. As a representation, the Bagatelle resonates with a supremely calculated force. The source of its power was the displayed sexuality of the comte d'Artois, the Bagatelle's proprietor.[2] *Volupté*, or calculated pleasure, is the substance of the signification.[3]

As we shall see, Robert's witty allusions to voyeurism in the ornamental cycle of the *salle de bains* do not miss the mark. All visitors to the Bagatelle are in some

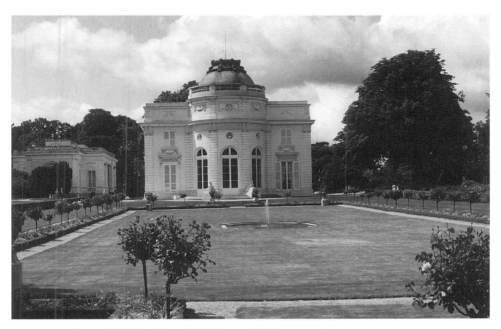

Figure 38. View of the Pavilion of the Bagatelle. Photo: author.

sense voyeurs – voyeurs who gaze with fascination at a display of the intimate and personal Artois. Thus the Bagatelle can be said to wield its power and authority through an emphatic public celebration of *la vie privée*.[4]

The power quotient explains why its proprietor would open the Bagatelle to visitors. As were the *folies* owned by the financiers Gaillard de La Bouxière and Charles-Robert Boutin, the Bagatelle was open to the public by a form of ticket entry on Thursdays, Sundays, and holidays.[5] With both Artois *and* Parisian society in mind as consumers of their representation, the Bagatelle's designer, the architect François-Joseph Belanger, and the artists he hired, such as Hubert Robert, indulged in certain ironies. It is this public as voyeurs that Hubert Robert slyly addresses in the imagery he produced as decoration for the structure.

Only this public could be expected to fully appreciate the famous epigram borrowed from Aristo – "parva sed apta" (small but convenient) – cut into the lintel of the Bagatelle's Batîment des Pages. Belanger meant this ironically. Aristo (1474–1533) had placed the epigram on his house in Ferrara to mock his patrons, the cardinal Ippolito d'Este and his brother, the duke of Ferrara, who had systematically withheld the great poet's pensions.[6] Emblazoned over the entrance to the Bagatelle, an extravagant *folie* costing over a million and a half francs, "small but convenient" doubtless amused Artois *and* Belanger, but for different reasons. In fact, as a patron, Artois shared certain deficiencies of character with the duke

of Ferrera and his brother, for the young prince frequently failed to pay for the works of art he commissioned.[7] In addition, the prince reputedly had neither the taste nor the intelligence of a connoisseur. The Scot Thomas Blaikie, the garden's designer, recalled being told not to fret too much over Artois's lack of interest in the Bagatelle garden, because the prince "took more pleasure in a girl than a garden."[8]

The "Petite Maison"

The garden and pavilion of the Bagatelle fall into a class of domestic architecture known in the eighteenth century as a *maison de plaisance*. As J. F. Blondel defined the term in his *Cours*, the *maison de plaisance* was where the elite sought respite from the burdens of court or city life.[9] Not to be confused with the country estate, these scaled-down retreats stood within easy reach of the capital. The Bagatelle, for example, was located in the Bois de Boulogne. Within the generic category of the *maison de plaisance*, moreover, a finely shaded distinction existed to differentiate a country house used for innocent pastimes from an abode devoted to markedly libertine pleasures. The latter was designated by the term *petite maison*.

Both the erotically charged *petite maison* and the politically charged Parisian salon discussed in Chapter 2 are fundamental Enlightenment institutions. In fact, I argue they were conceptually linked in the eighteenth-century mind because both were ruled by women. While gossiping in 1768 about the disreputable *soupers* of the Opera dancer Mademoiselle Guimard, Bachaumont observes in his *Mémoires* that one set of her weekly habitués include literati and artists "who come to entertain this muse, rival of Madame Geoffrin in this respect." He thus draws a direct but ironic comparison between the Guimard parties and those hosted by Madame Geoffrin. Artists, by the way, were generally invited to Guimard's second weekly dinner rather than her third, reputed to be the weekly orgy.[10] Saint-Beuve also writes that the "intimate dinners and licentious suppers" of Mademoiselles Quinault and Guimard and certain "men of finance" were the counterpart of Madame Geoffrin's *soupers*.[11] And Marmontel, in his *Mémoires*, moves straight from a description of the polite pursuits of the Geoffrin salon, which he avows did not really allow men "liberty of thought," to an account of Pelletier's "salon" – "the most free, or at least the most licentious of all," where eight to ten men would gather "all friends of joy" (*tous amis de la joie*).[12]

Historians such as Yves Durand have related the two spaces – the *petites maisons* and salons – sociologically, noting that the siting of Parisian *petites maisons* presented an interesting social zone in which the leisure dwellings of tax farmers stood side by side with those of high-ranking court nobility.[13] A distinctive feature of the social activities connected with the *petite maison* is the mixing of classes. Some of this mingling occurred because a primary purpose of the *petite*

maison was to shelter prestige mistresses, who came mostly from the theater. The same women were shared successively by the same circle of wealthy lovers – "tous amis de la joie," as Marmontel put it. Artois's passion during this period, a woman still regarded as the first hostess of the Bagatelle, was the actress Rosalie Duthé.[14]

At the time of its construction, the Bagatelle was construed by contemporaries as a *petite maison*, not a *maison de plaisance*. Artois lunched and dined there "en compagnie," remarked the baronne d'Oberkirch, but never, openly at least, with women of the court.[15] From our perspective, the essential point about the structure and its decor is its sensual connotations.

Beyond the *maison de plaisance* and the *petite maison* is yet a third dimension of the form, known as the *folie*. Technically, a *folie* is nothing more than a di-minutive pleasure palace set in a capacious garden. The term "folly" alludes in part to the connotation of madness and delirium attached to carnal love, but it also refers to the vast sums of money required to construct these whimsical con-fections. For example, "Tivoli," Boutin's park, was popularly called "la Folie-Boutin" because of the staggering expenditures its owner had lavished upon it.[16] The extravagant circumstances under which the Bagatelle came into being – the result of a crazy wager between Artois and his sister-in-law, Marie-Antoinette, over whether the little palace could be constructed by the time the court returned to Versailles, roughly two months time from start to finish – epitomized the es-sential nature of the *folie*.[17] Details about the 100,000 franc bet and about Artois's debts were highly publicized and combined to fix a notoriety upon the Bagatelle as a *folie* of the first order.

Bathing and Bathing Rooms in the Eighteenth Century

The space that Hubert Robert was commissioned to decorate in Artois's *folie* was the bathing room, or *salle de bains*. As Georges Vigarello has shown, in the early modern period bathing for hygienic reasons was still rare, a consequence of fears concerning the permeable nature of the human body.[18] But around the middle of the eighteenth century attitudes toward water use seem to undergo a slight change. Certain types of wet-bathing develop, which immersed the body in water, though the practice was confined to a narrow elite and "did not correspond to any height-ened concern with matters of hygiene."[19] When the *salle de bains* gradually ap-pears as a specialized space in the eighteenth-century hôtel, it does so as a visible expression of a particular coterie in which great wealth and sensuality are linked. In short, the same cultural matrix begetting the *petite maison* and the *folie* spawns the *salle de bains*.[20]

The late eighteenth-century bathing room signaled the voluptuous inclina-tions of the domicile's patron.[21] At the end of the ancien régime bathing rooms

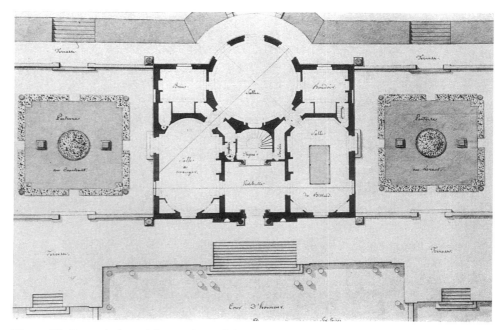

Figure 39. Ground plan of the Pavilion of the Bagatelle by F.-J. Belanger (ink-wash drawing). Paris, Bibliothèque Nationale. Photo: author.

had a clearly defined character of exhibitionist sensuality. They often had great French windows opening out onto the garden, as the *salle de bains* at the Bagatelle does (far right; Fig. 38). "The sense of idleness that accompanies the bath calls for objects of distraction. . . . The bath itself . . . will be so placed as to command a pleasing outlook," wrote Le Camus de Mézières in his architectural treatise of 1780, *Le Génie de l'Architecture ou l'Analogue de cet art avec nos sensations.*[22] For Le Camus, the principal task for the decorator of this chamber is simple. He must "make illusion rule there; prepare the fore-stage (avant-scène)." And above all, he must be whimsical: "il faut donner du jeu" in the *salle de bains.*[23]

The Pictures In Situ

In his book on architecture, Le Camus may have had the *salle de bains* at the Bagatelle in mind, because the building was constructed in the winter of 1777–78, and his treatise was published in 1780. As is evident from Belanger's ground plan (Fig. 39), the room he labels "bains" (upper left) is a rectangular chamber, dominated by a large French window directly opposite the tub, which is set in a niche. The bathing room is located on the garden side of the structure. As the

bather faces the window, on the left stands a chimney and on the right a doorway leading to the circular salon.

In 1786, Thiéry's *Guide des Amateurs* indicated that the Bagatelle's "salle de bains . . . est ornée de glaces et de six tableaux charmans peints par M. Robert."[24] We know that a pair of pictures flanked each side of the chimney – probably *The Mouth of a Cave* (Fig. 40), which bears the date 1784, and *The Fountain* (Fig. 41). *The Swing* (Fig. 42) and *The Dance* (Fig. 43) would have been placed on each side of the entrance portal to the salon.[25] Another set of paintings framed the window – probably the largest pair of the series, *Wandering Minstrels* (Fig. 44) and *The Bathing Pool* (Fig. 45). If Le Camus is any guide, the mirrors were fixed opposite the window and above the mantel, hung low "so that one may see oneself from every angle."[26] Wispy clouds of a *trompe l'oeil* sky floated on the ceiling overhead.[27]

As a picture type, Robert's six canvases are rather difficult to categorize. A palace "enfilade" (a sweeping architectural vista) is represented in *Wandering Minstrels* (Fig. 44), and "bowery trees, fountains and waterfalls" appear in some of the other canvases of the ensemble. That particular taxonomy was applied by William Beckford to describe works by Robert that he saw in 1784. Beckford, a tourist in Paris, was trolling one of his "favorite haunts," the studios of the Louvre, "hunting out the Artists in harbours." Luck was with him, for he "caught Robert (who is as industrious as a spider) spinning a most beautiful web, light aerial enfilades of palaces, bowery trees, fountains and waterfalls, gay as Watteau, but more classical."[28] The canvases, Beckford learned, were intended for the comte d'Artois: "and most heartily do I envy H. R. Royal Highness their possession – the hues of these lengthened perspectives, these graceful avenues, are so delicate, so vapoury," he added wistfully. Because several Bagatelle panels were in Robert's studio in 1784 for repainting and restoration, Beckford may have been scrutinizing the very pictures the artist had created for the Bagatelle's *salle de bains*.[29]

"gay as Watteau, but more classical"

Beckford's angle on the Roberts may help us see the paintings more clearly. To catch a sense of what he might have meant by "gay as Watteau, but more classical," let us compare Robert's *Wandering Minstrels* (Fig. 44) to a Watteau, such as the *Assemblée dans un parc* (Fig. 46).

Each artist has represented a kind of palace fête, though Robert limits his entertainers to a group of serenading musicians. The performers in the Robert, however, do not appear to be eighteenth-century French amateurs costumed for a courtly pastime. Rather, they appear to be Italians, just as the angled *enfilade* decorated with columns and statues appears to be a version of the Campidoglio in Rome. Borrowing a conceit from Watteau's repertoire of expressive devices,

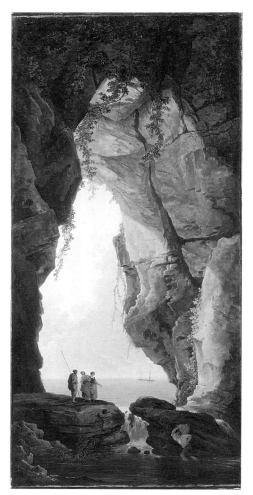 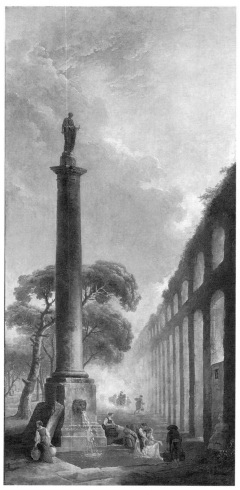

Figure 40. Hubert Robert, *The Mouth of a Cave* (oil on canvas, 174.6 × 79.4 cm). Signed and dated "H. Robert 1784." New York, The Metropolitan Museum of Art, Gift of J. Pierpont Morgan, 1917. Photo: Photograph Services, The Metropolitan Museum of Art, New York, N.Y.

Figure 41. Hubert Robert, *The Fountain* (oil on canvas, 173.4 × 79.7 cm). New York, The Metropolitan Museum of Art, Gift of J. Pierpont Morgan, 1917. Photo: Photograph Services, The Metropolitan Museum of Art, New York, N.Y.

(it doesn't appear in the *Assemblée dans un parc,* but see, e.g., Fig. 15), Robert poses a statue – the antique Flora – as if extending a wreath and a beneficent look in the direction of the musicians. "Bowery trees" are visible in both artists' canvases, evoking the presence of an adjacent garden. Beckford's reference to Watteau, it seems, may be well taken, at least for Robert's *Wandering Minstrels.*

Beckford was equally astute in adding the qualification "but more classical."

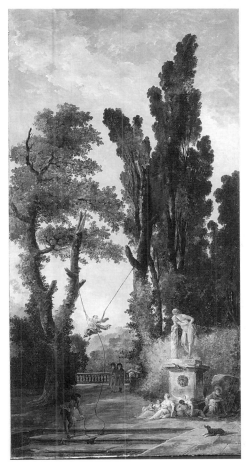 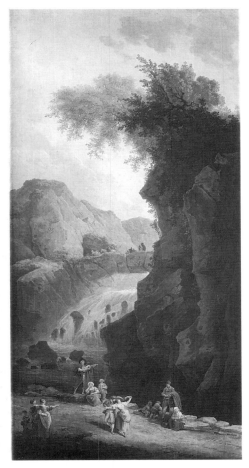

Figure 42. Hubert Robert, *The Swing* (oil on canvas, 173.4 × 87.9 cm). Signed "H. Robert." New York, The Metropolitan Museum of Art, Gift of J. Pierpont Morgan, 1917. Photo: Photograph Services, The Metropolitan Museum of Art, New York, N.Y.

Figure 43. Hubert Robert, *The Dance* (oil on canvas, 173.4 × 85.4 cm). New York, The Metropolitan Museum of Art, Gift of J. Pierpont Morgan, 1917. Photo: Photograph Services, The Metropolitan Museum of Art, New York, N.Y.

In *Wandering Minstrels*, the style of the architecture and sculpture, not to mention the clothing of the figures, suggests a site in Italy constructed after 1500. Significantly, the temporal frame in which the image is set remains indeterminate, although we recognize the signs of great age pitting the surface of the palazzo. Fragments of architectural masonry piled beneath the Flora and littering the periphery of the fountain strengthen this connotation. Juxtaposed with the imagery of the other panels in the series – the marble faun in *The Swing* (Fig. 42), the monopteral temple in *The Bathing Pool* (Fig. 45), the Trajan-like column and

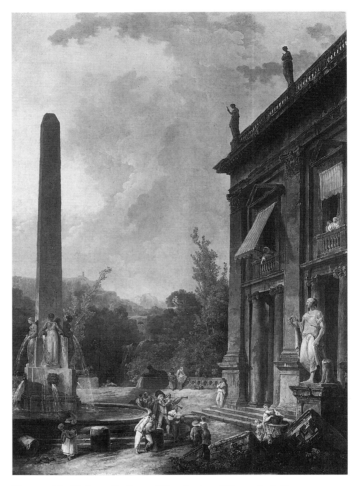

Figure 44. Hubert Robert, *Wandering Minstrels* (oil on canvas, 174.6 × 122.6 cm). New York, The Metropolitan Museum of Art, Gift of J. Pierpont Morgan, 1917. Photo: Photograph Services, The Metropolitan Museum of Art, New York, N.Y.

aqueduct in *The Fountain* (Fig. 41), and, in *The Mouth of a Cave* (Fig. 40), the grotto vaguely resembling the ancient tunnel carved through the hill between Pozzuoli and Naples – the cumulative impression of the Bagatelle ensemble is emphatically Italianate. Nonetheless, it is important to register that Hubert Robert consistently obscured cues identifying the imagery with a particular time and place. Just when we feel transported to a timeless Neapolitan coast, we notice that the two men in *The Swing* (Fig. 42) wear fashionable French morning clothes and hats, the *chapeau jockei*, of the 1780s. Classical character falls far short of antiquarianism in these pictures.

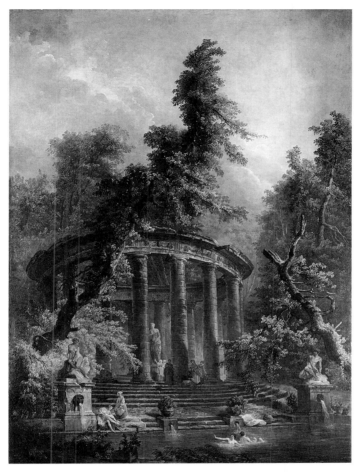

Figure 45. Hubert Robert, *The Bathing Pool* (oil on canvas, 174.6 × 123.8 cm). New York, The Metropolitan Museum of Art, Gift of J. Pierpont Morgan, 1917. Photo: Photograph Services, The Metropolitan Museum of Art, New York, N.Y.

Reading the Roberts

My exploration of how these pictures in the *salle de bains* may have been received by beholders in the 1780s builds on the work of Marian Hobson and Mary Sheriff. Clearly, the series constitutes an exemplar of what Hobson has termed "bimodal illusionism," an illusion apprehended simultaneously by the viewer as both fact and fiction.[30] Within the confined space of the *salle de bains*, the viewer is enveloped by an exquisitely fashioned sequence of mirrors and fictive openings to the outside – reflections and representations – all deployed around a huge framed window offering a "real" prospect of the garden outdoors (Fig. 39).

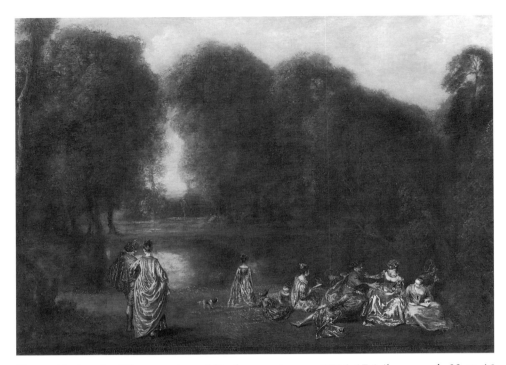

Figure 46. Antoine Watteau, *Assemblée dans un parc*, c. 1716–17 (oil on panel, 32 × 46 cm). Paris, Musée du Louvre. Photo: Art Resource.

Grounded in a dual awareness of surface and depth, bimodal illusionism is absolutely characteristic of the art we call "rococo." Because Robert's compositional formats are so stable – all are configured around strongly accented vertical masses forming a spatial "hole" for the eye to penetrate – the rococo qualities of his idiom are often overlooked. But *papillotage*, Hobson's term for the to-and-fro movement between compositional and thematic accents, is nonetheless a principle operating throughout this cycle. It is manifested in the series format, where the beholder's eye oscillates between separate panels, correlating content (such as water) and shapes (such as columns). *Papillotage* also describes the artist's handling of light and shadow and the facility of his brushwork. Beckford's metaphor for Robert's painting process – the artist was like a spider spinning a web – is brilliantly evocative of bimodal illusionism. Qualities of surface and the rents in the plane are both suggested at once. Robert's ornamental paintings in the *salle de bains* work as wall, plane, *and* window.

In her insightful analysis of the Louveciennes panels by Fragonard (1771–73), Sheriff argues convincingly that the logic of Fragonard's celebrated series does not depend upon an episodic concept of the "progress" of love, as the paintings have come to be known over time.[31] The dynamics of decoration she describes do not

aim to "tell a story," but to evoke certain associations within spectators that prompt them to fabricate a "story" of their own to explain the perceived relations between the canvases. Robert's Bagatelle panels resemble Fragonard's in this, only they are even *less* narrative and sequential than those of his old friend.

Robert's panels are formatted to be narrow and vertical. Within these compressed visual fields, diminutive figures are dwarfed by grandiose natural or architectural masses. Such formats militate against the detailed facial expressions and other attitudes of the human body needed to successfully communicate to the viewer narrative subjects drawn from history or other literary sources. Hubert Robert dispensed with the human figure as his primary means of expression, which he could afford to do with no loss of expressive power to his art. Amusing analogies, contrasts, juxtapositions, and parallels interested him more than did literary narratives. Rock formations, trees, water, architecture, and sculpture, and the codes of art history become his rhetorical devices.

The imagery Robert selected to ornament the *salle de bains* thus was far from meaningless because he used a variety of formal and iconographic strategies to set up parallels and oppositions for the knowledgeable viewer to enjoy.[32] The Temple of Love (Fig. 45) and the swing (Fig. 42), both overdetermined symbols of love in the eighteenth century,[33] suggest the purpose of the *salle de bains*. Serenaders (Fig. 44) and dancers (Fig. 43) introduce the courtship theme without belaboring it. The comparison was one of Robert's favorite expressive devices, especially the comparison between the ancients and the moderns. The marble faun (Fig. 42), the Flora (Fig. 44), and the Cnidian Venus of Modesty (Fig. 45), all attributed to Praxiteles in the eighteenth century,[34] can be compared with the modern masterpieces by Jean-Baptiste Pigalle (1714–85) mounted on each side of the temple in *The Bathing Pool* (Fig. 45), pendant sculptures representing Venus and Mercury.[35]

Likewise, in *The Bathing Pool* (Fig. 45), we are presented with an analogy between a bathing goddess (the Cnidian Venus) inside the temple and the modern "Venuses" who have tossed aside their garments on the steps to bathe in the pool.[36] The fictive pool, moreover, alludes to the bathing activities taking place within the real *salle de bains*. All of these jokes are related to the playful nature ("il faut donner du jeu") of the *salle de bains*.[37]

The significance of veiled imagery in the rococo decorative cycle has been studied by Sheriff in her analysis of Fragonard's art. As she puts it, "We call these erotic symbols covert because sexual allusion depended on the obvious fiction that what was being seen was not sexual in content."[38] What Sheriff calls the *double entendre* is surely at work in the *salle de bains*. The gourds and hats standing for male genitals in Boucher and Fragonard are configured here as obelisks (Fig. 44) and columns (Fig. 41), whereas the empty baskets signifying the female sex take the form of "the mouth of the cave" (Fig. 40). As Sheriff observes, the rationale

behind this veiling tactic is to set up the poles of licit and illicit viewing. On one level, the imagery Robert fabricated to decorate the *salle de bains* innocently recasts the subjects that Pliny and Vitruvius had indicated the ancient Romans had enjoyed picturing too – country houses, gardens, coastlines, and promontories.[39] On another, though, sexual puns proliferate. Getting the joke constituted the connoisseur's delight.

As a *petite maison* consecrated to "pleasure and liberty," the fine line between decorum and license was of central significance to the Bagatelle's decorators. Indecencies could not be permitted to intrude into the decor, for they would revolt the morals of the outsiders, "personnes de dehors," who came to visit.[40]

Voyeurism

In studying the figures of *The Bathing Pool* (Fig. 45), we become aware that no males appear in the image except the statue of Mercury. Venuses, however, as noted earlier, abound. Within the temple stands an antique sculpture of a Praxitelian Venus of Modesty, on the edge of the pool a modern sculpture of Venus by Jean-Baptiste Pigalle (the pendant of his *Mercury*), and in the water and on the steps, three flesh-and-blood Venuses perform their ablutions. Indeed, the Mercury of Pigalle's pendant is fastening his sandals to fetch another woman, Psyche, to the spot, in response to Venus's directive. The theme of the picture, then, appears to be women bathing under the sign of Venus, or Love, a felicitous invention given the nature of the space, strikingly concordant with the meanings ascribed to the *salle de bains* in a *petite maison*.

One of the most quoted images in eighteenth-century art appears in *The Bathing Pool*. It is the woman seated on the steps with crossed legs, one knee dramatically and suggestively foreshortened in the direction of the viewer. Hubert Robert borrowed the figure directly from the Larmessin print after François Boucher's *Le Fleuve Scamandre* (Salon of 1743; known only from the print; Fig. 47),[41] but the figure is found in Louis de Boullongne's *Diana and Her Companions* (1707), in Watteau's *Diana at the Bath* (c. 1715), and Boucher's *Nymphs Reposing from the Chase* (1745). The pose is reversed in Boucher's *Diana at the Bath* (1742) and Natoire's *Dorothea Surprised at Her Bath* (c. 1740s). Each of these pictures implies or actually includes a voyeur. Sometimes a figure in the picture plays this role, directing our gaze up along the raised leg of the seated figure, as we see in the Larmessin print (Fig. 47).

Voyeurism is markedly thematicized in Robert's representation (Fig. 45).[42] Three cleverly nested levels of voyeuristic activity are inscribed in the image, beginning with the bathing woman in the foreground gesturing with extended arm and upraised palm, a rhetorical posture alerting us to the possible presence of an intruder. The figure's arm and angled body direct our eye to the seated figure

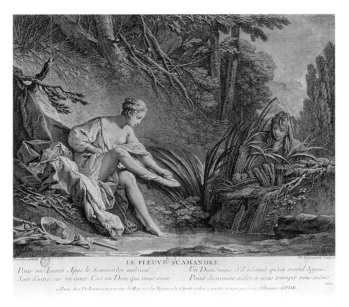

Figure 47. Print by Nicolas Larmessin (1684–1755) after François Boucher, *Le Fleuve Scamandre*, 1746. Paris, Bibliothèque Nationale. Photo: Bibliothèque Nationale de France.

taking off her clothes, a motif in any of its permutations grounded on a voyeuristic exchange between painted subject and viewer. The third example of the motif is the Praxitelian statue of Venus surprised at her bath, sheltered by the temple.[43] Distinctions between ancients and moderns, Robert jocularly implies, collapse when the subject involves a clandestine, furtive look at female nakedness.

Are these allusions directed to the discerning patron, as they were in the case of Madame Geoffrin? I think not. Artois rarely stayed at the Bagatelle. Indeed, as of 1780, some sources indicate, he had yet to inhabit his bedroom there.[44] A statement made by the baroness d'Oberkirch suggests that Parisians and tourists profited more from this exquisite park than did its owner, who "s'y promène rarement."[45] No matter. The primary purpose of the Bagatelle was not to shelter the prince, but to present a certain representation of him to the cultured and educated elites of Paris.

Representing Artois

If "the pen institutes itself as gaze," as Louis Marin writes,[46] then proof for my argument is furnished by a description of the Bagatelle that appeared in Bachaumont's *Mémoires secrets* on 26 May 1780.[47] The *Mémoires* epitomize a new form of expression emerging in the 1760s that presented readers with more substantive

material than the anecdotes and letters they had become accustomed to reading in the *nouvelles à la main*. Dena Goodman argues that "the readership of the *Mémoires* was the public that the philosophes had been shaping since the 1750s."[48] From this perspective, then, the following account provides an indication of the codes brought to a reading of the Bagatelle by an enlightened public.

The piece in the *Mémoires* begins by observing that the owner of the Bagatelle is away, thus providing an occasion for the reader to visit (via the pen) "this pretty fairy palace." "Seeing nothing at first; one enters the grounds through a small bit of unkempt wood . . . and reaches the chateau by a tortuous route."

The narrator is engaged in the game of successive penetrations. We see nothing at first, not even the road, but "finally" we find what we seek – the chateau. "One finds it finally and lifting one's head reads this motto *Parva sed apta*." A bit of text, then, frames this narrative voyage. The line from Aristo – small but convenient – left untranslated for the erudite readers of the *Mémoires*, poses the question: convenient for what? Our cicerone slyly points to the answer. "Six statues placed around the circular entry of the interior characterize the use of the building, Silence, Mystery, Folly, etc., and a Hercules, standing nearby, in his most shining avatar, appears to share with those figures dominion over this place."[49] Moving beyond text to symbol, our narrator provides an allegorical reading of the statues lining the foyer, linking them to the house's "usage." We are in a setting ruled by a Hercules, only this Hercules/Artois surrounds himself with silence, mystery, and sensual madness.

Continuing our tour of the ground floor, we move with the narrator into "a vestibule, a dining room, a salon, a boudoir, and a billiard room." Only the boudoir arrests our collective gaze. It "offers all kinds of voluptuous pictures painted by our modern masters, Greuze, Fragonard, Lagrenée, etc." Fragonard, in particular, is conjured up by the knowledgeable reader as the tour proceeds. The boudoir contains "a bed and mirrors all around that reflect from all angles the lovers' poses" just "like the boudoir in the pavillon du roi," our savant guide declares. Clearly, exhibited sexuality is power – regal power – and Artois is not the first to display it.

We are led up the spiral stairwell to the next floor and we step into the bedroom. "That of the prince, *which he has never slept in* [emphasis is mine], is truly remarkable." Literally no one has slept in the bed, so we are free to indulge in our wildest imaginings. Like everything else that we have experienced on this vicarious narrative tour, the bed stimulates our speculations.

"The bedchamber is in the form of a military tent."[50] (Striped tentlike cloth sheathed the walls and ceiling, expediently obviating the need for paneling.) "The pilasters of the room are shaped like weapons, the chimney jambs are formed into mock cannons, and the andirons into cannonballs." This conceit is not explained,

no doubt because readers of the *Mémoires* were in on the joke. Belanger had waggishly adapted a military motif for the bedroom, an allusion to Artois's title Grand maître de l'Artillerie. Such motifs, in addition, were invested with over-determined, leery innuendoes about amatory conquest.[51]

Our guide has taken us to Artois's very bed in an expedition of the imagination that affords special pleasures. We are told how servants are relegated to separate structures and meals delivered by dumb waiter so that "the profane" do not trouble the "mysteries of this place" with their presence. It is striking that despite the pro-*parlementaire* stance of the Bachaumont *Mémoires*, no criticism of Artois or his *petite maison* is expressed. The voyeuristic gaze does not condemn in this text; it admires. More significantly, it invites the reader to *share* the pleasures it describes.

Performing Artois

In a fascinating essay on Adam Smith's *The Theory of Moral Sentiments*, David Marshall explores Smith's notion of sympathy as an operative principle "in a world in which people face each other as spectators and spectacles." Adam Smith's is an interesting text to bring to an interpretation of the Bagatelle, because Smith's theory of sympathy, despite its being grounded in a rhetoric of performance usually associated with the court, was devised to operate in a brave new world of commercial capitalism. The problem Smith addresses in *The Theory of Moral Sentiments* is connected to the thematic of "luxury." What will mediate and order the claims of individuals who have suddenly been released by the Church to pursue their every whim and desire, Smith wonders? He contends that we will have to restrain ourselves: we will "suppose ourselves the spectators of our own behavior, and endeavour to imagine what effect it would, in this light, produce upon us. This is the only looking-glass by which we can, in some measure, with the eyes of other people, scrutinize the propriety of our conduct."[52]

In his analysis of Smith's concept of sympathy, Marshall emphasizes its theatrical dimensions: "We are actors not just because we appear before spectators played by ourselves, but also because we personate ourselves in different parts, persons, and characters. The self is theatricalized in its relation to others and in its self-conscious relation to itself."[53] It may be useful to think about this idea of sympathy in relation to French culture in the 1770s and 1780s. I do not mean to imply that the Bagatelle is about ethics, like Adam Smith's book. But I am attracted to the idea that an appeal is being made to the subjectivity of the reader/beholder to perform a role, a stratagem seen as particularly appropriate to men and women in commercial society and, by extension, perhaps intrinsic to a conceptualization of *la vie privée*. Katie Scott's argument about an "empower[d] spec-

tatorship" that developed in eighteenth-century France out of the proliferation of printed material dealing with art, both pictorial and textual, and offered for sale to an ever-increasing base of consumers is relevant to this issue.[54]

The experience of the Bagatelle, either as text in the *Mémoires secrets* or as spectacle procured by ticket entry or some other means, relates to this role playing. The visitor to the Bagatelle may take the parts of both the voyeur and the libertine. He or she may be both an active and a passive agent in the phantasmic space that the artists have constructed. Thiébault, who was in the habit of touring the Bagatelle with women who were first-time visitors, furnishes one example of this experience. He particularly enjoyed the women's embarrassment in the notorious boudoir, where, as he put it, in the midst of paintings "très peu orthodoxes," the mirrored enclosure provided a view up the skirts of the discomfited women, who vainly attempted to pull their dresses in at the ankles.[55] In other words, Thiébault actually seems to have tried to use this space to play the role of a libertine. Even after the Revolution, the Bagatelle is described as a spot for people to eat, drink, dance, "and especially get lost in the bushes."[56] (Is this perhaps a parallel to the "viewer response" prompted by Praxiteles's Cnidian Venus, said by Pliny to be so admirable that he had heard of a man who, having fallen in love with the statue, hid in the temple at night and embraced it intimately, so that "a stain bears witness to his lust?")[57]

Obviously, such interactions between works of art and their consumers did not regularly occur at the Salon exhibitions mounted by the Academy of Painting and Sculpture. In the Salon Carré of Louvre, paintings by different artists lined the walls four or five deep, stretching high overhead to the towering ceiling. In the Bagatelle's *salle de bains* all the pictures were by Robert, and they hung two to a wall in a room of diminutive proportions. Unlike the self-reflexivity of Salon paintings in the hermetically sealed installation of the Salon Carré, Robert's paintings of *enfilades* and antique temples gained resonance by inviting comparison with their three-dimensional counterparts glimpsed in the garden through the open window. ("One enjoys views and cleverly managed prospects out of each window," observed one visitor to the Bagatelle.)[58] At the Salon, the names of the artists, the artists' ranks within the Academy, the titles of artworks, and reviews by critics all mediated viewer response. In the Bagatelle, on the other hand, the Roberts were displayed in a territory controlled by the artist. Within these frontiers, the pictures seem to have encouraged a range of undisciplined (at least as measured by Diderot's norms) responses from spectators.

As a space, the *salle de bains* at the Bagatelle is reminiscent of the Vauxhalls constructed in Paris after the 1760s. These pleasure palaces were construed as "sites of self-celebration, of self-observation, even of self-creation, as opposed to the theatre of kingly recognition and acknowledgement that was Versailles."[59]

Vauxhalls provided courtly entertainment to anyone who could afford the entry fee; in this respect, they were not unlike the Bagatelle. After visiting the Bagatelle in 1787, one provincial visitor, François Cognel, travels across the boulevards to Vauxhall, the "rendez-vous des plus jolies filles de Paris." Like the Bagatelle experience, Vauxhall included a garden, albeit one deemed by our diarist to be "too small for the number of persons gathered together there." And like the octagonal salon in the Bagatelle pavilion, the salon at Vauxhall is proclaimed "very fine." Viewing protocols were ambiguous at Vauxhall, just as they were at the Bagatelle. Our young tourist from the provinces finds himself disconcerted by the Vauxhall's scantily clad women posed provocatively on swings. Cognel writes, "The play of the swing permitted many distracting licenses for the spectator," even though they could "be attributed to accidental causes." For him, the boundary between the swinging women as spectacles and the women as flesh-and-blood objects of sexual attraction become problematic; his consternation is expressed by the odd construction of his sentence.[60] Is he supposed to be a passive beholder at Vauxhall, or is he supposed to be an agent with the will to act?[61] The gap between these poles seems to be the same zone that Hubert Robert cultivated, but with a good deal more subtlety, in the decorative paintings that he produced for the *salle de bains* at the Bagatelle.

The Bagatelle, Taste and Luxe

In the 1780s, rumors about Artois's debts began to draw criticism from promoters of the "public good," but thanks to the artistry of Belanger, Blaikie, and Robert, the Bagatelle did not become a detested symbol of Bourbon profligacy. It deflected such cavils because it managed to be wildly extravagant without being ostentatious. The polemic against *luxe* was bound up in the display of things as status signs – number of servants, carriages, jewels, and wines. The charming park that surrounded the palace veiled Artois's magnificence, absorbed it, and ultimately naturalized it.

The chateau itself, moreover, was fashioned out of lowly plaster and wood, causing one observer to dismiss it as "too bourgeois."[62] But it was precisely this "bourgeois" quality that countered charges of *luxe*. As our young tourist from Nancy described it in 1787: "The decorations [of the Bagatelle] are only of plaster, but formed with the greatest art; the different chambers are small and simply furnished; a meticulous cleanliness (*propreté*) reigns throughout."[63]

Reinforcing the idiom of the "natural, clean and simple" were the equally positive connotations of antiquity brought to the whole by the chateau. The pavilion's overarching decorative syntax was classical. Belanger borrowed motifs from the publications of Piranesi for the fireplace mantles and for other decorative

details in the interior. Nicolas-François-Daniel Lhuillier's creamy stucco figures set against a pale dusky rose field on the inside walls of the circular salon convey an impression of delicate restraint and austerity.

Coming back to William Beckford's description of them, Robert's "classical" subjects played a crucial part in the impression of simplicity and antiquity evoked by the Bagatelle. Although the classicism emerging in France during the 1770s and 1780s had multiple roots, one of them was Madame Geoffrin's salon, for it was Caylus who had redirected antiquarian study to include works of art.[64] Furthermore, Caylus set the parameters of the inquiry as one interrogating expressions of taste. Ancient art in the form of the Barberini Faun (Fig. 42) or the Cnidian Venus (Fig. 45) was a certain means of parading "good taste."[65] The uses of antiquity in this iconography have everything to do with the distinction between *luxe* and art – negotiating between them is always "taste."

Chapter 5

Dining Amid the Ruins
Hubert Robert's Les Monuments de la France

IN THE SALON exhibition of 1787 Hubert Robert exhibited an ensemble of four paintings "representing the principal monuments of France." Number 46 bore the title *The Interior of the Temple of Diana at Nîmes* (Fig. 48). Number 47 offered an aggregate of famous monuments brought together into one visual field – the Maison Carré, the Arena, and the Magne Tower, all located at Nîmes, though not within sight of one another as they are shown in the picture (Fig. 49). Number 48 was likewise a *capriccio* representing the Commemorative Arch and Amphitheater of Orange juxtaposed with the Commemorative Arch and the Mausoleum from Saint Rémy-de-Provence (Fig. 50). The last painting, no. 49, featured a view of the Pont du Gard (Fig. 51).[1] These large paintings, approximately eight feet square, had been commissioned by the minister of fine arts, the comte d'Angiviller, to decorate a new dining room at the palace of Fontainebleau.

Analysis of this commission places certain stresses on the explanatory model that we have been using thus far. First, the patron here was the state, not an amateur. Second, the destination of the paintings was a king's palace, which surely resulted in atypical decorations keyed to special social practices. The space was, after all, a sociological zone connected to the court, a feature distinguishing it from nonroyal dining rooms decorated by Hubert Robert at the same time. On the other hand, within these parameters, the new dining room seems to have been designed to facilitate sociability rather than ceremony at court. At any rate, as with the Salle des États and the *salle de bains*, inquiry into this commission proves how careful we must be when we denote eighteenth-century spaces as either public or private. What we discover instead is a more nuanced dimension of "public" intersecting with the values of "la vie privée" in pre-Revolutionary France.

The formulation I want to pose is this: Why did d'Angiviller decide he wanted works like these for the new dining room?

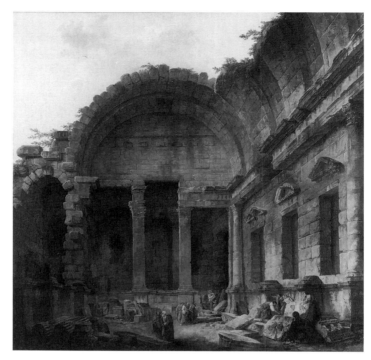

Figure 48. Hubert Robert, *Intérieur du Temple de Diane à Nîmes* (oil on canvas, 2 m. 42 × 2 m. 42). Paris, Musée du Louvre. Photo: Réunion des Musées Nationaux.

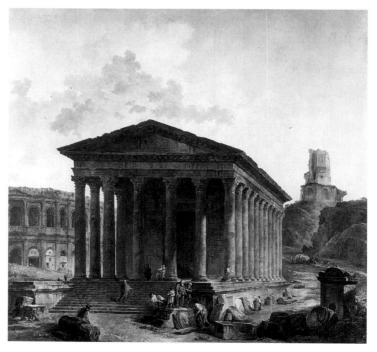

Figure 49. Hubert Robert, *La Maison Carré, les Arènes et la Tour Magne à Nîmes* (oil on canvas, 2 m. 43 × 2 m. 44). Paris, Musée du Louvre. Photo: Art Resource.

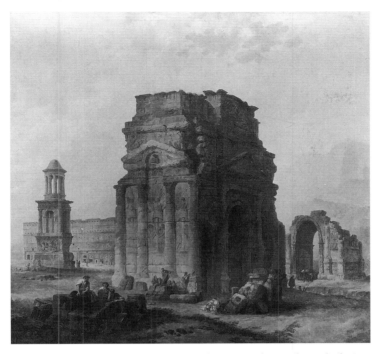

Figure 50. Hubert Robert, *L'Arc de Triomphe et l'amphithéâtre d'Orange*, 1787 (oil on canvas, 2 m. 42 × 2 m. 42). Signed "H. Robert 1787." Paris, Musée du Louvre. Photo: Art Resource.

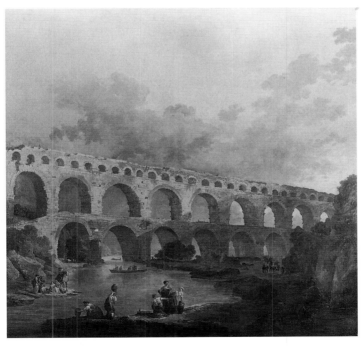

Figure 51. Hubert Robert, *Le Pont du Gard* (oil on canvas, 2 m. 42 × 2 m. 42). Paris, Musée du Louvre. Photo: Art Resource.

Who Chose the Subjects?

The subjects Robert painted for the Fontainebleau dining room were not new ones for the artist. Hubert Robert had painted them in the past. For example, in the Salon of 1785, he exhibited a set of pendants (no. 51 in the *livret*) contrasting the interior of the Temple of Diana with "the ruins of a long gallery, lit by an opening in the vault." But it was Robert's first offering, no. 49 in the 1785 exhibition, that no doubt caught d'Angiviller's eye, because these two pictures had been lent by Paul Petrovitch, grand duke of Russia, son of Catherine II. One of these enormous canvases – the size is given as eleven feet by eight feet – represented "the combination of the most celebrated antique Monuments of France (*le Réunion des plus célèbres Monumens antiques de la France*)," specifically, the Arena and the Maison Carré at Nîmes, the Pont du Gard, the Commemorative Arch and Mausoleum of Saint Rémy, and the triumphal Arch at Orange. This caprice was paired with a picture showing a fire in Rome as seen through the openings of a colonnade.

We infer that d'Angiviller admired these paintings and determined to commission a set of four like them for the king.[2] Uniqueness was not considered in awarding of the commission; rather d'Angiviller acted according to his own intentions. He appropriated imagery that Robert had already produced for the market.

Although it has been suggested that these pictures are related to a project advanced fourteen years earlier in which a cycle of representations showing antiquities in southern France were to form a pendant to the celebrated *Ports* of Joseph Vernet (see, e.g., Fig. 36),[3] evidence is wanting to support this hypothesis. Likewise, the link between the Roberts and the publication of Clérisseau's *Antiquités de La France* (1778) remains largely speculative.[4] Efforts to pin the Roberts to this tradition are fundamentally misguided, I believe, for Robert's Languedoc paintings are not created in the spirit of either topography or antiquarianism.

Capricci

It is important to register that the representations comprising the "Monuments de France" by Hubert Robert are not technically view paintings. Two of them, the compositions showing the Maison Carré (Fig. 49) and the Arch at Orange (Fig. 50), are actually *capricci*—inventions that bring together disparate monuments located some distance from one another into one pictorial field. Nor are *The Interior of Temple of Diana at Nîmes* (Fig. 48) and *The Pont du Gard* (Fig. 51) either genuinely archeological or genuinely topographical. Though they appear to resemble the edifices pictured in the *Antiquités de La France* published by Charles-Louis Clérisseau in 1778,[5] the depictions by Clérisseau and by Robert differ rather

dramatically. Clérisseau's renderings in this volume *are* archeological. His aim was to measure the monuments, to draw up accurate ground plans, and to describe them as completely as possible.

Robert's representations violate standards of topographical exactitude and accuracy on several counts. The splendid isolation of the majestic Maison Carré in Robert's canvas, for example, was the antithesis of its appearance in reality. The temple actually stood in the center of a square surrounded by modern buildings.[6] According to Millin, writing in 1806, one part of the structure was so covered with refuse that one might think the temple was dedicated to the goddess of the cesspool; he suggested it be protected by an iron fence and open only to tourists.[7]

Similar complaints were made about the state of the amphitheater at Nîmes. Claude-Marie Saugrain expressed his indignation in 1778 that "the aspect of such a rare piece is disturbed to the point it is by fifty or sixty ugly houses occupied by wool workers."[8] In the eighteenth century, one thousand Frenchmen lived in the amphitheater at Nîmes, wedged in cells at the base of the arena and about the enclosure.[9] Government efforts to remove them from the time of François I through Louis XVI met with obdurate resistance. Robert's rendering of the Roman amphitheater, shown on the left behind the Maison Carré (Fig. 49), includes its modern wooden doorways, a sign of contemporary habitation. Dilettantes and archeologists noted the intrusions and accretions of modern local culture on these structures with barely concealed disgust. In his commentary on Nîmes, Charles-Nicolas Cochin, for example, observed stoically that the amphitheater "is full of houses" and the chapel inside the Maison Carré "is pitiful."[10] Millin describes Orange as a small city with narrow, dark, dirty, and badly paved streets. Without its remarkable antiquities, he grumbles, one would hardly enter the city without wanting to leave it.[11] The negative remarks of such observers as Saugrain, Cochin, and Millin are not entirely erased by Robert's representations of the Languedoc monuments, but they are certainly neutralized.

All the edifices in Robert's ensemble, moreover, are conspicuously enlarged. For example, the rendering of the Temple of Diana at Nîmes (Fig. 48) depicts a towering structure on the order of the Basilica of Constantine; in fact, the dimensions of the Temple of Diana are approximately fifteen meters by ten. The illustration of the same site published by Ménard, though crudely rendered, is more true to scale (Fig. 52). Although the engraver in Ménard took a different vantage point, turning the temple to the left some ninety degrees, a comparison of the two images indicates how much Robert altered the dimensions of the edifice. He did so to make the ruin more imposing, which it emphatically was not in reality. After visiting it in the 1780s, one bewildered commentator, François de la Rochefoucauld, wondered why it was so celebrated: "One sees the beginning of several arches and one thinks one perceives where the sacrificial animals entered, the ramps for the priests, etc., and I, who am not such a connoisseur, I saw practically

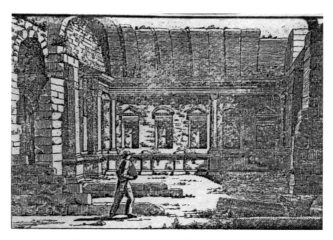

Figure 52. Illustration, *Intérieur de Temple de Diane*, from Léon Ménard, *Histoire des antiquités de la ville de Nismes et de ses environs* (Nismes: l'Éditeur, 1829). Photo: author.

nothing there at all."[12] Rochefoucauld's honest, if somewhat chagrined, assessment of the *Temple of Diana* helps us understand the play between fact and fiction at the heart of Hubert Robert's representational strategies.

Grandeur and monumentality consistently take precedence over the dictates of mimesis and its handmaiden, linear perspective, in Hubert Robert's compositions. The constant harping of critics about the faulty perspective in Robert's paintings does target a critical issue in his artwork. To paint substantive figures displaces attention from the grandeur of the buildings, just as to render the structures in dry, two-point perspective trivializes them.[13] Robert chose to maintain the impact of the architectural volumes by amplification. Measured against the actual size of the Temple of Diana, Robert's human beings must be Lilliputians. Applying the lessons he had gleaned from Piranesi, Robert enlivened his pictures with miniscule human figures to exaggerate the monumentality of the structures. One looks closely and sees scores of tiny, antlike human beings on the upper edge of the Pont du Gard (Fig. 51). To evoke in the beholder wonder rather than reason was Robert's aim. His representations were designed to transgress the bounds of common sense.

A critic used that locution in 1785, in response to one of Robert's caprices exhibited at the Salon that year. He was frankly dismayed by the displayed picture's "revolting strangeness," which assembled within the frame "disparate structures that never existed together," thus transgressing the standards of "good taste" and "good sense."[14] What the reviewer labeled transgressions were there for a purpose, though. Quite simply, they acted as an index to the artist's invention, a matter of more than passing significance in an artistic climate that defined value

increasingly by reference to the supposed primacy of history painting. According to the logic behind this claim, one that d'Angiviller was instrumental in promoting, historical imagery exercised the painter's faculty of invention more than did any other type of subject matter. Applying this idea to architectural subjects, it is obvious how invention and imagination distinguish the *capriccio* from the topographical view, its less exalted relative lodged at the bottom end of that scale still known as the hierarchy of genres.[15]

The Space: The New Dining Room at Fontainebleau

Under Louis XVI, as under previous French kings, the court periodically abandoned Versailles during specific times of the year to hunt and to pursue diverse pleasures and entertainments at different royal châteaux. The annual sojourn at Fontainebleau was among the most popular of these visits because of its splendid theatrical performances and high-stakes gambling. "Everyone knows," recalled the countess de Boigne, "that nowhere did the court of France shine more magnificently than at Fontainebleau."[16] Fontainebleau, however, although one of the oldest and most venerable of the royal palaces, lacked many of the comforts to which the royal family had become accustomed. Accordingly, in 1785, the king decided to add a two-story wing to the palace, doubling the space from the Galerie François I toward the Jardin de Diane. The extension would contain the new *petits appartements* for Louis XVI and his family. One of these chambers, according to the express wishes of the king, was to be a *salle à manger*. Louis XVI relayed his wishes to the contrôleur des Bâtiments du château, who began work on the foundations as soon as the court departed at the end of the 1785 visit. Louis also had some thoughts about the interior decoration of the new chambers. Three of the interiors should be gilded and decorated to resemble the other private rooms in the wing. The others, though, should be white (*mais tout le rest en blanc*).[17] In May 1786, the contrôleur of the palace reiterated this directive: the king wished to have no gilding in the rooms except on the mirror frames.

The new dining chamber, located on the ground floor, was a rectangular space oriented to provide window openings at both its north and south ends. In the ground plan from November 1785, it appears as the second chamber on the left, the only room extending two widths within the new wing (Fig. 53). Adjoining it on the west was a room designated as the *pièce de buffet*, and on the east, two game rooms, a *salon de jeux* and a *salon de billiard*. A dining chamber like this one in a royal palace was a novel architectural phenomenon in the eighteenth century, a response to a new social practice, the *petit souper*, or the "souper dans les cabinets," as the countess de Boigne termed it.

The *petit souper* took its characteristic form during the reign of Louis XV when that monarch began to host intimate dinners in the private apartments of

Figure 53. Ground plan of the new wing (ground floor) at Fontainebleau, November 1785. Paris, Arch.nat. 0¹437,72. Photo: author.

Versailles. In the newly remodeled *salles à manger* in the Cabinets du Roi, adorned with Lancret's *La Partie de Plaisirs* (Fig. 7), guests of both sexes were invited to sit in no particular order at the same table with the king, an unprecedented breach of court etiquette. (Louis XIV had never dined with his subjects except in circumstances involving the military.)[18] The *petit souper* differed in other significant respects from formal dining. Whereas at a conventional formal dinner, guests would be attended by their own liveried servants stationed behind their chairs to fetch food and drink for them, rather as Lancret pictures it in *La Partie de Plaisirs* (Fig. 7), at a *petit souper* guests left their own servants at home, and the number of domestics utilized by the host was severely reduced. In fact, at a *petit souper*, the king performed some servants' tasks himself, such as warming and pouring his own coffee.

Relative intimacy and informality, then, were the marks of a *petit souper*. The countess de Boigne remembered these intimate suppers in Louis XVI's private apartments as cramped and casual by necessity. The chambers were so small that a billiard table was converted into a buffet by virtue of some planks, and the monarch was forced to expedite his actions ("sa part") to make room for the meal.[19] The countess's description suggests why the king specifically requested a dining chamber in the new wing of private apartments at Fontainebleau. Furthermore, the customs and habits attached to its use, which emphasized sociability over court ceremonial, put Louis's admonishments about the decorations – no gilding, white walls – into perspective. Magnificence, in its old pre-encyclopedic form, was definitely *démodé*, even in royal palaces.

D'Angiviller as Patron

Hubert Robert's taskmaster for the Fontainebleau pictures was the sober, diligent bureaucrat who headed the Ministry of Fine Arts, Charles-Joseph Flahaut de La Billarderie, comte d'Angiviller. A greater contrast to the circumstances of the Bagatelle commission can hardly be imagined. Although the titular patron of that pictorial cycle had been Artois, the king's brother, Robert's actual supervisor at the Bagatelle was François-Joseph Belanger. Belanger's irreverence resonates throughout the entire Bagatelle project, and it echoes in the pictures Robert painted for the *salle de bains*. Belanger's idea of humor, after all, was to install a contraption in his mistress's chimney that could cause her sculpted portrait on the mantelpiece to mysteriously disappear and be replaced by a great winged Priapus.[20] In the Fontainebleau commission, however, Robert's employer had a temperament of a dramatically different cast.

D'Angiviller took his duties and loyalties to the crown seriously, but he was no reactionary. On the contrary, he attended the salons of Madame Geoffrin and Madame de Marchais, whom he was eventually to marry, and formed firm friendships with *philosophes* such as Turgot. Not surprisingly, he shared with encylopedists such as Diderot the conception of public art discussed in Chapter 1. The Enlightenment *parti* was committed to an art that preached virtue. Unlike the encyclopedists, though, D'Angiviller believed that the content of edifying public art should be tightly controlled by the crown and used to promote the interests of the monarchy, a position most of the *philosophes* opposed. The *philosophes* had their own notion of "public" as an oppositional sphere from which to criticize, rather than to sustain, existing authority.

By illustrating exemplary ethical acts or by picturing persons who symbolized them, good public art, according to the reasoning of both the minister and the encyclopedists, would provide the populace with moral instruction. Accordingly, when d'Angiviller took over the administration of Bâtiments in 1775, he nurtured public taste by commissioning for the crown subjects depicting inspiring acts from French national history or from classical antiquity.[21] As a result, comparatively few projects of an ornamental nature were underwritten by the crown under his administration. The decorative commissions that had dominated the patronage dispensed by Marigny were replaced by easel paintings representing Cimon or Portia (1777), Bayard or Patroclus (1781).[22]

Under Louis XV, in contrast, Nicolas Lancret and Jean-François de Troy had produced decorations (1735) for the dining chamber in the *petits appartements* of Versailles that burst with signs of privilege and *luxe*.[23] For example, it was for this chamber that Lancret had painted a circle of boisterous aristocrats in deshabillé gathered around a table in a park and feasting upon ham and wine (see Fig.

7 for the print by Moitte after Lancret's picture). In the picture, an overturned chair, broken dishware, and a multitude of empty wine bottles suggestively litter the foreground. The privileged in Lancret's rendering are well fed and well served, but not well behaved. de Troy's pendant, to cite another example, featured "a magnificently decorated chamber" in which several noblemen, again attended by numerous servants, dined heartily on oysters.[24] No doubt it pleased Louis XV to contemplate these images of sociability during his own reputedly lively private *soupers* in the new dining room. From the perspective of subsequent Enlightenment reformers, however, such portrayals of aristocratic *dîners* contained little to excite admiration. On the contrary, the obvious dissipation of Lancret's figures, in particular, was proof positive of the debilitating effects of a social system grounded in privilege.

The debased consumption of food and drink rendered with such evident gusto by Lancret and de Troy was transformed under Marigny's administration into a more respectable allegorical variant. For the dining chamber in the new Petit Trianon in 1768, Cochin proposed an ensemble of four subjects divided among four different artists – Doyen, Vien, La Grenée, and Hallé – combining seasonal imagery with pagan gods and goddesses.[25]

A different *mode* was desired, evidently, in the 1780s. And we are reminded that "the Robert look" was the height of fashion. Still, the Robert commission, falling outside historical narrative, represents a rather surprising departure from the principles governing D'Angiviller's program of public art.[26] Moreover, exempting state portraits, the price the *surintendant* set on Robert's four panels was exceeded by only two other examples of royal patronage during his administration.[27] Relatively speaking, the crown offered to pay handsomely for Robert's ornamental ensemble.

"Une intention historique . . ."

Whether at his own initiative or to please the bias of his patron, Hubert Robert produced images for the Fontainebleau commission that more closely approximate the norms of history painting than did the others we have examined. In a letter to d'Angiviller dated 11 May 1787, Jean-Baptiste-Marie Pierre, director of the Academy, reports to the minister that he has seen Robert working on the paintings for Fontainebleau and found "the figures with which he is enriching them made with more care than artists of genre (*les artistes de genre*) ordinarily do."

Pierre offers a sophisticated discussion of the problems faced by the architectural painter when figures are introduced into the composition. In this type of painting, Pierre explains to d'Angiviller, figures set the scale for the architecture and the grandeur of the setting. Consequently, it is difficult to admit additional figures of "a historical intention, a subject, because such figures must measure at

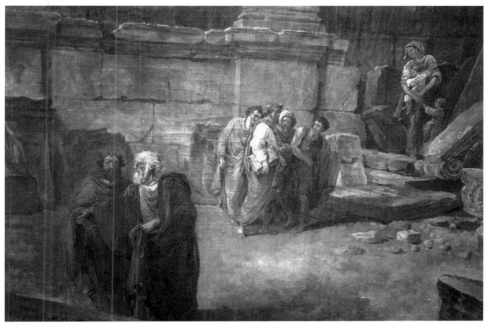

Figure 54. Hubert Robert, Detail of *Intérieur du Temple de Diane à Nîmes*. Photo: author.

least twenty inches in the foreground, instead of seven or eight, in order to sort out from there (*afin d'y démêler*) some expression." And when they do, Pierre concludes ruefully, the grandeur of the monument is diminished.[28] Architectural painting, in other words, cannot sustain a historical subject and a grandeur of form simultaneously.

One might suppose from this letter that d'Angiviller had asked the artist to fashion figures of "a historical intention" for the Fontainebleau commission. This may explain the unusual staffage in two of the pictures. In an earlier painting (1771) depicting the interior of the Temple of Diana (now in the Phillips Family Collection), Robert was content to feature figures in modern dress.[29] In the Fontainebleau picture of the same temple interior, on the other hand, he painted a young man in toga accompanied by a group of deferential figures sweeping into the ruined vaulted interior; other draped figures are pictured scrutinizing fragmented sculptural reliefs in the foreground (Fig. 54). Among them is a commanding elderly man with white hair and beard. A number of these figures seem to quote motifs from Raphael and Poussin. The group of four in the middle ground of Robert's temple interior resembles Raphael's four-person cluster to the far left of the *Parnassus* in the Stanza della Segnatura or Poussin's variation on the motif, also to the far left, in his *Apollo and the Muses on Parnassus* (Prado, Madrid). Perhaps Robert has quoted from the Old Masters here so that these figures could

not be criticized for looking too "French," as his figures sometimes were by hostile reviewers.[30]

In Figure 49, the bearded elderly man is again included within the composition, only now he appears about to be cast off with only a single servant (Fig. 55). The staffage in this painting is enigmatic. Robert positions the figures in a configuration that suggests a narrative, but then he withholds the key we need to comprehend the story. The old man stands inexplicably on a fallen block of marble along with two other figures, a young servant with a staff and a turbaned character who points derisively at him and seems about to lead him away. The humped shoulders and downcast head of the elderly man seem to express disgrace and humiliation, an impression strengthened by three passing townspeople who visibly recoil from his presence. On the left, an important-looking man mounts the steps of the temple, gesturing rhetorically. Indeed, many figures in this painting point, and most of them angle our attention back to the dejected Belisarius-like character making his exit from center stage.

Belisarius, the courageous general unjustly accused of plotting against his leader, is a subject belonging to the discourse of "public art" (discussed in Chapter 1).[31] With Socrates, he epitomized eighteenth-century ideals of ancient virtue and devotion to the state. Celebrated representations of Socrates by Jacques-Louis David and Jean-François-Pierre Peyron appeared in this Salon, the Salon of 1787, attracting a good deal of critical notice.

Pannini

The role of the figures is less pronounced in the other two Fontainebleau paintings. In the picture representing the Arch at Orange (Fig. 50), the figures wear tunics, mantles, and Roman-looking helmets, but our eye simply scans them, moving swiftly to the obliquely positioned triumphal arch instead, perhaps because the figures in the foreground are rendered in such passive poses. The group of three male figures, in particular, resembles staffage characteristic of works by Giovanni Paolo Pannini.

Alexandre Paillet, an art dealer who knew Robert well, wrote that Hubert Robert considered Pannini to be the supreme master of ruin painting.[32] As proof of this high regard, Robert, over the years, acquired twenty-five pictures by the Italian master – pictures, according to Paillet, that Robert regarded as the source of his own education (*le trésor de ses études*), and after "la Nature," the secret of his success. Certainly, a number of Robert's most significant pictorial ideas derive from the Italian master. Pannini, for example, had popularized the conceit of pitting the ancients against the moderns. He had painted two of his most famous pictures in this vein in the 1750s for the duke of Choiseul – *Imaginary Gallery of Ancient Roman Art* and *Picture Gallery with Views of Modern Rome*

Figure 55. Hubert Robert, Detail of *La Maison Carré, les Arènes et la Tour Magne à Nîmes.* Photo: author.

(Fig. 56). These paintings were so widely admired that the artist repeated them, with minor variations, three times. Robert owned one set of these.[33] (In the 1789 Salon, Robert adapted this format with his *Monuments de la France* series, pairing a picture of the antique sites in Languedoc with a painting representing a selection of edifices from modern Paris.) Pannini had also been an extremely visible practitioner of the architectural caprice, and Robert owned several of these as well. Nonetheless, although we see evidence of Robert's dependence on the iconography of the Italian painter's displayed *enfilades*, fountains, and statues shown "postcard style" on the walls of the gallery (cf., e.g., details of Fig. 56 to Figs. 41 and 44), Robert's caprices look different from those created by Pannini.

Paillet describes Robert's emulation of Pannini as if it were a crescendo building up to an overpowering force. He claims that the young Robert passed from the stage of admiring the older master, to that of wanting to equal him, and finally, to that of rivaling him.[34] I suspect that having reached the last triumphant stage, when the pupil rivals the master, had something to do with Robert's calibration of the figures to the architecture – the issue raised by Pierre and discussed earlier. Paillet comments that in two of the lots by Pannini he is selling, the figures measure ten to twelve inches. By Pierre's criteria, such figures had entered a kind of danger zone.[35] Their effect on the architecture is what concerns us here, for their assertiveness threatened to weaken other parts of the composition. Figures

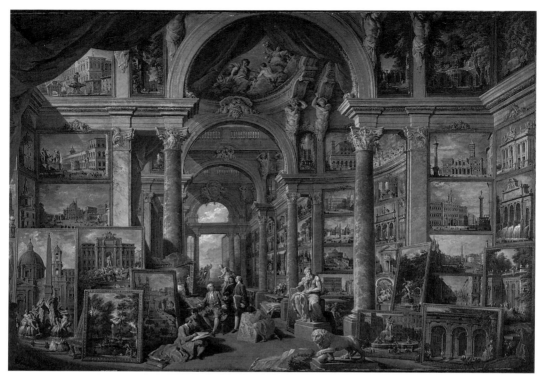

Figure 56. Giovanni Paolo Pannini, *Picture Gallery with Views of Modern Rome*, 1757 (oil on canvas, 170 × 244.5 cm). Boston, Museum of Fine Arts. Charles Potter King Fund. Photo: Museum of Fine Arts, Boston.

of a historical intention, as Pierre had perceived, diminished the grandeur of the monuments. Pannini's works often do seem to lack the dramatic focus and unity that Pierre took as normative for architectural subjects.

Hubert Robert's compositions (see, e.g., Fig. 67, which is structured like Fig. 56) almost always impress by a certain "largeness" of concept and form. Moreover, his compositions, in contrast to those of Pannini, are infused with abstracted patterns of chiaroscuro laid over broad, undifferentiated expanses of color – a stylistic that belonged neither to Pannini nor to the practices of the history painters associated with the genre in the 1770s and 1780s.[36] Indeed, for evidence that Robert did become the internationally famed rival of Pannini, Paillet points to two of the Fontainebleau pictures, the representation of the Maison Carré (Fig. 49) and the Arch at Orange (Fig. 50). What Paillet singles out as uniquely noteworthy about them in the context of Pannini is their "rich color" and "exquisite taste." He refers to *The Maison Carré* (Fig. 49) as a representation of "the magnificent monument of the Maison Carré."[37] Although Robert does not invariably configure his ancient ruins to evoke awe in the beholder (the Bagatelle's *Bathing*

Pool does not, e.g. in Fig. 45), the pictures in the *Monuments de France* ensemble surely do, in a way that a Pannini is rarely able to match.

Much of the effect of the *Monuments* paintings depends on the way their figures are handled in relation to the architecture. Robert set up a relation that placed the paintings tantalizingly on the threshold of "une intention historique, un sujet," but not quite there. From their position in the foreground, the staffage does "sort out" into a number of expressive signs – signs, but no narrative subject (Figs. 54 and Fig. 55). Robert negotiated a powerful expressive balance between "figures of a historical intention" and the formidable grandeur and amplitude of the ancient monuments he represented. Perhaps "balance" is too strong a term, for the real focus in these representations remains the monuments.

Monuments

The word "monument," as Keith Michael Baker has shown, had special resonance in pre-Revolutionary France. A monument was defined as an important historical record. The word's etymology comes from the Latin "momentum," to recall to us the memory of something.[38] In the *Mémoires secrets*, Moufle d'Angerville used the word in this sense when he observed that the announcement of the summons to an Assembly of Notables had prompted the magistrates to comb the registers and consult "les monuments de l'histoire" for "anything relative to the nature of assemblies like the one that has been called."[39]

As this remark indicates, in pre-Revolutionary France the past was a contested story. Competing political factions, particularly the crown and the parlements, proposed different accounts of history as the basis of their claims to authority. As one might expect, the crown's brief – its version of the past – proved to be the one most pertinent to the imagery of the *Monuments de France* as painted by Robert in 1787.

During the second half of the eighteenth century, monarchical apologists promulgated a Romanist, as opposed to a parlementary Frankish, or "Germanist," interpretation of the nation's origin.[40] Their history of France maintained that the Franks were essentially savages before coming into contact with the Romans. It was from the Romans that they acquired "civilization." As one of the most prominent of these historians, Jacob-Nicolas Moreau, explained, the barbaric Franks, lacking indigenous political institutions, found in Romanized Gaul "an admirable apparatus in place," and Clovis simply appropriated the systems established by the Romans "and regarded himself as their successor."[41] In this account, a highly significant continuity exists between the French monarchy and the imperial rule of the Caesars.[42] Furthermore, in this version of French history, a political role is denied to the tradition of Frankish tribal councils, a source of authority claimed by the parlements.

The ancient Roman triumphal arches and temples dotting the area around Orange and Nîmes represented a past that legitimated Bourbon absolutism. One monument in particular had acquired an even more specific political connotation. This was the Maison Carré (Fig. 49), widely regarded in the eighteenth century as the most perfect example of Roman architecture in the world. Arthur Young, usually reticent in his esthetic judgments, deemed it beyond all comparison "the most light, elegant, and pleasing building" he had ever beheld.[43] François de la Rochefoucauld, who was unimpressed by the Temple of Diana, adored the Maison Carré. He added that Mansart had learned the rules of his art by studying this building.[44] Thomas Jefferson used the structure as the model for the state capitol in Richmond, because it was "one of the most beautiful, if not the most beautiful and precious morsel of architecture left us by antiquity" and, consequently, would present "to travelers a specimen of taste in our infancy, promising much for our maturer age."[45]

Jefferson was not alone in imputing political and, ultimately, moral significance to the Maison Carré. Perhaps he was aware of the widespread tradition identifying the monument as an ancient state house or "capitol."[46] For centuries, the Maison Carré had been referred to by the people of Nîmes as the "capitole." As late as 1765, civic officials proudly maintained that in the eleventh or twelfth century the edifice had served as its city hall. To these individuals, the Maison Carré communicated beauty, certainly, but also connotations of the integrity and moral rectitude that they associated with a self-governing nation. An appropriate symbol for the infancy of a new state like the democracy forming across the Atlantic, the Maison Carré was equally meaningful as an expression of a rejuvenated monarchy. This latter thesis received reinforcement from antiquarian research in the eighteenth century. An inscription running across the architrave, part of which is duplicated in Robert's painting ("C.CAESARI AUGUSTI . . ."), had been deciphered in 1759, dating the temple to the time of Augustus.[47] Thus, for Robert and other knowledgeable antiquarians, the Maison Carré stood for Augustan Rome, not the Republic, and brought to mind the ancient glories of an effective monarchical system of government.[48]

On the level of political iconography, then, these monuments expressed the idea that the Bourbon monarchy was a repository for the heritage of ancient Rome. Significantly, the Salon *livret* calls them *monumens* (sic) *de la France*. Such a theme is entirely consistent with d'Angiviller's program of having edifying public art serve the state. Robert's paintings were hung in the dining chamber at Fontainebleau after they were exhibited at the Salon in September-October, but it is doubtful Louis XVI ever supped "Amid the Ruins." As a cost-saving measure, the king decided in October 1787 to suspend the annual peregrination to Fontainebleau.[49] The palace was closed down.

Luxe *and the King*

> A courtier inquired, some days ago, of a person coming from Paris: "What are
> the frogs saying?" – "They no longer invoke Jupiter, responded the interlocutor,
> they sing like quail." This pun, a bit tired around the ears, makes allusion to a
> fable of la Fontaine, where the frogs ask for a king, and to a popular punning
> riddle in which the song of the quail seems to say: *Pay your debts.*
>
> > (17 October 1786)[50]

As the political ditty just cited indicates, by 1786 the revenues and expenditures
of the king had become a matter of consuming topical interest to the educated
elites of the realm. We cannot speculate about why d'Angiviller wanted Roberts
such as the *Monuments de la France* for the new dining chamber without taking
this into account. Imputations of *luxe*, directed now toward the royal house, be-
came more overt in the charged political atmosphere following the Assembly of
Notables. Committed to the remodeling of the apartments, d'Angiviller still
needed to show that he had not indulged in wasteful expenditures that could be
deemed "revolting opulence," or *faste*. Symbolic politics called for the impression
of austerity. I do not mean to push this argument too far, but I believe this context
helps explain why these pictures look the way they do.

As he worked on the paintings in 1787, Robert had to imagine the king dining
with thirty or so favored courtiers amid the painted ruins. If the king is seen as
speaking through the language of ornament, then Robert gave him a sober and
severe script to perform. The chord these images sound is not a festive one. Like
the Rouen panels, the pictures in this space were extremely aggressive, for the
dry, chalky, ochre surfaces and angular contours of the objects in the paintings
were in stark contrast to the smooth, rectilinear expanse of the chamber's white
walls.[51]

Because the rectangular *salle à manger* (Fig. 53) was bound by two unbroken
surfaces on the long sides, Robert's four canvases must have been placed in pairs
along these walls.[52] How the pairs were arranged is not known. But, as is generally
true for Robert's ensembles, a logic governs the series. The four pictures divide
naturally into pairs: two views (Fig. 48 and Fig. 51) and two caprices (Fig. 49
and Fig. 50). In each pair the visibly decaying is pitted against the enduring.[53]
Thus the decrepit Temple of Diana (Fig. 48) complements the still-serviceable Pont
du Gard (Fig. 51) and the crumbling Arch at Orange (Fig. 50) confronts the
miraculously intact Maison Carré (Fig. 49).

Although the colors in the paintings contrast with the white wall, the shapes
in the paintings harmonize with it.[54] Like the exquisite marquetry patterns fash-
ioned by craftsmen at the time, the abstract compositional geometry of Robert's
straight lines and semicircles intercalates smoothly into the architectonic order of

a room panelled in Louis XVI style. One reason that geometric forms play such a pronounced role in Robert's decorative ensembles is their ability to insinuate themselves so smoothly into the architecture of the room.

The decorative unity of this chamber would have been very tight indeed. The *Monuments de la France*, created by Hubert Robert, succeeds brilliantly as ornament that conveys magnificence without *luxe*, grandeur without ceremony.

Sequel

Hubert Robert demonstrated in his paintings his *adresse* and invention. As he did for the ensembles he produced for the *archevêché* and the Bagatelle, the artist arguably chose "from among the thoughts that present themselves, those that are the most appropriate to the subject that one treats." Certainly, he considered the needs of his audience and the use of the site that his pictures would ornament. But what of the third component of "invention" examined in Chapter 1? Has the artist balanced "what one owes to one's audience" with "what one owes to oneself"?

In other words, to what extent can we track the sentiments of Hubert Robert toward the king and the court in these images? Although the *Monuments de la France* are reticent in this regard, appropriately so given their context, I think we can draw some inferences from other representations that Robert produced. Before examining this question, however, we must reject a crude equivalence between the artist and his patrons. That Robert created the Bagatelle representations for the comte d'Artois does not mean he was a royalist. Jacques-Louis David, to cite one example, painted his *Paris and Helen* (1789) for Artois too, and David was no royalist. Likewise, David produced *The Oath of the Horati* (1785) under commission from d'Angiviller, just as Robert configured the *Monuments de France* ensemble. Yet from this evidence we do not suppose any particular allegiance of David to the political values d'Angiviller represents – on the contrary.

In the context of this question, one small but significant painted motif merits another look, for it is a detail that points in the direction of the program put forward by the reformist contributors to the *Encyclopédie*. This detail is in Robert's *View of Dieppe* (Fig. 37), where he represents, in most emphatic terms, the class divisions of French society in the 1770s. In the picture, on the road, Robert has painted a noble on a hunt, a faggot gatherer with a child, and a horseman dressed in somber clothes. Here are the references to privilege – to inequality – that provide the sharp edge to a discourse on equality. Tensions between classes and the need to ameliorate them (though not necessarily to eradicate them) was a common theme among reformers like Anne Robert Jacques Turgot (1727–81) in the 1770s. Robert need not have painted these particular figures, but he did,

and in so doing, gestured pictorially to a crippling structural problem of French society, a problem regarded as pivotal on the reformist agenda.

In 1789 Robert painted a set of pendants that I interpret as further support of these sympathies. In the Salon of 1789, the artist exhibited "two sketches after nature: one . . . a view taken on the river, under one of the arches of the Pont Royal, during the time of the great frost of the previous winter; and the other . . . the Bastille in the first days of its demolitions."[55] The picture of the Bastille is almost certainly the canvas in the Musée Carnavalet (Fig. 57);[56] the pendant's whereabouts are not known.

The designation of the pictures in the Salon catalogue as sketches suggests that Robert planned to enlarge and refine the images once he had found a patron.[57] To call the pendants "sketches," furthermore, underlines their topicality. Sketches are associated with the rapid transcription of the real. Thus to present the Bastille in the form of a sketch accentuates the freshness—the startling novelty—of the event. At the time of the 1789 Salon, only a few brief but tumultuous months had passed since July 20, the date Robert inscribed on a boulder next to his name on the painting. Two representations of the Bastille by other artists also appeared in the exhibition, but these painters rendered it as a background for portrait subjects. Nonetheless Salon critics ignored Robert's picture, perhaps because they lacked a paradigm to discuss such a manifestly political image falling outside the conventional hierarchy of genres.[58]

A logic lies behind the yoking of the Bastille being demolished to the Seine engulfed by frost that critics continue to overlook, although Jean Starobinski recognized it at work in certain texts from the period. Starobinski observed that the various natural catastrophes of 1788–89, such as the freak hailstorm and freezing of the river, acquired portentous meaning for Parisians in the wake of July 1789. They connected these disastrous meteorological events with the bankruptcy of the state and the ensuing political crisis.[59]

Starobinski's thesis is supported by these paired representations. Hubert Robert's overarching metaphor is one of repression and release. Paralysis, thematized in the "view of the river . . . during the great frost of the previous winter" is a consequence of the icy hand of an unusually severe storm gripping the Seine, transforming flux into staticity. Release is expressed by the destruction of the Bastille, the most hated symbol of repression in France, brick by brick, course by course, by legions of Parisians. Nothing could be more typical of Robert's means of expression than such a joining of visual metaphors, in which the meaning of one depends on comparison and contrast with the other. Because the 1789 pendants were undertaken at his own initiative, Robert could use his invention to make a personal statement, allowing what he owed "to himself" to supersede what he owed to his audience. By formulating these two "storms" as parallel,

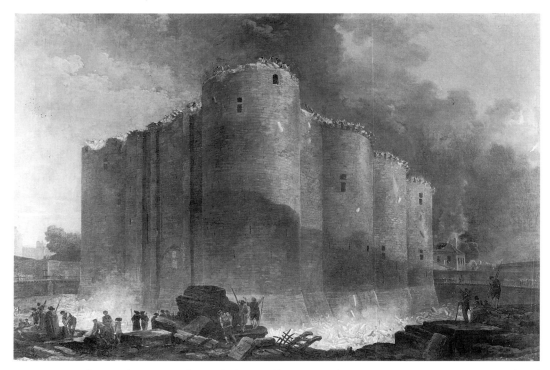

Figure 57. Hubert Robert, *Démolition de la Bastille*, 1789 (oil on canvas, 77 × 114 cm). Signed and dated "20 juillet 1789, H. Robert pinxit." Paris, Musée Carnavalet. Photo: Art Resource.

Robert indicated far more clearly his views regarding the need to reform the French state than he did in the *Monuments de la France* series. Such a pairing implies that both the workings of nature and those of the political order respect the same laws. It follows, then, that change, even violent political action, is "natural" and, in fact, inevitable. This pictorial formulation posits a reassuring view of the events taking place in 1787–89 – a view that Robert would not sustain during the ensuing decade of the 1790s.

In 1789, however, Hubert Robert was, I believe, a partisan of change and reform. Sébastien Mercier, a writer whose texts I bring to a reading of certain Roberts produced in the 1790s, was such a partisan as well. And Mercier and Robert share another feature too: both men were arrested and imprisoned during the Revolution.

Epilogue

Hubert Robert and the Revolution

The words "before the Revolution" now evoke a kind of nostalgia, like childhood memories. We were all children then, playing our philosophical games in a world that seemed destined to go on forever! since then we have become wiser and sadder. I have not lost faith; I believe that the deeds and words of these six years will echo down through the centuries to come, overturning vast empires, changing the life of all the peoples of the earth.

Restif de la Bretonne, Winter 1794

Summary and Introduction

In the opening pages of this book I discussed the need for a new critical apparatus to bring to a reading of the artwork of Hubert Robert. I proposed to develop a line of inquiry focused on the relation of commissioned ensembles painted by the artist to their setting. Although "setting" seems to be a simple, uncomplicated premise, it proved to be freighted with all kinds of theoretical issues. Whereas commissioned ensembles designed in the previous century, such as those decorating the palaces of Versailles or Vaux-le-Vicomte, had served ceremonial purposes geared to the use of the king and his courtiers, those devised by Hubert Robert served different ends for a far broader constituency. He became associated with "painting the salon," a site in which groups of individuals gathered together for conversation or other sociable activities. Madame Geoffrin's salon is normative in this regard; thus I tried in Chapter 2 to imagine how the social practices of *politesse*, or sociability, would unfold in a salon ornamented with pictures painted by living artists, particularly those painted by Robert. Conversely, I assumed that Hubert Robert, in fabricating the conversation pieces designed for display in the salon, would take account of these practices. The Saint Antoine ensemble, I argued, constituted a pictorial "genre d'esprit."

Historians have theorized that the discursive spaces of sociability were heavily

infused with, perhaps even molded by, elements of commerce, a supposition borne out by an examination of Madame Geoffrin's *lundi* salons. In Chapter 2, I described this dimension in detail because of its relevance to Robert's iconography in the conversation pictures, speculating that the motif of self-display running through so much of the artist's work becomes intelligible when viewed against this backdrop. The ubiquitous "peint par Robert" inscribed on the surface of the five Geoffrin canvases, in addition to the insertion of pictured references to the artist in the presence of his patron, while functioning as crude marketing devices extolling the talents of Hubert Robert, also reflect a growing interest of artists to mediate their works directly to consumers. We hardly know what to call these shifting relations in the developing civilization of early modern Europe. Labels such as master/servant, patron/client, employer/laborer, producer/market, and artist/public all describe aspects of the matrix emerging in the eighteenth century between artists, their product, and its consumers, but none does justice to it entirely. A new definition of artist's work was evolving, and Hubert Robert was one of the artists pulling the profession in new directions.

Commerce is also a thread in my analysis of Robert's Norman views, commissioned to decorate the long wall of the Salle des États in the archiepiscopal palace of Rouen. Hubert Robert formulated views of Rouen, Dieppe, and Le Havre that stand as paeans to economic well-being germinating under the eyes of God, Nature, and the archbishop of Rouen. Robert's cycle of representations transformed the medieval hall into a painted space of the Enlightenment, both literally and figuratively. Self-display emerges as a leitmotif here as well, for the artist insinuates himself into his painted prospect of Rouen, a reminder to beholders that the vistas we are admiring in the *archevêché* are the work of Hubert Robert. The Roberts are so powerful and so overwhelming in this setting that the Salle des États seems to have lost its identity as an architectural space and become nothing more than a surface on which to display paintings by Hubert Robert. This, I suspect, is the result of the painter's controlling or, at the very least, influencing, the conditions under which his artworks were presented to the spectator. (Robert used his position after the Revolution to see that the four paintings were regrouped and rehung where they are today.)

In Chapter 4, I concentrated upon the spectating consumer who paid to procure a look at the object, rather than to obtain the object itself, a shift in focus that turns the notions of public and private inside out. I suggested that ticket entry to the park and pavilion of the Bagatelle, which included a view of the bathing room and its custom-designed Roberts, induced the spectator to interact with art in a different way than they did with artworks exhibited at the Salon. Robert's paintings for the *salle de bains* are composed to exploit the nuances of their setting, especially *The Bathing Pool*, with its iconographic program geared to the theme of licit and illicit viewing. In the 1780s, despite its racy atmosphere, the Bagatelle evidently did not offend the visitor with high-minded civic ideals; the

negative associations of sexual license conflated with luxury were countered by
the positive connotations of a decorative idiom inflecting the outdoors and the
antique. Furthermore, the lowly nature of the pavilion's construction materials,
such as paper maché and wood, placed the mark of distinction on taste instead
of on magnificence.

Antiquity and thrift are linked units in the iconography of Robert's *Monu-
ments de la France* ensemble too. In Chapter 5, I showed how the imagery of
Imperial Rome expressed aspirations relevant to the Bourbon monarchy of France,
an institution in crisis at the time that Robert fashioned the four canvases to
decorate the new dining chamber at Fontainebleau Palace. However, the associ-
ation of the French monarchy with classical antiquity did not become a compelling
motif in the 1780s and 1790s; instead, the Revolutionaries identified the Bourbons
with feudalism, which they vilified.[1] They condemned *société* along with feudal-
ism, censuring it as a manifest attribute of a decadent political order that had
succumbed to the allure of *luxe*. In short, proponents of this view were Rous-
seauians, for whom *politesse* was an obstacle to the development of virtue.[2]

Sébastien Mercier's novel *L'An 2440*, published in 1771, is prescient on this
matter. The salon of the future in the year 2440 as described by Mercier *looks*
very different from those decorated by Hubert Robert. Mercier describes it as
ornamented only with "a lively tapestry, pleasing to the sight, and some finished
prints."[3] Elsewhere in the novel, we learn that the visual arts had become "useful"
by 2440, "as they were only employed to inspire sentiments of virtue, and to give
to the city that majesty, those charms, that noble and simple taste, which by a
secret connection elevates the minds of the people."[4] In Mercier's fictional utopia,
the march of progress is accompanied by the triumph of "public art" as I con-
ceptualized it (building on Diderot) in Chapter 1.

Writing about the visual arts in the early 1770s, Mercier waxed polemical. By
1792, however, much of what he had imagined had come to pass. The values of
la vie privée, in its pre-Revolutionary incarnation, aroused suspicion in the minds
of the new generation of reformers. And the associations of *luxe*, sociability, and
the salon with its decorators, associations which appeared insidious to Revolu-
tionaries, could lead even to arrest and imprisonment.[5]

Like the architects Claude-Nicolas Ledoux and François-Joseph Belanger,
Hubert Robert was imprisoned during the Revolution. Unfortunately, Robert had
neglected to renew his "carte de civisme,"[6] and he was arrested and incarcerated
in October 1793 under the Law of Suspects, which required that individuals with
either a lapsed or missing certificate of "civisme" be detained.

Robert's Prison Pictures

Hubert Robert's prison pictures have not received the critical attention they de-
serve. They have suffered from being viewed as illustration. Illustration is a kind

of representation that merely transcribes; thus, like propaganda, it is said to exclude independent thinking by both the producer and the consumer.[7] According to this construction, genuine art is informed by the imagination, whereas illustration is not; illustration cannot connote, it can only denote.

Robert's prison pictures have traditionally been framed and analyzed by the discourse of illustration. As mere illustration, they have been thought to have less value and less significance than "real" art. To see these works today, we must visit the Musée Carnavalet, an institution devoted to the history of Paris. That they are at this museum signifies that they are to be apprehended as historical rather than as artistic documents. On view at the Carnavalet is Hubert Robert's canvas of the Bastille in the first stages of demolition (see Fig. 57). The Carnavalet also possesses *The Recreation of Prisoners at the Prison of St Lazare: The Ball Game*, a picture invariably accompanied by the explanation that Robert was a skillful ball player, who played the game daily each afternoon during his imprisonment.[8] To the frequently reproduced canvas traditionally identified as the Germinal corridor of Saint Lazare is affixed the information that Robert was transferred to Saint Lazare in February 1794.[9] But one version of the tunnel by Robert (there are three) is dated 1793. Commentators ponder such inconsistencies at length. In the discourse of illustration "where is it?" becomes the key question to be answered.

"Who is it?" becomes the question when figures are concerned. Is the figure in the painting now part of the Wadsworth Atheneum Collection in Hartford, Connecticut, Camille Desmoulins or Antoine Roucher?[10] The discourse of illustration problematizes identities. Without understanding how this critical discourse has shaped commentary about these images, the designation of a figure *seen only from the rear* in one drawing as a portrait of Claude Fournier l'Héritier may appear to verge on the absurd. The last time this drawing was exhibited, in 1989, only the identity of the sitter was questioned, not the representation's status as an illustration.[11] Drawings, tangentially, are a form of expression associated with illustration because they can be done quickly in a small portable notebook.

The freshness and naiveté of such drawings, moreover, are qualities especially valued in the discourse of illustration. But, as Jean-Rémy Mantion has observed, naiveté is closely connected to the childlike. Only a short step separates the childlike from the puerile and the clearly insignificant.[12] If we were to relegate these pictures to insignificance, we might conclude that no "art" was produced during the French Revolution, that, as is sometimes implied, the events of the French Revolution were so overwhelming as to defy conventions of representation. It follows from this mistaken assumption that art and revolution are incompatible; instead of art, the end product of revolution is either propaganda or illustration.

I have overstated the case to emphasize the need to challenge these constructions. That the discourse of illustration should be applied uniformly and without

reflection to Robert's prison pictures is hugely ironic, because Robert's art rarely depended upon the conventions of topical illustration. Rather, he consistently composes representations marked by the use of visual puns and other conceits. The artist employs the same expressive devices in his most artfully contrived (*bien inventée*) and emotionally charged creations – the Grand Gallery pendants and the "Monument *composé*, displaying a broken obelisk around which young women dance" painted in 1798.[13] These works are political statements in which the artist's means of expression derives from the visual conventions of fine art.

The Prisoner Is an Artist

The order for Hubert Robert's arrest identifies its subject by two words, "Robert peintre."[14] The prisoner was a painter. During his ten-month confinement, Robert quite consciously turned his cell into a site of art production. One eulogist claimed that Robert produced fifty-three paintings while he was in prison and an unknown number of drawings. Some of the paintings he created at Saint-Lazare are surprisingly large. For example, he is known to have painted a panel representing a house near a lake for the countess de Segur. The picture is signed "H.Robert/ St.L." and measures 2,42 x 1,92 meters.[15] It is this representation of Robert that I find provocative – the art-making prisoner at Saint Lazare during the Terror, who was so intent upon making art that after he dined, he painted the plates on which his food had been served (Fig. 58). He signed these plates with inscriptions such as "le 4 Germinal de l'an II de la République/Par H. Robert détenu à Saint-Lazare." Another bears the sentence "Fait dans la prison de Saint-Lazare par Robert, en 1794" on the reverse.[16] Although a few of the scenes that Robert painted on the plates represent the prison, the majority of plates portray landscapes.

Like the Wilkite ceramics discussed by John Brewer in *The Birth of a Consumer Society*, these plates are political artifacts. Wilkite objects ranging from porcelain figures to mugs to medals to wigs were purchased by Wilkes supporters as concrete symbols of their support, which, as Brewer notes, allowed the radicals to display their political sentiments publicly.[17] Likewise, during the Revolution in France, plates and cups decorated with Revolutionary motifs were produced in a variety of materials and styles, from inexpensive ceramics to procelain from Sèvres. Politics commercialized provides the context for Robert's plates, but the dynamics have become more complex and ironic.

First, the process was inverted, because Robert transformed an artifact – a mass-produced clay plate – into a unique work of art, valorized by the signature of the artist. Second, whereas most of the plates present the innocuous imagery of a generic pastoral landscape, the knowledgeable beholder spies the letters "H.R.S.L.," for example, inscribed under the trees to the left (Fig. 58) and knows

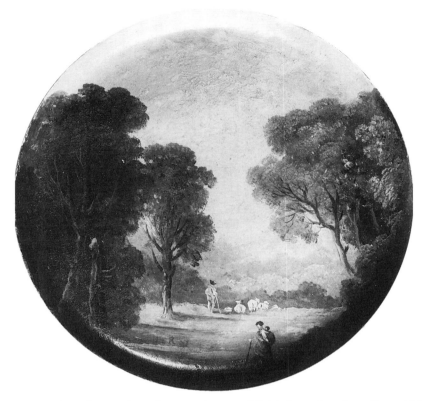

Figure 58. Hubert Robert, *Paysage Agreste*, 1794 (oil on clay plate, diam. 185 cm). Signed at base "H.R." and under the tree "S.L."; on the back of the plate "Fait dans la prison de Saint-Lazare par Robert, en 1794." Paris, Musée Carnavalet. Photo: Bulloz.

what they mean: [made by] Hubert Robert [at] Saint-Lazare prison. These inscriptions transform the representation into a political statement. How do we classify such works? Designations like illustration or propaganda do not define them adequately; perhaps we should call them political art artifacts. The meaning of these objects pivots on their mode of production being made explicit. The imagery is political because the artist created them while "détenu à Saint-Lazare," as another plate inscription informs us.

The plates show how old rhetorical structures such as composed landscapes (*paysage composé*) acquired new meanings in a different context. Nothing could be more symptomatic of the new Revolutionary age than an acute awareness of shifting codes of signification. For instance, what had been the Christian church of Sainte-Geneviève in the ancien régime became the secular temple of French heroes, the Pantheon, after 1791.

The Pantheon is a recurring motif in Robert's prison pictures. In his drawing

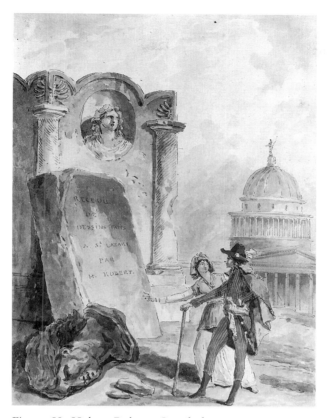

Figure 59. Hubert Robert, *Couple lisant une inscription: Dessin pour une page de titre*, 1794 (ink, bistre, watercolor, gouache highlights, 237 × 175 cm). Paris, Private Collection. Photo: Galerie Cailleux.

Couple lisant une inscription: Dessin pour une page de titre (Fig. 59), Robert renders the Pantheon in its post-Revolutionary incarnation, capped by a statue of Fame, instead of by the Christian cross.[18] Other novel and unprecedented signs enter Robert's visual lexicon in the 1790s too. The severed sculptured head lying on its side, a motif that certainly refers to the work of the guillotine during 1793, is one of these, and it appears in this drawing, which also bears the inscription "RECEUIL DE DESSINS FAITS A St LAZARE PAR H. ROBERT." Robert derived other aspects of the drawing's iconography from traditional sources though, notably Nicolas Poussin's *The Arcadian Shepherds* (c. 1660) – a masterwork belonging to the *ci-devant* royal collection (Fig. 60). In Poussin's picture, the shepherds decipher the inscription *Et in Arcadia Ego* (even in Arcadia I [Death] am to be found).

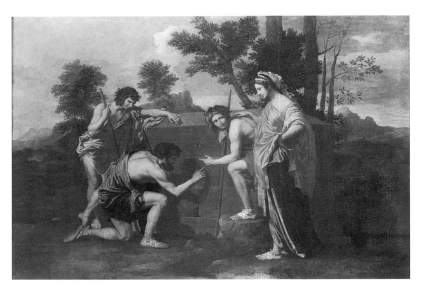

Figure 60. Nicolas Poussin, *Les bergers d'Arcadie*, c. 1660 (oil on canvas, 85 × 121 cm). Paris, Musée du Louvre. Photo: Art Resource.

Robert transformed Poussin's meditative classical shepherdess into a jaunty, even cocky, representative of the people, outfitted in a version of the newly designed uniforms for officials of the Republic. Robert's Revolutionary sports a sash, a feathered hat, a cape, and trousers that are a combination of knickers and stripped pants – a detail with political significance, because the sans-culottes were identified as Revolutionaries by the type of pants they wore. Robert's use of such imagery was, of course, a gesture to the famous costumes designed for the state by his fellow painter Jacques-Louis David, in 1794.[19] Next to the picture's male official, Robert has configured a woman who points to the inscription incised on the stone tablet, not Poussin's "Death in Arcadia," but "Drawings made by Robert in Saint Lazare prison." The play between the image and the referent is rich in connotation: Death exists in the new Arcadia-utopia of the Revolutionary state and is an eminent threat to "Robert . . . à St. Lazare [prison]," as the inscription (and the symbol of the severed head) clearly implies. But perhaps it is also a threat to others who, in ignorance or arrogance, have neglected to confront their own mortality in the new civilization they have created. That Death exists in the Republic is the overarching message of this inventively wrought "page de titre," or title page.

The Jacobins are savagely mocked by Robert in another work, *The Sleep of Marat* (as it is called by modern curators; Fig. 61) in the collection of the Albertina in Vienna. Although Hubert Robert had been officially detained on the charge of

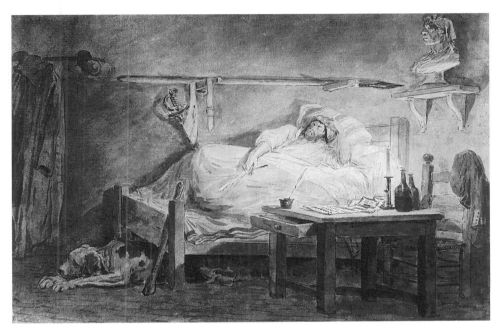

Figure 61. Hubert Robert, *Le Sommeil de Marat* (ink, pencil, watercolor, 23 × 34 cm). Vienna, Albertina. Photo: Bulloz.

holding an expired "carte de civisme," he indicates in this drawing that a man named Beaudoin had denounced him. On the table in the drawing is a piece of paper bearing the words "denunciation of Robert by Beaudoin." (Beaudoin's name does appear on Robert's arrest warrant as an official in the Tuileries section.) The representation, made with watercolor, pencil, and black ink, is replete with pointed visual references to the character of the men exercising authority on the Revolutionary Tribunal. In its means of expression, moreover, Robert cultivated a deliberate crudeness, drawing on the graphic language associated with his subject in certain popular prints of the time.

The pikes, the dog, the bust of Marat on the wall, and the signs of drinking in Robert's drawing appear, along with signs of smoking,[20] in a print created by Alexandre-Evariste Fragonard fils and Pierre-Gabriel Berthault in 1794–95 (Fig. 62). To the right in this depiction of "un comité Révolutionnaire sous le régime de La Terreur" is a group of men shown pouring themselves drinks, under the statue of Marat and another Revolutionary hero. Pikes are much in evidence. Moreover, the number of inscribed signs in the print is notable. A notice is tacked on the door, for instance, and another printed paper lies on the table, under a lettered banner. A placard hanging on the back wall bears the text of the Decla-

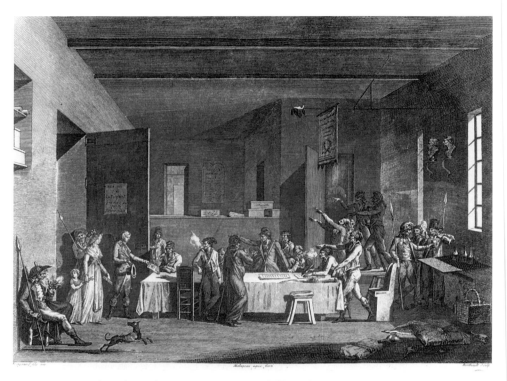

Figure 62. Print by Alexandre-Evariste Fragonard fils and Pierre-Gabriel Berthault, *Intérieur d'un comité révolutionnaire sous le régime de la Terreur*, 1794–95. Paris, Musée Carnavalet. Photo: Photothèque des Musées de la Ville de Paris.

ration of the Rights of Man and Citizens, approved by the Convention on 23 June 1793, and on the ledge in front of it, are boxes with labeled edges. Finally, the Jacobin seated at the end of the table is portrayed in the act of writing. Denunciation is expressed in the representation through the combined motifs of the pointing hand and the written word.

Likewise, the wine bottles and glass on the table in Robert's drawing (Fig. 61) imply that the man on the bed is in a drunken stupor.[21] In addition to the dog and the pike, Robert includes a sword and a club. It would be difficult to misinterpret these allusions to political force that is sustained by the use of violence rather than by reason. The incontinent figure identified as Beaudoin scowls, his hand still holding the pen he has used to accuse Hubert Robert. Robert depicted this man, Beaudoin, at the mercy of the irrational. He is a figure who is in the dark – unconscious – his field of action limited by weapons, drink, and the rhetoric of demagogues like Marat, symbolized by the bust on the wall.

Despite this, Robert infused the image with an oddly sacral quality. A lighted

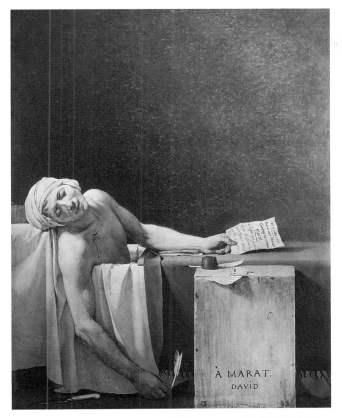

Figure 63. Jacques-Louis David, *Marat assassiné*, 1793 (oil on canvas, 165 × 128 cm). Brussels, Musées royaux des Beaux-Arts.

candle illuminates the statue of Marat, elevated in the visual field and set on a shelf resembling an altar. The references to Jacques-Louis David's *Marat assassiné*, painted in 1793, are unmistakable (Fig. 63). Robert copied the turban, the limp hand holding a quill pen, the bed sheets, the inkwell, the assignat conspicuously visible on the table, and the curled papers with their inscriptions. "Reference" is too weak to describe the dialogue between this representation and the David; Robert presented a stinging parody of it. He stripped David's figure of its signs of martyrdom, turning his Marat/Beaudoin Revolutionary into a contorted figure with a growth of beard and matted hair lying on a very ordinary bed. A detail like the cheap mattress ticking on the pillow that is supporting the man's head lampoons the ideal with masterful visual economy. If the evolution of civilization hinged upon the perfectibility of human beings, a subject upon which enlightened, reformist-minded philosophes such as Condorcet speculated, Beaudoin's lack of perfectibility is everywhere expressed in this representation.[22] Confined by a net-

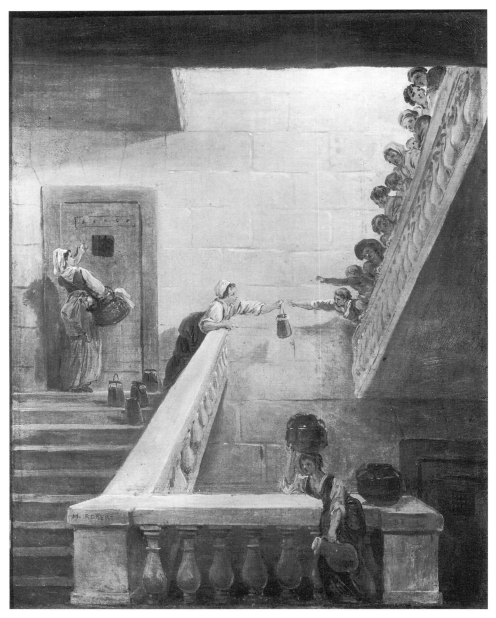

Figure 64. Hubert Robert, *Le Ravitaillement des prisonniers à Saint-Lazare* (oil on canvas, 325 × 410 cm). Signed "H.R." Paris, Musée Carnavalet. Photo: Art Resource.

work of horizontals and verticals into a compressed rectangular field, the figure is defined by limits, not by liberty. Given Robert's circumstances, such a perception is hardly surprising. But the point I want to emphasize is that the artist found the forms to express this idea in art.

Another "political art artifact" of the first order is the Carnavalet's *Le Ravitaillement des prisonniers à Saint-Lazare* (Fig. 64). Commissioned by one of the artist's fellow prisoners to preserve the memory of the women who brought milk to the inmates, the canvas had remained within the Pasquier family until the Carnavalet acquired it after 1933. It is signed "H.R."[23] Jean Starobinski illustrates his text with this painting in "The Solar Myth of the Revolution," a chapter of his *1789 Les Emblèmes de la Raison*.[24] Light and space, Starobinski observes, are key metaphors of the Revolution. Light symbolizes the triumph of a new age over the shadowy past; empty space is what remains after the vestiges of feudalism have been destroyed. Revolution, then, is like rays of light radiating out into a vast empty space.

Starobinski offers no commentary about the picture he has selected to illustrate these passages. Robert's painting must serve in this context to accentuate the falseness of the metaphor – the chapter's title is the solar *myth*, after all. The painting does not reference the birth of the Revolution in 1789, but a later stage, in 1794. Certainly, the artist has manipulated light and dark symbolically. It is the light of martyrdom, to be sure, but it does not radiate around the representatives of the new order. The Revolution's *victims* receive illumination here – men and women who, like Pasquier and Robert, were detained under the Law of Suspects without due process. Robert also used space expressively, but not in the way Starobinski's metaphor of Revolution suggests. He deployed forms along a vertical axis in which those on high suddenly find themselves marooned and manifestly dependent upon those who come and go along another tier (they are provided with doors). An abyss separates the two groups, and provisions pass only from one side to the opposite side, with both parties reaching deeply out into the space to make contact with the other. To suggest this, Robert used different vanishing points for the stairwells and the landings, breaking apart the unity supplied by linear perspective in the interest of expression. Is it not possible to see this representation as a metaphor in which women are figured not just as the sustainers of life – a point made by the symbolism of milk – but also as the vital metabolisms that circulate along the spine of the social order, keeping parts connected and making the system work?[25]

The Louvre in Ruins

Released from prison on 4 August 1794, Robert seems to have gathered together his older canvases to be exhibited at the 1795 Salon. At the Salon of the next year, however, he showed an unusual pair of pictures. In the Salon *livret*, they bore the titles: *Projet pour éclairer la Gallerie du Musée par la voûte et pour la diviser sans ôter la vue de la prolongation du local* (Fig. 65) and its pendant, *Ruines d'après le tableau précédent* (Fig. 66). The *Projet* is signed and dated on the base of the column at left "1796 H. Robert."

These famous pictures have been studied mainly for the light they shed on the remodeling of the Louvre's Grand Gallery into a "museum."[26] Thus like most of the art produced by Robert in the 1790s, they have been viewed as a type of illustration. In contrast, I propose to interpret them as political commentary. By offering such a reading, I do not mean to imply that these representations of the Louvre do not present serious schemes devised by the artist for the Grand Gallery. They do. But as in all of Robert's more densely fabricated works, the symbolic structures of the composition and the narrative ones are intricately woven together. To propose one reading of the pendants does not negate another.

Most contemporary assessments of the pictures neglect to mention one very provocative fact about them. It is likely that they were among either the last purchases made by Catherine II, who died in 1796, or the first acquisitions of Czar Paul I, her successor.[27] Hubert Robert had patrons and friends in Russia; in fact, he had been invited to travel to that country by Catherine herself. On 4 June 1791, Catherine wrote to Grimm: "If this Robert is neither a commanding general nor a demagogue nor an enragé and he comes here, he will discover views to paint. . . . But since he likes to paint ruins more and he has so many of them under his nose, he will have good reason not to displace himself from the land of ruins."[28] A woman who could write these words is one who could be expected to appreciate the irony of the prospect of the projected "Muséum" – the progeny of the Revolution – in ruins.[29]

In 1791, when Catherine the Great extended her invitation to Hubert Robert, he still held the position he had received from d'Angiviller in 1784 as conservator of the royal art collection.[30] This fact is important to note, because in the Salon of 1791, Robert exhibited his first painting of the Grand Gallery, entitled simply *Muséum* (no. 196), now lost.[31] As Jean-Rémy Mantion pointed out in "Déroutes de l'art, La destination de l'oeuvre d'art et le débat sur le musée," the "museum" at this time was virtually a "nonplace," a loosely conceived project erratically pursued by d'Angiviller and tied neither to a specific locale nor to a particular program. It became a reality only on 19 September 1792, when a decree authorizing the transport of artworks "qui sont répandus dans les maisons ci-devant dites Royales et autres édifices nationaux" established the *muséum* at the Louvre. The Revolution, then, was the agency responsible for creating the actual museum. Indeed, when it opened its doors to the public during the Terror in August 1793, its mission was to display trophies won by the Revolution on behalf of the nation.[32] Shortly after the museum made its debut, Hubert Robert was arrested.

When Robert painted the 1796 pendants, he was back on the newly reorganized conservatoire of the museum and deeply involved in the various projects to reshape the Grand Gallery into a permanent exhibition space. This explains why he painted so many different versions of the Grand Gallery, imagining it articulated by various wall systems and modes of overhead lighting. It does not explain, however, why he

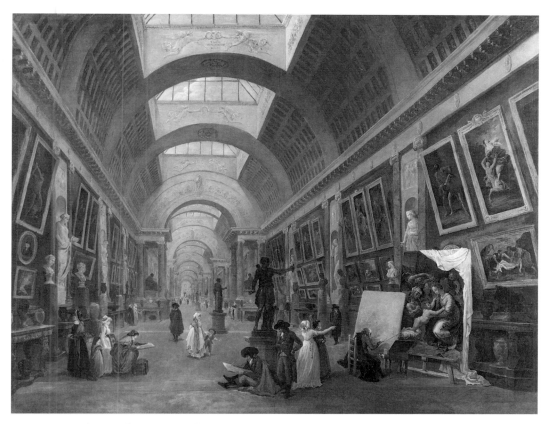

Figure 65. Hubert Robert, *Projet d'Aménagement de la Grande Galerie*, 1796 (oil on canvas, 1 m. 123 × 1 m. 432). Signed "1796 H.Robert." Paris, Musée du Louvre. Photo: Réunion des Musées Nationaux.

would produce *for exhibition* in 1796 a painted simulation of the gallery yoked to a representation showing it destroyed, thereby mocking his project, the entire undertaking, and the high-minded civic ideal of art for the people embodied in the "museum," this institution born of the Revolution. I am suggesting, by this last phrase, that the artist's experience in prison had changed him.

We may suppose on the basis of the popularity of Mercier's novel *L'An 2440* that the prospect of the present in ruins had a kind of currency in eighteenth-century French culture, both before and after the Revolution. This novel, as Robert Darnton has shown, was the number one underground (censored) best-seller in pre-Revolutionary France.[33] Some of its imagery significantly parallels the form and content of artworks by Hubert Robert. For example, at the end of the novel, when Mercier's protagonist visits the palace of Versailles, he enters a scene resembling one of Robert's pre-Revolutionary representations. Crouching on a column

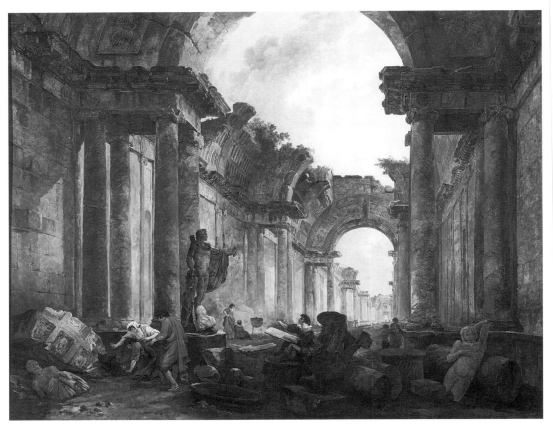

Figure 66. Hubert Robert, *Vue Imaginaire de la Grande Galerie en Ruines* (oil on canvas, 1 m. 145 × 1 m. 460). Paris, Musée du Louvre. Photo: Art Resource.

fragment is a lamenting incarnation of Louis XIV, surrounded by debris, by "walls half-open to the sky," and by mutilated statues.

The structure of the *L'An 2440* depends on two juxtaposed voices, one in the text and one in the footnotes. As our hero, transported to the year 2440, encounters various sites in Paris, he gapes in wonder at the achievements of this advanced civilization. In the lengthy footnotes that bristle on the border of practically every page, the voice of the author explains the context of each putative improvement, dwelling upon the failings of the present society and the need for reform. Consequently, the reader shuttles between future and present, shifting from the time frame of the text to the time frame of the footnotes. Mercier employs this strategy for a manifestly political purpose. In fact, in the 1799 edition of *L'An 2440*, he claims that his novel "announced and prepared the French Revolution."[34]

Paired or multiple "voices" are a rhetorical device utilized by Robert too.[35] We saw how he compared the Bastille and the great frost in the 1789 pendants to express an idea about political change. And in the *archevêché* at Rouen the antique ruins he depicted in the overdoors established a pointed contrast with the vision of a dynamic suburbanized eighteenth-century Normandy paraded on the walls. But, as Sahut has observed in her fine analysis of the 1796 Louvre pendants, the originality of this particular pairing extended beyond Robert's usual thematic or formal oppositions.

As happens to the reader in Mercier's *L'An 2440*, the beholder viewing the Roberts is shifted between two different time frames – in the Roberts the near future (the first is a *projet*, not reality) and the distant future. The motif connecting the two is the repeated image of the laboring artist. In one canvas (Fig. 65), Robert portrays himself as the copyist painting in front of Raphael's *Holy Family*; in the other (Fig. 66), he configured another "Robert," of the future, sketching the Apollo Belvedere amid the ruins of the Grand Gallery.[36] And despite the presence of a number of masterpieces that did not arrive at the Louvre until 1798, notably the Apollo Belvedere and the Zeno fragment, the site clearly *is* the Grand Gallery, although angled in a different direction.[37]

Unlike ruins Robert had pictured in the past, such as the *Interior of the Temple of Diana at Nîmes* (Fig. 48), this vision of destruction is bleak and desolate. In the background, amid a clutter of scattered masonry, human figures are seen warming themselves by a primitive brazier in the inhospitable ruin that was once a museum, a detail suggesting real loss and deprivation.[38] All that has unequivocally survived the devastation of the first gallery is the bust of Raphael, a motif that inspires the artist in both paintings.

The Sublime

"Sublime" is a descriptive term often associated with the *oeuvre* of Hubert Robert. Generally, the word is applied uncritically to a picture such as Robert's *The Finding of the* Laocoön, 1773 (Fig. 67), which exploits the deep shadows, infinite-appearing spatial regressions, and amplification of scale identified by Edmund Burke as constituents of the sublime. To label such an image sublime is not entirely unjustified, for the discovery of the *Laocoön* portrayed in the representation would have been construed as an awe-inspiring event by the eighteenth-century imagination.

In *A Philosophical Inquiry into the Origin of Our Ideas of the Sublime and Beautiful* (1757), Burke argues that in nature the chief passion caused by the sublime is astonishment. Awe is close enough to astonishment to fall within the broad parameters of this definition.

However, Burke has a different sense of "astonishment" in mind. "Astonish-

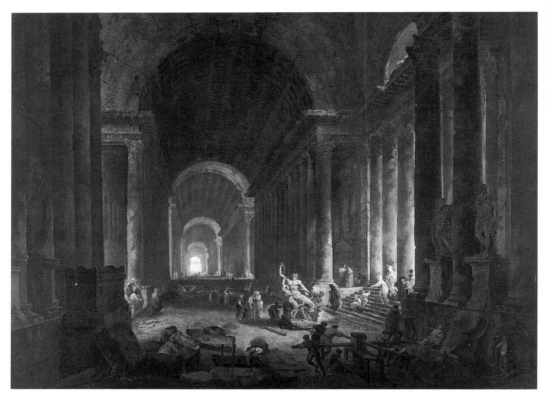

Figure 67. Hubert Robert, *The Finding of the* Laocoön, 1773 (oil on canvas, 119.4 × 162.5 cm). Signed "H. Robert 1773." Richmond, Va., Virginia Museum of Fine Arts, The Arthur and Margaret Glascow Fund. Photo: Ron Jennings, 1992, Virginia Museum of Fine Arts.

ment," he writes, "is that state of the soul in which all its motions are suspended with some of horror." Horror, and later fear ("whatever . . . is terrible with regard to sight"), danger ("for it is impossible to look on anything as trifling, or contemptible, that may be dangerous"), and finally, "vast power" are deemed by Burke central to the formulation of the sublime that he is striving to articulate.[39] It is this inflection that produces the political dimension of the sublime. When Burke exclaims, "All circumstances taken together, the French revolution is the most astonishing that has hitherto happened in the world," he is drawing on this set of connotations. In the same paragraph, he calls the Revolution a "monstrous tragi-comic scene," eliciting contradictory passions – "contempt and indignation; alternate laughter and tears; alternate scorn and horror."[40]

In a petition to the Committee of Public Instruction in 1794, Hubert Robert uses the term "sublimity." He is pleased, he writes, to present the committee with two sketches created in Saint-Lazare, which he proposes to execute *en grand*

"when he has the happiness to regain his studio." The word "sublimity" appears in a phrase at the end of the letter: "Le citoyen Robert ne prétend pas atteindre à la sublimité des sujets que présent la révolution française."[41] Is Robert being ironic? I think not, at least not entirely. In a Burkian sense, this sentence means that Robert, in 1794 when he wrote this letter, could not actually express visually and with precision the sublimity of subjects – the mingling of astonishment, horror, danger, and fear – presented by the French Revolution. I suggest, though, that after his release, he attempted to find form for his experience. The result was the Grand Gallery pendants.

One advantage offered by the pendant format is its ability to display two distinct but hyphenated states, such as "tragi-comic." In the first of the 1796 pendants (Fig. 65), Robert represented a peek into a near future that is ordinary to an extreme. But the unsuspecting artists and visitors scrutinizing the works of sixteenth- and seventeenth-century Italian art in the *Projet* are in for a surprise that the artist reveals for us, the beholders, in the pendant. We see what the distant future holds (Fig. 66). Do we experience scorn at the apathy of the figures in the painting, or do we feel horror at what is not apathy, but innocence? These questions are not the witty, sociable queries of a salon gathering in which tension can be deflected by a timely *bon mot*; we have crossed the threshold into a different domain whose frontier is marked by the events of 1793–94. Articulating the nature and meaning of that marker challenged those who had experienced the events. The Restif epigraph quoted at the opening of this chapter frames past and present with an apocalyptic vision of the future, one based on faith, mind you, not on experience or on reason, one in which the "deeds and words" of the Revolution will resonate "through the centuries to come," destroying civilizations.[42] This vision closely approximates the mood and the iconography of Hubert Robert's Grand Gallery pendants, exhibited at the Salon of 1796.

1798

The artist wrote only "1798 H. Robert" on his most powerful and enigmatic image, the large canvas described in the catalogue of the 1809 studio sale as *Un monument composé, offrant un obélisque brisé, autour duquel dansent des jeunes filles* (no. 79). It is not surprising that the picture remained in the artist's studio, for who would wish to purchase and display such a stark and profoundly melancholy painting?

In Robert's allegory (Fig. 68), young women wearing white dresses belted with tricolor ribbons dance around a shattered obelisk set in the middle of a desert.[43] On a ledge halfway up the broken monument are three musicians, who are playing wind and string instruments. Robert accentuates their bizarre placement by showing a discarded ladder in the picture's foreground, which they presumably used

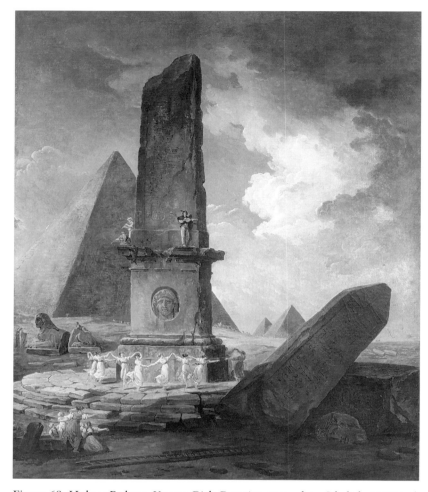

Figure 68. Hubert Robert, *Young Girls Dancing around an Obelisk*, 1798 (oil on canvas, 120 × 99.2 cm). Signed and dated "1798 H.Robert." Montreal, The Museum of Fine Arts, Lady Davis Bequest. Photo: The Montreal Museum of Fine Arts.

to reach their perch. The ladder draws our attention to the group of women and children on the picture's left, who point to the other side of the composition, where we see the remains of the obelisk and lying on its side, a sculptural fragment representing the head of an Egyptian pharaoh. The vastness of the desert is suggested by the diminishing scale of the three pyramids in the distance. We can make out on the horizon the forms of masses of people – just masses of people, for a close examination of the canvas reveals the sketchily rendered figures represent neither a procession nor an army. A stone sphinx, cleanly sliced into two

pieces, inexplicably bears a reclining man on its hindquarters.[44] Robert signed his name and the date on the coffinlike receptacle on the lower left out of which the children climb.

As a child of modernism, I cannot help but think of Mark Rothko when I look at this painting. The vertical bar set within an ascending series of horizontally layered value gradations reminds me of *Slow Swirl at the Edge of the Sea* (1944) or the *Primeval Landscape* (1945). Yves Tanguy springs to mind, too, with his illusionistically rendered monuments erupting like fungi or coral in an expanse of deep space.[45]

Like those artists, Robert constructed an image that hovers nervously, neurotically even, between two and three dimensions. Rococo cartouches fabricated by artists such as Meissonnier work the same way, but somehow the content of Robert's picture seems closer to Rothko or Tanguy, expressing the same sense of uncertain beginnings infused with tragic loss. It is, in this way, sublime. The loss relates to all that transpired during the Terror, for this image is emphatically post-Terror. Restif's comment about having become "wiser and sadder," invoked earlier, was prompted by a reunion at the end of 1794 with his old friend Sébastien Mercier. "What a joy to see Mercier again," writes Restif, "but also what a disappointment. His year in prison has changed him greatly – or perhaps it is that the same year in Paris has changed me."[46]

Remembering that Robert, like Mercier, had been jailed by the Jacobins in 1793–94, we realize that the year inscribed on this canvas is more than a part of the artist's signature: it is a title. The broken obelisk represents the year 1798. (Robert also used the date as title in the *Démolition of the Bastille*; Fig. 57.) Contoured like a broken sword, hilt planted in the ground, its edges defined by splintery, corrosive textures, the broken obelisk is a figure that stands for 18 fructidor. In September 1797 the coup of 18 fructidor portended a return of the Jacobins and the methods of the Terror. "L'effroi fut extrême," wrote Étienne-Denis Pasquier, who had commissioned the painting of the milkmaids at Saint Lazare (Fig. 64) from his fellow prisoner Hubert Robert. After 18 fructidor, Pasquier, for example, prepared to emigrate.[47] In 1798 fear was counterbalanced by exhilaration, and then by disappointment. In May of that year, Bonaparte's armies had successfully marched upon Malta, then captured Alexandria, and finally won Cairo. July 1798 witnessed a French victory at the Battle of the Pyramids. Parisians must have thought that they were on the verge of "overturning vast empires, changing the life of all the peoples of the earth," as Restif had predicted. But in August, Nelson destroyed the French navy at Aboukir Bay. Sudden victory in 1798 became equivocal and contingent.

Robert filled the image with highly charged political signs. He draws on the rich iconography that flourished in the political print of the 1790s. A reading of the *Monument . . . brisé* requires that "fine art" and topical prints be reintegrated

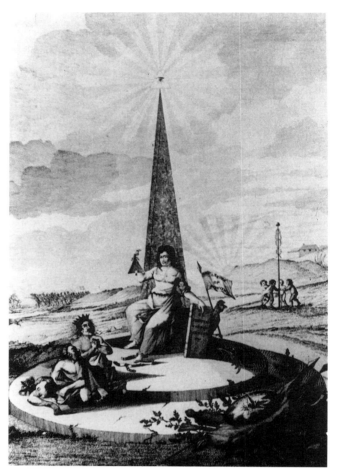

Figure 69. Print after W. H. van Bork, *Allegory of the Bata-vian Republic*. London, British Museum. Photo: author.

under the rubric of visual culture if we are to make sense of its imagery. A political print such as *Allegory of the Batavian Republic* (Fig. 69) utilizes many of the same signs that Hubert Robert employed: the obelisk, the triangle, the maypole, the severed head, and the crowd surging forward on the horizon.[48] In the print, the crowd can be identified as the Revolutionary army and the severed head as that of Louis XVI, cradled, on the left side of the image, by one of Europe's two remaining crowned monarchs. On the right-hand side of the print, four youngsters ring around a maypole surmounted by the red cap of liberty.

Yet how opaque these symbols become when they reappear in Hubert Robert's painting. Triangles become pyramids, literally the pyramids at Giza. We can say with some certainty that the dancing women in white with red, white, and blue

sashes cinched around their waists clearly stand for the Revolution, just as the sculptural head of a dead Egyptian king, cheek to the ground, points to the death of Louis Capet (see, e.g., Fig. 59). Beyond these, Robert provides no key for deciphering the picture.

Yet a beholder whose eyes are conditioned by Rothko's painting will find the broken obelisk mutates surrealistically into a maypole. The women, who wear the customary gowns donned by young female participants in the national festivals staged during the Revolution, dance joyously around the shattered obelisk as if it were a *mai*, the ancient symbol of regeneration. Stationed on the ledge above them is a musette, or dance hall band, to keep time for the circling dancers.[49] Is this then a painted ode to creation or to destruction? Perhaps the binary opposition of this formulation misses the mark, for what we have here is another hyphenated subject, "creation-destruction," falling within the discourse of the sublime. As he did in the Pasquier canvas of the milkmaids at Saint Lazare (Fig. 64), Robert has featured the actions of women in the representation. But in this allegory of 1798, women sustain the culture by bacchantic ritual, instead of arbitering it by some act associated with Reason, like the charity pictured in *Ravitaillement des prisonniers* (Fig. 64) or the conversation portrayed in *Madame Geoffrin déjeunant avec les dames de l'Abbaye Saint-Antoine* (Fig. 2). If ever a visual icon expressed the end of the Enlightenment, this is it.

Notes

Chapter 1. Introduction: Hubert Robert and La Vie Privée

1. Fournier-Desormes died in 1850; however, in the *Epître*, he claims to have been Robert's friend. He lived in Chartres and seems to have been a painter himself. On Fournier-Desormes, see Louis Dimier, "Témoignages inconnus sur Hubert Robert," *Bulletin de la Société de l'Histoire de l'Art Français* (1934), 38. The French text of my epigraph reads: "Laborieux à l'excès, infatigable dans ses travaux, il faisait encore les délices de la bonne compagnie par les agrémens de son esprit, qui s'était perfectionné dans la société des personnages illustres de son temps, qui tous étaient devenus ses amis." Fournier-Desormes, *Epître à Hubert Robert* (Paris: Persan et Cie., 1822), 6–7.

2. See, for example, the eulogy by Charles Lecarpentier, which likewise emphasized Robert's devotion to work ("he died at his easel . . . while painting a picture," p. 1) and his *politesse* ("this artist joined to his [artistic] talents *de grandes qualités sociales*," p. 6). Charles Lecarpentier, *Notice sur Hubert Robert* (Rouen: Vt. Guilbert, 1808).

3. Diderot is regarded as preeminent in the twentieth century. As is well-known, the actual number of subscribers to the publication in which Diderot's art reviews appeared, the *Correspondance Littéraire*, was quite small, consisting of foreign nobles and princes. As late as 1771, Diderot's artist-friends did not suspect that he was writing about their work for the public with access to the *Correspondance Littéraire*. By that time, artists had grown testy about the incursion of critics into their domain – especially in the evaluation of their art. Christian Michel cites an important passage by Cochin indicating that he did not believe Diderot was one of those who had "deviated" from the path of belles lettres to explore a subject, i.e., art, that he knew little about. Both Cochin and Diderot were habitués of Madame Geoffrin's salon, as was Hubert Robert (see Chap. 2), but the artists were evidently completely unaware of what Diderot was up to. The passage reads as follows: "D'ailleurs les plus célèbres d'entre [les gens de lettres] n'écrivent jamais sur les Arts. Les Voltaire, les Piron, les Duclos, les Dalembert, les Diderot, les Marmontel et en général ceux qui se sont le plus distingués dans la carrière des Belles-Lettres,

ne s'en écartent pas pour courrir sur des terres qui leur sont en partie inconnues." Letter of October 1771 from Cochin to Falconet, published in Falconet's *Traduction des XXXIV, XXXV, et XXXVIièmes Livres de Pline l'Ancien* (Amsterdam, 1771), 106, cited by Christian Michel, "Les Conseillers Artistiques de Diderot," *Revue de l'Art*, no. 66 (1984), 12.

4. Paul Henri Thiry, baron d'Holbach, *La Morale universelle ou les Devoirs de l'Homme fondés sur sa Nature*, 3 vols. (Amsterdam, 1776; rpt. Stuttgart-Bad Cannstatt: Friedrich Frommann Verlag, 1970).

5. Salon of 1769 in *Salons de Diderot*, ed. J. Seznec and J. Adhémar (Oxford: Clarendon Press, 1957–67), 4:65. "Votre condition, monsieur de Laborde, est injuste, antipatriotique et malhonnête . . . Croyez-vous qu'il n'y ait aucune différence entre l'homme qui travaille pour un peuple immense qui doit le juger, et l'homme qui travaille pour un petit particulier qui condamne ses productions à n'arrêter que deux yeux stupides? . . . Plus de Salon, plus de modèles pour les élèves, plus de comparaison d'un faire à un autre; ces enfants n'entendront plus ni le jugement des maîtres, ni la critique des amateurs et des gens de lettres, ni la voix de ce public qu'ils auront un jour à satisfaire."

6. Thomas E. Crow, *Painters and Public Life in Eighteenth-Century Paris* (New Haven: Yale University Press, 1985).

7. On this subject, see Joan B. Landes, *Women and the Public Sphere in the Age of the French Revolution* (Ithaca: Cornell University Press, 1988).

8. For an excellent overview of luxury from the standpoint of the history of ideas, see Christopher Berry, *The Idea of Luxury* (Cambridge: Cambridge University Press, 1994). I began to develop these arguments in "Deconstructing Dissipation," a paper delivered at the annual meeting of the College Art Association, San Antonio, 1995, in a session organized by Julie Plax, and later published in the Forum section of *Eighteenth-Century Studies* 29 (winter 1995–96), 222–25.

9. This is discussed by Madelyn Gutwirth in *The Twilight of the Goddesses* (New Brunswick: Rutgers University Press, 1992). For an eighteenth-century expression of this idea, see Sébastien Mercier: "When women govern the arts, the arts degenerate . . . They [women] have enervated painting and wish to do the same to poetry: they cherish sprightly, vagabond, and fugitive ideas that resemble their caprices; but they have a mortal fear of the moralist poet who comes to speak to them of their duties, recommend modesty to them and teach them there is no merit in rouging anything, and one can be 'aimiable' without being dedicated to vice." Louis-Sébastien Mercier, *Du Théâtre, ou Nouvel Essai sur l'Art Dramatique* (Amsterdam: E. van Harrevelt, 1773; Geneva: Slatkine rpt., 1970), 133 n a.

10. "The Salon of 1767" in *Diderot on Art*, ed. and trans. John Goodman (New Haven: Yale University Press, 1995), 2: 77.

11. Louis-Sébastien Mercier, *Le Tableau de Paris*, Introduction et choix des textes par Jeffry Kaplow (Paris: Éditions la Découverte, 1989), 118. The first edition was published between 1781 and 1788.

12. The Physiocrats did not differentiate between the products of artists and artisans, but they were adamant that the wealth for all luxuries must come from the land

and to a certain extent be ploughed back into the land. Consequently, the role reserved in their system for artists remained limited.

13. Mercier, *Le Tableau*, 120.

14. Cited by Michael Sonenscher, *Work and Wages: Natural Law, Politics, and the Eighteenth-Century French Trades* (Cambridge: Cambridge University Press, 1989), 210.

15. On this see Rémy Saisselin, *The Enlightenment against the Baroque: Economics and Aesthetics in the Eighteenth Century* (Berkeley: University of California Press, 1992).

16. "(Un mot sur Robert. Si cet artiste continue à esquisser, il perdra l'habitude de finir, sa tête et sa main deviendront libertines. Il ébauche jeune, que fera-t-il donc lorsqu'il vieillira? Il veut gagner ses dix louis dans la matinée; il est fastueux, sa femme est une élégante, il faut faire vite, mais on perd son talent, et né pour être grand, on reste médiocre. Finissez, Monsieur Robert, il ne vous en coûtera presque pas plus pour faire un tableau qu'une esquisse.)" Seznec and Adhémar, *Salons*, 4: 189.

17. The aversion of critics to an artist's making money is discussed in Richard Wrigley, *The Origins of French Art Criticism from the Ancien Régime to the Restoration* (Oxford: Clarendon Press, 1993), 132ff. Wrigley also surveys the values of "finish," 276ff.

18. My information on fashion comes from Jennifer Jones, "Selling the Grisette: Femininity, Commerce and Fashion in Ancien Régime Paris," paper presented at the annual meeting of the American Society for Eighteenth-Century Studies, Charleston, 1994. Both artists and dressmakers could command substantial fees at this time. For example, Joseph Vernet abandoned the royal commission for the *Ports of France* series because the 6,000 livres he had negotiated from the crown for each canvas was less than his brush could command nine years later in 1762. See Général Thiervoz, "Les Ports de France de Joseph Vernet," *Neptunia* 58 (1960), 18. In addition, the state was notoriously slow in paying its bill to the artist. Rose Bertin, the most famous dressmaker of the era, referred to the same Vernet in response to a complaint that *she* received about the high cost of her wares. "Oh, is Vernet paid only according to the cost of his canvas and colors?" Cited in Pierre de Nouvion and Emile Liez, *Un Ministre des modes sous Louis XVI: Mademoiselle Bertin* (Paris, 1911), 146. I thank Jennifer Jones for this reference.

19. Ironically, on this issue, the enlightened critic of the guild system reflects the reactionary position of a guildmaster who argues that "a worker hurrying to finish his alloted pieces will not give each one the necessary perfection." Cited by Sonenscher, *Work and Wages*, 188–89 (un ouvrier empressé de finir les pièces dont il est chargé ne s'applique point à leur donner la perfection nécessaire). For an interesting analysis of Diderot on work, see Cynthia J. Koepp, "The Alphabetical Order: Work in Diderot's Encyclopedia," in Steven Laurence Kaplan and Cynthia J. Koepp, eds., *Work in France: Representations, Meaning, Organization, and Practice* (Ithaca: Cornell University Press, 1986), 229–57.

20. *Petits tableaux*, as Krzysztof Pomian explains, refers to works of the seventeenth-century Dutch and Flemish schools. As prices for these works rose at auction, so

did the role of the dealer, who vouchsafed their authenticity. Because of the extraordinary popularity of these paintings among a new group of collectors, in the 1760s, the dealer displaced the old-fashioned connoisseur from the position of dominance; thus esthetic appreciation became subordinate to attribution. See Pomian's fine study on this subject, *Collectors and Curiosities: Paris and Venice, 1500–1800*, trans. Elizabeth Wiles-Portier (Cambridge: Polity Press, 1990), 153–68.

21. "C'est une fort jolie esquisse et dont M. Robert pouvait se faire un mérite réel, si moins expéditif, moins croquant, il eût voulu traiter ce morceau plus en grand et le traiter sérieusement. Panini en eût fait un tableau admirable. Mais aujourd'hui il nous faut des petits tableaux, on ne les examine guère, mais on les compte, et l'artiste y trouve le sien." Seznec and Adhémar, *Salons*, 4: 188.

22. "Encore des idées multipliées et point de tableaux. Eh! mes amis, dirais-je à ces Messieurs les croqueurs, gardez vos dessins et croquis, bistrés, coloriés, et tout comme il vous plaira, dans vos portefeuilles, et qu'ils ne paraissent à nos yeux qu'en tableaux bien rendus et bien finis. On court après les dessins de Raphaël, de Rubens, etc. parce qu'on n'a pas de leurs tableaux autant qu'on en désire, et que tout ce qui vient d'eux est marqué au coin de l'homme savant, du grand homme. Mais vos *progénitures* [sic] si promptement mises au jour décèlent la quantité de vos idées, il est vrai; sont-elles grandes et sublimes?" Seznec and Adhémar, *Salons*, 4: 189.

23. Colin Jones, "Bourgeois Revolution Revivified: 1789 and Social Change," in *Rewriting the French Revolution*, ed. Colin Lucas (Oxford: Clarendon Press, 1991), 110. Another element that Jones emphasizes is an increasing sense of self-worth and autonomy experienced by individuals in certain professions in the eighteenth century. Professionalization proves to be a useful category to apply to an examination of Robert's social origins, too. His father (like the father of Madame Geoffrin) was employed in the higher ranks of domestic service, a squire, or "officier," in the retinue of the marquis de Stainville. As Jean de Cayeux describes it, this was a post with certain important administrative responsibilities – not quite the "service elite" who worked as government officials, lawyers, clergymen, and teachers, but "bourgeois" nonetheless. Jean de Cayeux, *Hubert Robert* (Paris: Fayard, 1989), 23. Moreover, and this is perhaps more significant, in 1767 the artist married Gabrielle Soos, the daughter of a surgeon, one of the career groups in the eighteenth century to define itself in distinct professional terms in claiming a comparatively extensive formal education and "prestige, wealth, and status," in Jones's words.

24. P. J. Mariette, *Abecedario* (Paris: J.B. Dumoulin, 1857–58; rpt. Paris: F. de Nobele, 1966), 414.

25. Bachaumont, giving advice to the maréchal d'Isenghien about furnishing his country house in Suresnes, writes: "Prendre MJ. Contant et Cartaut pour les grands parcs et les grands jardins, M. de la chapelle, le meilleur élève de Le Nôtre, pour les bosquets, parterres et autres gentillesses; pour les ornements intérieurs et extérieurs d'une maison qui concernent la sculpture, comme cheminées, buffets, coquilles, cuvettes de marbre pour une salle à manger, tables de marbre, lambris scuoptez, corniches, pieds de table, encognures, vases pour les jardins en pierre, en bronze, en plomb, en terre cuite, en potin, incrustations aussi de marbre, lieux à l'anglaise

et autres ornements extérieurs de sculpture, il faut se servir de Messieurs Slodtz, sculpteurs du Roy, qui demeurent au Louvre; ils sont très entendus en toutes sortes d'ornements et décorations, gens d'honneur et de probité, point chers, point intéressés, ennemis des colifichets si fort à la modes présentement, . . ." Cited by François Souchal, *Les Slodtz, sculpteurs et décorateurs du Roi (1685–1764)* (Paris: Éditions E. de Boccard, 1967), 358. The Bachaumont mss is cited as it appears in the Bibl. de l'arsenal, Ms 4041, fol. 584.

26. Souchal, *Les Slodtz*, 88. He designed props for royal ceremonies and spectacles, including stage sets for theater. The Taillasson eulogy states that Slodtz recognized Robert's talent for drawing architectural ruins and spoke to Joseph Vernet about him. Vernet encouraged him, helped him with advice, and loaned him one of his pictures, which Robert copied faithfully. J. J. Taillasson, "Notice nécrologique 'Hubert Robert,' " *Le Moniteur Universel* (20 avril 1808), 1.

27. "Etudier pour étudier, il vaut encore mieux être défrayé de l'étude." The context of this story is amusing. Caylus had originally employed an artist named Louis to produce the topographical views he needed for his volumes of antiquities. Louis pilfered some of these from Robert's portfolio, not realizing that they were caprices, i.e., composite or imagined views. Caylus just barely missed becoming an international laughingstock by publishing these views as accurate descriptions of ancient monuments. Subsequent to this, Caylus hired Robert to do the views, but the artist was always accompanied by an antiquarian who must vouch to Caylus for the archeological veracity of the representation – not Robert's specialty! *Correspondance inédite du Comte de Caylus avec le P. Paciaudi, Théatin (1757–1765), suivi de celles de l'abbé Barthélemy et de P. Mariette avec le même,* publiées par Charles Nisard (Paris: L'imprimerie Nationale, 1877), 1: 195–97.

28. Hubert Robert, it should be noted, was unusually well educated for a young man in his circumstances. He had attended the Collège de Navarre, a campus of the University of Paris, from the age of twelve to eighteen (1745–51). Thus he received the same Jesuit education received by a number of Enlightenment intellectuals, for instance, Condorcet and Chénier, who went to the same college. An avid student, whose scholarly efforts were rewarded with prizes "dans toutes ses classes," Robert would flaunt his learning by garnishing his drawings and paintings with Latin inscriptions, a device functionally similar to the Latin mottos planted like banners at the openings of essays in *The Spectator* by those avatars of sociability, Addison and Steele, at the start of the century. On Robert's education, see Taillasson, "Notice nécrologique," 1.

29. In addition, Robert was a "professional curator" and garden designer. In 1778, he assumed curatorial responsibilities over the royal collection of art, a post he received from the minister of fine arts (made official in 1784). The choice of Robert for this position provides further proof that his familiarity with the buying and selling of art was well known, because the job required a person conversant with the practices of the market in Old Master artworks. Robert advised the crown about purchases, estimated values, and made bids. See Cayeux, who discusses these activities in detail in *Hubert Robert*, Chap. XIX. The same year Robert also received the title "De-

signer of the King's Gardens" as a result of his involvement with the Bains d'Apollon project at Versailles (Fig. 1). Subsequently, he was to have a hand in many garden constructions. Sites in Ermenonville, Bellevue, Rambouillet, and, of course, Méréville, have been associated with him. To understand Robert's success as an artist, we must disregard the outmoded notion prevailing in art history that the hierarchy of genres governed distinction within the visual arts profession during the eighteenth century. None of the activities I have described interfered with Robert's status in the Royal Academy of Painting. The young artist had been nominated (by Joseph Vernet) and accepted to the Academy at the same *séance* in 1766. This "Painter of architecture," as he was inscribed on the Academy register, submitted *Le Port de Rome, orné de différents monuments d'architecture ancien et moderne* as his reception piece. That he was not a history painter did not prevent him from advancing, in 1784, to the rank of "conseiller" within the Academy.

30. Mariette, *Abecedario*, 414: "Chacun lui en demande."

31. On the three-dimensional *Bains*, see Susan Taylor-Leduc, "Louis XVI's Public Gardens: The Replantation of Versailles in the Eighteenth Century," *Journal of Garden History* (summer 1994), 67–91. It is precisely because of his "versatility" that no catalogue raisonné exists on Hubert Robert.

32. I have been greatly influenced by two projects underwritten by the NEH in which I was fortunate to participate. The first, directed by Ann Bermingham and sponsored by the Center for Seventeenth and Eighteenth Century Studies and the Clark Library at UCLA, was a year-long workshop, "Culture and Consumption in the Seventeenth and Eighteenth Centuries." The papers from this workshop have been published as *The Consumption of Culture, 1600–1800, Image, Object, Text,* ed. Ann Bermingham and John Brewer (London: Routledge, 1995). The second was the NEH Summer Institute on Jürgen Habermas and the public sphere, directed by Keith Michael Baker and John Bender at Stanford in 1995. During this six-week institute, I developed a deep appreciation for Habermas's book, as well as became aware of the sociological and historical problems with its thesis. Like many scholars in the field of eighteenth-century studies I have found *fragments* of Habermas's work to be inspirational. I benefited enormously from the insights of the institute directors, to whom I owe a very special thanks. I gained many of my assumptions about pre-Revolutionary French culture from Keith Michael Baker, *Inventing the French Revolution* (Cambridge: Cambridge University Press, 1990). In both these NEH experiences specialists spoke to one another across discourse communities, and I have endeavored to maintain the tone of that discussion in this study.

33. Indeed, in "La Vie d'Antoine Watteau," by the comte de Caylus (1748), Caylus insists that Watteau's own work disgusted the artist, because he thought it very inferior to "the great ideas that he had about painting." Moreover, according to Caylus, Watteau was completely impervious to money: "C'est qu'il n'aimait point l'argent, et qu'il n'y était nullement attaché." Caylus in *Vies anciennes de Watteau,* ed. Pierre Rosenberg (Paris: Hermann, 1984), 67. What interests me about the representation of Watteau in the Caylus text is how differently he is said to construe

the value of his work from an artist like Hubert Robert. For an interesting dis-
cussion of Gersaint's textual representation of Watteau, see Julie Plax, "Ger-
saint's Biography of Antoine Watteau: Reading Between and Beyond the Lines,"
Eighteenth-Century Studies 25 (summer, 1992), 545–60.

34. Fournier-Desormes wrote: "J'entre en ton ermitage, et mon regard surpris / De
chefs-d'oeuvre partout voit ses murs embellis. / Là, de tes seuls tableaux se compose
un musée, / Dont l'heureux souvenir charme encor ma pensée." *Epître à Hubert
Robert*, 16. He explained: "Robert avait son atelier dans une salle du Louvre, et
occupait la maison de campagne de Boileau, à Auteuil. On y voyait une galerie
ornée de ses seuls tableaux" (55 n. 12). For the inventory of the studio sales in
1809 and 1821, see Claude Gabillot, *Hubert Robert et son temps* (Paris: Librairie
de l'art, 1895), 248–71.

35. The description of Jullienne as an "entrepreneurial promoter" is from Crow, *Pain-
ters and Public Life*, 40.

36. I am indebted to Carl-Gustaf Tessin for this line of thought. In his book of 1755,
Tessin divided art into three schools of painting: the Italian, the Flemish/Dutch, and
the French. Following earlier theorists, such as Roger de Piles, he claimed that the
Italians excelled in idealization and the Flemings in imitation. He seems to have
thought more carefully about how to characterize eighteenth-century French art,
however, which he admired greatly. The French school of painting, he concluded,
excelled in "ordonnance," or the arrangement of parts to form a whole. The French
see everything with eyes that absorb only pleasure and joy, he explained. All things
stir, engage, and act in their works, and that is what causes their representations
to be gracious, warm and well-invented. "Tout agit, tout rit, tout joue dans ses
ouvrages, & c'est ce qui fait que l'ordonnance en est gracieuse, riante & bien in-
ventée." I like the way Tessin struggled to define these terms because he was speak-
ing as a connoisseur rather than as a theorist. Moreover, he had the advantage of
being able to discuss his ideas with the likes of Chardin and Boucher, whose works
he personally commissioned for his private art collection. Tessin was a special em-
issary to France from Sweden between 1739 and 1742. Although Tessin probably
had never heard of Hubert Robert in 1755 – Robert would have just been com-
pleting his apprenticeship under Slodtz – his description of the strengths of the
French school describes Robert's art admirably. C. G. Tessin, *Lettres au Prince
Royal de Suede par M. le Comte Tessin, Ministre d'Etat, et Gouverneur de ce jeune
Prince*, Traduites du Suédois (Paris: Jombert, 1755), 1: 140.

37. "Mais invention proprement dite, consiste à choisir entre les pensées qui se présen-
tent, celles qui sont les plus convenables au sujet que l'on traite, les plus nobles, &
les plus solides, à retrancher celles qui sont fausses ou frivoles, ou triviales; à con-
sidérer le tems, le lieu où l'on parle; ce qu'on se doit à soi-même, & ce qu'on doit
à ceux qui nous écoutent."

38. On Madame Geoffrin and on the salonnieres in general, see Dena Goodman, *The
Republic of Letters: A Cultural History of the French Enlightenment* (Ithaca: Cor-
nell University Press, 1994).

39. On this subject, see Daniel Gordon, *Citizens without Sovereignty: Equality and*

Sociability in French Thought, 1670–1789 (Princeton: Princeton University Press, 1994), 129–76.

40. *Mémoires inédits de Charles-Nicolas Cochin sur le Comte de Caylus, Bouchardon, les Slodtz*, publiés d'après le manuscrit autographe, avec introduction, notes et appendice par Charles Henry (Paris: Baur, 1880), 77, 28. See Crow on Crozat, *Painters and Public Life*, 39–42.

41. D. Gordon, *Citizens without Sovereignty*, 65–73.

42. Katie Scott, *The Rococo Interior: Decoration and Social Spaces in Early Eighteenth-Century Paris* (New Haven: Yale University Press, 1995), 107–17.

43. K. Scott, *Rococo Interior*, 116.

44. Georges de Lastic Saint-Jal, "La Reine de la Rue Saint-Honoré," *L'Oeil*, no. 33 (1957), 51–57. Lastic Saint-Jal included a photograph of the townhouse at 372 rue Saint Honoré where Madame Geoffrin lived. He also reproduced a drawing by Boucher showing a gathering in the salon of her townhouse in which the walls are laden with paintings. Ségur described her grand salon as decorated with "les tapisseries de Beauvais, les tableaux de maîtres, les meubles, . . ." Pierre de Ségur, *Le Royaume de la Rue Saint-Honoré, Madame Geoffrin et sa Fille* 4th ed. (Paris: Calmann Lévy, 1898), 106.

45. *Mémoires pour servir à l'histoire des événemens de la fin du dix-huitième siècle depuis 1760 jusqu'en 1806–1810 par feu M. l'Abbé Georgel*, publiés par M. Georgel (Paris: Alexis Eymery, 1820), 219.

46. As Katie Scott explains, "The structure of sociability is thus quite different from the structure of distinction. To maximise the levels of contact intrinsic to sociation, all those attributes likely to form barriers to interaction – such as rank, office and wealth – have to be concealed, not emphasised." Scott, *Rococo Interior*, 107.

47. Ségur, *Le Royaume de la Rue Saint-Honoré*, 106. Because Madame Geoffrin was bourgeoise, the old courtly business of ceremonial display practiced by the nobility did not apply. I think leaving it at this, however, leads to an overly simplistic assessment of the social forces at work here. Madame Geoffrin's daughter, the marquise de la Ferté-Imbault, had married into one of the most illustrious houses of the old nobility. After the marquise was widowed at age twenty-two, she lived in the other wing of her mother's townhouse, where she entertained friends drawn predominantly from court, men such as Maurepas, Nivernais, and Bernis. One senses that the marquise had apartments "de parade." Walpole used political imagery to describe the relations between the mother and daughter in their townhouse: "each of the two rivals," he wrote, *cantonnée* "in its own little realm, . . . denigrated the society of its neighbor." Cited by Ségur, p. 122. Madame Geoffrin, of course, is a superb example of what Jürgen Habermas has described so brilliantly in his study of the emerging public sphere in the eighteenth century. Her salon represents a site where private people came together outside the court to determine cultural "meaning on their own (by way of rational, verbal communication with one another), verbalize it and thus state explicitly what precisely in its implicitness for so long could assert its authority." Jürgen Habermas, *The Structural Transformation of the Public Sphere: An Inquiry into a Category of Bourgeois Society*, trans. Tho-

mas Burger and Frederick Lawrence (Cambridge, Mass., 1989), 37. Rather than see this development strictly in Marxist terms, though, as Habermas does in his book, I am inclined to view it as an illustration of what Colin Jones has called the "bourgeoisification" of French culture. Colin Jones, "Bourgeois Revolution Revivified," 109.

48. According to Georgel: "Madame Geoffrin étoit une de ces femmes rares, qui, sans afficher le faste au sein de l'opulence, avoit su, avec un esprit ordinaire et beaucoup de bon sens, donner de la célébrité à son nom et à la société qu'elle réunissoit tous les lundis et les mercredis dans un dîner où étoit invités, le premier jour, les artistes les plus renommés; le second jour étoit consacré aux gens de lettres, au milieu desquels les ambassadeurs et les étrangers du plus haut rang s'empressoient de se trouver." *Mémoires*, 219.

49. Gabriel Sénac de Meilhan, *Du Gouvernement, des Moeurs, et des Conditions en France avant la Révolution, avec le caractère des principaux personnages du Règne du Louis XVI* (Londres: Benjamin & Jean White, 1795), 136: "Il est à remarquer dans cette seule Nation regne une puissance supreme appellée *Mode*. Elle tient son empire de la légéreté, qui adopte sans examen, de la vivacité de l'imagination, qui s'attache promptement à un objet, et du penchant à l'imitation." In his book, Sénac de Meilhan analyzes how the influence *de la mode* contributed to the French Revolution.

50. References to other cycles by Robert, now dispersed or displaced, also exist. For example, decorative ensembles by Robert were to be found in the hôtel owned by the duke of Villeroy, presently known as the Hôtel Beauharnais (see Karl Hammer, *Hotel Beauharnais* [Munich: Artemis Verlag, 1983], 37). Pascal Etienne mentions two in the faubourg Poissonnière – one in the Hôtel Botteral-Quintin and the other in the dining room of the architect Bélanger. *Le Faubourg Poissonnière: Architecture, élégance et décor*, ed. Pascal Étienne (Paris, 1986), 204, 227. On a cycle of Roberts commissioned by Laborde for a "petit salon" at the chateau of Méréville, see my article, "La Chose Publique: Hubert Robert's Decorations for the petit salon at Méréville," in Bermingham and Brewer, *The Consumption of Culture*, 401–15.

51. "Il était de mode, et très-magnifique, de faire peindre son salon par Robert." E. Vigée-Lebrun, *Souvenirs*, ed. Claudine Herrmann (Paris: Éditions Des Femmes, 1986), 2: 308. The first edition of the *Souvenirs* was in 1835.

52. *Souvenirs du Baron de Frénilly, pair de France, (1768–1828)*, publiés avec introduction et notes par Arthur Chuquet (Paris: Plon, 1909), 251–52. Frénilly judged the Molé project to be in extremely bad taste: "Il n'y avait pas une étincelle de goût dans toute cette famille."

53. The letter is discussed by Cayeux in *Hubert Robert*, 270.

54. On the signification that antiquity held for this elite, see Edouard Pommier, "Winckelmann et la vision de l'Antiquité classique dans la France des Lumières et de la Révolution," *Revue de l'Art* 83 (1989), 9–20. Also see Simon Schama, *Citizens: A Chronicle of the French Revolution* (New York: Vintage Books, 1990).

55. Good secondary sources have been published on Hubert Robert. Claude Gabillot's fine monograph, *Hubert Robert et son temps*, reproduces invaluable extracts from

such documents as the catalogue of the studio sale that took place upon the artist's death in 1809 and the *après-décès* of his wife in 1821. Jean de Cayeux has published extensively on the artist. See Cayeux, *Hubert Robert*; Cayeux, *Hubert Robert et les Jardins* (Paris: Éditions Herscher, 1987); Cayeux, *Les Hubert Robert de la Collection Veyrenc au Musée de Valence* (Valence: Le Musée de Valence, 1985); and Catherine Boulot, Jean de Cayeux, and Hélène Moulin, *Hubert Robert et la Révolution* (Valence: Le Musée de Valence, 1989). Also important for any study of Robert is Marie-Catherine Sahut and Nicole Garnier, *Le Louvre d'Hubert Robert* (Paris: Éditions de la Réunion des Musées Nationaux, 1979).

Chapter 2. *Making Conversation: Hubert Robert in the Salon of Madame Geoffrin*

1. Excerpts from Madame Geoffrin's account books are reprinted in Appendix II of Ségur, *Le Royaume de la Rue Saint-Honoré*, 403–407.
2. Ellen G. D'Oench, *The Conversation Piece: Arthur Devis and His Contemporaries* (New Haven: Yale Center for British Art, 1980), 1. Mario Praz defines conversation pieces as paintings "which represent two or more identifiable people in attitudes implying that they are conversing or communicating with each other informally, against a background reproduced in detail." *Conversation Pieces: A Survey of the Informal Group Portrait in Europe and America* (University Park: The Pennsylvania State University Press, 1971). Marcia Pointon has also written on this subject; see Marcia Pointon, *Hanging the Head: Portraiture and Social Formation in Eighteenth-Century England* (New Haven: Yale University Press, 1993), Chap. VI. See also Ann Bermingham's insightful discussion of the conversation piece in *Landscape and Ideology: The English Rustic Tradition, 1740–1860* (Berkeley: University of California Press, 1986), Chap. 1.
3. Cited by D'Oench, *Conversation Piece*, 3. I have modernized the spelling.
4. A sketch for this painting is in the Musée Carnavalet, Paris.
5. One can make out "Faub. St. Antoine" on the right side of the map shown in Fig. 34, which dates from 1724; the Abbey St. Antoine is marked by an angled rectangle underneath the letters "St."
6. See Ronald Paulson's discussion of the conversation piece in *Emblem and Expression: Meaning in English Art of the Eighteenth Century* (Cambridge, Mass.: Harvard University Press, 1975), 121–36. Paulson defines the conversation piece as "a portrait group of a family or friends in some degree of rapport seen in their home surroundings or engaged in some favourite occupation."
7. William Hogarth hit upon the same formula in the late 1720s and 1730s. Conversation pictures play a role in the genesis of the new genre of visual narrative he developed beginning with *A Harlot's Progress*. On this see Ronald Paulson, *Hogarth, The Modern Moral Subject 1697–1732*, vol. 1 (New Brunswick, N.J.: Rutgers University Press, 1991).
8. Vigée-Lebrun, *Souvenirs*, 1: 37.
9. The sobriquet "Czarine of Paris" comes from P. Paciaudi writing to his friend the

count of Caylus. See *Correspondance inédite du comte de Caylus avec le P. Paciaudi*, 1: 279 n. 2. I wish to thank Dena Goodman, who read this chapter in manuscript form, for her comments on it.

10. According to Ségur, the marriage contract, signed in July 1713, records her dowry as 185,538 livres and 15 sols; his fortune is listed as 254,066 livres. These are considerable amounts of money. Geoffrin also purchased various positions. He is described in the wedding contract as an "écuyer, conseiller-sécretaire du Roy, maison, couronne de France et des ses finances," as well as a "lieutenant-colonel de la milice bourgeoise."

11. *The Letters of Horace Walpole*, ed. John Wright (London: Richard Bentley, 1840), 5: 80.

12. "Voilà donc plusieurs pertes cruelles que la philosophie vient d'éprouver dans l'espace de peu de mois: la mort de Mlle de Lespinasse, celle du Mme de Trudaine, la disgrâce de M. Turgot, et l'apoplexie du Mme Geoffrin. Il n'y a que l'élévation de M. Necker qui puisse nous consoler de tous ces malheurs;" *Correspondance Littéraire*, t. XI (Paris: Garnier Frères, 1880), 367. The date is November 1776. Grimm goes on to praise the young Louis XVI for appointing Necker, concluding that "le triomphe que le mérite a remporté dans cette occasion sur de vains préjugés doit être regardé sans doute comme une preuve du progrès que la raison et les lumières ont fait en France."

13. C.-A. Sainte-Beuve, *Causeries du Lundi*, 3rd ed. (Paris: Garnier Frères, 1858), 2: 315.

14. Karl Hammer, *Hôtel Beauharnais Paris* (Munich: Artemis Verlag, 1983). The predominant subject matter was religious and mythological. Although paintings of animals, fruits, and flowers embellished the walls of the Hotel Torcy, landscapes were scarce. Also see Colin B. Bailey, "Conventions of the Eighteenth-Century *Cabinet de tableaux*: Blondel d'Azincourt's *La première idée de la curiosité*," *The Art Bulletin* 69 (September 1987), 431–47.

15. Colin B. Bailey, " 'Quel dommage qu'une telle dispersion': Collectors of French Painting and the French Revolution," in *1789: French Art during the Revolution*, ed. A. Wintermute (New York: Colnaghi, 1989), 11–26. The taste for collecting in eighteenth-century Paris was not confined to the elites. On this see Annik Pardailhé-Galabrun, *The Birth of Intimacy: Privacy and Domestic Life in Early Modern Paris*, trans. Jocelyn Phelps (Philadelphia: University of Pennsylvania Press: 1991), 154–64.

16. Letter dated beginning of June 1746, reprinted in Carl Fredrik Scheffer, *Lettres particulières à Carl Gustaf Tessin 1744–1752*, ed. Jan Heidner (Stockholm: Kung. Samfundet for utgivande av handskrifter rorande Skandinaviens historia, 1982), 125.

17. *Mémoires et Journal inédit du Marquis d'Argenson* (Paris: P. Jannet, 1763), 96–99.

18. J.-F. Marmontel, *Mémoires*, ed. John Renwick (Clermont-Ferrand: G. de Bussac, 1972), 1: 168.

19. Saint-Beuve, *Causeries*, 2: 309.

20. See Saint-Beuve, who observed that there were always reasons behind "une grande

influence sociale . . . sous ces fortunes célèbres qui se résument de loin en un simple nom qu'on répète, il y a eu bien du travail, de l'étude et du talent; dans le cas présent de Madame Geoffrin, il faut ajouter, bien du bon sens." *Causeries*, 2: 310.

21. *Éloges de Madame Geoffrin* par MM. Morellet, Thomas et d'Alembert suivis de Lettres de Madame Geoffrin et à Madame Geoffrin (Paris: H. Nicolle, 1812), 57.

22. *Correspondance Inédite du Roi Stanislas-Poniatowski et de Madame Geoffrin (1764–1777)*, précédée d'une étude sur Stanislas-Auguste et Madame Geoffrin par Charles De Möüy (Paris, 1875; Geneve: Slatkine rpt., 1970), 219.

23. "J'ai commencé la collection de mes tableaux en 1750," she writes in her *carnet*; "Ils ont tous été faits sous mes yeux." Reprinted in Ségur, *Le Royaume de la Rue Saint-Honoré*, 406.

24. She noted she had commissioned three large "tableaux de fabrique et paysages" in 1771 and 1772 from Robert for 2,760 livres; then three large paintings representing the gardens of the Abbey Saint-Antoine for 1,800 livres; and then the two showing the interior of her hôtel for 864 livres. The last two were given away, not sold, to M. de Trudaine (*j'ai donnés à M. de Trudaine*). Ségur, *Le Royaume de la Rue Saint-Honoré*, 406.

25. Jean-Marc Nattier's portrait of Madame Geoffrin is illustrated in David Wakefield, *French Eighteenth-Century Painting* (New York: Alpine Fine Arts Collection, 1984), 158; Nattier's *La Marquise de la Ferté-Imbault*, 1740, is illustrated in Jacques Thuiller and Albert Châtelet, *French Painting from Le Nain to Fragonard* (Geneva: Skira, 1964), 190.

26. On this subject see Pomian, *Collectors and Curiosities*, Chap. 5.

27. Pomian discusses rising prices for works of art. See also Jean Chatelus, *Peindre à Paris au XVIIIe Siècle*, (Nîmes: Éditions Jacqueline Chambon, 1991), 284–96.

28. Quoted by Chatelus, *Peindre à Paris*, 289.

29. Chatelus, *Peindre à Paris*,105.

30. J.-A.-B. marquis Costa de Beauregard, *Un Homme d'Autrefois*, souvenirs recueillis par son arrière-petit-fils, le marquis Costa de Beauregard (Paris: Plon, 1878), 52. The form of a roundtable discussion is, of course, consonant with salon culture. As d'Alembert, who was a stalwart member of the Wednesday salon at Madame Geoffrin's, contended – discussion enhanced the understanding and pleasure produced by works of art: "C'est sans doute sur les ouvrages qui ont réussi en chaque genre, que les règles doivent être faites; mais ce n'est point d'après le résultat général du plaisir que ces ouvrages nous ont donné: c'est d'après une discussion réfléchie, qui nous fasse discerner les endroits dont nous avons été vraiment affectés, d'avec ceux qui n'étaient destinés qu'à servir d'ombre ou de repos, d'avec ceux même où l'auteur s'est négligé sans le vouloir." I thank Dena Goodman for pointing out this reference to me. See d'Alembert's "Réflexions sur l'usage et sur l'abus de la philosophie dans les matières de goût (1757)," in *Oeuvres complètes* (Paris: A. Belin, 1822), 4: 330.

31. *Éloges de Madame Geoffrin*, 57.

32. To establish a visual tradition or make a point about iconography, I prefer to use the eighteenth-century prints that were available to Hubert Robert as my illustrations. Such prints enjoyed wide circulation during the period and thus were far

more familar to artists than the paintings on which they were based. Unless otherwise noted, prints reverse the image of the original.

33. Most cost around 600 livres each.

34. It is important to stress that the salon was not composed of individuals who stood apart from the court and the academy, like the avant-garde in the nineteenth century. *Lundi* regulars like Carle Van Loo enjoyed prestigious posts at court like that of *premier peintre du roi*; after Van Loo's death, Boucher, another habitué of the salon, received the honor. Likewise, notable members of the Wednesday salon, d'Alembert and Delille, for instance, were accepted by the Académie Française.

35. In 1771, Madame Geoffrin arranged a meeting with Marie-Antoinette at Versailles – but she insisted that the audience take place on neither a Monday nor a Wednesday, for on those days she was devoted "à des sociétés particulières, et dont l'assemblage subsiste depuis trente ans." See the letter to the comtesse de Noailles in the family archive cited by Ségur, *Le Royaume de la Rue Saint-Honoré*, 201.

36. Letter is reprinted in Cayeux, *Hubert Robert*, 81.

37. Ségur, *Le Royaume de la Rue Saint-Honoré*, 53.

38. Crow, *Painters and Public Life*, 40. Crow discusses the importance of the Crozat coterie to Watteau in Chap. 2. Also see M. J. Dumesnil, *Histoire des Plus Célèbres Amateurs Français et de leurs relations avec les Artistes, Tome I: Pierre-Jean Mariette, 1694–1774* (Paris: Jules Renouard, 1858), 17.

39. Scott, *Rococo Interior*, 221–22.

40. *Correspondance Inédite du Roi Stanislas-Poniatowski*, 264. Aldis writes that foreigners who wanted a special artist or craftsman often appealed to Madame Geoffrin. She cites an excerpt from Walpole to his friend, George Selwyn, who was going to Paris "to ask Madame Geoffrin where Mons. Guibert, the king's carver lives, and then to send him a guinea for a drawing he made for me, which will deduct from the lottery tickets!" The Earl Marischal of Scotland, in another example, asked David Hume to ask Madame Geoffrin about some prints representing famous philosophers, which he needed to complete his collection. Janet Aldis, *Madame Geoffrin: Her Salon and Her Times, 1750–1777* (London: Methuen & Co., 1905), 82–83.

41. Academicians were forbidden from displaying their wares in shops. See Annie Becq, "Expositions, Peintres et Critiques: Vers l'Image Moderne de L'Artiste," *Dix-huitième siècle* 14 (1982), 131–48.

42. On this subject, see *Le Cabinet d'un Grand Amateur P.-J. Mariette, 1694–1774*, exh. Musée du Louvre (Paris: Ministère des Affaires Culturelles, 1967). After selling the business, Mariette purchased the post of *contrôleur général* in the Grande Chancellerie de France; he was also admitted as an *associé libre* in the Royal Academy of Painting in 1750.

43. *Éloges de Madame Geoffrin*, 57–58. As Morellet described it, certain "gens du monde," distinguished by a little learning, or even by a bit of innate taste or *esprit*, felt a lack (*sentent trop bien le vide*) when the conversation turned to artistic matters. They eagerly welcomed an opportunity to mix with "hommes à talens et des

gens de lettres," who, having made the culture of the arts or sciences their life's work, naturally had greater knowledge and better taste than did they.

44. "C'est là qu'il acquit un jugement sûr et que, malgré lui, il épura son goût. Que de peine tous ces habiles gens que j'ai connus m'ont dit avoir eue à lui inculquer le goût du vrai beau, qu'il sentait, mais dont son amour-propre l'éloignait!" Comte Dufort de Cheverny, *Mémoires* (Paris: Les Amis de l'Histoire, 1970), 1: 140–41.

45. *Correspondance inédite du comte du Caylus avec le P. Paciaudi*, 1: 302. No doubt this is one reason she was called the "Czarine de Paris" (1: 279).

46. "le bon usage que Mme Geoffrin fait de sa fortune ne permet pas de douter qu'elle n'emploie d'une manière convenable le gain qu'elle vient de faire dans ce marché." *Correspondance Littéraire*, 10: 118.

47. Duc de Castries, *Julie de Lespinasse: Le drame d'un double amour* (Paris: Albin Michel, 1985), 73.

48. Sharon Kettering, "Patronage in Early Modern France," *French Historical Studies*, 17 (fall 1992), 849–51, 856; see also Sharon Kettering, "Gift-Giving and Patronage in Early Modern France," *French History* 2 (June 1988), 131–51.

49. *Correspondance Inédite du Roi Stanislas-Poniatowski*, 219.

50. "Tired of seeing only Alexanders, Caesars, Scipions, she had proposed to the artists who are her friends, to discover in European costumes some worthy subject that will create an effect." Cited in *Diderot et l'Art de Boucher à David: Les Salons, 1759–1781*, exhibition Hôtel de la Monnaie (Paris: Editions de la Réunion des Musées nationaux, 1984), 370.

51. Charles-Henri Gleichen, *Souvenirs de Charles-Henri Baron de Gleichen* (Paris: Léon Techener, 1868), 100. The painter was Hubert Robert and the commission was the Saint-Antoine series, of which more shortly.

52. Her support of the *philosophes* and of such enterprises as the *Encyclopédie* are also documented. See *Éloges de Madame Geoffrin*, 30–36, and Grimm, *Correspondance Littéraire*, 11: 407–408.

53. *Diderot et l'Art de Boucher à David*, 76–77.

54. L. Petit de Bachaumont, *Mémoires secrets pour servir à l'histoire de la république des lettres en France* (Londres: 1777–89), vol. 5 (1770), 123.

55. *Correspondance Inédite du Roi Stanislas-Poniatowski*, 339. The accounts book notes artworks from her collection given as gifts to madame de Marchais, the marquis de Sérent, and monsieur de Trudaine.

56. *Correspondance Inédite du Roi Stanislas-Poniatowski*, 460.

57. Barbara Scott, "Madame Geoffrin: A Patron and Friend of Artists," *Apollo* 85 (February 1967), 98–103. Madame Geoffrin also had a taste for images of young girls and children. The collection contained two pictures of young girls by Vien, the head of a baby and a young priestess by Van Loo, five pictures of children by Drouais, and a young girl by Greuze (although this may be the picture she gave to Marigny as a gift in 1759). Note that the picture Robert presented to her in Figure 9 is a tondo of a young woman. The third well-represented category in the collection is that of Holy Families, of which there were five. See also Lastic Saint-Jal, "La Reine de la Rue Saint-Honoré," 50–57.

58. B. Scott, "Madame Geoffrin," 101. In the companion piece by Van Loo, *La Conversation Espagnole* (both now in The Hermitage, St. Petersburg), the lady dressed in white with the musical score is a likeness of Madame Geoffrin's daughter, the marquise de la Ferté-Imbault. Later, Van Loo painted his own daughter, Rosalie, for Madame Geoffrin, depicted as a pagan priestess carrying baskets of flowers.

59. Madame Geoffrin had mounted on her wall a whole series of profile portraits, in tondo, representing her friends. Catroux illustrates the profile portraits of Caylus, Mariette, and Marigny, among others that she owned. R.-Claude Catroux, "Hubert Robert et Madame Geoffrin," *La Revue de l'Art Ancien et Moderne* 40 (June 1921), 39.

60. Catroux,"Hubert Robert et Madame Geoffrin," 38.

61. Ségur, *Le Royaume de la Rue Saint-Honoré*, 495. These identifications were communicated to him by la comtesse de La Bédoyère, to whom the pictures belonged in 1898 when Ségur published the book. Ségur had access to a great store of letters and other archival material maintained by the family of Louis d'Estampes, the marquis de Mauny, nephew of the deceased husband of Madame Geoffrin's daughter, the marquise de la Ferté-Imbault, and the person to whom she left all her property when she died, childless, in 1791.

62. *Diderot et l'Art de Boucher à David*, 403–405. See his other comments on p. 372, and the anecdote about Greuze in Aldis, *Madame Geoffrin*, 55–56.

63. Catroux reads the three pictures this way.

64. Ronald Paulson, for example, illustrates one example in his discussion of the conversation piece. See Ronald Paulson, *Emblem and Expression: Meaning in English Art of the Eighteenth Century* (Cambridge, Mass.: Harvard University Press, 1975), 125.

65. "J'ai voulu aller au-devant d'une époque toujours difficile, répondait-elle à quelqu'un qui lui parlait avec surprise de l'austérité de son costume; j'ai voulu me faire vieille de bonne heure. Quand la vieillesse viendra véritablement, elle me trouvera toute prête." Cited in La Duchesse d'Abrantès, *Une Soirée chez Mme. Geoffrin* (Bruxelles: Société Générale d'Imprimerie, 1837), 8. There are many anecdotes about Madame Geoffrin's mode of dress, which was subdued and monastical from the time that she began her salon. That the king of Poland called her "maman" is related to this carefully constructed feature of her identity. She never appeared to her friends as a young woman.

66. Dena Goodman, "Enlightenment Salons: The Convergence of Female and Philosophic Ambitions," *Eighteenth-Century Studies* 22, no. 3 (1989), 340–50.

67. I owe this description to Dena Goodman.

68. Lancret's *The Ham Dinner* was painted for the new dining room in the private apartments of Louis XV at Versailles in 1735; it was widely known through an engraving by P.-E. Moitte, which appeared in 1756. William Hogarth painted a number of rowdy scenes of male conviviality; see, e.g., *A Midnight Modern Conversation*, c. 1730.

69. Early in the century the abbess was a Condé, a princess of the blood. Her successor, a Beauvau-Craon, was also a princess.

70. This area is resonant with other significations relating to the identity of Madame Geoffrin. Much of the fortune that Madame Geoffrin inherited upon her husband's death in 1749 was the result of the appreciating value of her husband's shares in the state-supported mirror manufactory of Saint-Gobain. Monsieur Geoffrin had been a major officer and stockholder in this venture, and after his demise, his wife sat on the company's board, where she played an active role in the management of the enterprise. The company's weekly board meetings were held in the same massive old building in which the glass underwent its final polishing and packing, which was located on the rue de Reuilly, literally around the corner from the abbey Saint-Antoine. See Augustin Cochin, *Études Sociales et Économiques* (Paris: Didier et Cie., 1880), 312–16.

71. One would like to know more about the sociability of nuns in convents and of their connection to Habermas's developing "public sphere." Madame Geoffrin's identification with this abbey suggests that such a relation existed.

72. William Cole, *A Journal of My Journey to Paris in the Year 1765 by the Rev. William Cole*, ed. Francis Griffin Stokes (London: Constable & Co., 1931), 81–82. This is a damning description by Cole because he believed the *philosophes* were responsible for "that general Spirit of Infidelity & Skepticism so prevalent thro'out France" (p. 14).

73. Marmontel, *Mémoires*, 1: 161. To complicate matters, Madame Geoffrin's daughter, the marquise de la Ferté-Imbault, was a strong advocate of the Catholic Church, who detested salon regulars such as d'Alembert primarily because of the religious question. Her attempts to bar the door to d'Alembert and the other *philosophes* when Madame Geoffrin lay on her deathbed created a scandal.

74. "J'assure Votre Majesté que je vois l'époque de ma mort morale très-gaiement." *Correspondance Inédite du Roi Stanislas-Poniatowski*, 316.

75. *Correspondance Inédite du Roi Stanislas-Poniatowski*, 349. Letter dated 30 octobre 1768. In fact, the first health problems this remarkably hale woman suffered were in 1769, when she was 70. See Ségur, 356.

76. Gleichen, *Souvenirs*, 100–101.

77. Bachaumont, *Mémoires secrets*, 3: 26.

78. *Éloges de Madame Geoffrin*, 47–48. Grimm also related this incident and said that Sterne himself did not disavow the two fabricated chapters. *Correspondance Littéraire*, 12: 13.

79. Though he is not addressing questions pertaining to the eighteenth-century salon in his essay "Metaphor and the Cultivation of Intimacy," in his analysis of the dynamics of metaphor, Ted Cohen provides a brilliant insight into salon *mentalité*. Cohen argues that one value attained by the use of figurative allusion is intimacy. The speaker issues a "concealed invitation," the listener reacts to it, and if the listener has done so appropriately, the transaction constitutes the "acknowledgement of a community." The point in using a metaphor, as in telling a joke (another subject about which Cohen has written) is the pleasurable complicity of speaker and hearer. To outsiders who lack access to certain information in the "community," the figurative use will be incomprehensible. This seems to me to perfectly

describe the dynamics at work in Robert's representations of Madame Geoffrin. See Ted Cohen, "Metaphor and the Cultivation of Intimacy," in *On Metaphor*, ed. Sheldon Sacks (Chicago: The University of Chicago Press, 1978), 1–10; and Ted Cohen, "Jokes," in *Pleasure, Preference, and Value: Studies in Philosophical Aesthetics*, ed. Eva Schaper (Cambridge: Cambridge University Press, 1983), 120–36.

80. "On peut dire que ses portraits avoient l'expression du genre flamand, mais avec une familiarité plus noble dans les figures." Thomas in *Éloges de madame Geoffrin*, 88.

81. Gleichen, *Souvenirs*, 97.

82. *Éloges de Madame Geoffrin*,18.

83. Gleichen, *Souvenirs*, 97; "Le genre d'esprit favori de madame Geoffrin était celui des comparaisons, et elle en a trouvé qui sont infiniment justes et ingénieuses."

84. David Smith discusses the symbolism of the doorway in "Carel Fabritius and Portraiture in Delft," *Art History* 13 (June 1990), 151–74.

85. The nuns do not appear to be playing cards, as others have asserted. I am indebted to present owner of the pictures, who graciously permitted me to examine and to photograph them.

86. It is doubtful that such an odd-sized basin existed in fact; it is even questionable whether this particular arbor existed at the Abbey of Saint-Antoine. Robert had represented a family with children and servants sitting under exactly the same arbor in a watercolor drawing dated 1773. The drawing is illustrated in Jean de Cayeux, *Hubert Robert et les Jardins*, 125. Cayeux speculates that the family in the drawing may be Robert's.

87. *Iconologie, ou, explication nouvelle de plusieurs images, emblemes, et autres figures; tirée des recherches et des figures de Cesar Ripa*, moralisées par E. Baudoin (Paris: Mathieu Guillemot, 1644), 28. Baudoin defines "bienveillance" as the good will a wife holds for her husband.

88. *Éloges de Madame Geoffrin*, 72.

89. *Éloges de Madame Geoffrin*, 93.

90. Gleichen, *Souvenirs*, 95.

91. J.-F. de La Harpe, *Oeuvres de La Harpe* (Genève: Slatkine rpt., 1968), 10: 243.

92. La duchesse d'Abrantès, *Une Soirée chez Mme. Geoffrin*, 20.

93. Cited in *Éloges de Madame Geoffrin*, 47. These terms are close in meaning, but with slight differences in inflection. "Beneficence" (*bienfaisance*) is defined as being kind or doing good, a kindly action or gift; and "Benevolence" (*bienveillance*) as an inclination to do good, a kindly, charitable activity. *Bonté* means goodness or kindness.

94. "Dans sa manière de donner, elle s'effaçoit, pour ainsi dire, elle-même, autant qu'il étoit possible"; Thomas in *Éloges de Madame Geoffrin*, 95.

95. *Éloges de Madame Geoffrin*, 25.

96. *Éloges de Madame Geoffrin*, 48: "l'amitié goûter [sic], aux yeux de l'amitié, des jouissances qu'elle eût voulu se réserver à elle seule, et qui n'en étoient que plus douces en se partageant." D'Angiviller adds his testimony also when he criticizes Marmontel for ridiculing Madame Geoffrin for "bienfaisance active et modeste qui marche

toujours envelopée d'un voile." *Mémoires de Charles Claude Flahaut Comte de la Billarderie d'Angiviller, Notes sur les Mémoires de Marmontel,* publiés d'après le manuscrit par Louis Bobé (Copenhague: Levin & Munksgaard, 1933), 17–18.

97. On this see Marc Fumaroli, *Le genre des genres littéraires français: La conversation,* the Zaharoff Lecture for 1990–91 (Oxford: Clarendon Press, 1992), 27: "The essence of the conversation was to attain a second state – euphoric and inventive – that made unexpected mots d'esprit shoot forth . . . very analogous to a state of literary inspiration, only this was not solitary, but a process exalting itself by the improvisations of others."

98. Bailey discusses this subject in "Conventions," 438–43.

99. See Mary D. Sheriff's analysis of how the pendants painted by Boucher for Madame Geoffrin reviewed by Diderot in the Salon of 1765 worked together. Mary D. Sheriff, *Fragonard: Art and Eroticism* (Chicago: The University of Chicago Press, 1990), 66–67, and Chap. 2, "Dynamics of Decoration." I owe a great debt to Sheriff, who emphasizes the importance of the artist-created subject, one not supported by a text. By this she means that viewers are called upon to devise their own "story" for the panels, exactly the point I have been making here.

100. Hogarth's *A Harlot's Progress* again furnishes a corollary. Paulson argues that Hogarth began with the principle of contrast – beauty vs. corruption – and then expanded the imagery into a causal sequence that explained how the harlot got to where she was. Putting the prints two deep on a wall results in different sorts of ligations and connections between the images, a structure analogous to the Roberts under consideration. See Paulson, *Hogarth,* 1: 238–77.

101. *Un Artiste Présente un portrait à Madame Geoffrin,* canvas, 66 x 58 cm, signed "Peint par H. Robert"; *Le Déjeuner de Madame Geoffrin,* canvas, 66 x 58 cm, signed "Peint par H. Robert;" both are in the same private collection.

102. Ségur, *Le Royaume de la Rue Saint-Honoré,* 495; Catroux, 31.

103. Trudaine seems to have been fond of conversation-type pictures. He had purchased Robert's *Décintrement du pont de Neuilly* also. The two pictures seem to have been returned at some point to Madame Geoffrin's daughter, the marquise de la Ferté-Imbault and, like the Saint-Antoine series, remained within the family in the collection of the comte La Bédoyère until 1921.

104. Hogarth's pictures owe a debt to "Dutch droils," or drolleries as they were called. Robert also imitated artists like Brouwer and Teniers; see in particular drawings in the National Gallery in Washington, D.C.

105. The duc de Choiseul's most prized paintings were *The Sick Woman* and *The Poulterer's Shop,* both by Gerard Dou, and Gerard Terborch's *Woman Playing a Thorebo to Two Men.* The esteem in which the duke held these paintings was evidently general; the pair brought in over 36,000 livres when they were auctioned in 1773 (the year before Robert painted the Geoffrin pictures). Robert owned the illustrated catalogue of the Choiseul collection, the *Recueil d'estampes gravées d'après les tableaux du cabinet de Monseigneur le duc de Choiseul,* engraved by P. F. Basan in 1771 (no. 377 in Robert's studio sale of 1809). Pomian connects the taste for these Dutch and Flemish seventeenth-century "petits tableaux" to the

growth of collecting. He argues that the new collectors believed works of these schools were harder to fake than were Old Masters of the Italian school, and so they were avid to procure them; eventually, this developed into a bifurcated market of "vrais connoisseurs" and "simples curieux," the former preferring works of history and religion conventionally categorized under the rubric of "grand goût" and the latter preferring works of genre. Pomian, *Collectors and Curiosities*, 153–68.

106. He owned some seventeenth-century Dutch pictures – a large Jacob Ruisdael, a Jan van Goyen, and an Asselyn, for example.

107. Robert owned a Watteau representing the Mezetin, Scapin, Pierrot, etc. – no. 26 in the studio sale.

108. Oil on panel, Toledo Museum of Art.

109. See David R. Smith, "Irony and Civility: Notes on the Convergence of Genre and Portraiture in Seventeenth-Century Dutch Painting," *The Art Bulletin* 69 (September 1987), 407–30. My approach to reading the Roberts is similar to Smith's.

110. Robert's Chardin, purchased at an unknown time (probably after 1773), was a copy of the *Lady Sealing a Letter*, c. 1733. When it was put up for auction at the 1809 studio sale, Paillet, the compiler of the catalogue, observed that the figure in the Chardin wore a dress "qui tient à celui de feue Madame Joffrin [*sic*]," a feature that rendered this piece "vraiment curieux et original." In her discussion of the Geoffrin drawings, Marguerite Beau treats the remark skeptically. Marguerite Beau, *La collection des dessins d'Hubert Robert au Musée de Valence* (Lyon: Audin, 1968). Paillet, however, may have been aware of Robert's drawing of Madame Geoffrin, now in Valence (or a version thereof), because in it he portrays Madame Geoffrin wearing a gown with a marked pattern of stripes. Both Chardins were engraved and thus available to Robert in graphic form. Chardin (1699–1779) and Robert, of course, knew each other, because both had ateliers at the Louvre.

111. Salon of 1738, National Museum, Stockholm.

112. In Robert's *oeuvre*, the motif appears very early. See *Intérieur du Colisée*, a drawing in Valence, signed and dated 1759; *Le dessinateur au musée du Capitole* (sanguine, 335 x 450 cm) from around 1762, and *The Draughtsman in an Italian Church*, dated 1763, (sanguine, 329 x 448 cm, Pierpont Morgan Library, New York). One of the Bouchers that Robert owned represented the painter at his easel (no. 33 in the 1809 studio sale) – *The Landscape Painter* (oil/panel, 27 x 22 cm, Musée du Louvre, Paris). This picture has also been interpreted as an image that deflates the exalted nature of the artist's calling by picturing the unidealized, hard-working painter laboring in a garret; however, in the Boucher, the artist is shown painting a landscape from the imagination, thus he is not "aping" nature as in the Chardin. See *François Boucher, 1703–1770*, exhibition (New York: The Metropolitan Museum of Art, 1986), 149.

113. The picture has a pendant showing a group of Polichinelle figures engaged in musical activity; both are conserved at Amiens, Musée de Picardie. They belonged first to the artist Natoire and then were sold in 1778 to the comte d'Houdetot.

114. Paulson says that Hogarth picked up the motif of the animals in "equivocal"

postures from Watteau – a means of drawing attention to the gap between civilized behaviors and instinct, art, and nature, as well as the use of emblematic objects like bagpipes. Paulson, *Hogarth*, 1: 210.

115. On the *Fêtes Vénitiennes*, see Crow, *Painters and Public Life*, 63–65.

116. The male figure showing Madame Geoffrin the canvas in Figure 9 is generally identified as Hubert Robert, an identification I support. The figure resembles what seems to be an early portrait of Robert tentatively attributed to Fragonard. It is illustrated in *J. H. Fragonard e H. Robert a Roma*, exhibition Villa Medici (Roma: Frateli Palombi Editori-Edizioni Carte Segrete, 1990), 53. It can also be compared with the several portraits of the artist illustrated in Pontus Grate, "Hubert Robert et l'iconographie d'Augustin Pajou," *Gazette des Beaux-Arts* (juillet-août 1985), 7–14.

117. Paulson, Hogarth, 1: 222–30.

118. Paulson argues that Hogarth was poking fun at his patrons in his 1729 conversation picture of the Castlemaines, but "part of Hogarth's joke was that none of the subversive play would have registered on the Castlemaines." Paulson, *Hogarth*, 1: 208.

119. *Französische Zeichnungen im Städelschen Kunstinstitut, 1550 bis 1800* (Frankfurt am Main: Städtische galerie im Städelschen Kunstinstitut, 1986), no. 128. The annotation connects the imagery to a popular song with a refrain that can be roughly translated as ridding Versailles of Dubarry by giving her a kick in the backside: "Allégorie sur la décadence de la famille Dubarry et sur le refrain d'une chanson qui se terminait par la pelle au cul. La Comtesse Dubarry après la mort de Louis Quinze fut rejoindre sa mère dans un village près Monthlery [*sic*]. L'artiste a fait allusion au mot pour démontrer leur ignorance et leur bassesse en faisant sortir deux ânes de l'hotel, et accrochant les maquereaux à une croisée, en faisant cultiver un Rosier dans un pôt de chambre." The drawing belonged to the duchesse de Grammont (née Choiseul).

120. Other examples of "comical" Roberts include *Laundress and Child*, 1761 (o/c; 35.1 x 31.6 cm), in the Sterling and Francine Clark Art Institute, Williamstown, Mass., which juxtaposes a urinating little boy against a relief of a male face spouting water into a fountain; here Robert depended on analogical structures for his joke – but it is a point we do well to remember when he pictures spouting fountains and rushing waters in his garden scenes. A more wry humor is represented in *L'Accident* (Musée Cognacq-Jay, Paris) where Robert has painted a man falling head over heels from the top of a ruined temple into an open antique sarcophogas, its lid conveniently removed and set against it.

121. "Raillerie" was what the salon valued, according to Jean-Paul Sermain – not irony. Irony, he maintains, exludes those out of the coterie who cannot catch the reference; it ridicules them, and it supposes that the audience shares the same opinion as the speaker/author. See "La Conversation au Dix-huitième siècle: Un théâtre pour les lumières?" in *Convivalité et politesse: Du gigot, des mots et autres savoir-vivre*, ed. Alain Montandon (Clermont-Ferrand: Association des Publications de la Faculté des Lettres et Science Humaines, 1993), 105–30.

122. Grimm, *Correspondance Littéraire*, t. XI, 366.
123. Ségur, *Le Royaume de la Rue Saint-Honoré*, 179–91.
124. "Ses lois principales étaient de n'avoir pas le sens commun, de faire des chansons, et de dire des bêtises spirituelles." Gleichen, *Souvenirs*, 102.
125. Gleichen, *Souvenirs*, 102.
126. On this subject, see Dena Goodman, "Filial Rebellion in the Salon: Madame Geoffrin and Her Daughter," *French Historical Studies* 16 (spring 1989), 28–47.
127. An excerpt from one of these reads as follows: "Je veux y danser comme un fou / Entre Minette et son Matou. / Je conviendrai pourtant sans peine / Que ce ne sont pas jeux d'enfants: / Minette a soixante et seize ans, / Et le Matou la soixantaine!" Cited by Ségur, *Le Royaume de la Rue Saint-Honoré*, 195.
128. Grimm, *Correspondance Littéraire*, 12: 259. Grimm was also a member of the Lanturelus.
129. A counterproof of Figure 17 exists also. See Beau, *La Collection des dessins d'Hubert Robert au Musée de Valence*, Figs. 86 and 87; and Cayeux, *Les Hubert Robert de la Collection Veyrenc au Musée de Valence*, 240–45.
130. See *Diderot et l'Art de Boucher à David*, 411, on the works by Vien.
131. Whether these existed is questionable. In her inventory, Madame Geoffrin mentions overdoors, but they do not resemble these. The ones she lists are "quatre dessus de porte en guirlandes," which cost 600 livres. And if the one panel features Madame Geoffrin as Minerva, the other may be playing with a representation of her as Aphrodite, the sensual (Fig. 9) as opposed to the cerebral apprehension of culture (Fig. 10).
132. The patron regarding a work of art on an easel is also common iconography in the conversation picture. See, e.g., William Hogarth's *The Fountaine Family*, c. 1730, illustrated in Paulson, *Hogarth*, 1: Fig. 77; another example in the same book is Sir James Thornhill's *Sketch of His Family*, c. 1730, showing them posed around one of the Raphael cartoons (Fig. 72), the most highly venerated work of the Italian Renaissance in England.
133. There is yet another iconographic tradition in the pendants – one that involves the "Times of Day." Warming by the fire, e.g., is a common emblematic attribute of Morning. The work activities of early risers such as shepherds and hunters is reprised here most amusingly by Robert in the domestic employments of Madame Geoffrin's servant, who begins his day by sweeping and dusting his mistress's rooms. Likewise, the first cup of hot brew – coffee or chocolate – was commonly associated with morning. In Lancret's *Times of Day*, e.g., the lady of the house shares a cup of coffee with her first caller, an abbé, in the print entitled "Morning." The complement of Morning is Evening. Robert could not employ the traditional imagery of Nox or Night here, because these usually included references to drinking and merrymaking as the typical occupations of the nighttime hours. Madame Geoffrin rarely made evening calls and never attended habitual eighteenth-century amusements like the theater. The artist could, however, suggest the evening light casting its long shadows in the dusky bedchamber of the salonniere, where the bed itself symbolizes nighttime. Moreover, the visual arts have sometimes been

associated emblematically with Night because of the illusion of reality that both dreams and the graphic arts can produce, so a conceit of presenting her evaluating a work of art is perfectly consonant with these conventions.

134. See Boucher's *Le déjeuner* of 1739 (Musée du Louvre, Paris) or Lancret's *Famille dans un jardin* of 1742 (The National Gallery, London).

135. Cissie Fairchilds, *Domestic Enemies: Servants and Their Masters in Old Regime France* (Baltimore: The Johns Hopkins University Press, 1984).

136. Sarah C. Maza, *Servants and Masters in Eighteenth-Century France: The Uses of Loyalty* (Princeton: Princeton University Press, 1983).

137. *Correspondance Inédite du Roi Stanislas-Poniatowski*, 228.

138. Her *maître d'hôtel* received 720 livres, so did her *portier*. Ségur, *Le Royaume de la Rue Saint-Honoré*, 108.

139. The account book indicates that Nanteuil and Marianne both received gold watches, valued at 300 francs, from their employer.

140. Gleichen, *Souvenirs*, 105. Also Ségur, *Le Royaume de la Rue Saint-Honoré*, 255, where she speaks of waking up the maids Marianne and Nanette at 4 a.m. and asking them "très poliment" to wake the "beaux messieurs," Nanteuil and Pichard.

141. *Correspondance Inédite du Roi Stanislas-Poniatowski*, 228.

142. "Il faut conserver de l'autorité dans son domestique, mais une autorité douce." *Oeuvres morales de Mme. Saint-Lambert*, précédées d'une étude critique par M. de Lescure (Paris: Librairie des Bibliophiles, 1883), 96.

143. Conisbee reads the pictures this way; Philip Conisbee, *Chardin* (Lewisburg: Bucknell University Press, 1985), 123. The prints I reproduce as illustrations reverse the figures in the painted versions, but the reversal does not affect my argument about how the two images complement one another. Chardin exhibited the two paintings on which the prints are based in the Salon of 1738.

144. *Correspondance Inédite du Roi Stanislas-Poniatowski*, 219. Randolph Starn and Loren Partridge discuss Mantegna's relation to Ludovico Gonzaga in similar terms, in *Arts of Power: Three Halls of State in Italy, 1300–1600* (Berkeley: University of California Press, 1992), 110–14.

145. As it does in d'Alembert's mordant "Essai sur la société des gens de lettres et des grands," from *Mélanges de littérature, d'histoire, et de philosophie*, nouvelle édition (Amsterdam, 1759–68), t. I, 325–410.

Chapter 3. Sanctifying Circulation: Hubert Robert in the Archiepiscopal Palace of Rouen

1. They are very large – 4,20 x 3,20 m – and were designed specifically for this wall. The *Vue du château de Gaillon en Normandie* was exhibited in the Paris Salon of 1775. The representation of Rouen is signed and is dated 1773.

2. Nadine-Josette Chaline, ed., *Le Diocèse de Rouen-Le Havre* (Paris: Editions Beauchesne, 1976). The diocese of Rouen in the ancien régime included the *archidiaconé* of Grand Caux, in which Le Havre was located; the *archidiaconé* of Petit Caux, in

which Dieppe was located; and the grand *archidiaconé* of Rouen, in which the city of Rouen was located. Sites not represented in the paintings include the *archidiaconé* of Eu, the *archidiaconé* of Vexin Normand, and the *archidiaconé* of Vexin Français.

3. Gaillon is located on the road between Rouen and Paris about nine leagues outside of Rouen. Ironically, the chateau had fallen outside the ecclesiastical jurisdiction of Rouen until 1740, when it was formally acquired from Evreux.

4. The pictures were returned to the Salle des États in the year X. See Cécile Jéglot, "Les vues de Normandie, par Hubert Robert à l'archevêché de Rouen," *La Revue de l'Art* (1924), 190.

5. Lucia Nuti explains that this mode of representation developed out of the needs of seamen to identify coastal towns from a distance while sailing; profile maps thus "might be compared to the image exposed in a slowly unwinding film as the viewer moves by." Lucia Nuti, "The Perspective Plan in the Sixteenth Century: The Invention of a Representational Language," *The Art Bulletin* 76 (March 1994), 112–15.

6. M. Le Carpentier, *Receuil des plans, coupes et élévations* (Paris, 1758), cited by Jean-Pierre Bardet, *Rouen aux XVIIe et XVIIIe siècles. Les mutations d'un espace social*, preface de Pierre Chaunu (Paris: Société d'Édition d'Enseignement Supérieur, 1983), 55, n. 16.

7. Léon Jouen, ed., *Comptes, Devis et Inventaires du Manoir Archiépiscopal de Rouen*, recueillis et annotés par m. le Chanoine Jouen publiés avec une introduction historique par Mgtr. Fuzet, archevêque de Rouen (Paris: A. Picard et Fils & Rouen: Imprimerie de la Vicomté, 1908), xlvi-xlvii, 528–31.

8. The body type, at least, is consistent with the portrait of the cardinal de la Rochefoucauld by François-Hubert Drouais, exhibited in Rouen, Musée des Beaux-Arts (INV. 909.37.15).

9. Ann Bermingham discusses with regard to Gainsborough the motif of the spectating figure, a type related to the "sketching figure" in these pictures. She argues that for the English artist, the spectating figure is a way of being simultaneously present and detached from the object of attention, suggesting a kind of "alienated involvement." Ann Bermingham, *Landscape and Ideology: The English Rustic Tradition, 1740–1860* (Berkeley: University of California Press, 1986), 46. I believe Hubert Robert is using the device in a similar fashion.

10. Rouen and Le Havre, in particular, were invariably described as "très commerçante, très peuplée" in the eighteenth century. See, for example, Calonne, who responds to the king's query in 1786 about what is to be seen in Rouen by recommending the port, the extent of the quais, and the city's numerous population. He adds that the city itself, "irregular . . . [and] badly built," will interest the monarch only insofar as he can change things for the better. Correspondance reprinted in Jean-Marie Gaudillot, *Le Voyage de Louis XVI en Normandie, 21–29 Juin 1786* (Caen: Société d'Impressions Caron & Cie, 1967), 27, 151.

 Le Havre, because of its modern port facility, was even more impressive to travelers seeking signs of progressive urban change. Arthur Young, in 1788, writes of Le Havre: "Enquiries are not necessary to find out the prosperity of this town; it is nothing equivocal: fuller of motion, life, and activity, than any place I have

been at in France. . . . The harbour's mouth is narrow and formed by a mole, but it enlarges into two oblong basons of greater breadth; these are full of ships, to the number of some hundreds, and the quays around are thronged with business, all hurry, bustle, and animation." *Arthur Young's Travels in France during the Years 1787, 1788, 1789*, ed. Miss Betham-Edwards (London: George Bell & Sons, 1892), 114. For a French commentary dating from Robert's time, see Le Coq de Villeray, who writes of Le Havre: "Cette Ville est d'ailleurs très-peuplée & fort commerçante par le nombre de riches Négocians qui y font leur résidence, & qui y ont des maisons considérables." Pierre Le Coq de Villeray, *Abrégé de l'Histoire ecclesiastique, civile et politique de la ville de Rouen avec son Origine & ses Accroissemens jusqu'à nos jours* (Rouen: François Oursel, 1759), 528–29. For a modern assessment of these ports in the eighteenth century, see Pierre Dardel, *Commerce, Industrie et Navigation à Rouen et au Havre au XVIIIe Siècle* (Rouen: Société Libre d'Émulation de la Seine-Maritime, 1966). The Seven Years War had ended in 1763 and war with England was not to begin until 1778; thus in 1773, at the time of their representation by Robert, the ports were undergoing a period of especially marked commercial prosperity.

11. For example, the archbishop enjoyed, along with his office, the prerogatives of vicomte de Dieppe. In this role, he was the court of last appeal for criminals condemned in Dieppe, and he collected duties on a wide range of Dieppe trades and merchandise, including fishing, pottery, and tobacco; Jouen, *Comptes, Devis et Inventaires*, lxxiii. Loth estimates the revenues from all his dependencies amounted to approximately 172,933 livres annually for De Rochefoucauld. Julien Loth, *Histoire du Cardinal de la Rochefoucauld et du diocèse de Rouen pendant la Révolution* (Evreux: Imprimerie de l'Eure, 1893), 24.

12. "les productions des deux mondes, les vices de toutes les nations." Abbé Jarry, *Oraison funebre de son éminence monseigneur le cardinal de la Rochefoucauld* (Munster: Ant. Guil. Aschendorf, 1801), 14. Rochefoucauld was made a cardinal in 1778.

13. The encyclopedist draws extensively from Montesquieu in this entry. "Or le Christianisme qui proscrit le luxe, qui l'étouffe, détruit & anéantit toutes ces choses qui en sont de dépendences nécessaires. Par cet esprit d'abnégation & de renoncement à toute vanité, il introduit à leur place la paresse, la pauvreté, l'abandon de tout, en un mot la destruction des arts. Il est donc par sa constitution peu propre à faire le bonheur des états."

14. In fact, the conversation became unusually divisive in the Republic of Letters with the appearance of the abbé Galiani's *Dialogues sur le commerce des bleds* (1770). Galiani, who argued against the tenets of Physiocracy, forced the encylopedists to choose sides in the controversy. Most of them, especially the more militant philosophes like Denis Diderot, continued to support Physiocratic tenets.

15. Daniel Roche, *La France des Lumières* (Paris: Fayard, 1993), 137.

16. Cayeux, *Hubert Robert*, 147. Cayeux documents Robert's ties to the Rochefoucauld clan. Robert had known Duke Louis-Alexandre de la Rochefoucauld since 1765, when the former sought him out in Rome. Louis-François de La Rochefou-

cauld de Roye was intimate enough with Hubert Robert to be a signatory of Robert's marriage contract. The countess of Chabot, Watelet, and the duke de la Rochefoucauld-Liancourt all received lessons in the private drawing "academy" staffed by Hubert Robert and several other artists. Robert represented the duchess de Chabot, née la Rochefoucauld, in a large, monumental painting of the chateau of La Roche-Guyon, where she is shown in the act of recording its likeness. This painting was evidently owned by the archbishop of Rouen and displayed in the archiepiscopal palace. Today it is in the Museum of Fine Arts in Rouen, but Jouin inventoried it in the *archevêché* as late as 1907. See Jéglot, "Les vues de Normandy," 197–99.

17. On the archbishop, see Nigel Aston, *The End of an Elite: The French Bishops and the Coming of the Revolution, 1786–1790* (Oxford: Clarendon Press, 1992), 159, 170; Loth, *Histoire du Cardinal de la Rochefoucauld*; and M. Join-Lambert, "La pratique religieuse dans le Diocèse de Rouen de 1707 à 1789," *Annales de Normandie* 5 (1955), 36–49.

18. William M. Reddy, "The Textile Trade and the Language of the Crowd at Rouen 1752–1871," *Past and Present* 74 (1977), 62–89. Micromesnil, reporting back to the royal minister in 1769, writes: "Quant à la ville de Rouen, le peuple gémit de la cherté du pain et du deffaut de travail dans les manufactures. Le cotton est à très bas prix: 1) parce que les fabriques ne vont pas comme il seroit à désirer qu'elles fussent, ce qui fait que les femmes qui filent, ne trouvent pas à vendre leur fil assés bien pour pouvoir vivre, et qu'il y même bien des marchands et de fabriquans qui ne veulent point en acheter, ce qui occasionne des murmures." The price of wheat remained very high until 1777–78. The early 1770s is the beginning of an era of general economic depression. See Dardel, *Commerce, Industrie et Navigation à Rouen*, 53.

19. Abbé Jarry, *Oraison funebre*, 17.

20. Guy Lemarchand, "Les troubles de subsistances dans la généralité de Rouen," *Annales Historiques de la Révolution Française* 35 (1963), 412. In 1775 there were riots over grain too, starting in Vexin Normand, the forest of Lyons, parts of Bray, the territory of Caux and finally the environs of Rouen. Numerous acts of "brigandage" were reported in 1776, and in March 1777 another grain riot erupted in Rouen. See also Ernest Labrousse, Pierre Léon, Pierre Goubert, Jean Bouvier, Charles Carrière, Paul Harsin, *Histoire économique et sociale de la France*, tome II (Paris: Presses universitaires de France, 1984), 550–51.

21. Report attributed to Letellier, mayor of Harfleur reprinted in Gaudillot, *Le Voyage de Louis XVI*, 55. "Le Roi dîna; une multitude de citoyens assiégea portes pour jouir de sa présence; mais un petit nombre eut alors cet avantage. A peine eut-il donné quelques moments aux personnes admises à son couvert qu'il passa dans le salon des Etats pour y recevoir le Bailliage, l'Election, l'Académie, l'Hôtel des Monnaies et le Bureau des Finances. . . . M. de Couteulx, qui présidait cette Compagnie, eut l'honneur d'adresser un compliment au Roi, et le bonheur d'en être écouté favorablement. Il se retirait, lorsque le duc d'Harcourt lui fit connaître, de la part de S.M. qui, pour se soustraire à des démonstrations de reconnaissance, ne l'avait

pas annoncé de sa bouche, que par bienveillance pour le commerce de la province elle supprimait l'ancien droit sur les sucres et les cires."

22. The present archbishop mentioned concerts, in particular.

23. Jouen, *Comptes, Devis et Inventaires*, 605. It was either a picture or a map, the inventories are unclear on this point. One notary described it as "un grand tableau représentant le plan de Gaillon." Gaillon remained a *seigneurie* until feudal rights and privileges were abolished in August 1789.

24. Bernard Aikema and Boudewijn Bakker, *Painters of Venice: The Story of the Venetian "Veduta"* (Rijksmuseum Amsterdam, Gary Schwartz, SDU The Hague, 1990), 50–54.

25. The *Rio dei Mendicanti* and its pendant, the *Piazza San Marco*, painted by Canaletto around 1723–24, are thought to be early examples of this type of commission. Like the Roberts, these Canalettos are large; the *Piazza San Marco*, which is in the Thyssen-Bornemisza Collection, measures 141.5 x 204.5 cm. Aikema and Bakker, *Painters of Venice*, 50, 128. Acts of philanthropy may also be recorded in the imagery of such *vedute*. For instance, a patron may have contributed money to install new paving stones in the Piazzo San Marco or provided funds for the municipal poorhouse on the Rio dei Mendicanti. Having images of these sites on the walls of his residence served to announce the proprietor's charitable support of these civic projects.

26. The four paintings represent the following: a fishing scene dominated by a structure reminiscent of the Castle S. Angelo, a palace *enfilade* flanked by an obelisk, a Greco-Roman temple half-buried in the earth, and an arch supporting either a bridge or an aquaduct across a river.

27. Aikema and Bakker, *Painters of Venice*, 53, n. 105.

28. Bardet, *Rouen aux XVIIe et XVIIIe siècles*, 63–64.

29. Daniel Roche, *The People of Paris: An Essay in Popular Culture in the Eighteenth Century*, trans. Marie Evans (Berkeley: University of California Press, 1987), Chap. 1, esp. pp. 12–16, 32–35. I have built extensively on Roche's discussion here, applying his insights to the configuration of Robert's Normandy views.

30. "Cette ville est un autre monde / Dedans un monde florissant, / En peuples et en biens puissant / Qui de toutes choses abonde." In the version of the map that I examined at the Bibliothèque de l'Histoire de la Ville de Paris, the quatrain is signed by P. Mariette, execudit.

31. Daniel Roche, *La France des Lumières*, 38. The same thematic characterizes Robert's *Le Château de La Roche-Guyon* (see note 16), a composition in which the focus is divided equally between the barge, the chateau, and the figure of the duchess sheltered by a bright pink umbrella. The river as a commercial thoroughfare is the overwhelming impression we take away from that image as well. *Le Château de La-Guyon*, oil/canvas, 1,95 x 2,76 (INV.909.37.1), Rouen, Musée des Beaux-Arts.

32. As H. Lüthy described Physiocracy; cited by Catherine Larrère, *L'Invention de l'Economie au XVIIIe siècle: Du droit naturel à la physiocratie* (Paris: Presses universitaires de France, 1992), 211. Also note the writer in the *Ephémérides du citoyen* (the Physiocratic journal edited by Dupont de Nemours), who declared, in 1771,

that his object was to show how the real interest of the temporal realm accords with the execution of the sacred realm: "there are not two moralities, one Christian and the other economic, only one." Cited in Georges Weulersse, *La Physiocratie à la fin du règne de Louis XV (1770–1774)* (Paris: Presses universitaires de France, 1959), 112, n. 8. Note too the article "Christianity" in the *Encyclopédie*, which cites Montesquieu, who claimed that the Church presents no arguments against commerce, progress, or the industry of workers: "Were the rich not to be lavish, the poor would starve."

33. Reddy, "Textile Trade," 73.

34. One factor in the wide acceptance of Physiocracy among the educated classes in France was the logical simplicity of the circulation metaphor. Larrère, e.g., singles out the "readability" of François de Quesnay's *Tableau Économique*. When the *Tableau* was published in 1758–59, she explains, the wealth, abundance, and leisure, posited now as the common goals of the entire society, became directly *lisibles*. Larèrre, *L'Invention de l'Economie*, 244. See also Stephen Gudeman, *Economics as Culture: Models and Metaphors of Livelihood* (London: Routledge & Kegan Paul, 1986).

35. Claude Morilhat, *La Prise de Conscience du Capitalisme: Economie et philosophie chez Turgot* (Paris: Méridiens Klincksieck, 1988), 25, 42.

36. Mercier, *Du Théatre*, 159–60. "Que j'aime le commerce dans un port de mer! comme ce peuple actif, ces flots de travailleurs, ce mouvement perpétuel, ces canaux, ces chemins, ces voitures, cette circulation vaste & facile annoncent la santé d'un Etat qui se porte bien!" 151 n. a. On the relation of the *drame bourgeois* to political reform, see the stimulating book by Scott S. Bryson, *The Chastised Stage: Bourgeois Drama and the Exercise of Power*, Stanford French and Italian Studies (Stanford: Anma Libri & Co., 1991). What happens when a "patron" is supplanted by an "audience" for a particular work of art is a question that Bryson introduces. I have profited from his ideas throughout this book.

37. The mound of fish stacked in a large basket recalls a similar motif in Vernet's *View of Dieppe*, which was the last canvas Vernet painted (in 1765) in the *Ports*. Like Vernet, Robert inserted into his composition figures wearing traditional Norman costume. The Vernet was not engraved until 1778, but Robert could have known the painting firsthand because it was completed in Vernet's Louvre atelier. Robert and Vernet had been friends since 1766, when Vernet sponsored Robert's admission into the Royal Academy of Painting. In one of the first ports Vernet painted, *L'entrée du port de Marseille* (1754), he included himself at work, along with portraits of his wife and other family members. Likewise, in the *Vue de l'intérieur du port de Marseille prise du pavillon de l'Horloge du Parc* (1754), Vernet portrayed an abbé and a beggar, a motif that reappears in Robert's *View of Rouen*. This image was engraved in 1760. Le Bas also engraved a series of vignettes featuring certain figures taken from Vernet's *Ports*, which Robert may have studied.

38. Jutta Held, *Monument und Volk: Vorrevolutionäre Wahrnehmung in Bildern des ausgehenden Ancien Régime* (Köln: Böhlau Verlag, 1990), Chap. III. Also on the

Ports, see Thiervoz, "Les Ports de France de Joseph Vernet," *Neptunia* 57 (1960), 6–14; 58 (1960), 7–18; 59 (1960), 8–16.

39. Robert utilized the same expressive devices in the pendants he painted of the Versailles gardens, created at approximately the same time. See my "The King Prunes His Garden: Hubert Robert's Picture of the Versailles Gardens in 1775," *Eighteenth-Century Studies* (summer 1988), 454–71. There the figures reference the hopes for reform ushered in by the new young king and his adminstration. I feel less confident reading the motif this way in *Vue de Dieppe*, though Robert could well have been at work on this picture in 1774, when Louis XV died. Only the Rouen canvas is dated (1773), and Gaillon was exhibited at the Salon of 1775. A new reign in France is certainly not without significance to my argument.

40. Such a motif is thoroughly consistent with a Physiocratic reading of the imagery too; see note 34.

Chapter 4. Performing the Libertine: Hubert Robert in the Bagatelle

1. The fêtes consisted of outdoor celebrations involving temporary installations of lights (*illuminations*) artfully arranged to reveal cartouchelike constructions, such as a Temple of Love. On fêtes, see the excellent book by Alain-Charles Gruber, *Les Grandes Fêtes et leur Décors à l'Epoque de Louis XVI* (Genève: Droz, 1972).

2. Obviously, sheer virility was also a factor. And even on the grounds of licit sexuality, Artois commanded attention. Though only twenty years old in 1777, he had sired two children, unlike his unlucky brother Louis XVI, whose inability to beget offspring had begun to become a national disgrace.

3. Angelica Goodden, *The Complete Lover: Eros, Nature, and Artifice in the Eighteenth-Century French Novel* (Oxford: Clarendon Press, 1989).

4. Originally Belanger had planned to surround the pavilion with the geometrically aligned paths and terraces of a French-style formal garden, but in November 1778, he decided to expand the park and alter its form into a fashionable *jardin Anglois*, a type of garden associated with the private rather than the public. The area directly facing the pavilion on the garden side was the only sector to remain in the French style (it remains so; see Fig. 38). On this subject, see Monique Mosser's "Histoire d'un Jardin," in *La Folie d'Artois*, ed. Jean-Louis Gaillemin (Paris: L'Objet d'Art, 1988), 51–71. Mosser reproduces Belanger's first plans of the English garden. In May 1779, Artois purchased more land – "dix-huit arpents deux perches du Bois de Boulogne" – enlarging the property. A Scot named Thomas Blaikie was hired to supervise the garden project. In his diary, Blaikie contemptuously called Belanger's *jardin Anglois* "a ridiculous affaire," for he disliked the idea of planting quixotic garden structures along "a great number of narrow serpentine walks without reason or meaning." By 1786, though, the reluctant Blaikie had planted trees and lawns around a number of fabriques, including a temple to Pan, an Egyptian obelisk, a grotto of the hermit, a philosopher's hut, a Chinese bridge, an island of tombs, a medieval tower, and a Temple of Love. Thomas Blaikie, *Diary of a Scotch Gardener at the French Court at the End of the Eighteenth Century*, introduction by Francis

Birrell (London: George Routledge & Sons, 1931). Hubert Robert was already associated with this sort of garden design, as Blaikie notes with disdain in his diary.

5. Béatrice d'Andia, "Folies, Fêtes et Favorites," in Bernard de Montgolfier, ed., *De Bagatelle à Monceau, 1778–1978: Folies du XVIII Siècle à Paris*, introduction and catalogue by Béatrice d'Andia, Exhibition Domaine de Bagatelle, 13 juillet-11 sept. 1978, et Musée Carnavalet, 6 déc.-28 jan. 1979 (Alençon: Imprimerie Alençonnaise, 1978), 10. See Barbara Scott, "Bagatelle: Folie of the Comte d'Artois," *Apollo 95* (April-June 1972), 484, for a reproduction of the ticket/entry permission. Madame Dubarry's memoirs suggest that, on the contrary, permission was difficult to procure. She declares "peu de monde parmi les profanes avait pu le voir encore; il était difficile d'obtenir la permission d'y être introduit." Madame Dubarry, however, had acquired a particular sort of notoriety by 1780 (evidently the date of her visit – for she mentions the Fragonard in the boudoir), which made it awkward for her to apply by name to the steward of the Bagatelle. *Mémoires de la Comtesse Du Barri*, texte rendu public par Etienne-Léon de Lamothe-Langon (Paris: Jean de Bonnot, 1967), t. 5, p. 133. The authenticy of these memoirs is questionable, though they date from the eighteenth century. Mmes. Oberkirche, Sabran, and Arnould all described sojourns at the Bagatelle. Cognel, a young tourist from the provinces, also visited the Bagatelle, although he and his friends had to pay for the favor of visiting the estates without a "carte de la maison du prince." François Cognel, *La Vie Parisienne sous Louis XVI* (Paris: Calmann Lévy, 1882) 31. Add to this Blaikie's testament in 1780 that "great numbers" of people came to see the gardens during the summer.

6. The epigram meant that Aristo's house, though small, was suited to his needs and purchased with his own funds, not those of the duke. Marigny had used a variant of the epigram earlier; on a grotto in his garden was inscribed "piccola ma garbata" – "small but pretty." Hubert Robert used the inscription in an allegorical painting of 1795, perhaps in reference to his incarceration. See Catherine Boulot, Jean de Cayeux, and Hélène Moulin, *Hubert Robert et la Révolution*, exhibition, Le Musée de Valence, 1989, 134–35. Madame Dubarry catches the irony of the inscription, for she begins her own description of the Bagatelle with it, noting that "Le duc de Cossé me l'expliqua par une plaisanterie un peu libre, qui me prouva que le latin signifie tout ce qu'on veut." *Mémoires de la Comtesse Du Barri*, 5: 134. Blaikie is also alluding to "parva sed apta" when he notes in his diary that he had left his lodgings at the Bagatelle's gate and moved to one of the new pavilions (after 1783) "although small was rather more convenient." Blaikie, *Diary*, 183. For details on Belanger's involvement with Artois, see Jean Stern, *À l'ombre de Sophie Arnould, François-Joseph Belanger, Architecte des Menus Plaisirs, Premier Architecte de Comte D'Artois* (Paris: Plon, 1930).

7. Blaikie, on this count, complains about the difficulty of getting paid there: "Mr. St. Foix at last gave an order upon Mr. Nogaret to pay me[,] then Mr. Nogaret and the last sent me to Mr. Labelle until my patience was entirely worn out; at last on Monday the 22 December Mr. Labelle paid me." *Diary*, 141. Because he was the architect, Belanger advanced the money required to cover construction

costs. In 1780, *he* demanded payment from Artois, claiming he had advanced 360,000 livres for Artois and received only 72,000; he complained of being ruined and demanded 288,000 livres, plus 10,000 per year. He had to wait until 1783 for his money. See Henri-Gaston Duchesne, *Le Château de Bagatelle* (Paris: Jean Schemit, 1909), 127.

8. Blaikie, *Diary*, 160. In another instance Blaikie delights some ladies of the court who have come to visit the Bagatelle by telling them that he was not contented with Artois as a patron, "that I never saw a more Lazier and a Man of less taste and that he had not once come to see the gardens since he lodged there." Blaikie, *Diary*, 182.

9. Jacques-François Blondel, *Cours d'Architecture ou Traité de la Décoration, Distribution et Construction des Bâtiments* (Paris: Chez Desaint, 1771), 2: 249.

10. ". . . qui viennent amuser cette muse, rivale de madame Geoffrin en cette partie." As Bachaumont describes them, these were parties "où sont invitées les filles les plus séduisantes, les plus lascives, & où la luxure & la débauche sont portées à leur comble." Louis Petit de Bachaumont, *Mémoires secrets pour servir à l'histoire de la république des lettres en France* (Londres: 1777–89), 3: 288.

11. ". . . petits dîners et soupers licencieux." Sainte-Beuve, *Causeries du Lundi*, 2: 316.

12. Marmontel, *Mémoires*, 1: 170–71.

13. Yves Durand, *Les Fermiers Généraux au XVIIIe siècle* (Paris: Presses universitaires de France, 1971), 324.

14. Athough by December 1777 Bachaumont is able to report "le sort de Mlle. Duthé," who was in England with a lord "qui en est fou" (*Mémoires*, 10: 300)." On Duthé, see the baronne d'Oberkirch, who recorded the latest Parisian *bon mot*: "On raconta un mot qui courait tout Paris. M. le comte d'Artois, ayant eu une indigestion de biscuit de Savoie, a pris du thé. Mlle. Duthé était alors la maîtresse du jeune prince." *Mémoires de la Baronne d'Oberkirch*, ed. Suzanne Burkard (Paris: Mercure de France, 1970), 231. Vigée-Lebrun recollected seeing the "elegant and pretty Mlle. Duthé at the Palais-Royal, walking arm and arm with other 'filles entretenues.' " She laments that no one ruins himself for a woman anymore; Mlle. Duthé "a mangé des millions." *Souvenirs*, 1: 40. The catalogue of the exhibition *De Bagatelle à Monceau, 1778–1978: Les Folies du XVIII Siècle à Paris* claims that the two sphinxes outside the entrance of the Bagatelle represent the features of Rosalie Duthé. In 1780, Belanger would design a house for Duthé in Les Porcherons, the same district in which Mlle. Guimard's famous house by Ledoux was located.

15. Oberkirch, *Mémoires*, 343. References to Artois's orgies at the Bagatelle occur frequently in the secondary literature. For instance, frescoes representing scenes of debauchery supposedly decorated the walls of the Bagatelle (unlikely because the decor did not include frescoes) and six nude women served the food at *soupers* given for the duke of Chartres and Artois's other debauched friends. See Joseph Turquan and Jules d'Auriac, *Monsieur Le Comte d'Artois* (Paris: Éditions Émile-Paul Frères, 1928), 19.

16. Of Boutin's *folie*, Madame Oberkirch wrote: "C'est un lieu de plaisance ravissant, les surprises s'y trouvent à chaque pas; les grottes, les bosquets, les statues, un

charmant pavillon meublé avec un luxe de prince. Il faut être roi ou financier pour se créer des fantaisies semblables." *Mémoires*, 189.

17. The wager was for 100,000 francs. Bachaumont reports: "Il [Artois] a pris une tournure fort ingénieuse pour se satisfaire aux frais de qui appartiendroit. Il a parié cent mille francs avec la Reine que ce palais de fée seroit commencé & achevé durant la voyage de Fontainebleau, au point d'y donner un fête à Sa Majesté au retour. Il y a huit cents ouvriers, & l'architecte de son altesse royale espère bien la faire gagner." *Mémoires*, 10: 259 (22 octobre 1777); also see 10: 272, 281, 288. On 19 November 1777, Mercy-Argenteau informed the empress Marie-Thérèse of the incident: "Peu de jours avant le départ de Fontainebleau le comte d'Artois imagina de faire raser une petite maison qu'il a dans le bois de Boulogne et que l'on nomme Bagatelle, et de faire rebâtir de fond en comble, arranger et meubler cette même maison sur de plans nouveaux, pour y donner une fête à la reine quand la cour quittera Choisy pour rentrer à Versailles." See *Correspondance secrète entre Marie-Thérèse et le Cte de Mercy-Argenteau*, publiée avec une introduction et notes par M. le Chevalier Alfred d'Arnetii et M. A. Geffroy (Paris: Firmin Didot Frères, Fils et Cie., 1874), t. 3, pp. 135–36. Throughout the correspondence, Mercy-Argenteau voices strong disapproval of Artois's behavior. Everyone considered the project absurd, grumbles Mercy-Argenteau, and he wonders how the king could tolerate such "semblables légèretés." He writes of 900 workmen laboring day and night to erect the Bagatelle. Short of plaster and stone, the prince authorized regiments of Swiss guards to confiscate shipments of masonry passing into Paris. Though Artois paid for these supplies, they had already been sold to individuals – the violence of Artois's methods, concluded Mercy-Argenteau, "a révolté le public." For further details, see Montgolfier, *De Bagatelle à Monceau*, 16. Also see Bachaumont on the wager and the confiscation of materials in Bachaumont, *Mémoires*, 10: 259, 10: 272, 10: 281, 10: 288.

18. To flood the body with water was regarded in the early modern period as an invitation to infection, because the human skin was believed to be porous and fragile. Although it is true that Louis XIV installed a marble bath at Versailles, he was known to have bathed only twice in his life – both times for explicitly medical (as opposed to hygienic) reasons. Status lay behind the great marble bath at Versailles, but it was not the king's status as a clean man that the bath represented because cleanliness was signified during this period by swaths of white linen, powder, and fragrances. Rather, it was the association of the French monarch with ancient Roman baths and their imperial users that the Versailles counterpart vaguely sought to promote. On this, see Georges Vigarello, *Concepts of Cleanliness: Changing Attitudes in France since the Middle Ages*, trans. Jean Birrell (Cambridge: 1988), 13, 25. For a brief history of bathing, also see Lawrence Wright, *Clean and Decent: The History of the Bath and Loo* (London: Boston & Henley, 1980).

19. Vigarello, *Concepts of Cleanliness*, 94.

20. Vigarello, *Concepts of Cleanliness*, 100. Also see Pardailhé-Galabrun, *Birth of Intimacy*, 136–44.

21. In J. F. Bastide's novelette, *La Petite Maison* (c. 1753–54), the suave marquis wins

over the virtuous Mélite by the exquisite taste of his dwelling, which is revealed to his guest (and the reader) in lavish detail, room by room, each chamber more stylishly ornamented than the next. The *salle de bains* is the *pièce de résistance*. Mélite begins to succumb to her host when she sees it, sighing "Je n'y tiens plus; cela est trop beau." We conclude from this story that a beautifully decorated *salle de bains* can serve as a *means* of seduction: Mélite's love is not excited by the marquis, but by the different rooms of his dwelling. J. F. Bastide, *La Petite Maison* (Paris: Librairie des Bibliophiles, 1879). The story of the seduction of Mélite by the house of the marquis is fascinating. Publishing it in 1758 in the *Nouveau spectateur*, Bastide probably procured all the details about fashionable decoration and good taste from his friend Jacques-François Blondel. In his introduction to the English translation of Le Camus, Middleton also singles it out as important. Nicolas Le Camus de Mézières, *The Genius of Architecture; or, The Analogy of that Art with Our Sensations*, trans. David Brit (Santa Monica: The Getty Center for the History of Art and the Humanities, 1992), 54–55.

22. Nicolas Le Camus de Mézières, *Le Génie de l'Architecture ou l'Analogue de cet art avec nos sensations* (Paris: Auteur ou Benoit Morin, 1780), 137–38. I quote here from the English translation, Le Camus, *The Genius of Architecture*, 123. Baths were commonly placed in the orangerie in the eighteenth century. See Jacques-François Blondel, *De la Distribution des Maisons de plaisance et de la décoration des édifices en général* (Paris: Charles-Antoine Jombert, 1737–38), 1: 71–75; 2: 129–35. Blondel, for instance, suggests two tubs for the *salle de bains* "soit afin que deux personnes puissent s'y tenir compagnie & s'amuser reciproquement dans leur solitude."

23. I quote here from the French edition, Le Camus, *Le Génie de l'Architecture*, 139–41. The frivolity of the *salle de bains* contrasts with the darkness, privacy, and solitude that ought to reign in the bath's *chambre à coucher*. Belanger became something of specialist in baths; see his bathing room for Mille. Dervieux, an actress, designed in 1774 with Brongniart. It included the requisite dressing room, sleeping room, and bathing room. The last gave out onto an arbor decorated with greenery and statues, just as Le Camus describes. The Dervieux ground plan is illustrated in Michael Dennis, *Court and Garden* (Cambridge, Mass., MIT Press, 1986), 161.

24. L. V. Thiéry, *Guide des Amateurs et des Étrangers* (Paris: Hardouin et Galley, 1786), 1: 28–29.

25. The pairs I suggest are based on the dimensions of the pictures, which fall into roughly three groups. Today the six canvases hang in the Wrightsman Galleries of the Metropolitan Museum in New York, a gift to the museum from J. Pierpont Morgan, Jr., in 1917. Jean de Cayeux has written an article expressing some doubts about the Metropolitan pictures and the Bagatelle commission in which he concludes that perhaps not all the paintings were in place in 1777. It may have been, Cayeux speculates, that the two largest were hung only after the Salon of 1779 and that others were finished in 1784. See Jean de Cayeux, "Jeux d'eau pour une salle de Bains," *L'Objet d'Art*, no. 8 (1988), 64–68. Scholars seem to agree that *Wan-*

dering Minstrels was the picture shown as no. 90 in the Salon of 1779. A note in the dossier about the paintings in the Metropolitan Museum of Art refers to a letter from Morgan, dated 1912, in which he claims that there had been eight panels by Robert in the *salle de bains*. However, two more panels would not have fit into this chamber, even with the removal of the mirror. Perhaps two other works by Robert were destined for some other room, such as the boudoir. Also, Morgan (or his sources) may have had two other Robert pictures commissioned by Artois confused with the *salle de bains* commission. Two other paintings by Robert shown under no. 89 in the Salon of 1779 are described as follows: "no. 89. Deux tableaux: l'un *Une pêche sur un canal couvert d'un brouillard*; et l'autre *Un grand jet d'eau dans des jardins d'Italie*; on voit sur le devant du tableau des femmes qui jouent à la main chaude. De 5 pieds de haut sur 3 de large. no. 90. *Une partie de la cour du Capitole*, ornée de musiciens ambulants, près d'une fontaine. De 5 pieds de haut sur 4 de large. Ce trois tableaux appartiennent à Monseigneur le comte d'Artois." No. 90 refers to *Wandering Minstrels*.

26. Le Camus, *The Genius of Architecture*, 123.

27. Jean-Jacques Gautier, "Décor et Ameublement de Bagatelle," in *La Folie d'Artois*, ed. Jean-Louis Gaillemin (Paris: L'Objet d'Art/Antiquaires à Paris, 1988), 130.

28. Letters are reprinted in J. W. Oliver, *The Life of William Beckford* (London: Oxford University Press, 1932), 166–67. "It is astonishing with what facility these creations grow under his pencil," marveled Beckford.

29. In 1784 Robert was given funds to restore the two smallest pictures, located on either side of the chimney in the *salle de bains*, which had been damaged by excessive humidity. See Charles Yriarte, "Mémoires de Bagatelle," *La Revue de Paris* (1 July 1903), 21. L. de Quellern cites a letter, dated 18 mai 1784, regarding the "tableaux de paysages qui étaient à refaire dans le boudoir de Bagatelle." It was decided to repaint only the two of them, for 25 louis apiece. A note from the surintendant concluded "Bon, pour refaire les 2 petits tableaux, à côté de la cheminée dans la salle de bains." See L. de Quellern, *Le Château de Bagatelle: Étude historique et descriptive* (Paris: Charles Foulard, 1909), 45–46. *The Mouth of a Cave* is signed and dated 1784. The first published account of the pictures in the *salle de bains* is Thiéry's from 1786. Unlike Bachaumont (see note 47), Thiéry reports that the boudoir is decorated with six pictures by Callet. Thiéry, *Guide des Amateurs et des Étrangers*, 1: 28–29.

30. Marian Hobson, *The Object of Art: The Theory of Illusion in Eighteenth-Century France* (Cambridge: Cambridge University Press, 1982), Pt. I. Sheriff also makes this point eloquently and persuasively in her analysis of the Louveciennes panels by Fragonard (see note 31).

31. I am much indebted to Sheriff's discussion of seriality in her chapter on Fragonard's Louveciennes panels. Mary D. Sheriff, *Fragonard: Art and Eroticism* (Chicago: University of Chicago Press, 1990).

32. The arrangement of the Luxembourg Gallery between 1750 and 1779 was governed by the same desire to set up comparisons and contrasts. This way of receiving pictures in the eighteenth century was influenced by de Piles's *Balance of Painters*.

See Andrew McClellan, *Inventing the Louvre* (Cambridge: Cambridge University Press, 1994), 13–48.

33. On the swing, see Donald Posner, "The Swinging Women of Watteau and Fragonard," *Art Bulletin* 64 (March 1982), 75–88.

34. Francis Haskell and Nicholas Penny, *Taste and the Antique* (New Haven: Yale University Press, 1981), 210, 218. The Aphrodite of Cnidus was, of course, universally attributed to Praxiteles. Falconet discussed the Aphrodite of Cnidus in his translation of Pliny. *Oeuvres complètes*, 2: 10–12; also see Montfaucon's description (French edition 1719, revised 1722–24) of antique representations of Venus in Bernard de Montfaucon, *Antiquity Explained and Represented in Sculptures*, trans. David Humphreys (London, 1721–22; Garland rpt. New York, 1976), 1: 101–103. In Montfaucon's *Supplement* (1725) the Cnidian temple is described as "open on all sides, that it [the sculpture] might be every way seen" (*Supplement*, 1: 70).

35. In the Salon of 1747, a large plaster version of this Venus by Pigalle was exhibited; it was described as "Un modèle en plâtre de six pieds de proportions représentant Vénus qui fait pendant à un Mercure, ci-devant exécuté en marbre pour le Roy." Mercury acting as an envoy was taken from the myth of Cupid and Psyche. Robert replicated a version of the Venus figure different from the one sent as a diplomatic gift to Frederick II in 1752. On the Pigalle statues, see Marguerite Charageat, "Vénus donnant un message à Mercure par Pigalle," *Revue des Arts* (1953–54), 217–22. The Mercury is depicted in another painting by Robert representing the Terrace at Marly (now in Kansas City, Nelson and Atkins Gallery of Art).

36. Lazzaro discusses the principle of heroic/mundane juxtaposition in Renaissance gardens such as that of the Villa Medici. See Claudia Lazzaro, *The Italian Renaissance Garden: From the Conventions of Planting, Design, and Ornament to the Grand Gardens of Sixteenth-Century Central Italy* (New Haven: Yale University Press, 1990), 151–52.

37. Tomlinson makes the same case about the reading of Goya's tapestry cartoons designed for the bedroom of the prince and princess of Asturias, which date from exactly the same time, 1778–79. See Janis A. Tomlinson, *Francisco Goya: The Tapestry Cartoons and Early Career at the Court of Madrid* (Cambridge: Cambridge University Press, 1989), 19.

38. Sheriff, Fragonard, 107.

39. Pliny writes of one Spurius Tadius, "the first to introduce the extremely attractive feature of painting room walls with representations of country houses, porticoes, landscaped gardens, groves, woods, hills, fishponds, canals, rivers, coasts, and anything else one could wish for." Pliny the Elder, *Natural History: A Selection*, introd. and trans. John F. Healy (Harmondsworth, Middlesex, Eng.: Penguin, 1991) 335. Also see Vitruvius, VII, 5, 1–7: "Their walks because of the extended length of the wall space, they decorated with landscapes of various sorts, modeling these images on the features of actual places. In these are painted harbors, promontories, coastlines, rivers, springs, straits, sanctuaries, groves, mountains, flocks, and shepherds." Rpt. in *The Art of Rome c.753 B.C.-337 A.D., Sources and Documents*, ed. J. J. Pollit (Englewood Cliffs, N.J.: Prentice-Hall, 1966), 127–28.

40. Blondel, *Cours*, 2: 251. A sense of the suggestive decor of some of these interiors can be gained from Mrs. Thrale's strong reaction to the Hôtel de Monville. Monville's hôtel, designed by Etienne-Louis Boullée, provided "no pleasure" for the party of English tourists that innocently visited it. It seemed to be "contrived merely for the purposes of disgusting Lewdness, & is executed as I conceive on the model of some of the Roman Emperors' Retirements – the Ornaments are all obscene – and of no value that I can perceive unless considered as [perfect] in that character." *The French Journals of Mrs. Thrale and Doctor Johnson*, ed. Moses Tyson and Henry Guppy (Manchester: The Manchester University Press, 1932), 113.

41. Lifting figural imagery from Boucher drawings or prints was a highly characteristic practice of Hubert Robert, who often made tracings or counterproofs for this purpose. On this subject, see Jean Cailleux, "Hubert Robert a pris modèle sur Boucher," *Connaissance des arts* (Octobre 1959), 100–107. The motif is discussed at length in Colin B. Bailey, ed., *The Loves of the Gods: Mythological Painting from Watteau to David*, exhibition Kimball Art Museum (New York: Rizzoli, 1992), esp. 394.

42. A similar phenomenon is described by Steven Z. Levine in his essay "To See or Not to See: The Myth of Diana and Acteon in the Eighteenth Century," in Bailey, *The Loves of the Gods*, 73–88. Levine charts a thematic progression from the late seventeenth and early eighteenth centuries, in which the unauthorized look of Acteon at Diana constitutes an act of transgression in social relations that must be severely punished, to a later, eroticized, variant of Diana that expresses an ambivalent, perhaps even welcoming, response to the intrusion. Robert's Bagatelle pictures valorize this sort of voyeurism.

43. Many examples of voyeurs peeping through windows at women bathing in luxuriously appointed bathing rooms exist in eighteenth-century prints and book illustrations. For instance, Eisen showed such a scene in an illustration to *Angola* (1751) by C. J. L. A. Rochette de la Morlière. See the illustration in Owen E. Holloway, *French Rococo Book Illustration* (New York: Transatlantic Arts, 1969), Fig. 169. Another example is *Le Plaisir de l'Été* (1741), illustrated in Wright, *Clean and Decent*, 137. The voyeuristic associations of the Cnidian Venus were equally well-established in the eighteenth century. Montfaucon, e.g., cites Lucian as follows: "Lucian describes thus this Cnidian Venus. 'We enter'd the Temple, in the midst of which is the Goddess; the Statue is of Parian Marble, and admirable Workmanship, she seems to smile, and hath no sort of Dress on, but covers her modest Parts with her Hand slightly.' " Montfaucon, *Supplement*, 1: 70.

44. Bachaumont, *Mémoires*, 15: 168.

45. Oberkirch, *Mémoires*, 343. Also note Sophie Arnould's oft-quoted response to Belanger's creation: "Vous devez être bien satisfait de votre ouvrage; Paris s'occupera longtemps de Bagatelle." Cited in Stern, *À l'ombre de Sophie Arnould, François-Joseph Belanger*, 1: 73–74.

46. Louis Marin, *Portrait of the King*, trans. Martha M. Houle; Foreword by Tom Conley (Minneapolis: University of Minnesota Press, 1988), 183.

47. Bachaumont, *Mémoires*, 15: 167.

48. D. Goodman, *Republic of Letters*, 158.

49. According to the Dubarry memoirs, the other three statues represented Night, Pleasure, and Reason. Why Reason, she asks? "Chacun se demande ce qu'elle peut faire en si bonne compagnie." *Mémoires de la Comtesse Du Barri*, 5: 134. The front of this structure was decorated with two reliefs: one represented Cupid blindfolded; the other, Cupid archly stealing an arrow, his finger on his lips to command secrecy. See Annie Jacques and Jean-Pierre Mouilleseaux, "La Folie d'Artois," in *La Folie d'Artois*, ed. Jean-Louis Gaillemin (Paris: Antiquaires à Paris, 1988), 33.

50. Françoise Scherer, "La Chambre à Coucher du Comte d'Artois à Bagatelle d'après les documents des Archives Nationale, *Gazette des Beaux-Arts*, t. 105 (avril 1985), 147–54. Also see Stern, *À l'ombre de Sophie Arnould, François-Joseph Belanger*, 1: 56–75. Artois's bedroom at Versailles was also decorated with military motifs when he was married in 1773. He evidently favored this conceit, just as he enjoyed "les turqueries" – decor evocative of a Turkish seraglio. Reclining on an ottoman in his Turkish *appartements*, Artois could imagine himself a sultan. See Claude Arnaud, "La Comte d'Artois et sa Coterie," in *La Folie d'Artois*, 22. Artois's taste definitely inclined toward the theatrical, as Jean-Jacques Gautier notes in his essay, "Le Goût du Prince," in *La Folie d'Artois*, 93: "Le désir de surprendre, l'aspect ludique où se mêlaient le plaisir du théâtre à celui de l'illusion sont à l'origine des décors que nous venons d'évoquer."

51. The military metaphor is common in eighteenth-century libertine fiction. Though Artois was a Grand Maître de l'Artillerie, he was admittedly no great soldier. Goya's tapestries for the bedroom of the prince and princess of Asturias, dating from the same time (1778–79), are similarly infused with the same sort of playful eroticism. Rather than use a martial theme, Goya opted for one centered on the amorous connotations of the ball game, a thematic whose sexual content is revealed only through the interplay of the adjacent images on the bedroom walls. Tomlison reveals how in *The Ball Game*, the tapestry facing the bed, a hulking *majo* smoking a cigar makes a lewd phallic gesture punning on both his cigar and the balls used in the sporting game – an obviously playful erotic reference to the sport of the bedchamber. One of the smaller tapestries in the room represented children playing soldier, the same sort of imagery used by Belanger in the Bagatelle. See Tomlinson, *Goya*, Chap. 3.

52. Adam Smith, *The Theory of Moral Sentiments*, ed. D. D. Raphael and A. L. Macfie (London, 1759; rpt. Indianapolis: Liberty Fund, 1984), 112.

53. David Marshall, "Adam Smith and the Theatricality of Moral Sentiments," *The Figure of Theater: Shaftesbury, Defoe, Adam Smith, and George Eliot* (New York: Columbia University Press, 1986), 175–76.

54. K. Scott, *Rococo Interior*, 251.

55. "J'amenais souvent des dames à Bagatelle (le comte d'Artois autorisait très facilement cette visite) et je m'amusais parfois de l'embarras que leur causait un boudoir dans lequel, au milieu de peintures très peu orthodoxes, le plancher, les murs et le plafond étaient tout en glaces et où il ne leur restait d'autre parti à prendre qu'à se

dépêcher de faire de leurs robes des espèces de pantalons." *Mémoires du général Thiébault* (Paris: Plon, 1893), 1: 156.

56. Sébastien Mercier cited by Yriarte, *Mémoires de Bagatelle*, 34. Robert took advantage of his position in 1795 on the Conservatoire du Muséum des Arts to remove his six paintings from the *salle de bains* to the safety of his studio, claiming that they required restoration, but by 1797, he had returned them. The German architect Friedrich Gilly reports seeing the Roberts there in 1797. Gilly's long description of the Bagatelle is reprinted in Edgar Wedepohl, "Descriptions de Bagatelle," *L'Oeil*, no. 126 (1965), 17–23. Between 1806 and 1810, the six paintings were removed to the Château de Malmaison.

57. Pliny, *Natural History*, 346. Also see Erica Rand's article, "Diderot and Girl Group Erotics, *Eighteenth-Century Studies* 25 (summer 1991–92), 495–516, esp. 509, where she discusses a statue in the Versailles gardens that seems to have played this role in Diderot's time.

58. *Mémoires de la Comtesse Du Barri*, 5: 135.

59. The quote is from John Goodman. See his excellent article on Vauxhall culture, " 'Altar Against Altar': The Colisée, Vauxhall Utopianism, and Symbolic Politics in Paris (1769–77)," *Art History* 15 (December 1992), 439–40.

60. It is the last sentence in the passage. Cognel, *La Vie Parisienne sous Louis XVI*, 31–32: "Ce spectacle ne se donne que les jeudis et dimanches; le jardin est trop petit pour la quantité de monde qui s'y rassemble; le salon très-beau; on y monte par deux larges escaliers; des élèves de l'opéra y dansent; dans le jardin, le carrousel et l'escarpolette contribuent aux divertissemens; les femmes y affectent une tenue plus libre encore qu'ailleurs, et le jeu d'escarpolette permet beaucoup de licences distrayantes pour le spectateur, et qui néanmoins peuvent être attribuées à des causes accidentelles." Another pamphlet written in 1789 refers to the swinging women as follows: "Je ne vous ai point parlé des Redoutes, des Wauxhals, vrais mauvais lieux d'où il est impossible de sortir chaste. Là sont des escarpolettes où les femmes publiques se balancent, dans des attitudes conformes à leurs vues." *Lettre à un Père de famille sur les petits spectacles de Paris par un honnête homme* (Paris: Garnéry, 1789), 42. The same imagery of swinging women (see, e.g., Fig. 42), dancers, and musicians entertained in the representations fabricated by Robert for the Bagatelle's *salle de bains*.

61. David Marshall concludes that this became a dilemma for Adam Smith, too. *The Figure of Theater*, Chap. 7.

62. *Mémoires de la Comtesse Du Barri*, 5: 135.

63. Cognel, *La Vie Parisienne sous Louis XVI*, 32.

64. Pomian discusses this at length in *Collectors and Curiosities*, 175ff.

65. "When I first started to engrave this series, I had most in mind the man of letters, who studies monuments solely with a view to discovering their links with the accounts left by the ancients . . . However, being neither sufficiently learned nor sufficiently patient to use these methods consistently throughout, I often chose to employ another in its stead, one which will, perhaps interest lovers of the arts . . . In other words, I look at monuments as the proof and expression of the prevailing

taste in a given country at a given period." Caylus, *Receuil*, 1: vi-vii, cited by Pomian, Collectors and Curiosities, 175.

Chapter 5. Dining Amid the Ruins: Hubert Robert's Les Monuments de la France

1. This is the only title that bore an explanatory, as opposed to a descriptive, text. It stated "Le Pont du Gare [*sic*], qui servoit autrefois d'aqueduc pour porter les eaux à Nîmes." The entry was followed by: "Ces quatre Tableaux représentans les principaux monumens de la France, de 8 pieds 6 pouces de large, sur 8 pieds 2 pouces de haut, appartiennent au Roi."

2. Robert had painted the Temple of Diana at Nîmes as early as 1771. Cayeux claims that the d'Angiviller commission was offered in 1782. Another, smaller, version of the Maison Carré, signed and dated "H. Robert 1783," is on view in The State Hermitage Museum in Petersburg. The Gemäldegalerie in the Bodemuseum in Berlin also has an undated version of the ruins of Nîmes (o/c; 117 x 174 cm). No doubt other examples exist; the Roman remains in Languedoc was one of the themes Robert recycled as subject matter many times. The commission from Paul Petrovitch, which had been for an ensemble of four canvases, only two of which were displayed in the Salon of 1785, dated from some time between 1782 and 1785. D'Angiviller might well have seen the paintings before 1785, and later, in the artist's studio.

3. Jules Guiffrey, ed., *La peinture au musée du Louvre*, (Paris, 1929), 1: 93.

4. Cayeux, *Hubert Robert*, 338–39; Eric M. Zafran, *The Rococo Age: French Masterpieces of the Eighteenth-Century* (Atlanta: The High Museum of Art, 1983), 138–39.

5. Clérisseau had gone to Provence in 1767–69. He had intended to publish several volumes, but completed only the one. In 1804 an enlarged version of the book, edited by J. G. Legrand, his son-in-law, appeared. On this, see Thomas J. McCormick, *Charles-Louis Clérisseau and the Genesis of Neo-Classicism* (New York: The Architectural History Foundation, and Cambridge: The MIT Press, 1990), 135–39. Clérisseau's book was an important contribution to the Roman Revival in art and architecture, which was taking place around the middle of the eighteenth century.

6. See Fragonard's drawing, e.g., from 1761, illustrated in Pierre Rosenberg, *Fragonard* (New York: The Metropolitan Museum of Art, 1988), 147, or the engraving opposite p. 33 in Leon Ménard, *Histoire des antiquités de la ville de Nismes et de ses environs* (Nismes: l'Éditeur, 1829).

7. Aubin-Louis Millin, *Voyage dans les Départemens du Midi de la France* (Paris: De l'Imprimerie Impériale, 1806), 4: 219.

8. "L'aspect d'une piece si rare soit choqué au point qu'il est, par cinquante ou soixante mauvaise maisons de Cardeurs de laine qui l'offusquent." Claude-Marie Saugrain, *Nouveau Voyage de France: Géographique, historique et curieux* , s.l., s.d. [Paris: Les Libraires Associées, 1778], 294.

9. J. Charles-Roux, *Nîmes* (Paris: Blond et Cie: 1908), 62.

10. Charles-Nicolas Cochin, *Voyage d'Italie ou Recueil de Notes sur les ouvrages de peinture et de sculpture, qu'on voit dans les principales villes d'Italie* (Paris, 1758; Geneva: Minkoff rpt., 1972), 3: 186.

11. Millin, *Voyage*, 2: 132–33.

12. "On voit la naissance de plusieurs voûtes et l'on croit apercevoir par où entraient les bêtes, des rampes pour les prêtes, etc., et moi qui ne suis pas si connaisseur, je n'ai presque rien vu." *Voyages en France de François de la Rochefoucauld (1781–1783)*, ed. Jean Marchand (Paris: Librairie Ancienne Honoré Champion, 1938), 46.

13. The inevitable comparison made between Demachy, who did observe the rules of perspective, and Robert indicates this difference was not lost upon many critics.

14. In 1785 Bachaumont's *Mémoires* complained about the "assemblage idéal d'édifices disparates qui n'ont jamais existé ensemble, bizarrerie révoltante pour le spectateur chez qui c'est supposer trop d'ignorance; M. Robert inventif rempli de ressources dans son art pour vouloir être original, pêche souvent contre le bon goût et le bon sens" (t. 30, pp. 170–71).

15. Ironically, Robert has been described as too inventive (see note 14 above). That tensions were emerging over the hierarchy of genres is suggested by the remark in the Bachaumont *Mémoires* that history painters resented Robert's appointment as a *garde* of the museum because he was a painter only of genre: "C'est M. Robert qui, quoique peintre de genre, a été nommé garde du Museum qui s'établit dans la galerie des Tuileries . . . Les peintres d'histoire, qui, qvec raison, croyoient que cette place leur étoit due, sont très-jaloux de M. Robert, qui ne l'a emporté que par une protection spéciale de m. le comte d'Angiviller." See t. 27, p. 36 (26 novembre 1784).

16. *Récits d'une tante: Mémoires de la Comtesse de Boigne née Osmond*, publiés d'après le manuscrit original par M. Charles Nicoullaud, vol.1, *1781–1814* (Paris: Plon, 1907), 28–29: "Tout le monde sait que nulle part la Cour de France ne se montrait plus magnifique qu'à Fontainebleau. C'était sur son petit théâtre que se donnaient les premières représentations les plus soignées, et il était presque admis que les intrigues ministérielles se dénouaient à Fontainebleau pour continuer apparemment l'existence historique de cette belle résidence Malgré l'inhospitalité apparente qui les accompagnait, ils coûtaient très cher à la Couronne; et le Roi, toujours prêt à sacrifier ses propres goûts, quoique ce séjour lui fût très agréable, y renonça. Il était plus aimable à Fontainebleau qu'ailleurs, il y faisait plus de frais."

17. "Le Roi m'a demandé que le cabinet de la poudre, celui de retraite et la bibliothèque fussent dorés et décorés pour faire suitte à ses autres appartements, mais tout le reste en blanc." Cited by Yves Bottineau, "Précisions sur le Fontainebleau de Louis XVI," *Gazette des Beaux-Arts*, 69 (Mars 1967), 153. The first floor of the remodeled wing would contain a *cabinet de la poudre*, a *cabinet intérieur*, a library, toilets, a private toilet for the king, and a *chambre de bains*, or bathing room. Marie-Antoinette's private rooms were designed by Richard Mique and executed by the Rousseau brothers in the new "Pompeiian" style; they included a boudoir and a game room.

18. Jean-François Solnon, *La Cour de France* (Paris: Fayard, 1987), 492.

19. The royal family and thirty or so guests would be average. Boigne, *Récits d'une tante*, 1: 22.

20. Stern, *À l'ombre de Sophie Arnuld, François-Joseph Belanger*, 1: 74. Among the charges when he was arrested during the Terror were "Enfin, sa vie morale ne dément pas sa vie politique; il ne dut sa place d'architecte de l'infâme d'Artois qu'à une vie de débauche avec la femme courtisane et prostituée Arnould." Cited in Stern, 2: 78.

21. On this, see Chapter 2 in McClellan, *Inventing the Louvre*.

22. See Engerend's "Table" listing all of the commissions dating from the eighteenth century. Fernand Engerand, ed., *Inventaire des Tableaux Commandés et achetés par la Direction des Bâtiments du Roi (1709–1792)*, rédigé et publié par Fernand Engerand (Paris: Ernest Leroux, 1900).

23. In the inventory that Engerand cites, the picture is described as a representation of a "partie de jeunes gens à table, faisant la débauche" (Engerand, *Inventaire*, 263). Nicolas Lancret, *Le Déjeuner de Jambon* (canvas, 1,88 x 1,23), now in Musée Condé, Chantilly. On this picture, see Mary Taverner Holmes, "Lancret, décorateur des "petits cabinets" de Louis XV à Versailles," *L'Oeil* no. 356 (March 1985), 24–31.

24. Engerand, *Inventaire*, 461. The *Oyster Dinner* (1,86 x 1,20) is today in Chantilly, at the Museé Condé.

25. Engerand, *Inventaire*, 162–63. Winter was represented by Neptune and Amphitrite fishing; spring by Diana at the hunt; summer by Ceres and Triptolemus distributing grain from the harvest; and fall by the triumph of Bacchus.

26. Hubert Robert was regarded as an artist who enjoyed "une protection spéciale de M. le comte d'Angiviller" (see note 15). Cayeux believed that they were intimate friends, citing, among other things, correspondance from d'Angiviller after his emigration. In an 1807 letter, d'Angiviller mentions how he valued the friendship of Peyron and "le bon" Robert over the years. See Jean de Cayeux, *Hubert Robert*, 309–10. Robert had received from d'Angiviller the following marks of favor: the commission to create the new Bains d'Apollon in the gardens at Versailles, the commission to paint the pendants of the garden replantation project, the post of gardener to the king, a lodging at the Louvre, and the position of *garde* of the royal collection.

27. Four pictures from Amédée Vanloo commissioned for the Gobelins in 1778 (18,000 livres) and a ceiling commissioned from Lagrenée the Younger in 1779 (14,100 livres). See Engerand for details. The price set on the Robert commission was 12,000 livres for the ensemble of four.

28. Letter from Pierre to d'Angiviller, dated 11 May 1787: "J'ai vu les tableaux pour Fontainebleau, auxquels travaille M. Robert, et j'ai trouvé les figures dont il les a enrichis faites avec plus de soin que les artistes de genre n'en mettent ordinairement. Ces mesures étant dans une proportion qui sert d'échelle à l'architecture et à grandir le local, il paroitroit assez difficile d'y en admettre d'autres, qui eussent une intention historique, un sujet, parce qu'il faudroit qu'au lieu de sept à huit pouces, elles eussent au moins vingt pouces sur les devans, afin d'y démêler quelqu'expression;

mais la grandeur du monument y perdroit." Reprinted in "Correspondance de M. D'Angiviller avec Jean-Baptiste Pierre," *Nouvelles Archives de l'Art Français*, t. XXII, p. 200.

29. *Interior of the Temple of Diana at Nîmes*, 1771; oil/canvas, 73.7 x 101.9 cm; signed and dated "H. Robert 1771"; The Phillips Family Collection; illustrated in Zafran, *The Rococo Age*, 131.

30. E.g., *Merlin au Salon* disliked the figures in another one of the pictures exhibited in the Salon of 1787. "Je n'ai pu me refuser au plaisir d'admirer ces petites femmes bien chiffonnées qui ont l'air de poupées au milieu des ruines de l'ancienne Rome. O fureur de tout françiser!" Cited in Gabillot, *Hubert Robert et son temps*, 134.

31. Crow, *Painters and Public Life*, 198–209.

32. Alexandre Paillet was the art dealer who served as d'Angiviller's agent between 1777 and 1791. He worked closely with Robert in the latter's capacity as a *garde* of the Museum. Paillet edited the 1809 catalogue of the Robert studio sale. See note 34.

33. In the catalogue of the 1809 sale after Robert's death, Paillet values them at 2,801 livres – the most expensive of the twenty-five pictures by Pannini in the Robert collection. See Gabillot, who reprints the catalogue, *Hubert Robert et son temps*, 257. Francis Haskell and Nicholas Penny state that only two copies of the Pannini ancient and modern galleries were painted. Haskell and Penney, *Taste and the Antique*, 84.

34. "Cette suite de 25 tableaux de la main de Panini [*sic*], qui offre la plus belle variété de ses compositions et ses différentes manières, était considérée par Hubert Robert comme le trésor des ses études; répétant journellement qu'il leur devait, après la Nature, la plus grande partie de ses succès. Déjà maître de son goût en arrivant à Rome, il fut naturellement très empressé d'aller voir le premier peintre du genre qu'il avait adopté. De l'admiration il passa au désir de l'atteindre et de le rivaliser, ce qu'il a complètement justifié par un nombre incalculable de morceaux répandus dans la France et chez l'étranger." See no. 24 in 1809 studio sale, reprinted in Gabillot, *Hubert Robert et son temps*, 258–59.

35. In fact, Paillet describes these figures as a "nombre de figures historiques;" See no. 10, 1809 sale, reprinted in Gabillot, *Hubert Robert et son temps*, 257.

36. In other words it resembles Fragonard much more than David.

37. After making the remark about rivaling Pannini (see note 34), Paillet adds "Il ne suffirait pour appuyer cette vérité que citer le riche salon de sa campagne, et s'arrêter sur le magnifique monument de la Maison Carrée [*sic*] de Nîmes, et son pendant, morceaux de la plus riche couleur et du goût le plus exquis." See no. 24 in the 1809 studio sale, reprinted in Gabillot, *Hubert Robert et son temps*, 259.

38. Keith Michael Baker, "Memory and Practice: Politics and the Representation of the Past in Eighteenth-Century France," *Representations* 11 (summer 1985), 163 n. 35. My interpretation of these pictures builds upon Baker's insights. Millin was to write in 1808 that the Arch at Orange did not serve well as a "monument" of memory because its history was speculative; poetry and history, he argued, provides a surer means of conserving memory (Millin, *Voyage*, 2: 145–46).

39. Bachaumont, *Mémoires secrets*, 1787; t. 34, p. 20. Bachaumont had died by 1787; these issues were written by Moufle d'Angerville.

40. A Frankish version of history was proposed by the *parlements*. Frankish history also loomed large as justification for the authority of the nobility, although this issue does not appear to have generated great debate in the second half of the eighteenth century. See Harold A. Ellis, *Boulainvilliers and the French Monarchy: Aristocratic Politics in Early Eighteenth-Century France* (Ithaca: Cornell University Press, 1988). Baker analyzes these historical representations, along with the account of French history written by Mably, who presented yet another "revolutionary" version, in "Memory and Practice." Also relevant is François Furet, "Two Historical Legitimations of Eighteenth-Century French Society: Mably and Boulainvilliers," in *In the Workshop of History*, trans. Jonathan Mandelbaum (Chicago: The University of Chicago Press, 1984), 129–31.

41. Jacob-Nicolas Moreau, *Leçons de Morale, de Politique et de Droit Public puisées dans l'Histoire de notre Monarchie ou Nouveau Plan d'Etude de l'Histoire de France* (Versailles: De l'imprimerie du Départ, 1773), 33.

42. Baker, "Memory and Practice," 154.

43. *Arthur Young's Travels in France during the Years 1787, 1788, 1789* (London: George Bell & Sons, 1892), 50.

44. Rochefoucauld, *Voyages en France*, 44.

45. The words appear in a 1785 letter to James Madison. Reprinted in Elizabeth Gilmore Holt, ed., *From the Classicists to the Impressionists: Art and Architecture in the Nineteenth Century*, volume 3 of A Documentary History of Art (Garden City: Anchor Books, 1966), 251–52.

46. This tradition dated from Poldo d'Albenas in 1560. See Emile Ségui, *Le Trésor de la Maison Carrée* (Nîmes: Éditions Méridionales, 1937), 15–18. No doubt Jefferson was familiar with Bernard de Montfaucon, the most widely read antiquarian in the eighteenth century, who repeated these claims.

47. For a summary of the antiquarian history of the building in the eighteenth century, see Millin, *Voyage*, 4: 216–18. Jutta Held discusses the political significance of this image, noting that it was associated with the crown because the crown had undertaken to renovate and restore it at about this time. See *Monument und Volk*, 298–312.

48. Cited by Ségui, *Le Trésor*, 96. A decree issued by Calonne in 1787 clearly appropriated the temple as the property of the king and the nation. The edict demanded the demolition of a gallery constructed by the religious order using the temple: "Sa Majesté a jugé que la conservation de ce monument qui par la beauté de son architecture a été regardé de tout tems comme un modèle (des maîtres de l'art) devoit attirer son attention aussi bien que les Arènes dont (le dégagement) et le rétablissement ont été ordonnés par l'arrêt du Conseil du 28 août dernier (1786)" (Ségui, *Le Trésor*, 159).

49. In the letter dated 7 octobre 1787, the writer stated that it was very definite that there would definitely not be a voyage to Fontainebleau, but only some hunts in the late season. The trip traditionally took place in the fall. See *Correspondance*

secrète . . . *publiée d'après les manuscrits de la Bibliothèque Impériale de Saint-Pétersbourg* . . . , par M. de Lescure, 2: 188.

50. *Correspondance secrète*, 2: 76.

51. The color of the walls was certainly a factor. For a sense of how the walls strengthened the range of hue and value in a Robert, we have only to visit room 63 in the Musée Carnavalet. Restored in 1994, this room contains boiseries from the Château de Conflans that date from the reign of Louis XVI. The hues of the two Robert canvases hanging on these pale, opaque green-gray wall units, trimmed in white – *La démolition des maisons du pont Notre-Dame en 1786* and *La démolition des maisons du Pont-au-Change en 1788* – glow with an extraordinary luminosity that must be due to a vibration provoked between Robert's colors and the color of the wall. On the iconography of the two paintings, see my study about Robert's views of Paris, "Hubert Robert's Paris: Truth, Artifice, and Spectacle," *Studies on Voltaire and the Eighteenth Century*, no. 245 (1986), 501–18

52. When the contents of the chamber were inventoried in 1793, the room contained only a console table and the four framed paintings by Robert. The report (Arch. nat. F[17] 1263) is reprinted in *Nouvelles Archives de l'Art Français* 18 (1902), 182–83. In another report, dated 5 prairial an IV (May-June 1796), "Objets extraits du ci-devant château pour le Muséum," the four paintings by Robert representing the antiquities of Languedoc are again listed. Evidently, all four were supposed to go to the museum, but Robert kept two back. In 1795 Robert, after being released from prison, had been appointed to the Conservatoire of the Museum. See Gabillot, *Hubert Robert et son temps*, 211–12.

53. I am following Robert's logic in these divisions. The two paintings he reclaimed after the Terror were the caprices, Figures 49 and 50. I infer, on this basis, that he thought of them as pendants and, likewise, thought of the other two, which remained in the museum, as pendants too. See inventory of 1821 studio sale, number 253 – reprinted in Gabillot, *Hubert Robert et son temps*, 252. The two pictures that Robert kept are mentioned in the catalogues of the 1809 studio sale and the 1821 sale. The 1809 reference follows the entries on the twenty-five works by Pannini owned by Robert and offered for sale, discussed earlier. The two works were not for sale, though, in 1809. After Madame Robert died, the two works were listed in the 1821 sale as pendants valued at 1,000 francs, the highest price of any Robert in the catalogue. These wound up being bequeathed to the Louvre. The two works are described in the catalogue as "des plus importants de M. Robert" (reprinted in Gabillot, *Hubert Robert et son temps*, 252).

54. I am relying on textual evidence and inference here, i.e., on the norms current in the Louis XVI style by 1787, because the room itself at Fontainebleau has been remodeled.

55. "Deux esquisses faites d'après nature: l'une est *Une vue prise dur la rivière*, sous l'une des arches du Pont-Royal, dans le temps de la grande gelée de l'hiver dernier; et l'autre représente *La Bastille dans les premiers jours de sa démolition*. Elles ont 4 pieds de long sur 3 de haut."

56. Signed on the boulder at right, "20 juillet 1789, H. Robert pinxit." See Boulot et

al., *Hubert Robert et la Révolution*, 62–63, for a summary of the picture's provenance.

57. Perhaps he had a series in mind. He also represented the last mass of the royal family at the Tuileries palace, the so-called Day of the Wheelbarrows (the preparations for the Festival of Federation), the Festival of Federation, and the desacralization of the royal crypts at Saint Denis.

58. See Mantion's article, to which I am indebted. Jean-Rémy Mantion, "Autopsie de la Bastille, Peindre l'événement en 1789," *Dix-Huitième Siècle* 20 (1988), 237.

59. Jean Starobinski, *1789: Les Emblèmes de la Raison* (Paris: Flammarion, 1979), 9–15.

Epiloque: Hubert Robert and the Revolution

1. On this subject, see the works of historian Lynn Hunt, which have contributed so much to the new awareness of the role of symbol and metaphor in understanding historical change. Lynn Hunt, *The Family Romance of the French Revolution* (Berkeley: University of California Press, 1992); *Politics, Culture and Class in the French Revolution* (Berkeley: University of California Press, 1984); ed., *Eroticism and the Body Politic* (Baltimore: The Johns Hopkins University Press, 1991).

2. Gordon, *Citizens without Sovereignty*, 175.

3. I quote here from the 1795 English translation by Hooper (who rounded off the date in the title to the year 2500!). Louis-Sébastien Mercier, *Memoirs of the Year 2500 [sic]*, trans. by W. Hooper (Philadelphia: Thomas Dobson, 1795; rpt. Clifton, N. J.: Augustus M. Kelley, n.d.), 318.

4. Mercier, *Memoirs of the Year 2500*, 239.

5. A paradigm that equates the artist's work with the pleasure his person brings to others, notably the company of "the illustrious," in Fournier-Desormes's words (see Chapter 1, epigraph), can cut both ways. Fournier-Desormes had philosophers, scientists and individuals in the arts and letters in mind, not members of the court. He identified Robert's "friends" as Buffon, Visconti, Vernet, Greuze, Grétry, Delille, Lekain, and Voltaire.

6. For a summary of the documentary evidence regarding Robert's arrest, see Catherine Boulot, "Hubert Robert, Un Peintre Emprisonné Sous La Terreur," in Boulot et al., *Hubert Robert et la Révolution*, 19–27. Outside of the warrant specifying his lapsed identity card as the reason for the arrest, all evidence is speculative and anecdotal.

7. This chapter developed out of a session on propaganda at the Annual Meeting of French Historical Studies in Boston, 1996, particularly a paper by Jerrine Mitchell entitled "Considering the Idea of Art as Propaganda." Mantion makes the argument about "the discourse of illustration" in his article, "Autopsie de la Bastille," to which I am especially indebted.

8. *Récreation des prisonniers à la prison de Saint-Lazare: La partie de ballon* (o/c; 0,33 x 0,41). See, e.g., Charles Sterling, *Exposition Hubert Robert*, à l'occasion du

Deuxième Centenaire de sa Naissance (Paris, Musée de l'Orangerie, 1933), 102–103.

9. *Intérieur de la prison de Saint-Lazare, en 1793* (o/c; 0,40 x 0,32); signed at right, on bottom: "H. Robert"; Paris, Musée Carnavalet. See commentary in Alan Wintermute, ed., *1789: French Art during the Revolution*, exhibition, (New York: Colnaghi, 1989), 280, n 2.

10. *Camille Desmoulins* (o/c; 0,32 x 0,40); signed, on bedframe: "H. Robert Pinxit"; the Wadsworth Atheneum, Hartford, Conn.; The Ella Gallup Sumner and Mary Catlin Sumner Collection. The Colnaghi Exhibition catalogue identifies the figure as Antoine Roucher. Wintermute, *1789*, 274. Excerpts from Antoine Roucher's correspondance penned during his imprisonment at Sainte Pélagie and Saint Lazare, *Consolations de ma captivité*, 1797, are often juxtaposed against the Roberts in the absence of a theoretical model, as if Roucher's statements provide a explanation of the representations.

11. See the Colnaghi catalogue, Wintermute, *1789*, 278–280.

12. Mantion, "Autopsie de la Bastille," 236.

13. This is the way the picture is described (no. 79) in the Robert studio sale of 1809; the catalogue is reprinted in Gabillot.

14. A photograph of the arrest warrant is reproduced in Boulot et al., *Hubert Robert et la Révolution*, 168.

15. Boulot et al., *Hubert Robert et la Révolution*, 21.

16. Several of these plates are illustrated and discussed by Boulot et al. See, *Hubert Robert et la Révolution*, 92–94.

17. John Brewer, "Commercialization and Politics," in Neil McKendrick, John Brewer, and J. H. Plumb, *The Birth of a Consumer Society: The Commercialization of Eighteenth-Century England* (London: Europa, 1982), 197–262.

18. Boulot et al., *Hubert Robert et la Révolution*, 106–107. As the inscription indicates, this was designed as a title page for a collection of drawings made at St. Lazare by the artist.

19. Examples are illustrated in *La Révolution Française, Le Premier Empire: Dessins du Musée Carnavalet*, exhibition Février 1983 (Paris: Les Amis du Musée Carnavalet, 1983), 36–37.

20. Smoking was thought to induce a kind of narcotic state, similar to that produced by alcohol. Robert leaves out the references to smoking, so bountifully displayed in the Fragonard/Berthault print.

21. The same idea is evident in the cardboard vignettes of Revolutionary events created by Lesueur and now exhibited in the Carnavalet. In the annotation to Lesueur's representation of an individual pleading his case before the Revolutionary Tribunal, the artist explains that the men in his picture are hardened revolutionaries who lack understanding of the judicial process. Dazed by wine and smoke, they send everyone to the scaffold, except those whose names appear on the daily list. See *La Révolution Française*, 82–96.

22. I have in mind the Condorcet of the *Esquisse d'un tableau historique des progrès de l'esprit humain*, a prospectus for a vast study of civilizations that he wrote in

1793 while he was in hiding after a warrant had been issued for his arrest. Condorcet committed suicide in 1794.

23. Sterling, *Exposition Hubert Robert*, 102.

24. Starobinski, *1789*, 31–37.

25. It is this view of women as active agents outside the home that the revolutionaries rejected. Condorcet's "On the Admission of Women to the Rights of Citizenship," published in the *Journal of the Society of 1789*, comes to mind as a text to bring to a reading of this image.

26. See Sahut's analysis. Sahut and Garnier, *Le Louvre d'Hubert Robert*; see also McClellan, *Inventing the Louvre*.

27. One notable exception to this tendency to ignore the patron is the commentary in *La France et la Russie au Siècle des Lumières, Relations culturelles et artistiques de la France et de la Russie au XVIIIe siècle*, exposition, Galeries Nationales du Grand Palais, 20 novembre 1986–9 février 1987 (Paris: Association Française d'Action Artistique, 1986), 335. Precise information about how these works entered the imperial collection is not known. Other paintings from this time also appeared in Russian collections. In the same exhibition, e.g., see no. 331, entitled "La fête du printemps" and dated 1794. It was owned by Chouvalov. The 1796 pendants are not among the items listed in the 1809 studio sale. The two pictures were acquired by the Louvre in 1975.

28. The letter is reprinted in Louis Réau, "L'Art français dans les pays du nord et de l'est de l'Europe," *Archives de l'Art français*, t. 17 (1932), p. 186. "Si ce Robert n'était ni général commandant, ni démagogue, ni enragé et qu'il vînt ici, il trouverait des vues à peindre, car tout Tsarsko-Selo est un immense ramas des plus jolis points de vue qu'on puisse voir; la colonnade seule en fournirait une honnête quantité. Si vous avez de l'argent à moi, payez Robert pour ce tableau [a view of Tsarsko-Selo painted for count Stroganov in 1783]. Puisque ce peintre aime mieux à peindre des ruines, et qu'il en a tant sous les yeux, il aura grand'raison de ne pas se déplacer du pays des ruines."

29. Moreover, in 1795, one of Hubert Robert's intimates, Elisabeth Vigée-Lebrun, arrived in St. Petersburg as an émigré. She became a prominent figure in the social and artistic life of the city until her departure in 1801. If the pictures entered the imperial collection in 1796, and there is no evidence that they did not, Vigée-Lebrun would have been quite knowledgeable about the connotations of their iconography.

30. At least, in 1790–91, he was trying to bid on works in the collections of certain emigrés that were being bought by foreigners such as Catherine the Great. See Cayeux, *Hubert Robert*, 250–53.

31. Sahut speculates that the Louvre's R.G.1952–15 might be a sketch for the picture exhibited in 1791 or perhaps even the work itself, though "l'hypothèse est fragile." Sahut and Garnier, *Le Louvre d'Hubert Robert*, 27.

32. Jean-Rémy Mantion, "Déroutes de l'art, La destination de l'oeuvre d'art et le débat sur le musée," in *La Carmagnole des Muses: L'homme de lettres et l'artiste dans la Révolution* (Paris: Armand Colin, 1988), 104–106.

33. Robert Darnton, *The Forbidden Best-Sellers of Pre-Revolutionary France* (New York: W. W. Norton & Co., 1995).

34. "C'est n'est pas sans une satisfaction intime, que je réimprime, au bout de vingt-huit années et pour la troisième fois, un *Rêve* qui a annoncé et préparé la révolution française."

35. In a drawing identified by the Carnavalet as the Church of the Sorbonne in ruins, Robert seems to have imagined the present from the vantage point of the future too, just as Cochin and Saint-Aubin invented a prospect of Sainte-Geneviève in the years 2355 and 3000. On this, see Sahut and Garnier, *Le Louvre d'Hubert Robert*, 32.

36. A sketchbook by Robert that contains detailed drawings of the Old Master copies appearing in this painting is presently in the The Getty Center, Special Collections, notebook #930069. A drawing of the Apollo Belevedere is also in the sketchbook. All the artworks pictured along the wall in Robert's Grand Gallery have been identified. All but one were mentioned in the catalogue of objects exhibited in 1793. Most of them represent works by Raphael and Guido Reni. Sahut and Garner, *Le Louvre d'Hubert Robert*, 28. I find it fascinating that the pictures are hung in the newly reopened eighteenth-century galleries in the Louvre in reverse order, i.e., with the picture showing the gallery in ruins on the beholder's left and the representation of the projected gallery on the beholder's right. The titles in the Salon livret of 1796 clearly indicate that the intact gallery is the originating concept, with the second picture entitled ruins of "the preceding [canvas]."

37. Michelangelo's *Dying Slave*, recognizable to the right, and Alexandre Rondoni's bust of Raphael, propped against the feet of the Apollo Belvedere, evidently were on display in the Grand Gallery during this period.

38. Robert's picture in the Carnavalet Museum of the despoiling of the royal tombs of Saint Denis is clearly a negative comment on the activities of the vandals who destroyed works of art during the Terror. It is tempting to see a similar subtext here, though the visual evidence in the Grand Gallery pendants is ultimately equivocal on this subject.

39. "Besides those things which *directly* suggest the idea of danger, and those which produce a similar effect from a mechanical cause, I know of nothing sublime which is not some modification of power . . . And indeed the ideas of pain, and above all of death, are so very affecting that whilst we remain in the presence of whatever is supposed to have the power of inflicting either, it is impossible to be perfectly free from *terror*;" Edmund Burke, *A Philosophical Inquiry into the Origin of Our Ideas of the Sublime and Beautiful*, Pt. II, sects. 1–5, reprinted in Louis I. Bredvold, Alan D. McKillop, and Lois Whitney, eds., *Eighteenth-Century Poetry and Prose*, 2d ed. (New York: Ronald Press Co., 1956), 1168.

40. Edmund Burke, *Reflections on the Revolution in France*, with Thomas Paine, *The Rights of Man* (Garden City, N.Y.: Anchor Books, 1973), 21–22.

41. Reprinted in Georges Wildenstein, *Mélanges*, (Paris: Les Beaux Arts, 1925), 1: 41–42. The proposed paintings were a representation of the deputy Beauvais and one of the young Barra.

42. Restif de la Bretonne, *My Revolution: Promenades in Paris, 1789–1794, Being the Diary of Restif de la Bretonne*, trans. Alex Karmel (New York: McGraw Hill, 1970), 383.

43. A preliminary sketch for the figures of the dancers has been reproduced in the exhibition catalogue *J. H. Fragonard e H. Robert a Roma*, 100. Thus this motif, like so many others, seems to originate from the artist's Roman sojourn.

44. A sketch of the sphinx intact appears in the sketchbook at the Getty Center, Special Collections.

45. A picture such as Tanguy's *Dame à l'absence* (1942), perhaps. And the fractured sphinx mounted by a man, is that not a detail of macabre humor, such as we might find in Miro or Dali?

46. Restif de la Bretonne, *My Revolution*, 382.

47. Etienne-Denis Pasquier, *Histoire de Mon Temps: Mémoires du Chancelier Pasquier*, publiés par le duc d'Audiffret-Pasquier (Paris: Plon, Nourrit et Cie., 1893), 1: 132.

48. The obelisk could symbolize the "glory of princes," following Ripa's *Iconologia*, or its opposite, the French Republic, as it does in the print. Likewise, pyramids could signify "les monumens du despotisme," as Mercier wrote in *L'An 2440*, or they could be taken as massive triangles, the Republican symbol of law and equality.

49. Mona Ozouf, *La fête révolutionaire 1789–1799* (Paris: Éditions Gallimard, 1976), 280–316. The musette did perform this function for dancers. No symbol was more emblematic of popular Revolutionary fervor after 1789 than the maypole. Initially a pole or mast, much like an obelisk, the maypole was erected spontaneously by peasants in the countryside during the early years of the Revolution. After draping the pole with insignia and signs of feudalism, celebrants danced in a ring around it. Thus the maypole stood for both the renewal and the termination of feudal debts. After 1793, the death of Louis XVI elided into this ritual. At the *fête* held every January after 1794 to commemorate the king's execution, a liberty tree, a less populist variant of the *mai* favored by festival organizers, was ceremoniously planted in the ground. See Ozouf, *La fête révolutionaire*, 212ff.

Bibliography of Works Cited

Abrantès, Laure Junot, duchesse d'. *Une Soirée chez Mme. Geoffrin*. Bruxelles: Société Générale d'Imprimerie, 1837.

Adams, William Howard. *The French Garden, 1500–1800*. New York: George Braziller, 1979.

Aikema, Bernard, and Boudewijn Bakker. *Painters of Venice: The Story of the Venetian "Veduta."* The Hague: SDU, 1990.

Aldis, Janet. *Madame Geoffrin: Her Salon and Her Times, 1750–1777*. London: Methuen & Co., 1905.

Alembert, Jean d'. "Essai sur la société des gens de lettres et des grands." In *Mélanges de littérature, d'histoire, et de philosophie*. Nouvelle édition. 5 vols. Amsterdam, 1759–68.

Oeuvres complètes. 5 vols. Paris: A. Belin, 1822.

Allérès, Danielle. *L'empire du luxe*. Paris: Pierre Belfond, 1992.

Angiviller, Charles-Claude de Flahaut, comte de la Billarderie d'. *Mémoires de Charles Claude Flahaut Comte de la Billarderie d'Angiviller: Notes sur les Mémoires de Marmontel*. Publiés d'après le manuscrit par Louis Bobé. Copenhague: Levin & Munksgaard, 1933.

Argenson, R. L. de Voyer, marquis de. *Mémoires et Journal inédit du Marquis d'Argenson*. Paris: P. Jannet, 1763.

Arnaud, Claude. "La Comte d'Artois et sa Coterie." Pp. 15–26 in *La Folie d'Artois*, ed. J.-L. Gaillemin. Paris: Antiquitaires à Paris, 1988.

The Art of Rome c.753 B.C.-337 A.D., Sources and Documents. Ed. J. J. Politt. Englewood Cliffs, N.J.: Prentice-Hall, 1966.

Aston, Nigel. *The End of an Elite: The French Bishops and the Coming of the Revolution, 1786–1790*. Oxford: Clarendon Press, 1992.

Bachaumont, Louis Petit de. *Mémoires secrets pour servir à l'histoire de la république des lettres en France*. 36 vols. Londres: 1777–89.

Bailey, Colin B. "Conventions of the Eighteenth-Century *Cabinet de tableaux*: Blondel d'Azincourt's *La première idée de la curiosité*." *The Art Bulletin* 69 (September 1987): 431–47.

" 'Quel dommage qu'une telle dispersion': Collectors of French Painting and the

French Revolution." Pp. 11–26 in *1789: French Art during the Revolution*. Ed. A. Wintermute. New York: Colnaghi, 1989.

Ed. *The Loves of the Gods: Mythological Painting from Watteau to David*. Exhibition. New York: Rizzoli, 1992.

Baker, Keith Michael. "Memory and Practice: Politics and the Representation of the Past in Eighteenth-Century France." *Representations* 11 (summer 1985): 134–64.

Inventing the French Revolution. Cambridge: Cambridge University Press, 1990.

Bandiera, J. D. "Form and Meaning in Hubert Robert's Ruin Caprices: Four Paintings of Fictive Ruins for the Château de Méréville." *Art Institute of Chicago Museum Studies* 15 (1989): 21–37.

Bardet, Jean-Pierre. *Rouen aux XVIIe et XVIIIe siècles. Les Mutations d'un espace social*. Préface de Pierre Chaunu. Paris: Société d'Édition d'Enseignement Supérieur, 1983.

Bastide, J. F. *La Petite Maison*. Paris: Librairie des Bibliophiles, 1879.

Beau, Marguerite. *La collection des dessins d'Hubert Robert au Musée de Valence*. Lyon: Audin, 1968.

Becq, Annie. "Artistes et marché." Pp. 81–95 in *La Carmagnole des Muses, L'homme de lettres et l'artiste dans la Révolution*. Paris: Armand Colin, 1988.

"Creation, Aesthetics, Market: Origins of the Modern Concept of Art." Pp. 240–55 in *Eighteenth-Century Aesthetics and the Reconstruction of Art*. Ed. Paul Mattick, Jr. Cambridge: Cambridge University Press, 1993.

"Expositions, Peintres et Critiques: Vers l'Image Moderne de L'Artiste." *Dix-huitième siècle* 14 (1982): 131–49.

Bermingham, Ann. *Landscape and Ideology: The English Rustic Tradition, 1740–1860*. Berkeley: University of California Press, 1986.

Berry, Christopher. *The Idea of Luxury*. Cambridge: Cambridge University Press, 1994.

Blaikie, Thomas. *Diary of a Scotch Gardener at the French Court at the End of the Eighteenth Century*. Introduction by Francis Birrell. London: George Routledge & Sons, 1931.

Blondel, Jacques-François. *Cours d'Architecture ou Traité de la Décoration, Distribution et Construction des Bâtiments*. 6 vols. Paris: Chez Desaint, 1771–77.

De la Distribution des Maisons de plaisance et de la décoration des édifices en général. 2 vols. Paris: Charles-Antoine Jombert, 1737–38.

Boigne, Louise-Eleonore-Charles-Adelaide d'Osmond, comtesse de. *Récits d'une tante: Mémoires de la Comtesse de Boigne* née Osmond. Publiés d'après le manuscrit original par M. Charles Nicoullaud. 4 vols. Paris: Plon, 1907.

Bottineau, Yves. "Précisions sur le Fontainebleau de Louis XVI." *Gazette des Beaux-Arts* 69 (Mars 1967): 138–58.

Boulot, Catherine, Jean de Cayeux, and Hélène Moulin, eds. *Hubert Robert et la Révolution*. Exhibition. Valence: Le Musée de Valence, 1989.

Braham, Allen. *The Architecture of the French Enlightenment*. Berkeley: University of California Press, 1980.

Bredvold, Louis I., Alan D. McKillop, and Lois Whitney, eds. *Eighteenth-Century Poetry and Prose*. 2d ed. New York: Ronald Press, 1956.

Brewer, John. "Commercialization and Politics." Pp. 197–262 in Neil McKendrick, John Brewer, and J. H. Plumb, *The Birth of a Consumer Society: The Commercialization of Eighteenth-Century England*. London: Europa, 1982.

Bryson, Scott S. *The Chastised Stage: Bourgeois Drama and the Exercise of Power*. Stanford French and Italian Studies. Stanford: Anma Libri & Co., 1991.

Burke, Edmund. *Reflections on the Revolution in France*, with Thomas Paine, *The Rights of Man*. Originally published 1790. Garden City: Anchor Books, 1973.

Cailleux, Jean. "Hubert Robert a pris modèle sur Boucher." *Connaissance des arts* (Octobre 1959): 100–107.

Carlson, V. *Hubert Robert, Drawings and Watercolors*. Exhibition, Washington, D.C., 1978.

Castries, duc de. *Julie de Lespinasse: Le drame d'un double amour*. Paris: Albin Michel, 1985.

Catroux, R.-Claude. "Hubert Robert et Madame Geoffrin." *La Revue de l'Art Ancien et Moderne* 40 (June 1921): 28–40.

Cayeux, Jean de. *Hubert Robert et les Jardins*. Paris: Éditions Herscher, 1987.

 Hubert Robert. Paris: Fayard, 1989.

 "Jeux d'eau pour une salle de Bains." *L'Objet d'Art*, no. 8 (1988): 64–68.

 Les Hubert Robert de la Collection Veyrenc au Musée de Valence. Valence: Le Musée de Valence, 1985.

Caylus, Anne-Claude-Philippe, comte de. *Correspondance inédite du Comte de Caylus avec le P. Paciaudi, Théatin (1757–1765), suivi de celles de l'abbé Barthélemy et de P. Mariette avec le même*. Publiées par Charles Nisard. 2 vols. Paris: L'imprimerie Nationale, 1877.

 Receuil d'antiquités egyptiennes, etrusques, grecques et romaines. 7 vols. Paris, 1752–64.

Chaline, Nadine-Josette, ed. *Le Diocèse de Rouen-Le Havre*. Paris: Éditions Beauchesne, 1976.

Charageat, Marguerite. "Vénus donnant un message à Mercure par Pigalle." *Revue des Arts* (1953–54): 217–22.

Charles-Roux, J. *Nîmes*. Paris: Blond et Cie: 1908.

Chatelus, Jean. *Peindre à Paris au XVIIIe Siècle*. Nîmes: Éditions Jacqueline Chambon, 1991.

Cochin, Augustin. *Études Sociales et Économiques*. Paris: Didier et Cie, 1880.

Cochin, Charles-Nicolas. *Mémoires inédits de Charles-Nicolas Cochin sur le Comte de Caylus, Bouchardon, les Slodtz*. Publiés d'après le manuscrit autographe, avec introduction, notes et appendice par Charles Henry. Paris: Baur, 1880.

 Voyage d'Italie ou Recueil de Notes sur les ouvrages de peinture et de sculpture, qu'on voit dans les principales villes d'Italie. 3 vols. Paris, 1758; Geneva: Minkoff rpt., 1972.

Cognel, François. *La Vie Parisienne sous Louis XVI*. Paris: Calmann Lévy, 1882.

Cohen, Ted. "Jokes." Pp. 120–36 in *Pleasure, Preference, and Value: Studies in Philosophical Aesthetics*. Ed. Eva Schaper. Cambridge: Cambridge University Press, 1983.

"Metaphor and the Cultivation of Intimacy." Pp. 1–10 in *On Metaphor*. Ed. Sheldon Sacks. Chicago: The University of Chicago Press, 1978.

Cole, William. *A Journal of My Journey to Paris in the Year 1765 by the Rev. William Cole*. Ed. Francis Griffin Stokes. London: Constable & Co., 1931.

Condorcet, Jean-Antoine-Nicolas de Caritat, marquis de. *Esquisse d'un tableau historique des progrès de l'esprit humain*. 4th ed. Paris: Ahasse, an VI (1798).

Conisbee, Philip. *Chardin*. Lewisburg: Bucknell University Press, 1985.

"Correspondance de M. D'Angiviller avec Jean-Baptiste Pierre," t. XXII, *Nouvelles Archives de l'Art Français*.

Correspondance littéraire, philosophique et critique par Grimm, Diderot, Raynal, Meister, etc. Ed. Maurice Tourneux. 16 vols. Paris: Garnier Frères, 1877–82.

Correspondance secrète entre Marie-Thérèse et le Cte de Mercy-Argenteau. Introduction and notes by M. le Chevalier Alfred d'Arneth et M. A. Geffroy. 4 vols. Paris: Firmin Didot Frères, Fils et Cie., 1874.

Correspondance secrète inedite sur Louis XVI, Marie-Antoinette, la cour et la ville de 1777 à 1792. Ed. Mathurin de Lescure. 2 vols. Paris: Plon, 1866.

Costa de Beauregard, J.-A.-B. marquis de. *Un Homme d'Autrefois*. Souvenirs recueillis par son arrière-petit-fils, le marquis Costa de Beauregard. Paris: Plon, 1878.

Craddock, Patricia B. "Edward Gibbon and the 'Ruins of the Capitol.'" Pp. 63–82 in *Roman Images*. Ed. A. Patterson. Baltimore: The Johns Hopkins University Press, 1984.

Crow, Thomas E. *Painters and Public Life in Eighteenth-Century Paris*. New Haven: Yale University Press, 1985.

Dardel, Pierre. *Commerce, Industrie et Navigation à Rouen et au Havre au XVIIIe Siècle*. Rouen: Société Libre d'émulation de la Seine-Maritime, 1966.

Darnton, Robert. *The Forbidden Best-Sellers of Pre-Revolutionary France*. New York: W. W. Norton & Co., 1995.

Delille, J. *La conversation: Poème en trois chants*. Paris: Michaud, 1812.

Dennis, Michael. *Court and Garden*. Cambridge, Mass.: MIT Press, 1986.

Diderot, Denis. *Salons*. Ed. J. Seznec and J. Adhémar. 4 vols. Oxford: Clarendon Press, 1957–67.

Diderot, Denis, and Jean Le Rond d'Alembert. *Encyclopédie méthodique, ou par ordre des matières; par une société de gens de lettres, de savans et d'artistes*. 46 vols. Paris: Panckoucke, 1782–1832.

Diderot et l'Art de Boucher à David: Les Salons, 1759–1781. Exhibition Hôtel de la Monnaie. Paris: Éditions de la Réunion des Musées nationaux, 1984.

Dimier, Louis. "Témoignages Inconnus sur Hubert Robert." *Bulletin de la Société de l'Histoire de l'Art Français* (1934): 38–41.

D'Oench, Ellen G. *The Conversation Piece: Arthur Devis and His Contemporaries*. New Haven: Yale Center for British Art, 1980.

Duchesne, Henri-Gaston. *Le Château de Bagatelle*. Paris: Jean Schemit, 1909.

Dufort de Cheverny, Jean-Nicholas, comte de. *Mémoires*. 2 vols. Paris: Les Amis de l'Histoire, 1970.

Dumesnil, M. J. *Histoire des Plus Célèbres Amateurs Français et de leurs relations avec les Artistes, Tome I: Pierre-Jean Mariette, 1694–1774.* Paris: Jules Renouard, 1858.

Durand, Yves. *Les Fermiers Généraux au XVIIIe siècle.* Paris: Presses universitaires de France, 1971.

Egret, Jean. *The French Pre-Revolution, 1787–1788.* Trans. W. D. Camp; introduction by J. F. Bosher. Chicago: The University of Chicago Press, 1977.

Ellis, Harold A. *Boulainvilliers and the French Monarchy: Aristocratic Politics in Early Eighteenth-Century France.* Ithaca: Cornell University Press, 1988.

Éloges de Madame Geoffrin par MM. Morellet, Thomas et d'Alembert suivis de Lettres de Madame Geoffrin et à Madame Geoffrin. Paris: H. Nicolle, 1812.

Engerand, Fernand, ed. *Inventaire des Tableaux Commandés et achetés par la Direction des Bâtiments du Roi (1709–1792).* Paris: Ernest Leroux, 1900.

Etienne, Pascal, ed. *Le Faubourg Poissonnière: Architecture, élégance et décor.* Paris, 1986.

Fairchilds, Cissie. *Domestic Enemies: Servants and Their Masters in Old Regime France.* Baltimore: The John Hopkins University Press, 1984.

Falconet, Etienne. *Oeuvres complètes d'Etienne Falconet.* 3 vols. Paris: 1808; Genève: Slatkine rpts., 1970.

Fournier-Desormes. *Epître à Hubert Robert.* Paris: Persan et Cie, 1822.

François Boucher, 1703–1770. Exhibition. New York: The Metropolitan Museum of Art, 1986.

Französische Zeichnungen im Städelchen Kunstinstitut, 1550 bis 1800. Frankfurt am Main: Städtische Galerie im Städelschen Kunstinstitut, 1986.

Frénilly, A. F., marquis de. *Souvenirs du Baron de Frénilly*, pair de France (1768–1828). Publiés avec introduction et notes par Arthur Chuquet. Paris: Plon, 1909.

Fumaroli, Marc. *Le genre des genres littéraires français: La conversation.* The Zaharoff Lecture for 1990–91. Oxford: Clarendon Press, 1992.

Furet, François. *Penser la Révolution française.* Paris: Gallimard, 1978.

"Two Historical Legitimations of Eighteenth-Century French Society: Mably and Boulainvilliers." Pp. 125–39 in *In the Workshop of History.* Trans. Jonathan Mandelbaum. Chicago: The University of Chicago Press, 1984.

Gabillot, Claude. *Hubert Robert et son temps.* Paris: Librairie de l'art, 1895.

Gaudillot, Jean-Marie. *Le Voyage de Louis XVI en Normandie, 21–29 Juin 1786.* Caen: Société d'Impressions Caron & Cie, 1967.

Gautier, Jean-Jacques. "Le Goût du Prince." Pp. 81–142 in *La Folie d'Artois.* Ed. Jean-Louis Gaillemin. Paris: Antiquaires à Paris, 1988.

[Geoffrin.] *Correspondance Inédite du Roi Stanislas-Poniatowski et de Madame Geoffrin (1764–1777).* Précédée d'une étude sur Stanislas-Auguste et Madame Geoffrin par Charles De Moüy. Paris, 1875; Genève: Slatkine rpt., 1970.

Georgel, Jean-François, abbé de. *Mémoires pour servir à l'histoire des événemens de la fin du dix-huitième siècle depuis 1760 jusqu'en 1806–1810 par feu M. l'Abbé Georgel.* Publiés par M. Georgel. Paris: Alexis Eymery, 1820.

Gleichen, Charles-Henri. *Souvenirs de Charles-Henri Baron de Gleichen*. Paris: Léon Techener, 1868.

Goodden, Angelica. *The Complete Lover: Eros, Nature, and Artifice in the Eighteenth-Century French Novel*. Oxford: Clarendon Press, 1989.

Goodman, Dena. "Enlightenment Salons: The Convergence of Female and Philosophic Ambitions." *Eighteenth-Century Studies* 22 (1989): 340–50.

"Filial Rebellion in the Salon: Madame Geoffrin and Her Daughter." *French Historical Studies* 16 (spring 1989), 28–47.

The Republic of Letters, A Cultural History of the French Enlightenment. Ithaca: Cornell University Press, 1994.

Goodman, John. " 'Altar Against Altar': The Colisée, Vauxhall Utopianism, and Symbolic Politics in Paris (1769–77)." *Art History* 15 (December 1992): 434–69.

Ed. and trans. *Diderot on Art*. 2 vols. New Haven: Yale University Press, 1995.

Gordon, Daniel. *Citizens without Sovereignty: Equality and Sociability in French Thought, 1670–1789*. Princeton: Princeton University Press, 1994.

Grate, P. "Hubert Robert et l'iconographie d'Augustin Pajou." *Gazette des Beaux-Arts* (juillet-août 1985): 7–14.

Gruber, Alain-Charles. *Les Grandes Fêtes et leur Décors à l'Epoque de Louis XVI*. Genève: Droz, 1972.

Gruder, Vivian R. "Class and Politics in the Pre-Revolution: The Assembly of Notables of 1787." Pp. 207–32 in *Vom Ancien Régime zur Französischen Revolution*. Ed. E. Hinrichs. Göttingen: Vandenhoeck & Ruprecht, 1978.

Gudeman, Stephen. *Economics as Culture: Models and Metaphors of Livelihood*. London: Routledge & Kegan Paul, 1986.

Guiffrey, Jules, ed. *Le peinture au musée du Louvre*. 2 vols. Paris: Publiée sous la direction de J. Guiffrey, 1929.

Gutwirth, Madelyn. *The Twilight of the Goddesses*. New Brunswick: Rutgers University Press, 1992.

Habermas, Jürgen. *The Structural Transformation of the Public Sphere: An Inquiry into a Category of Bourgeois Society*. Trans. Thomas Burger and Frederick Lawrence. Cambridge, Mass., 1989.

Hammer, Karl. *Hôtel Beauharnais*. Munich: Artemis Verlag, 1983.

Haskell, Francis, and Nicholas Penny. *Taste and the Antique*. New Haven: Yale University Press, 1981.

Held, Jutta. *Monument und Volk: Vorrevolutionäre Wahrnehmung in Bildern des ausgehenden Ancien Régime*. Köln: Böhlau Verlag, 1990.

Henriot, Gabriel. *Collection David Weill*. 3 vols. Paris: Des Presses De Braun & Co., 1928.

Hobson, Marian. *The Object of Art: The Theory of Illusion in Eighteenth-Century France*. Cambridge: Cambridge University Press, 1982.

Holbach, Paul Henri Thiry, baron d'. *La Morale universelle ou les Devoirs de l'Homme fondés sur sa Nature*. 3 vols. Amsterdam, 1776; rpt. Stuttgart-Bad Cannstatt: Friedrich Frommann Verlag, 1970.

Holloway, Owen E. *French Rococo Book Illustration*. New York: Transatlantic Arts, 1969.

Holmes, Mary Taverner. "Lancret, décorateur des 'petits cabinets' de Louis XV à Versailles." *L'Oeil* no. 356 (March 1985): 24–31.

Holt, Elizabeth Gilmore, ed. *From the Classicists to the Impressionists, Art and Architecture in the Nineteenth Century*. A Documentary History of Art. Vol. 3. Garden City: Anchor Books, 1966.

Hunt, Lynn, ed. *Eroticism and the Body Politic*. Baltimore: The Johns Hopkins University Press, 1991.

 Politics, Culture, and Class in the French Revolution. Berkeley: University of California Press, 1984.

 The Family Romance of the French Revolution. Berkeley: University of California Press, 1992.

Iconologie, ou, explication nouvelle de plusieurs images, emblèmes, et autres figures; tirées des recherches et de figures de César Ripa. Moralisées par I. Baudoin. Paris: Mathieu Guillemot, 1644.

J. H. Fragonard e H. Robert a Roma. Exhibition Villa Medici. Roma: Frateli Palombi Editori-Edizioni Carte Segrete, 1990.

Jacques, Annie, and Jean-Pierre Mouilleseaux. "La Folie d'Artois." Pp. 27–50 in *La Folie d'Artois*. Ed. Jean-Louis Gaillemin. Paris: Antiquaires à Paris, 1988.

Janowitz, Anne. *England's Ruins, Poetic Purpose and the National Landscape*. Cambridge, Mass.: Basil Blackwell, 1990.

Jarry, Abbé. *Oraison funebre de son éminence monseigneur le cardinal de la Rochefoucauld*. Munster: Ant. Guil. Aschendorf, 1801.

Jéglot, Cécile. "Les vues de Normandie, par Hubert Robert à l'archêveché de Rouen." *La Revue de l'Art* (1924): 186–200.

Join-Lambert, M. "La pratique religieuse dans le Diocèse de Rouen de 1707 à 1789." *Annales de Normandie* 5 (1955): 36–49.

Jones, Colin. "Bourgeois Revolution Revivified: 1789 and Social Change." Pp. 69–98 in *Rewriting the French Revolution*. Ed. Colin Lucas. Oxford: Clarendon Press, 1991.

Jones, Jennifer. "Selling the Grisette: Femininity, Commerce and Fashion in Ancien Régime Paris." Paper presented at the annual meeting of the American Society for Eighteenth-Century Studies, Charleston, 1994.

Jouen, Léon. *Comptes, Devis et Inventaires du Manoir Archiépiscopal de Rouen*. Recueillis et annotés par m. le Chanoine Jouen publiés avec une introduction historique par Mgtr. Fuzet, archevêque de Rouen. Paris: A. Picard et Fils & Rouen: Imprimerie de la Vicomté, 1908.

Kaplan, Steven Laurence, and Cynthia J. Koepp, eds. *Work in France: Representations, Meaning, Organization, and Practice*. Ithaca: Cornell University Press, 1986.

Kettering, Sharon. "Gift-Giving and Patronage in Early Modern France." *French History* 2 (June 1988): 131–51.

 "Patronage in Early Modern France." *French Historical Studies* 17 (fall 1992): 839–62.

Koepp, Cynthia J. "The Alphabetical Order: Work in Diderot's Encyclopedia." Pp. 229–57 in *Work in France: Representations, Meaning, Organization, and Practice*, ed. Steven Laurence Kaplan and Cynthia J. Koepp. Ithaca: Cornell University Press, 1986.

Labrousse, Ernest, Pierre Léon, Pierre Goubert, Jean Bouvier, Charles Carrière, and Paul Harsin. *Histoire économique et sociale de la France*. 4 vols. Paris: Presses universitaires de France, 1984.

Lacour-Gayet, Robert. *Calonne, Financier, Réformateur, Contre-Revolutionaire, 1734–1802*. Paris: Hachette, 1963.

La France et la Russie au Siècle des Lumières: Relations culturelles et artistiques de la France et de la Russie au XVIIIe siècle. Exposition, Galeries Nationales du Grand Palais, 20 novembre 1986–9 février 1987. Paris: Association Française d'Action Artistique, 1986.

La Harpe, Jean-François de. *Oeuvres de La Harpe*. 16 vols. Genève: Slatkine rpt., 1968.

Landes, Joan B. *Women and the Public Sphere in the Age of the French Revolution*. Ithaca: Cornell University Press, 1988.

La Révolution Française, Le Premier Empire: Dessins du Musée Carnavalet. Paris: Les Amis du Musée Carnavalet, 1983.

Larrère, Catherine. *L'Invention de l'Économie au XVIIIe siècle, Du droit naturel à la physiocratie*. Paris: Presses universitaires de France, 1992.

Lastic Saint-Jal, Georges de. "La Reine de la Rue Saint-Honoré." *L'Oeil* no. 33 (1957): 51–57.

Lazzaro, Claudia. *The Italian Renaissance Garden, From the Conventions of Planting, Design, and Ornament to the Grand Gardens of Sixteenth-Century Central Italy*. New Haven: Yale University Press, 1990.

Le Cabinet d'un Grand Amateur P.-J. Mariette, 1694–1774. Paris: Ministère des Affaires Culturelles, 1967.

Le Camus de Mézières, Nicolas. *Le Génie de l'Architecture ou l'Analogue de cet art avec nos sensations*. Paris: Auteur ou Benoit Morin, 1780.

 The Genius of Architecture; or, The Analogy of that Art with Our Sensations. Trans. David Britt. Introduction by Robin Middleton. Texts and Documents, A Series of The Getty Center Publication Programs. Santa Monica: The Getty Center for the History of Art and the Humanities, 1992.

Lecarpentier, Charles. *Notice sur Hubert Robert*. Rouen: Vt. Guilbert, 1808.

Le Coq de Villeray, Pierre. *Abrégé de l'Histoire ecclésiastique, civile et politique, de la ville de Rouen avec son Origine et ses Accroissemens jusqu'à nos jours*. Rouen: François Oursel, 1759.

Lemarchand, Guy. "Les troubles de subsistances dans la généralité de Rouen." *Annales Historiques de la Révolution Française* 35 (1963): 401–27.

Lettre à un Père de famille sur les petits spectacles de Paris par un honnête homme. Paris: Garnéry, 1789.

Levine, Steven Z. "To See or Not to See: The Myth of Diana and Acteon in the Eighteenth Century." Pp. 73–88 in *The Loves of the Gods*. Ed. Colin B. Bailey. New York: Rizzoli, 1992.

Loth, Julien. *Histoire du Cardinal de la Rochefoucauld et du diocèse de Rouen pendant la Révolution.* Evreux: Imprimerie de l'Eure, 1893.

Mantion, Jean-Rémy. "Autopsie de la Bastille: Peindre l'événement en 1789." *Dix-Huitième Siècle* 20 (1988): 235–47.

——— "Déroutes de l'art, La destination de l'oeuvre d'art et le débat sur le musée." Pp. 97–129 in *La Carmagnole des Muses, L'homme de lettres et l'artiste dans la Révolution.* Paris: Armand Colin, 1988.

Mariette, P. J. *Abecedario.* Paris: J.B. Dumoulin, 1857–58; rpt. Paris: F. de Nobele, 1966.

Marin, Louis. *Portrait of the King.* Trans. Martha M. Houle; Foreword by Tom Conley. Minneapolis: University of Minnesota Press, 1988.

Marmontel, Jean-François. *Mémoires.* Ed. John Renwick. 2 vols. Clermont-Ferrand: G. de Bussac, 1972.

Marshall, David. *The Figure of Theater: Shaftesbury, Defoe, Adam Smith, and George Eliot.* New York: Columbia University Press, 1986.

Martin, Georges. *Histoire et genealogie de la Maison de la Rochefoucauld.* La Ricamarie: Chez l'auteur, n.d.

Martin, Marietta. *Une Française à Varsovie en 1766: Madame Geoffrin chez le Roi de Pologne Stanislas-Auguste.* Paris: Bibliothèque Polonaise, 1936.

Mattick, Paul, Jr., ed. "Art and Money." Pp. 152–77 in *Eighteenth-Century Aesthetics and The Reconstruction of Art.* Cambridge: Cambridge University Press, 1993.

Maza, Sarah C. *Servants and Masters in Eighteenth-Century France: The Uses of Loyalty.* Princeton: Princeton University Press, 1983.

McClellan, Andrew. *Inventing the Louvre.* Cambridge: Cambridge University Press, 1994.

McCormick, Thomas J. *Charles-Louis Clérisseau and the Genesis of Neo-Classicism.* New York: The Architectural History Fundation; and Cambridge, Mass.: The MIT Press, 1990.

Mémoires de la Comtesse Du Barri. Texte rendu public par Etienne-Léon de Lamothe-Langon. 5 vols. Paris: Jean de Bonnot, 1967.

Ménard, Léon. *Histoire des antiquités de la ville de Mismes et de ses environs.* Nismes: l'Éditeur, 1829.

Mercier, Louis-Sébastien. *Du Théâtre, ou Nouvel Essai sur l'Art Dramatique.* Amsterdam: E. van Harrevelt, 1773; Genève: Slatkine rpt., 1970.

——— *Le Tableau de Paris.* Introduction et choix des textes par Jeffry Kaplow. Paris: Éditions la Découverte, 1989.

——— *Memoirs of the Year 2500 [sic].* Trans. W. Hooper. Philadelphia: Thomas Dobson, 1795; rpt. Clifton: Augustus M. Kelley, n.d.

Michel, Christian. "Les Conseillers Artistiques de Diderot." *Revue de l'Art,* no. 66 (1984): 9–16.

Millin, Aubin-Louis. *Voyage dans les Départemens du Midi de la France.* 4 vols. Paris: De l'Imprimerie Impériale, 1806.

Mitchell, Jerrine E. "Considering the Idea of Art as Propaganda." Paper presented at the annual meeting of French Historical Studies, Boston, 1996.

"Shaping the Arts in the French Revolution." Ph.D. diss. University of California, Los Angeles, 1992.

Montaiglon, Anatole de, and Jules Guiffrey, eds. *Correspondance des directeurs de l'Académie de France à Rome avec les Surintendants des Bâtiments*. 21 vols. Paris: Jean Schemit, 1906.

Montfaucon, Bernard de. *Antiquity Explained and Represented in Sculptures*. Trans. David Humphreys. 2 vols. London, 1721–22; Garland rpt. New York, 1976.

Montgolfier, Bernard de, ed. *De Bagatelle à Monceau, 1778–1978: Folies du XVIIIe siècle à Paris*. Introduction and catalogue by Béatrice d'Andia. Exhibition Domaine de Bagatelle, 13 juillet-11 sept. 1978 et Musée Carnavalet, 6 déc.-28 jan. 1979. Alençon: Imprimerie Alençonnaise, 1978.

Moreau, Jacob-Nicolas. *Leçons de Morale, de Politique et de Droit Public puisées dans l'Histoire de notre Monarchie ou Nouveau Plan d'Etude de l'Histoire de France*. Versailles: De l'imprimerie du Départ, 1773.

Morilhat, Claude. *La Prise de Conscience du Capitalisme: Économie et philosophie chez Turgot*. Paris: Méridiens Klincksieck, 1988.

Mosser, Monique. "Histoire d'un Jardin." Pp. 51–71 in *La Folie d'Artois*. Ed. Jean-Louis Gaillemin. Paris: Antiquitaires à Paris, 1988.

Nuti, Lucia. "The Perspective Plan in the Sixteenth Century: The Invention of a Representational Language." *The Art Bulletin* 76 (March 1994): 105–28.

Oberkirch, Henriette Louise von Waldner, Baronne d'. *Mémoires de la Baronne d'Oberkirch*. Ed. Suzanne Burkard. Paris: Mercure de France, 1970.

Oliver, J. W. *The Life of William Beckford*. London: Oxford University Press, 1932.

Ozouf, Mona. *La fête révolutionaire, 1789–1799*. Paris: Éditions Gallimard, 1976.

Pardailhé-Galabrun, Annik. *The Birth of Intimacy: Privacy and Domestic Life in Early Modern Paris*. Trans. Jocelyn Phelps. Philadelphia: University of Pennsylvania Press, 1991.

Pasquier, Étienne-Denis. *Histoire de Mon Temps: Mémoires du Chancelier Pasquier*. Publiés par le duc d'Audiffret-Pasquier. 6 vols. Paris: Plon, Nourrit et Cie., 1893.

Paulson, Ronald. *Emblem and Expression: Meaning in English Art of the Eighteenth Century*. Cambridge, Mass.: Harvard University Press, 1975.

——. *Hogarth*. 3 vols. New Brunswick, N.J.: Rutgers University Press, 1991–93.

Piles, Roger de. *Cours de Peinture par Principes*. Paris: Éditions Jacqueline Chambon, 1990.

Plax, Julie. "Gersaint's Biography of Antoine Watteau: Reading Between and Beyond the Lines." *Eighteenth-Century Studies* 25 (summer 1992), 545–60.

Pliny the Elder. *Natural History: A Selection*. Introduction and translation by John F. Healey. Harmondsworth, Middlesex, Eng.: Penguin, 1991.

Pointon, Marcia. *Hanging the Head: Portraiture and Social Formation in Eighteenth-Century England*. New Haven: Yale University Press, 1993.

Pomian, Krzysztof. *Collectors and Curiosities: Paris and Venice, 1500–1800*. Trans. Elizabeth Wiles-Portier. Cambridge: Polity Press, 1990.

Pommier, Edouard. "Winckelmann et la vision de l'Antiquité classique dans la France des Lumières et de la Révolution." *Revue de l'Art* 83 (1989): 9–20.

Posner, Donald. "The Swinging Women of Watteau and Fragonard." *The Art Bulletin* 64 (March 1982): 75–88.

Praz, Mario. *Conversation Pieces: A Survey of the Informal Group Portrait in Europe and America*. University Park: The Pennsylvania State University Press, 1971.

"Procès-Verbaux de la Commission des Monuments, 8 nov.-27 aout 1793." *Nouvelles Archives de l'Art Français* 17(1901) and 18(1902).

Quellern, L. de. *Le Chateau de Bagatelle: Étude historique et descriptive*. Paris: Charles Foulard, 1909.

Radisich, Paula. "Deconstructing Dissipation." *Eighteenth-Century Studies* 29 (winter 1995–96): 222–25.

 "Hubert Robert's Paris: Truth, Artifice, and Spectacle." *Studies on Voltaire and the Eighteenth Century* no. 245 (1986): 501–18.

 "The King Prunes His Garden: Hubert Robert's Picture of the Versailles Gardens in 1775." *Eighteenth-Century Studies* (summer 1988): 454–71.

 "*La Chose Publique*: Hubert Robert's Decorations for the *Petit Salon* at Méréville." Pp. 401–15 in *The Consumption of Culture, 1600–1800, Image, Object, Text*. Ed. Ann Bermingham and John Brewer. London: Routledge, 1995.

 "*Qui peut définir les femmes*? Vigée-Lebrun's Portraits of an Artist." *Eighteenth-Century Studies* 25 (summer 1992): 441–68.

Rand, Erica, "Diderot and Girl Group Erotics." *Eighteenth-Century Studies* 25 (summer 1992): 495–516.

Réau, Louis. "Hubert Robert, peintre de Paris." *Bulletin de la Société de l'Histoire de l'Art Français* (1927): 207–27.

 "L'Art français dans les pays du nord et de l'est de l'Europe." *Archives de l'Art français*, vol. 17 (1932).

Reddy, William M. "The Textile Trade and the Language of the Crowd at Rouen, 1752–1871." *Past and Present* 74 (1977): 62–89.

Restif de la Bretonne, N.-E. *My Revolution: Promenades in Paris, 1789–1794. Being the Diary of Restif de la Bretonne*. Trans. Alex Karmel. New York: McGraw-Hill, 1970.

Roche, Daniel. *La France des Lumières*. Paris: Fayard, 1993.

 The People of Paris: An Essay in Popular Culture in the Eighteenth Century. Trans. Marie Evans. Berkeley: University of California Press, 1987.

Rochefoucauld, François de la. *Voyages en France de François de la Rochefoucauld (1781–1783)*. Ed. Jean Marchand. Paris: Librairie Ancienne Honoré Champion, 1938.

Rosenberg, Pierre. *Chardin, 1699–1779*. Exhibition. Cleveland: The Cleveland Museum of Art and Indiana University Press, 1979.

 Fragonard. Exhibition. New York: The Metropolitan Museum of Art, 1988.

 Ed. *Vies anciennes de Watteau*. Paris: Hermann, 1984.

Roucher, Antoine. *Consolations de ma captivité, ou Correspondance de Roucher*. 2 vols. Paris: H. Agasse, 1797.

Sahut, Marie-Catherine, and Nicole Garnier. *Le Louvre d'Hubert Robert*. Paris: Éditions de la Réunion des Musées Nationaux, 1979.

Saint-Lambert, Anne-Thérèse de Marquenat de Courcelles, marquise de. *Oeuvres morales de Mme. Saint-Lambert*. Précedées d'une étude critique par M. de Lescure. Paris: Librairie des Bibliophiles, 1883.

Sainte-Beuve, C.-A. *Causeries du Lundi*. 3d ed. 16 vols. Paris: Garnier Frères, 1858.

Saisselin, Rémy. *The Enlightenment against the Baroque: Economics and Aesthetics in the Eighteenth Century*. Berkeley: University of California Press, 1992.

Saugrain, Claude-Marie. *Nouveau Voyage de France, géographique, historique et curieux* , s.l. s.d. [Paris: Les Libraires Associées, 1778].

Schama, Simon. *Citizens: A Chronicle of the French Revolution*. New York: Vintage Books, 1990.

Scheffer, Carl Fredrik. *Lettres particulières à Carl Gustaf Tessin, 1744–1752*. Ed. Jan Heidner. Stockholm: Kung. Samfundet för utgivande av handskrifter rörande Skandinaviens historia, 1982.

Scherer, Françoise. "La Chambre à Coucher du Comte d'Artois à Bagatelle d'après les documents des Archives Nationale." *Gazette des Beaux-Arts* 105 (avril 1985): 147–54.

Scherf, Guilhem, ed. *Clodion et la sculpture française de la fin du XVIIIe siècle*. Actes du colloque organisé au musée du Louvre par le service culturel les 20 et 21 mars 1992. Paris: La Documentation française, 1993.

Scott, Barbara. "Bagatelle: Folie of the Comte d'Artois." *Apollo* 95 (April-June 1972): 476–85.

 "Madame Geoffrin: A Patron and Friend of Artists." *Apollo* 85 (February 1967): 98–103.

Scott, Katie. "Hierarchy, Liberty, and Order: Languages of Art and Institutional Conflict in Paris (1766–1776)." *The Oxford Art Journal* (1989): 59–70.

 The Rococo Interior: Decoration and Social Spaces in Early Eighteenth-Century Paris. New Haven: Yale University Press, 1995.

Ségui, Emile. *Le Trésor de la Maison Carrée*. Nîmes: Éditions Méridionales, 1937.

Ségur, Pierre de. *Le Royaume de la Rue Saint-Honoré: Madame Geoffrin et sa Fille*. 4th ed. Paris: Calmann Lévy, 1898.

Sénac de Meilhan, Gabriel. *Du Gouvernement, des Moeurs, et des Conditions en France avant la Révolution, avec le caractère des principaux personnages du Règne du Louis XVI*. Londres: Benjamin & Jean White, 1795.

Sermain, Jean-Paul. "La Conversation au Dix-huitième siècle: Un théâtre pour les lumières?" Pp. 105–30 in *Convivialité et politesse: Du gigot, des mots et autres savoir-vivre*. Ed. Alain Montandon. Clermont-Ferrand: Association des Publications de la Faculté des Lettres et Science Humaines, 1993.

Sheriff, Mary D. *Fragonard: Art and Eroticism*. Chicago: The University of Chicago Press, 1990.

 The Exceptional Woman: Elisabeth Vigée-Lebrun and the Cultural Politics of Art. Chicago: The University of Chicago Press, 1996.

Smith, Adam. *The Theory of Moral Sentiments*. Ed. D. D. Raphael and A. L. Macfie. London, 1759; rpt. Indianapolis: Liberty Fund, 1984.

Smith, David R. "Carel Fabritius and Portraiture in Delft." *Art History* 13 (June 1990): 151–74.

"Irony and Civility: Notes on the Convergence of Genre and Portraiture in Seventeenth-Century Dutch Painting." *The Art Bulletin* 69 (September 1987): 407–30.

Solnon, Jean-François. *La Cour de France*. Paris: Fayard, 1987.

Sonenscher, Michael. *Work and Wages: Natural Law, Politics, and the Eighteenth-Century French Trades*. Cambridge: Cambridge University Press, 1989.

Souchal, François. *Les Slodtz: Sculpteurs et décorateurs du Roi (1685–1764)*. Paris: Éditions E. de Boccard, 1967.

Starn, Randolph, and Loren Partridge. *Arts of Power: Three Halls of State in Italy, 1300–1600*. Berkeley: University of California Press, 1992.

Starobinski, Jean. *1789: Les Emblèmes de la Raison*. Paris: Flammarion, 1979.

Sterling, Charles. *Exposition Hubert Robert*, à l'occasion du Deuxième Centenaire de sa Naissance. Paris: Musée de l'Orangerie, 1933.

Stern, Jean. *À l'ombre de Sophie Arnould, François-Joseph Belanger, Architecte des Menus Plaisirs, Premier Architecte de Comte D'Artois*. 2 vols. Paris: Plon, 1930.

Stewart, Philip. *Engraven Desire: Eros, Image, and Text in the French Eighteenth Century*. Durham: Duke University Press, 1992.

"Representations of Love in the French Eighteenth Century." *Studies in Iconography* 4 (1978): 124–48.

Szambien, Werner. *Symétrie, Goût, Caractère: Théorie et Terminologie de l'Architecture à l'Age Classique, 1550–1800*. Paris: Picard, 1986.

Taillasson, J. J. "Notice nécrologique 'Hubert Robert.' " *Le Moniteur Universel* (20 avril 1808): 1–4.

Taylor-Leduc, Susan. "Louis XVI's Public Gardens: The Replantation of Versailles in the Eighteenth Century." *Journal of Garden History* (summer 1994): 67–91.

Tessin, C. G. *Lettres au Prince Royal de Suède par M. le Comte Tessin, Ministre d'Etat, et Gouverneur de ce jeune Prince*. Traduites du Suédois. 2 vols. Paris: Jombert, 1755.

Thiébault, Paul Charles François Adrien Henri Dieudonne, baron. *Mémoires du général Bon Thiébault*. 5 vols. Paris: Plon, 1893.

Thiervoz, Général. "Les Ports de France de Joseph Vernet." *Neptunia* 57 (1960): 6–14; 58 (1960): 7–18; 59 (1960): 8–16.

Thiéry, L. V. *Guide des Amateurs et des Étrangers*. 2 vols. Paris: Hardouin et Galley, 1786.

Thrale, H. *The French Journals of Mrs. Thrale and Doctor Johnson*. Ed. Moses Tyson and Henry Guppy. Manchester: The Manchester University Press, 1932.

Thuiller, Jacques, and Albert Châtelet. *French Painting from Le Nain to Fragonard*. Geneva: Skira, 1964.

Tomlinson, Janis A. *Francisco Goya: The Tapestry Cartoons and Early Career at the Court of Madrid*. Cambridge: Cambridge University Press, 1989.

Turquan, Joseph, and Jules d'Auriac. *Monsieur Le Comte d'Artois*. Paris: Éditions Émile-Paul Frères, 1928.

Vigarello, Georges. *Concepts of Cleanliness: Changing Attitudes in France since the Middle Ages*. Trans. Jean Birrell. Cambridge: Cambridge University Press, 1988.

Vigée-Lebrun, E. *Souvenirs*. Ed. Claudine Herrmann. 2 vols. 1835; Paris: Éditions Des Femmes, 1986.

Wakefield, David. *French Eighteenth-Century Painting*. New York: Alpine Fine Arts Collection, 1984.

Walpole, Horace. *The Letters of Horace Walpole*. Ed. John Wright. 6 vols. London: Richard Bentley, 1840.

Wedepohl, Edgar. "Descriptions de Bagatelle." *L'Oeil* no. 126 (1965): 17–23.

Weulersse, Georges. *La Physiocratie à la fin du règne de Louis XV (1770–1774)*. Paris: Presses universitaires de France, 1959.

Wildenstein, Georges. *Mélanges*. 2 vol. Paris: Les Beaux Arts, 1925.

Wintermute, Alan, ed. *1789: French Art during the Revolution*. New York: Colnaghi, 1989.

Wright, Lawrence. *Clean and Decent: The History of the Bath and Loo*. 2d edition. London: Routledge & Kegan, 1980.

Wrigley, Richard. *The Origins of French Art Criticism from the Ancien Régime to the Restoration*. Oxford: Clarendon Press, 1993.

Yavchitz-Koehler, Sylvie. "Un dessin d'Hubert Robert: Le salon du bailli de Breteuil à Rome." *Revue du Louvre* 5/6 (1987): 369–78.

Young, Arthur. *Arthur Young's Travels in France During the Years 1787, 1788, 1789*. Ed. Miss Betham-Edwards. London: George Bell & Sons, 1892.

Yriarte, Charles. "Mémoires de Bagatelle." *La Revue de Paris* (1 July 1903): 21.

Zafran, Eric M. *The Rococo Age, French Masterpieces of the Eighteenth-Century*. Atlanta: The High Museum of Art, 1983.

Index